Julia Margaret Cameron

Julia Margaret Cameron

A POETRY OF PHOTOGRAPHY

Nichole J. Fazio

BODLEIAN
LIBRARY
PUBLISHING

Contents

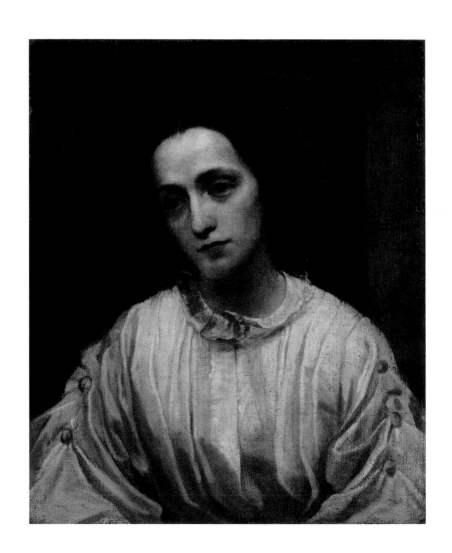

On 20 January 2016, the Bodleian Library hosted a symposium on Julia Margaret Cameron, convened by Dr Mirjam Brusius, then an Andrew W. Mellon Postdoctoral Fellow based jointly at the Bodleian and the Department of Art History at Oxford University. It accompanied an exhibition at the Weston Library which displayed a small selection of Cameron's photographs from the Henry Taylor collection and was one of several events that celebrated her 2015 bicentenary. Exhibition curators spoke at the symposium, as did several historians of photography responsible for introducing Cameron to specialist and general audiences alike. Early scholars on Cameron's photography, including Colin Ford, Pamela Roberts and Larry Schaaf, presented on their research and how it had shaped the direction of what one might call the first generation of Cameron scholarship.

Along with the symposium co-chair, Professor Geraldine Johnson from Oxford's art history department, we explained to the audience the library's significant commitment to early photography, as well as the university's increasing interest in teaching the subject formally. By that time, the department had been offering a regular seminar on the history of photography. Just over a year later, Professor Johnson would co-host Photo

G.F. Watts, *Julia Margaret Cameron*, c.1850–52
Oil on canvas, 61 × 50.8 cm
National Portrait Gallery, London, NPG 5046

Archives VI, a partnership with the Kunsthistorisches Institut (Max Planck KHI) in Florence, Italy, which took as its theme 'The Place of Photography'. Its plenary speaker was Geoffrey Batchen, a historian of photography and now professor of art history at Oxford. Oxford has become a place for photography and the Bodleian Library has been central to that effort.

The author of this book was also in the room on 20 January, waiting to speak about the friendship between Julia Margaret Cameron and Henry Taylor. It was a friendship that yielded one of the most wide-ranging collections held by an academic library and, as this book suggests, affords us a new way of thinking about the relationship between poetry and photography. Dr Nichole Fazio had begun her research on the subject ten years earlier as an Oxford postgraduate, poring over Cameron's photographs back when the very auditorium in which we convened had been the Special Collections and Western Manuscripts reading room of the then New Bodleian Library. The result is a book that has benefited from the overarching vision of the library, its committed staff, including Colin Harris, former superintendent of the Special Collections and Western Manuscripts reading room – and two scholars of photographic history, Mike Weaver and Anne Hammond, who all suspected there was still more of Cameron's story to be uncovered. These collaborative efforts have yielded this compendium of extraordinary photographs: it has also

resulted in the complete digitization of both the Taylor collection and the Bodleian's copy of volume two of Cameron's *Illustrations to Tennyson's Idylls of the King, and Other Poems*.

The library has since acquired additional photographs by Cameron, including *Sappho* (plate 86), which came into the collections along with materials by Anna Atkins, whose photogenic drawings and calotypes are among the earliest in the history of photography. Harris has continued his efforts at chronicling the photography in the library's general collection, identifying significant holdings that include photographs such as the Leslie-Melville, 13th Earl of Leven, collection with its photographs by Oscar G. Rejlander

and Cameron, among others. Similarly, the library's Sarah A. Acland and William Henry Fox Talbot collections have advanced new scholarship on early photography. As such, the Bodleian Library has become a leader in the advancement of photographic history, not just by preserving it materially but by ensuring that its collections are available to new generations of those interested in the history and art of photography – from students and researchers to the broader public. Julia Margaret Cameron worked hard to ensure her photographs could be seen by a wide audience: through exhibitions and printed publications. Here at the Bodleian we are conscious that our work must help fulfil her ambitions in the twenty-first century.

Richard Ovenden OBE
Bodley's Librarian

Acknowledgements

I would like to thank the Bodleian Library staff, particularly those in Special Collections, and Colin Harris, whose comprehensive knowledge of the library's collections, commitment to preserving its photographic material and general research counsel has contributed significantly to this book. I am also indebted to Dr Mike Weaver and Dr Anne Hammond for their contributions to the history of photography and the scholarship on Julia Margaret Cameron, as well as their academic mentorship and abiding friendship. I also extend my appreciation to the Department of the History of Art, University of Oxford, and Professor Geraldine Johnson and Professor Martin Kemp for their support of my scholarship on Cameron and nineteenth-century photography. Finally, I am grateful to my family, former teachers and students for their unwavering encouragement and inspiration.

Nichole J. Fazio

For Benjamin, who found beauty in the shadows.

'The Taylor Album', a collection of 112 original photographs taken by Julia Margaret Cameron, three by Oscar Gustav Rejlander and two by an unidentified photographer.
38.5 × 33.5 cm
Bequeathed to the Bodleian in 1930 by Ida Alice Ashworth Taylor, eldest daughter of Sir Henry Taylor.
Oxford, Bodleian Library, Arch. K b.12

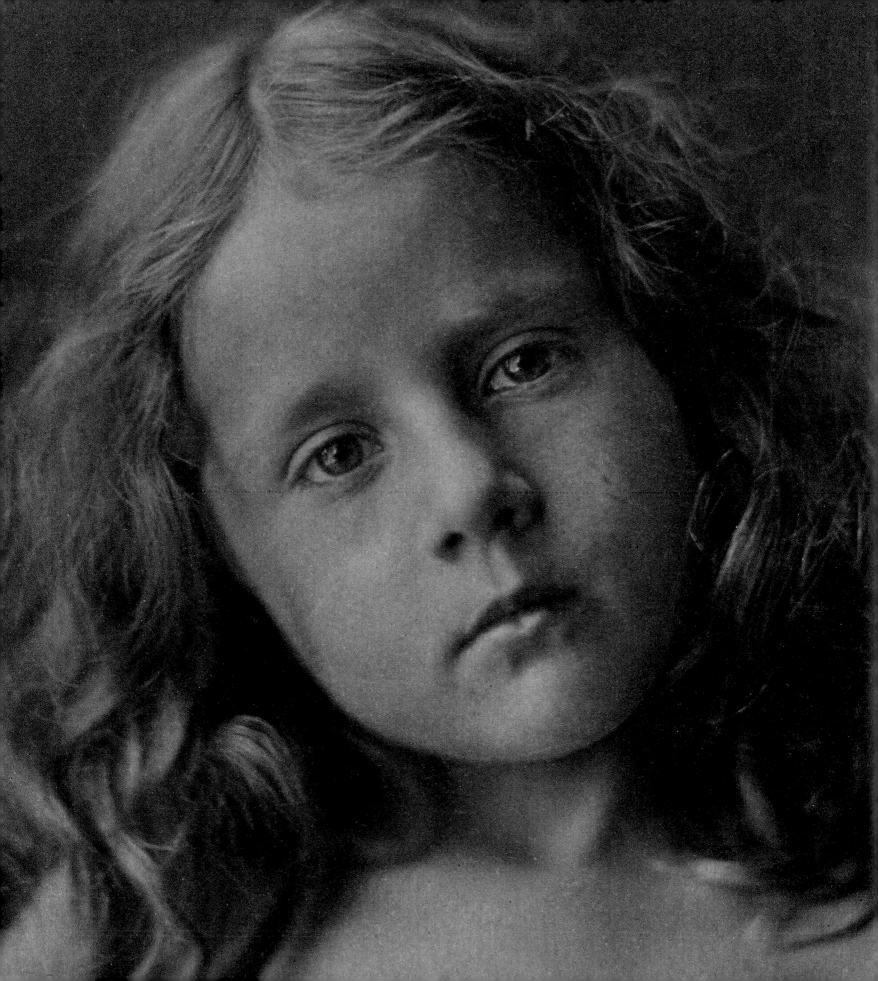

1 Julia Margaret Cameron

Oh, mystery of Beauty! who can tell
Thy mighty influence? who can best descry
How secret, swift, and subtle is the spell
Wherein the music of thy voice doth lie?

<div align="right">Julia Margaret Cameron, 'On a Portrait'</div>

The portraits and illustrative photographs held by the Bodleian Library and Ashmolean Museum at the University of Oxford include some of Julia Margaret Cameron's (1815–1879) most significant work, and span the duration of her short but prodigious photographic career. The collection is singular in its capacity to illustrate the aesthetic development of the photographer from her earliest pictures to her most poetic photographs. This development is increasingly evident in the portraits featured in the collection which benefit from her interest in moving beyond the portrait for posterity to a typological portraiture that ascribes layers of suggestive meaning to a single face. Cameron advances this further in her illustrations of Alfred Tennyson's poetry, which serialize portraits not exclusively of individual characters but as personifications of those themes in the text she found most compelling. By isolating parts of the poetic narrative into distinct 'frames', she not only pushes the boundaries of meaning taken from the original text, but asserts a visual poetic made possible by employing the most distinct features of her medium. A little more than a decade after she photographed Mary Hillier as Tennyson's Maud (plate 72), the British photographer Peter Henry Emerson (1856–1936), who held Cameron's work in high esteem, wrote:

> Thus, it will be seen how difficult a matter it is to produce a *picture*, even when we have thoroughly mastered our technique and practice … in a picture the arrangement of lines must be appropriate, the aerial perspective must be truly and subtly yet broadly rendered, the tonality must be perfect, the impression true, the subject distinguished, and if the picture is to be a masterpiece, the *motif* must be poetically rendered, for there is a poetry of photography as there is of painting and literature.[1]

This book explores how Cameron used the particularities of her own medium to achieve this 'poetry of photography'. The result were portraits of Tennyson as a nation's poet and as the 'Dirty Monk', of poet and playwright Henry Taylor as a man of sorrows, and of Mary Hillier as Maud, a Magdalene figure with additional allusions to the Queen of Heaven and Christ.

The Anniversary (Elizabeth Cowen), 1865 (detail of plate 6).

The formative years

Born in Calcutta (Kolkata), India, to James Pattle (1775–1845), an employee of the East India Company, and Adeline de l'Etang (c.1793–1845), a descendant of French aristocracy, Julia Margaret and her six sisters, like many expatriate children of the period, returned to Europe for their education. The Pattle sisters were educated by their maternal grandmother in France, and soon encountered people who were shaping the world of Victorian art and culture. William Makepeace Thackeray, the celebrated author, provided early accounts of Julia and her sisters from time shared in Paris, and it was he who coined the term 'Pattledom' in reference to this group of sisters, of which Julia was thought to be the plainest but the most talented. Thackeray's daughter later described the Pattle sisters as 'unconscious artists, divining beauty and living with it'.[2] In 1834 Julia returned to India, but in 1836 she travelled to the Cape of Good Hope (Cape Town), to recover from ill health. While there, she met the British astronomer and polymath Sir John Herschel (1792–1871), as well as her future husband Charles Hay Cameron (1795–1880), then a jurist and leading official with the Supreme Council of India (plate 2). Twenty years her senior, Charles had an established professional life and was a committed Benthamite, following in the steps of the utilitarian philosopher Jeremy Bentham through his active support of universal education as a tool for social reform.

In a recommendation letter on Charles's behalf, the poet, playwright and statesman Henry Taylor described him as 'an accomplished scholar and gentleman of great literary and general knowledge and his writings are in grace, force and clearness of diction, superior to almost any of his time that I am acquainted with'.[3] It was, in fact, Charles who introduced Julia to Taylor's tragic drama *Philip van Artevelde* (1834), describing it as the best of its kind. She may have been half her husband's age, but the two maintained a strong and, for the time in which they lived, comparatively equitable relationship, in which intellectual and artistic curiosities were shared and such pursuits were encouraged. While Charles continued to work towards reform in government and educational policies, Julia involved herself in several social and philanthropic pursuits. Their contemporary and lifelong friend Taylor later affirmed that Julia's confidence and ease of movement among various cultural norms stemmed from her childhood in India and the early years of her marriage spent in Calcutta. Writing of her role as stand-in for the Calcutta governor-general's wife, he described her as one who made small account of the world of England. Although married to a pragmatist and utilitarian, Julia was also steadfast in her religious beliefs and later expressed this in the biblical themes evident in her photography.

The Camerons returned to England in 1848, growing their own family to include six children and, over the course of their lives, welcoming those of family and friends in need into their home. Anne Thackeray Ritchie, Cameron's most prolific biographer, writes that this 'almost impossible to describe [woman] played the game of life with such vivid courage and disregard for ordinary rules: she entered into other people's interests with such warm-hearted sympathy and determined devotion'.[4] Cameron thrived on social interaction. In 1850 they moved to East Sheen, London, where she contributed to the dynamic social circles formed

first by her sister, Sarah Prinsep, at Little Holland House in Kensington. It was there that Cameron met the artist George Frederic (G.F.) Watts; she was later described by Watts's widow, Mary, as one who epitomized all the qualities of the entire Pattle family at once, 'presenting them in a doubly distilled form. She doubled the generosity of the most generous of the sisters, and the impulsiveness of the most impulsive. If they were enthusiastic, she was twice over; if they were persuasive, she was invincible'.[5] Her life in England was quickly populated with the artists and intellectuals who frequented Little Holland House, and it was in this period that she forged some of her most significant relationships, particularly with Henry Taylor, G.F. Watts and Alfred Tennyson. In choosing to name her son Henry Herschel Hay Cameron (who himself became a professional photographer of some repute and an important voice supporting his mother's use of soft focus), she demonstrated the esteem she felt for Taylor and Herschel.

Three years after the Camerons returned to England, the Great Exhibition was held at the Crystal Palace in London; in 1856 the National Portrait Gallery was founded, followed in 1857 by the South Kensington Museum, which was later to become the Victoria and Albert Museum. The collection of art reproductions amassed by Henry Cole, the first director of the South Kensington Museum, contributed to Cameron's growing knowledge of art history. The Manchester Art Treasures exhibition also took place that year and Cameron would have had access to the works on display through the accompanying publication, *Photographs of the Gems of the Art Treasure's Exhibition*.[6] Given her family's relationship

with Lord Samuel Jones Overstone, one of the principal benefactors and contributors to the exhibition, it is likely that Cameron was exposed to his holdings of paintings by Rembrandt, Giotto, Perugino and Murillo on display at Manchester. The Pre-Raphaelites were also coming into their own during this period; in September 1857 they decorated the University of Oxford Student Union with murals depicting scenes from the Arthurian legends, an effort that included the work of Cameron's nephew, Val Prinsep. Another important contributor to her artistic milieu was the art critic John Ruskin, who was an early supporter of the photographic arts.

Cameron's aesthetic interests extended to the literary as well as the visual. She committed herself to translating Gottfried August Bürger's ballad *Leonora*, published in 1847 with illustrations by the renowned Irish painter and illustrator Daniel Maclise. As the photo historian Mike Weaver argues, hers was also an aesthetic informed by the religious ethos of her time including the controversies and contributions of the so-called Oxford or Tractarian Movement. Supporters of the movement, including one of its principal leaders, John Keble, understood poetry to be a form of mythology, with several layers of potential meanings and associations, a notion relevant to the future photographer's approach to portraiture.[7] To this milieu was added the work of the most recognized Christian iconographer of the time, Anna Jameson, whose illustrated compendiums on religious art included *Sacred and Legendary Art* (1848), *Legends of the Madonna* (1852) and *Legends of the Monastic Orders* (1852). Lord Lindsay's *Sketches of the History of Christian Art* (1847) and Sir John Gilbert's illustrations of Shakespeare (1856) rounded

out such sources of inspiration as Cameron continued to build her literary and visual vernacular.

Cameron was also alert to early innovations in the art of photography. She had learned of the new medium through Herschel, who sent her early examples of this remarkable invention. He had discovered 'hypo' (hyposulfite of soda) in 1819, a necessary fixing agent in the photographic process, and later sent Cameron samples of another compound known as 'collodion', which she would eventually use in her own photographic practice. Herschel also contributed the terms 'snapshot', 'negative' and 'positive' as related to photography, and possibly coined the term 'photography' itself. She collected various photographs for her 'Signor 1857' album, which was presented to Watts, including images attributed to the Manchester photographer James Mudd and to Joseph Cundall, a founding member of the Calotype Club, the Photographic Institution and the Royal Photographic Society of London.[8] As a printer and publisher, Cundall worked closely with Cole, director of the South Kensington Museum, where Cameron made use of rooms as a temporary studio space. Cole also sat for portraits by Cameron in 1865 and 1868.

In terms of other cultural influences, the year 1859 stands as one of the most important in this formative period, as this was the year Cameron joined the Arundel Society. It was also known as the Society for Promoting the Knowledge of Art and its primary purpose was to build a collection of photographs, tracings, and watercolours of frescoes from the fourteenth, fifteenth and sixteenth centuries. The society exhibited and published its collections utilizing a variety of modern processes, including chromolithography. The high-quality prints of Italian paintings produced by the society lent access to the iconography deployed by Giotto, Titian and other old masters. *The Art Journal* acknowledged that these influences distinguished Cameron's work from that of other photographers: 'In common photographic portraiture, breadth of light is the rule; but it will be understood how much these examples differ from this rule when we say … that the visitor is occasionally reminded of Caravaggio, Tintoretto, Giorgione, Velázquez, and other of the Princes of Art.'[9]

Her membership would be long-standing, providing ready access to its reproductions and association with fellow members, whose 1859 council included the Pre-Raphaelite artist William Holman Hunt, John Ruskin, the watercolourist and founder of the Grosvenor Gallery Sir Coutts Lindsay, and the archaeologist Henry Layard. Notably, Cameron would photograph Hunt in 1864, Lindsay in the following year and Layard in 1869. Additional members included Sir Charles Eastlake, director of the National Gallery, and the photographer Roger Fenton. It was also in 1859 that Watts began his work on the frescoes in the Great Hall of Lincoln's Inn, London. That year Charles Darwin published *On the Origin of Species*, and Cameron gave Alfred Tennyson copies of George Eliot's *Adam Bede*, Thomas Wright's edition of Malory's *Le Morte d'Arthur* and John Stuart Mill's *On Liberty*.[10] In the same year Tennyson published the first four segments of his *Idylls of the King*; just over ten years later, in 1873, Cameron would create the first and only known photographic illustrations of his epic Arthurian poem.

The following year, the Camerons moved to Freshwater on the Isle of Wight, where Julia joined two

cottages together to create Dimbola Lodge, named after the family's estate in Ceylon (Sri Lanka). She received her first camera from her daughter and son-in-law in 1863 and, with admirable ingenuity, turned her coalhouse into a dark room and her fowl-house into a studio where she could pursue her photography. Several recorded accounts by extended family and friends recall Cameron's charismatic presence at Dimbola. Her great-niece Virginia Woolf satirized her in the play *Freshwater: A Comedy* (c.1923; first performed in 1935), a fictionalized re-creation of Cameron's life on the Isle of Wight. In the introduction to their *Victorian Photographs of Famous Men and Fair Women*, Woolf and the critic Roger Fry irreverently describe Cameron's enterprise: 'Boatmen were turned into King Arthur; village girls into Queen Guinevere. Tennyson was wrapped in rugs: Sir Henry Taylor was crowned with tinsel. The parlour-maid sat for her portrait and the guest had to answer the bell.'[11] Also in this satiric vein were accounts that described Cameron's sitters as 'victims' of her photographic pursuits, and her interactions with friends like Tennyson as pestering to the point of weary submission.

Thackeray Ritchie, however, described Dimbola and Freshwater as an environment that was lively and enriching for all who spent time there. Cameron's own recollections about her first photographic efforts in her short autobiography, 'Annals of my Glass House', suggest a commitment that exceeds mere pastime:

> The gift from those I loved so tenderly added more
> and more impulse to my deeply seated love of the
> beautiful and from the first moment I handled my
> lens with a tender ardour, and it has become to be as
> a living thing, with voice and memory and creative

vigour. Many and many a week in the year '64 I worked fruitlessly, but not hopelessly –

> 'A crown of hopes
> That sought to sow themselves like winged lies
> Born out of everything I heard and saw
> Fluttered about my senses and my soul.'

I longed to arrest all beauty that came before me, and at length the longing has been satisfied. Its difficulty enhanced the value of the pursuit. I began with no knowledge of the art. I did not know where to place my dark box, how to focus my sitter, and my first picture I effaced to my consternation by rubbing my hand over the filmy side of the glass.[12]

Notably, she includes four lines taken from Tennyson's poem 'The Gardener's Daughter', which centres on the portrait of its subject Rose. The literary scholar Lawrence Starzyk describes the poem, subtitled 'The Pictures', as the exegesis of an icon, in which the poet considers the relationship between word and image, and between artist and artefact. Similar concerns would inform Cameron's photographic illustrations.

Often left on her own with her children while Charles attended to their estates in Ceylon, Cameron seems to have had a relatively high degree of freedom to pursue her own interests. Unusually for a woman of her time, she was able to construct a life in which her art and her domestic duties appeared productively intertwined. Cameron increasingly used albums, a practice that coincided with the growing popularity of illustrated books, as vehicles or curated exhibition spaces for her photographic work. While it is unclear precisely how many albums she made, ten were assembled between 1864 and 1866 and represent a significant body of work. Often created for family and friends, they

were diverse in decoration, size and presentation but all showcase Cameron's personal touch and artistic intent. Ultimately, she transitioned from album-making to photographic illustration; in her two-volume illustrations of Alfred Tennyson's *Idylls of the King* and other poems, Cameron's choice of subject and arrangement of images exhibits not only her capacity as a photographic portraitist and illustrator, but as an interpreter and visual translator of poetry.

A place in nineteenth-century photography

Armed with an expansive aesthetic sensibility, Cameron began to explore her medium primarily through the genre of portraiture. By the time she stated that her portrait of Annie Philpot was her first photographic success in early 1864, she had already been experimenting for several months, using a bulky wooden camera and the wet collodion process to produce albumen prints from large, glass-plate negatives (plate 3).[13] Cameron had presented her invalid sister Mia with a photographic album dated as early as 7 July 1863. The album included some of her earliest efforts, including portraits as well as narrative scenes indicative of the range of subjects she would traverse throughout her career. Among them are portraits of Cameron's niece, Mia's daughter, Julia Jackson (and mother of Virginia Woolf) and *The Kiss of Peace*, a photograph she later described as the most beautiful of all her photographs (plates 7 and 8). She returned to the composition frequently (plates 9–11).

Perhaps as important was the inclusion of the works of other notable photographers of the period – including Oscar G. Rejlander (1813–1875), a frequent visitor to the Isle of Wight who produced a portrait of Cameron in 1863 – who may have offered her some counsel on photographic techniques. Rejlander's photography was especially influential in its composition and the relative ease with which the sitter was portrayed. His photograph of the Tennyson family (Lionel, Emily, Alfred and Hallam), which was included in Cameron's early Mia Album (1863), is a marked departure from standard practice in Victorian portrait photography, replacing its formality with ease as the family walks together, relatively indifferent to the camera.

Rejlander was not the only practising photographer or even the earliest of the photographic influences that shaped Cameron's aesthetic and technical practice. The 'Signor 1857' album includes works by other British practitioners, notably two photographs most likely by Earl Somers, Cameron's brother-in-law and photography enthusiast, as well as images attributed to Reginald Southey (1835–1899), Mudd and Cundall (fig. 1). Southey visited both the Camerons and the Tennysons on the Isle of Wight, and took photographs of the Tennyson children and of Charles and Henry Hay Cameron. The photo historian Colin Ford suggests it may have been Southey who inspired her interest in photography and was among her earliest influences.[14] He also introduced photography to his friend Charles Lutwidge Dodgson (1832–1898) who later wrote under the pen-name of Lewis Carroll, and once Cameron began taking her own pictures the two engaged in debates over technique. These early albums suggest that, much as she intentionally exposed herself to poetry, literature and the art of the Dutch and Italian masters, Cameron was also an apprentice of some of the earliest

practitioners of photography – if not in actual practice, then at least virtually through the act of collecting their work in her albums. Hers was a self-conscious, deliberate form of photographic art-making, and when she finally declared her 1864 picture of Annie a success it was only after much study, reflection, experimentation and, most certainly, failure.

In her autobiographical fragment, 'Annals of My Glass House', Cameron indicates that, though she had been a student of photography for some time, her close-up portrait of Annie marked the origination of her career. With it, she entered the world of portrait photography on her own terms. Where traditional Victorian portraiture was rigidly staged and near clinical in its representation of the human face and form, Cameron's approach was attentive to the more generalized effects of framing, focus and the use of light and shadow. There is a dimensionality in Cameron's work that evokes the European masters she studied, including Rembrandt, Perugino and Leonardo da Vinci, whose use of chiaroscuro was especially apropos. Exposure to classical sculpture such as the Elgin Marbles (now known as the Parthenon Sculptures) informed her treatment of drapery and the human form. The resulting images, though portraits in principle, allowed flexibility both in what they literally represented and in what they aimed to suggest figuratively. They are unmistakably 'Cameron' portraits, despite the great variety of individuals who sat for her. Her allusive approach is also the likely reason why so much criticism was levied at her earliest, already distinctive efforts. There seems little to suggest that at any point Cameron sought to emulate the traditional portrait photography of the period.

Leading professional portrait photographers in England at the time included Thomas Annan, Camille Silvy, Horatio Nelson King and the American John Jabez Edwin Mayall. Commercial portrait photographers of the period regularly manipulated their photographs to better flatter their sitters. It was such contrived perfection that Cameron resisted, claiming that she refused to touch up any of her images to preserve the authentic representation of her sitters: 'I could have [the spots] touched out but I am *the only* photographer who always issues untouched photographs and artists for this reason amongst others value my photographs.'[15] She wrote 'from life' in many of her image captions to reinforce their authenticity and to potentially signal a broader interest in capturing the life principle of her subject, suggesting that 'from life' comes the character and characteristics worth bringing forth in a portrait. It was a sentiment she described in a letter to Herschel: 'They [my photographs] are not only *from* the Life, but *to the Life*, and startle the eye with wonder & delight.'[16] Cameron further distinguished her work by focusing almost exclusively on her sitter's head, a convention she adapted from painters like Rembrandt. Her portraits and prints, which were significantly larger than her contemporaries' work, reinforced her commitment to 'lifelike' images. Both the scale and composition of her portraits allowed her to achieve a kind of spectral effect thanks to the relative size of the subject's face within the frame, as well as the way in which the sitters emerge from the dark nondescript background and enter the viewer's space. She was a pioneer of what is now commonly called the 'close-up' photograph.

Cameron's early photographic ambitions resonated with the Pictorialism of her photographic peers, including Rejlander. To ascribe artistic value to the photographic image, they looked to align it with painting by applying its practices, prioritizing composition, form, subject and emotive impact over straight representation. Cameron was also exposed to the work of Henry Peach Robinson (1830–1901), who authored a key text on the pictorial in photography in 1869; he was also critical of her work. William Lake Price (1810–1896) was another early Pictorialist who influenced Cameron. Like Rejlander and Peach Robinson, he was originally a painter before taking up the new medium of photography. Among those whose work she most admired was David Wilkie Wynfield (1837–1887), particularly his treatment of the human figure.[17] However, unlike many of the early practitioners of Pictorialism, Cameron did not take on landscape or architecture as subjects, even as they solidified the international reputation of several British photographers. Instead, she focused on beauty, the suggestive and the symbolic which assured her place as an admired forebear to the next generation of Pictorialists, including Peter Henry Emerson (1856–1936) and Alvin Langdon Coburn (1882–1966).

Photography as high art

By the time Cameron began her work, Rejlander and Peach Robinson had started to claim a place for photography within the larger realm of the fine arts, which was itself a notion in dispute given, among other things, the ascendancy of the decorative arts. Philip Prodger, head of photographs and curator of the National Portrait Gallery's 2018 exhibition *Victorian Giants*, affords Rejlander, Cameron, Carroll and Lady Clementina Hawarden (1822–1865) equal position in advancing what would come to be known as art photography. He argues that the term 'photography', like 'art', was ambiguous but, even as it was contested, these photographers were exploring its capacity to contend with the tensions between the explicit and the implicit. Prodger writes: 'this productive but uneasy combination of reality and mystery was to become one of the defining innovations of art photography'.[18] In her consideration of the Victoria and Albert Museum's Cameron photographs, the senior curator Marta Weiss notes that the museum initially purchased her allegorical subjects and Madonna pictures, not her portraits of well-known men, which confirms an appreciation of the pictures 'as the works of art she intended them to be'.[19] Additionally, Weiss asserts that, in hanging her images near paintings, the museum was ahead of its time in recognizing photography as fine art.[20] The historian Mirjam Brusius further suggests that Cameron's explicit use of selective focus, of imprecision and of softening the acuity of the lens were exactly what allowed her effectively to assert the fine-art qualities of photography and proved that she understood the principles of art-making.[21] In addition to activating the particularities of her medium for artistic aims, Cameron also makes clear her ambitions for photography as 'high' art which, unlike 'fine art', was ultimately directed towards 'moral ends'.[22] The same year she produced her first successful photograph, Cameron wrote to Herschel about her ambition to 'ennoble' photography as a 'high' art, one that was rooted in a moral and spiritual commitment to truth, beauty and poetry.[23]

Cameron's interrogation of beauty was informed by nineteenth-century reconsiderations of its definition. These ranged from John Ruskin's concern with the natural world as an expression of beauty, itself a gift from God, to Darwin who treated the question of beauty as rooted in evolutionary biology, much to Ruskin's consternation.[24] The Pre-Raphaelites' varied interpretations of beauty as exemplary of utopian ideals, strident realism or religious mysticism, gave way to the Aesthetic Movement, which was preoccupied with ideal beauty as well as its representation in antique and Renaissance sources. Watts was interested in beauty as a manifestation of greater spiritual aspirations, which informed his allegorical and later Symbolist work. Together with her husband Charles, and artists like Watts, who shaped her early aesthetic sensibilities, Cameron believed that beauty was aligned with both the 'real' and 'Ideal', and could be understood both philosophically and spiritually. Watts wrote: 'surely the development of the conception of beauty indicates an assimilation to the most divine – which is most beyond our mere material existence.'[25] For Cameron, beauty existed in the material but corresponded to a spiritual beauty; her photographs suggest an ongoing effort to develop a visual language that combined to make manifest the metaphysical or essential nature of her subject. In this effort, Cameron helped advance art photography such that the next generation of Pictorialist photographers, for whom the spiritual and unseen became imperative, could articulate their own artistic vision by means of the kind of imprecise focus used by Cameron.[26]

As much as Cameron's work was informed by her immediate cultural and artistic milieu, she troubled contemporary notions of beauty. Taken as a whole, the photographs considered here represent a subtle interrogation of beauty as located in meeting the demands of artistic composition, as well as in representing the imperfect, often melancholic and suggestive aspects of the subject. In her assessment of Cameron's work, the scholar Carol Armstrong links her 'Dirty Monk' portrait of Tennyson with the medium itself, writing that 'Cameron not only associates the poet's messiness with her own, but also translates it into the terms of her art; the rough dishevelment of the man is made over into her celebrated slovenliness of photographic technique. And so, the likeness of the poet becomes an image of photography itself' (plate 54).[27] That very 'messiness' was an encounter with certain truths about the poet, himself prone to bouts of melancholy, and of a medium that was not only messy but unpredictable. When we are confronted by Cameron's portrait of Sir John Herschel, an encounter amplified by the picture's depth of tone and scale, we find something that extends beyond the traditional determinants of beauty towards an aesthetic that embraced frailty, the physical consequences of age, and that signalled the uncertainty of what comes after death (plate 77). It is a shockingly 'beautiful' portrait precisely because it forces an immediate confrontation with Herschel's wizened mortality and raises questions about the unknown, or the sublime.

Tellingly, Cameron described the experience of such portrait-making as the 'embodiment of a prayer'.[28] If one moves past conventional notions of 'worship' – a term coupled with critiques of Cameron as a hero-

worshipper – and understands prayer as the intimate and contemplative practice of presence with another, we find in her portraits an expression of beauty that is located in the highest order of philosophical enquiry *and* anchored in poignant mortality. In other words, when Cameron declares that her pictures are not just '*From* Life', but '*To* the Life', she was indicating an interest in a type of beauty possible only through engagement with what Mary Seton Watts described as the 'storms and vicissitudes of life'.[29] Therefore, Cameron's portraits of Herschel, Tennyson and Taylor, and of Hillier as the Madonna or Maud, present in high relief an encounter with beauty altogether more challenging, even discomforting. Her photographs indicate a poetic inclination to amplify the emotional potency of an image by reducing detail and prioritizing negative space as a site of encounter with beauty that does not deny the truth of temporal existence nor the mystery of the unseen.

Cameron's concept of the beautiful and the sublime as it related to her photographic practice was partly influenced by the philosophical work of her husband. Their aesthetic sensibilities developed in a cultural moiré informed by Edmund Burke's writing on the subject as evidenced twice over: materially by the fact that Charles Cameron's bookplate is found in eight volumes of Burke's *Works* given to Tennyson and by Charles's own contemplation on the subject in his *An Essay on the Sublime and Beautiful* (1835), written just a few years before the couple married.[30] His concise essay considers the act of reflection and the association of sorrow with beauty and sublimity that finds later expression in Cameron's photography. In the first instance, he argues that reflection is a crucial element in the act of perception: 'The mere presence, then, of Sublime or Beautiful feelings in the mind is not of itself sufficient to ensure the perception of their sublimity and beauty; for, unless the power of reflection is exerted, there can be no such perception.'[31] Charles affirms the significance of an active form of reflection that extends beyond the simple act of looking. It is an activity that demands the full engagement of the senses and requires empathy with the object of contemplation, be it another person or their courage, pity or love. He extends the argument to the feelings of beauty and sublimity; the presence in the mind of either is not enough. To perceive either or both requires the act of reflection.

It is an interesting assertion to consider in relation to the general practice of photography, which requires not mere looking but seeing. As photography is an art form that requires a distillation of the visual world, active reflection in the service of perception seems a vital skill for success. Although Cameron's own poetic treatise on beauty and the practice of art had yet to be written, it is plausible that photography was her principal method for active reflection and the mode via which she learned to 'see' better and, therefore, better understand and represent the subject before her lens. While hers was an art contingent on a quality of seeing, it was also one dependent on a repository of lived experience. We might not be surprised then that the success of the portraits considered in this book seem to result from precisely the type of empathetic reflection Charles described, an understanding of both the inner selves in relation to the outer lives of friends like Taylor, Watts and Tennyson.[32] The success of her photographic 'prayers' was thus wholly contingent on

embodiment, attentive presence and reflection.

Relatedly, Charles also elevates the significance of sorrow in his text when he writes:

> A weeping willow, as the very name of the species indicates, represents the attitude, and therefore partakes of the beauty of sorrow. The effect of sorrow on the human frame is to prevent all muscular exertion, consequently every part which in ordinary circumstances is sustained by such exertion alone, droops and collapses under the influence of that depressing passion. Every thing, therefore, which droops (for that word seems to express the whole idea of bending downwards, without any pressure, from the mere effect of gravitation and the want of support) has a sorrowful and beautiful expression.[33]

Cameron's success in visualizing what we might call an aesthetic of sorrow is what allows her to combine aspects of the beautiful and the sublime in her portraits of identifiable individuals as well as characters from history, literature, mythology and Christian scripture. In certain photographs, she emphasized the curve or bend in her human figures, which evokes the same kind of pathos Charles described when writing of a weeping willow. For nineteenth-century viewers familiar with religious iconography, and especially that of old master painting and sculpture, the curving form might also be associated with deposition scenes. Cameron's aesthetic sensibility integrated notions of the beautiful and sublime into a very particular leitmotif in which the visualization of the melancholic, especially as connected to love and loss, also evidences the life well lived, or, in Taylor's words, the 'life poetic'.[34] To the use of curving

forms and bending lines, tilted faces with hazy, unfocused eyes, she added the extreme juxtaposition of light and dark to suggest an imperative relationship between what was visible (and possibly beautiful) and what was invisible (and potentially sublime). In an early photographic portrait of her husband, she intimates the potential of her medium, with its rich tonal scale, to represent these two halves of an individual through the deft use of light and shadow. Parts of the image are in focus, others are not; this coupling of the observable with the obscure introduces to the picture something unknowable, or the hidden interior self, even in a subject she knew so well (plate 2).

'On a Portrait': in her own words

Forty-one years after Charles penned his treatise on the sublime and the beautiful, Cameron wrote her poem 'On a Portrait', her only published original literary work.[35] The poem, composed in 1875 in concert with the production of her photographs for *Illustrations to Tennyson's Idylls of the King, and Other Poems*, affords us a unique view into the artist's pursuit of beauty and articulates some of her key beliefs about what it was that she sought to accomplish in her art. Her writing affirms the belief that the human story – individual and collective – was to be found in the human face, and that transcendent beauty could be laid bare through the careful, considered study and representation of that face. Her words describe a particular type of countenance, eyes touched by love and sorrow, lips pressed in silence, a head turned in 'true courage', resolve 'flashing thro' the gloom'. Throughout her poem, she moves from describing detailed facial features to more vague terms that articulate the

emotive experience of the subject, zooming between the particular and the general much as she would do in her photography.

Cameron's text affirms what she sought to accomplish in her portraiture by detailing what she believed to be latent in her subjects and, in that sense, 'On a Portrait' is not just a poem but functions as a summative reflection on her work and even a type of artistic manifesto. It is a detailing in verse of her purpose and methodology; her first stanza presents her pursuit of beauty and understanding of it as mysterious, while the remaining lines give some indication of what she is looking for in her subject:

> Oh, mystery of Beauty! who can tell
> Thy mighty influence? who can best descry
> How secret, swift, and subtle is the spell
> Wherein the music of thy voice doth lie?

Cameron's poem is also her own philosophical treatise on beauty, describing the responsibility of the artist to pursue that which may be just beyond one's reach, what she calls 'the key-note'. She chooses to pursue this first through the human face, in a reverential manner that suggests a view of humanity as made in the image of God, in accordance with her religious beliefs. She further affirms this with the closing line: 'Is stamped forever on the immortal face'. The face, inextricably attached the visible and material, is described as immortal, which connects it to the spiritual and eternal. Her poem also reads as a type of psalm or blessing in which she alludes to the heroic in her charge to the 'noble painter', but also more broadly in her description of the subject whose face contains elements of courage, beauty and sorrow. She addresses sorrow outright in her poem, eyes full of love but concealing sadness:

> That but for lids behind which sorrow's touch
> Doth press and linger, one could almost prove
> That Earth had loved her favourite over much.
>
> A mouth where silence seems to gather strength
> From lips so gently closed, that almost say,
> 'Ask not my story, lest you hear at length
> Of sorrows where sweet hope has lost its way'.

'On A Portrait' also intimates her tendencies towards Symbolism, with language repeatedly referencing music, and likewise nods towards the sublime in its use of words like 'secret' and 'subtle'. Although Cameron ostensibly writes her poem as a charge to the painter, it is as much a precept to herself, as one who paints with light, as it is celebration of that which she valued. It seems that the poem, which upon first reading appears to be a simple meditation on the art of the portrait, encapsulates many of the poetic themes that suffuse her portrait work and her treatment of Tennyson's poetry – temporality, the melancholic and the combination of the material and the spiritual. Thus, it might be best understood as Cameron's philosophical reflection on all that informed her art, not just the approach she took in her portrait photography. It is the poetic expression of her views on beauty, the sublime and, indeed, the heroic expressed as both genius and love. 'On a Portrait' is Cameron's summary of her thoughts on these themes, having lived a life that included a poetic reimagining of the world through Jamin and Dallmeyer lenses.

The initial reception of her portraits, her 'fancy pictures' (that is, staged narrative, subject or iconographic images) and her photographic illustrations

of Tennyson's *Idylls of the King*, taken during her most productive years, from January 1864 until her final return to Ceylon in 1875, was not all positive. Her work was rejected outright as not professionally finished by contemporary photographers such as Peach Robinson, who also criticized her focusing technique. Most of the contemporary praise of her work came from painters like Watts rather than from other photographers, many of whom conformed to the preferences of the time, which still favoured the traditional, highly representational and detailed photographic portraits produced by professional studios. Agreeing with her son Henry's analysis of her technique, Cameron wrote, 'it is quite true, that my first successes *viz* my out of focus pictures were "a fluke" = that is to say that when focusing and coming to something which to my eye was very beautiful I stopped there, instead of screwing on the lens to the more definite focus which all other photographers insist upon'.[36] Cameron declared her technical intent in a letter to Herschel, while urging him to write on photography and

> Induce an ignorant public to believe in other than mere conventional photography – mapmaking – & skeleton rendering of feature and form without that roundness & fullness of form & feature that modeling of flesh & limb which the focus I use can only give tho' called & condemned as 'out of focus'[.] What is focus – & who has a right to say what focus is the legitimate focus –.[37]

The lack of sharp focus, resulting from certain artistic intent, the challenges of using her first lenses and the marked economy of detail make Cameron's large-format portraits not only distinct from most other nineteenth–century portrait photographs, but also decidedly modern in their visual impact.

Coburn drew inspiration from the work of Cameron and expressed his admiration for her distinctive approach to the portrait:

> Perhaps it is the humanity of it, for undoubtedly camera portraiture brings one in touch with the sitter in an intimate personal way not possible in the ordinary round of social functions. Perhaps, again, it is the mystery of it, for the strangeness of a negative flashing upon the developed, the absolute presentment of a living person, is a phenomenon that does not become commonplace even after a life-long acquaintance, but rather tends to intensify in the quality of the strangeness.[38]

In Coburn's reflection we are reminded of her commitment to material beauty and to the requisite intimacy of portraiture, one that preserved for posterity the mysterious, which arises out of the strangeness of a mechanistic medium capable of permanently fixing in time the face and spirit of a sitter. For Cameron, the poetic potential of the face proved a deeply satisfying subject, one she pursued with intensity during the early part of her relatively short career. In 'Annals', Cameron described her interest in 'arresting' or capturing all the beauty that came before her camera. Thackeray Ritchie described Cameron's ability to draw out the beauty of her subjects as intuitive, and with that intuition she was able to see and better represent her subject. Cameron once remarked, 'the history of the human face is a book we don't tire of if we can get its grand truths and

learn them by heart'.[39] Many of the portraits in this book illustrate her pursuit of the larger, if ultimately unknowable, truths available in that face.

The photographer-poet

By concentrating on Cameron's relationships with the two poets and the artist who are variously represented in these photographic collections, we are invited to consider how she may have come to understand the poetic potential of her medium. Her photographs of Taylor are an entrée into understanding her approach to portraiture, which extended well beyond the mere representation of the individual subject. Her relationship with Watts compelled an ongoing consideration of broader aesthetic concerns that included certain tenets of Symbolism. Cameron's relationship with Tennyson, and her significant engagement with his poetry, culminated in a series of images that concretize her interest in photography as a medium capable of expressing poetic themes. Cameron also had experience translating poetry, notably Gottfried August Bürger's poem *Leonora* in 1847, as well as some experience writing her own poetry.[40] Beyond her relationship with poets and her own practice as a writer, the latter half of this book considers how Cameron brought poetry and photography into conversation through her visual interrogation of some of Tennyson's most significant work.

When she finally turned her attention to illustrating *Idylls of the King*, as well as other poems by Tennyson, she was equipped with an appreciation for nineteenth-century poetry that was broadly defined by its interest in exploring and expressing the full range of human emotion. Poetry concentrated the imagination and elevated the sensorial and emotive through the aesthetic and rhythmic qualities of language, suggesting meaning, as opposed to the expository meaning-making of narrative. In Arthur Henry Hallam's assessment of Tennyson's earliest poetry, the poet's closest friend observed that he

> belongs decidedly to the class we have already described as Poets of Sensation. He sees all the forms of nature with the 'eruditus oculus', and his ear has a fairy fineness. There is a strange earnestness in his worship of beauty, which throws a charm over his impassioned song, more easily felt than described.[41]

This concentration of emotion, along with the invitation to reduce meaning to sensation rather than description, made poetry a particularly appealing subject for Cameron. She too was motivated by a 'strange earnestness' in her pursuit of beauty, but in her most compelling photographs there is also a sense of restraint; that the medium itself, with its limited aperture (or *oculus*), allowed her to surpass even the poet in concentrating her attention, and that of her viewers, on the poetic themes she found meritorious. H.M. McLuhan argues that Hallam's critical assessment of the poet goes on to insist that, 'in "pure poetry", the poetry of suggestion rather than statement, or poetry in which the statements are themselves suggestions and in which the poetic form is the mode of the creative process itself, the reader is co-creator with the poet'.[42] Perhaps Cameron found in Tennyson's poetry the potential for co-creation not only as its reader but as its photographer, and that her camera, which she described as a 'living thing', also made possible new forms of meaning.[43]

What we can be assured of is that the portraits and illustrations to follow provide evidence of an abiding appreciation for the decidedly unique aspects of the photographic medium. Among those are elements that align closely with prevalent themes in Tennyson's poetry, including temporality, the particular and the vague, the material and the spiritual, and a consideration of the sublime. Cameron's use of focus allowed her to respond visually to the invisible 'self', which she suggested through a diaphanous collusion of the 'inner' and 'outer' aspects of her subject, affixed photochemically. She did not get it right on all counts, and her practice violated the aesthetic orthodoxy of the day. But the blurring of the 'real' subject before her lens created unparalleled possibilities for a broader pursuit of beauty and the sublime. Her refusal to submit to the conventions of sharp focus opened up a space for the dialectics of the 'real' and the 'ideal', of the Tennysonian sense and soul and of the sacred and the profane.[44]

The literary scholar Gerhard Joseph aligns the poet's treatment of the particular and the distant with the photographer's privileging of the 'blurred over the hard-edged', which further connects his poetry and her photography. Joseph also suggests that Cameron understood and demonstrated, 'first intuitively and then with increasing sophistication, that photography could become an art form precisely because of its unrivalled potentials for calibration of focus'.[45] She may have learned some of this from Tennyson: 'as he explored nuances between the precisely and the vaguely focused in poetry, so Cameron matched his focal experiments in the new art form of photography'.[46] Her early use of what would come to be known as differential focus

allowed her to join the poet in contending with the tension between the precise detail of the real world and the blurred experience of the self, that is, a blurring between substance and shadow.

Ultimately, Cameron's aesthetic choices reflect a medium whose delimits are unbounded in that it produces an object that, theoretically, exists in a liminal space between the material and the immaterial. A photograph is a presence made from an absence; it takes as its subject something real, recorded by traces of light on a chemically treated plate, but itself exists as an indexical imprint – a trace, a shadow, a memory – pointing toward the unreal, the non-material and perhaps an ideal.[47] Joseph and Mary Ann Caws also suggest that Tennyson moved from an aesthetic of particularity towards a Symbolist aesthetic of sonal and visual suggestiveness. This is relevant given Cameron's own Symbolist tendencies, as well as her photographic response to the lyrical aspects of Tennyson's poetry in her *Illustrations*, including the sonnets from *The Princess* (plates 66–68).[48] The recurring themes of music (sound) and its echo, particularly as it relates to the photographic trace, reinforce the analogous aspects of how Cameron's photography intersects with Tennyson's interest in the irretrievable past.

Additionally, the descriptive terms of photography – the use of light and shade, of shadow and grades of tonality; the way an image crystallizes out of darkness through exposure to light – act as metaphors for the dual aspects of the physical self (sense) and the conscience (soul), that is, both the imperfection and the aspiration of the human condition that Cameron believed to be latent in her individual sitters and available in

Tennyson's poetry.[49] That latency, what was unseen – in marked contrast to the de facto visual demands of her medium – only crystallized the moment the image emerged through the developer. It correlated to important themes in Tennyson's poetry, and to her interest in the sublime. Not only does this distinguish her work from that of many of her contemporaries, but it also suggests a modern appreciation of the medium. As the art historian Robin Kelsey notes, even Cameron's decision to work with the new wet-plate processes contribute to the modernism of her practice, as the viscous surfaces were more liable to pick up the 'imperfections'.[50]

Cameron also responds to the theme of death that pervades Tennyson's poetry, a motif that found unprecedented rendition through the medium of photography. Subjects in deathlike or sleeping repose were favoured by nineteenth-century photographers for the simple practicality of keeping a subject still for long exposures. Mortuary portraits of the actual dead were also popular in the Victorian period, precisely for the medium's ability to record the features of a lost loved one, thereby tangibly preserving their image. In direct response to the poetic text, as well as to the allegorical themes of loss in the *Idylls*, Cameron's Arthurian illustrations include both sleep and death motifs. She revisits death, and explicitly Tennyson's concept of 'Death in Life' which speaks of irreconcilable loss, in her illustrations of his other poems, particularly the songs that contend with sorrow and the irretrievable passing of time (plates 67, 68). Photography, with its unique capacity to capture a moment that has passed or a subject as it once was, was deemed an appropriate medium for portraying various aspects of death – actual bodily death, the death of time and its trace (or memory), the death of love and even death as the inescapable bridge between the material and the spiritual. The literary scholar Amelia Scholtz asserts in her discussion of Cameron's illustrations of Tennyson's Arthurian subjects that 'the theoretical and historical connections between photography and death also make the photograph an appropriate medium for depicting a world [Camelot] defined by loss and the attempt to possess that which has always already disappeared with the passage of time'.[51]

Thus, the corollaries between the process of photography and the themes Cameron addresses in the images considered here suggests that she found photography to be precisely the medium required for 'arresting' (or fixing) the latent qualities of the self or soul, at once heroic and tragic, and for exploring certain aspects of the beautiful and the sublime. Therefore, it was also well suited to illustrating poetry. Counterintuitive though this may be, in Cameron's hands the medium was particularly apropos when the subject was the mythical (Arthurian) quest through the real world of humans towards the shadowy world of ideals and higher spiritual consciousness. Similarly, the camera lens may be a singularly apt filter for the themes of love and death, brokenness and redemption, and the haunting echoes and traces of time passed. As the historian Marina Warner writes in her discussion of Cameron and Charles Dodgson (Lewis Carroll), 'the time of the photograph abides out of time, in the *aevum*, or zone of art, a third order of time'.[52]

Not only does the material and immaterial collide in the actual making of a photograph, which itself is

a kind of incarnation, in Cameron's best images the subject also inhabits this third order of duration. A selective set of mnemonic particulars – the details of a face, the suggestive elements of a narrative or poetic episode – are included in an image to amplify the universal or generalizable aspects of beauty, love, life and death. Such temporal in-betweenness created space for the poetic in Cameron's photography by allowing for suggestion rather than strict record-keeping. That she chose a medium roiled in debates about truth in representation, and worked simultaneously to align it with poetry and painting, suggests that Cameron might have found in photography an art form that was not exclusively contingent on the veracity of its subject, its maker's visual imagination or the viewer's ability to ascribe meaning to the image. Perhaps for Cameron the photographic medium was provocative precisely because it made the real subject the point of departure, not of arrival; it opened the possibilities of both sorrow and beauty, the heroic and the human, the material and the immaterial.

As we shall see in the images to follow, Cameron strips away unnecessary detail and evokes meaning through the machinations of her medium to create a relationship between what is and is not literally in the photograph. Thus, the camera becomes an extension of Cameron's enduring interest in making the invisible visible without explicitly describing the enigmatic; the resulting images, at their finest, acknowledge the strange and generative threshold between the temporal and the timeless. Thus, we might wonder if Cameron understood that, like poetry and unlike other visual art forms, photography has the potential to push the 'real' or 'true' towards the *more* real and true, from the existential to the transcendent.

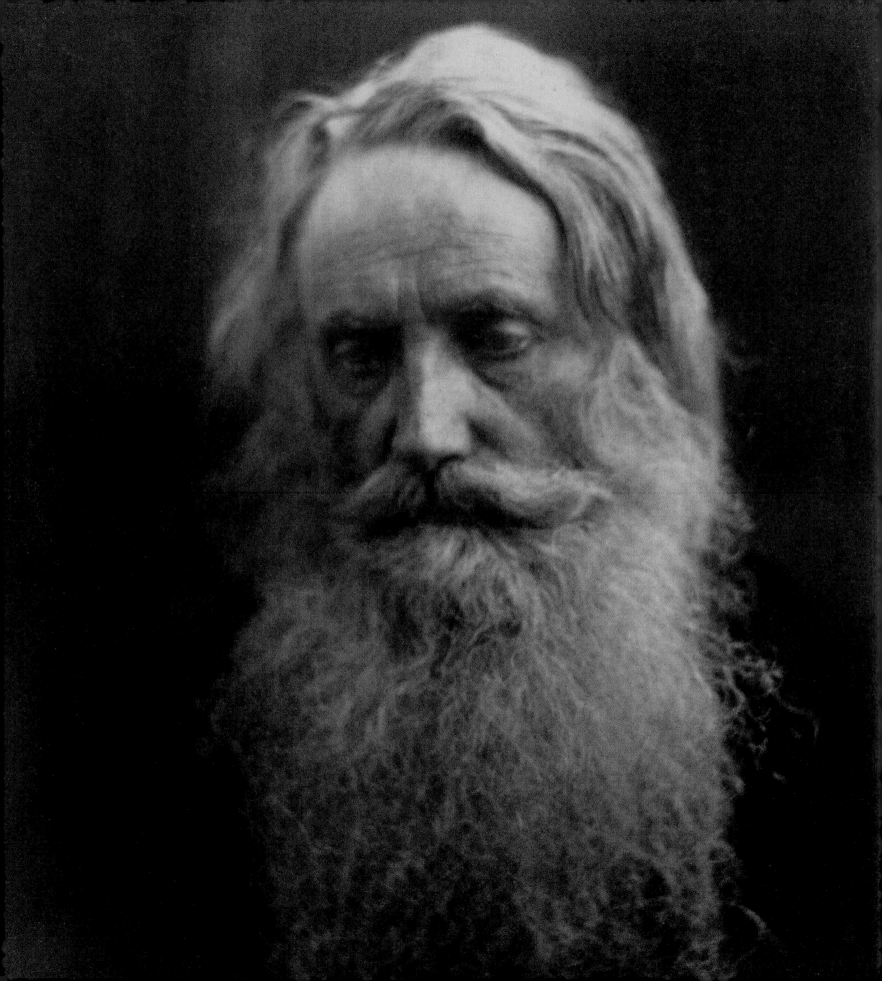

Out of the heart are the issues of life,
and out of the life are the issues of poetry.

Henry Taylor, *Notes from Life in Six Essays*

Julia Margaret Cameron's stated ambition was to 'ennoble Photography and to secure for it the character and uses of high art by combining the real and Ideal and sacrificing nothing of the Truth by all possible devotion to poetry and beauty'.[1] Her insistence on the combination of the real and the ideal finds expression in her portraiture, as does her commitment to the beauty and poetry of the human face. The photographs that comprise the Henry Taylor collection at the Bodleian Library illuminate Cameron's unique approach to portrait photography.[2] They also illustrate the importance of her friendship with Taylor and demonstrate the aesthetic choices she made in her portraiture and, more broadly, in her typological treatment of certain subjects.[3] Through her varied representations of Taylor, it is possible to re-evaluate her portraits of the men with whom she maintained significant relationships as illustrating aims higher than simple Victorian hero worship. Instead, they may be appreciated as complex portraits of individuals who, like Cameron and her female contemporaries, were situated

Henry Taylor, 1864 (detail of plate 34).

in a culture saturated with uncertainty and shifting questions about gender and identity. For Cameron, Taylor typified the possibilities of the 'life poetic' – a term he used to describe an active and contemplative life lived with intensity and force of expression – and her relationship with him exemplified the creative, if unusual, relationships she forged throughout her career as a woman photographer in the nineteenth century (plates 12, 13).[4]

Portrait of a friendship

The year 1848 proved critical to Cameron's artistic development and personal life. She and her husband, Charles, by then a retired colonial officer, moved to Tunbridge Wells, Kent, where she met Henry Taylor, a friend of Charles's from his school days. In the same year, moving among the circles of artists, writers, musicians and politicians who populated Little Holland House, the home of her sister Sara Prinsep, Cameron met the Victorian portrait artist George Frederic (G.F.) Watts. She had yet to take up photography – it would be another fifteen years before she received her first camera in 1863. But her early friendship with Taylor and the artistic influence of Watts eventually found expression in her portrait photography. Taylor's friendship is of particular significance to the Bodleian Library's collection, a friendship that his daughter, Una, later described as 'grafted on the tree of life'.[5]

If Cameron's early life in India and Europe had been characteristically vibrant, filled with family, friends and social engagements, Taylor's was quite the opposite. In his two–volume autobiography, he paints a melancholic picture of his earliest years. His mother died when he was very young, and Taylor spent his childhood with a father who, though lovingly committed to his three sons, was reclusive and 'lived too exclusively with his books, and his relations with his fellow creatures were more limited than is desirable for any man'.[6] Throughout the first volume of his autobiography, Taylor writes of the constant solitude in which he found himself in his youth and admits to cultivating questionable habits and revelling in the isolation. Despite moments of creative energy and socializing, especially after his father remarried, Taylor describes his early years as mostly dreary.

His youth, however, was also filled with literature and poetry. Educated at home, first by his father and then largely by himself, Taylor and his two elder brothers experimented with poetry and music: 'It was precisely in the twenty years covered by [his brothers'] lives that poetry in England was changing its mood. My father's [poetry] … was of the kind cultivated in the eighteenth century, – ethical and didactic. That of his sons was imaginative and romantic.'[7] But the future author of popular works including *Philip van Artevelde* (1834), *The Statesman* (1836) and *St. Clement's Eve* (1862), nevertheless felt second-rate in his father's eyes. 'With my brothers [William and George],' he wrote, 'his [father's] task was easy, for they had extraordinary gifts and powers. But with me it was otherwise. My mind was slow and languid, and the faculty of acquisition was

sadly defective.'[8] Ronald Chapman, an early scholar of G.F. Watts's art, accounts for Taylor's presence at Little Holland House and describes his self-esteem as 'so deep that he appeared to have none at all'.[9]

The year 1818 found Taylor living in London with his two elder brothers; his father had secured a clerkship for both Henry and George through a politician friend. It was also in this year that Taylor suffered significant loss: all three brothers contracted typhus, and William and George died within weeks of one another. From that time forward, Taylor recalls, his father fell into a grief-inspired depression that lifted only upon his second marriage, to Taylor's stepmother, Jane Mills, who was much loved and admired by the young Taylor. In his early adulthood, he distinguished himself in his work as a clerk with the British Colonial Office, yet described the constant pull he felt between his political work and his passion for writing, especially poetry. Taylor eventually developed key friendships with other clerks and government officials in London, particularly James Spedding and Charles Villiers. Through Charles, he met Thomas Hyde Villiers, with whom he shared accommodation and frequently attended debates at a popular club called The Academics. There, along with Thomas's friend John Stuart Mill and others of like mind, Taylor engaged in extended discussions on Benthamite politics. However, in 1832 Taylor suffered another loss with the premature death of Thomas, whom he described as 'of my male friends at least the dearest, – and indeed the only *very* intimate friend of my own age that I possessed'.[10] During his early tenure with the British Colonial Office, he also met Thomas Spring Rice, whose daughter, Alice, Taylor married after a three-year courtship.

Taylor and his daughter Una, who wrote a memoir in tribute to her parents, described his married life as being rich and fulfilling. The family home in London, and later in Bournemouth, was filled with notable guests including the much admired poet Aubrey de Vere, Mary Shelley and her son Percy, Robert Louis Stevenson and Benjamin Jowett, master of Balliol College, Oxford. Taylor's eldest son, Aubrey, was curious and talented in nearly all his pursuits, and he shared an especially strong bond with both parents.[11] His premature death was deeply felt by Taylor, who wrote in his autobiography, 'some of these losses were amongst the greatest events of my life, and it is for this reason that I am unable to give an account of them. On the 16th May 1876, I lost my eldest son.'[12] When he wrote those words, he was also referring to another loss he had suffered just three years before with the untimely death of Cameron's daughter Julia Norman, for whom Taylor held great affection. He recognized the importance of his many friendships with women, writing that 'it has been my fortune throughout life to be connected, by relationship, marriage, and friendship, with remarkable women'.[13] From 1848 on, the friendship with Cameron added to Taylor's good fortune.

Cameron admired his poetry and prose, sending Taylor's works to notable authors for critique, and continued to forge her relationship with the author who described her as having 'driven herself home to us by a power of loving which I have never seen exceeded, and an equal determination to be beloved … we all love her, Alice, I, Aubrey de Vere'.[14] Over the course of their long friendship he sat for more photographs by her than any other male subject. They corresponded extensively and Cameron's lengthy letters consistently met with a daily response from Taylor. Their friendship grew and, 'with whatever flights and falls, and in the course of time natural changes of tone and complexion, it has survived', Taylor wrote, 'for a quarter of a century, and is now good, sound, solid, and very genuine friendship in the first degree'.[15] Cameron recalls the day in Ceylon when she received his autobiography, writing that volume two contained the 'history of the Cameron friendship from beginning to end! *Not to the end* – it is there a very green tree bearing fruit – with branches high up, tossing no longer in the air but standing secure from wind and weather, and roots underground deepening and now, I hope, sanctifying the soil'.[16] This friendship, which lasted over thirty years, resulted in a significant and diverse collection of photographs of Taylor as one of the mostly frequently photographed subjects in her entire *oeuvre*.

Once Cameron took up photography, she often compiled her own photographs, supplemented with other images, into formal albums for her friends. However, the Bodleian Library's compendium of Cameron photographs appears to have arrived as a collection of 112 loose images, having been collated and bound by the library rather than by Cameron herself.[17] The collection was given to the library in 1930 and probably accompanied a significant portion of the Taylor family papers donated at the same time. The images span the length of Cameron's photographic career, including a print of her self-proclaimed 'first success', the portrait of nine-year-old Annie Philpot; a number of her allegorical photographs and portraits of other male subjects; and ones of the future actress

and wife of G.F. Watts, Ellen Terry (1847–1928), and of her niece Julia Jackson. But Henry Taylor is the most frequent subject of this collection. He later wrote that when he visited Freshwater Bay on the Isle of Wight, where the Camerons purchased a home in 1860, he was photographed nearly every day and recalls that, of 'the photographs being sent to Alice, her opinion was more flattering to them than to me: – "I like all except one of the little ones; and most of them I think very grand; decidedly grander than anything you have yet written or lived; so I begin to expect great things of you"'.[18]

The number of photographs with Taylor as the primary subject testify to the endurance of the friendship they shared and affirm Cameron's ongoing commitment to the study of the heroic, human narrative available in an individual face:

> Yes – the history of the human face is a book we
> don't tire of, if we can get to its grand truths, & learn
> them by heart. The life has so much to do with the
> individual character of each face influencing form as
> well as expression so much – + it is so refreshing to
> meet one who has not had enthusiasm trodden out
> but in whose soul love + reverence + trust survive
> the dust of this 19th century life of hurry + worry +
> crush + crowd.[19]

Her portraits of Taylor afford a view into his person-hood, but they do more than record it strictly for posterity. Instead, they suggest Cameron's awareness that notions of beauty and the relationship between 'real' and 'Ideal', were complex, even paradoxical. While Cameron encountered something of the heroic in her male subjects, she was hardly an unwitting, complacent hero-worshipper and, given her clever, at times even sharp, tongue, she saw herself in an equal partnership with her subjects. Una Taylor describes Cameron's freedom from the folly of blind hero worship:

> Brief sentences epitomize her powers of prompt
> reply and pungent speech … *Alfred Tennyson* to *Mrs.
> Cameron*: 'I don't see what you mean by his [Taylor's]
> extraordinary beauty! He has a smile like a fish.'
> *Mrs. Cameron to Alfred Tennyson*: 'Only when the Spirit
> of the Lord moves the face of the waters, Alfred.'[20]

She regularly confronted Taylor in letters for everything from requesting that she destroy their correspondence to painting too dark a portrait of Tennyson in his autobiography. Cameron understood her male subjects, and especially Taylor, as complex characters and there was a respect and appreciation for Taylor that extended beyond traditional gender boundaries. Cameron did not choose a medium typical for women of her time but one with a unique capacity to memorialize the poetic potential of her male subjects. Repeatedly writing below her photographs that they had been taken '*From Life*', she affirmed that, as much as she was recording an individual life, she was also seeking to capture the animating principle of life in general, which had invested light, shadow and certain character into the single face posed before her lens. In this, her work was not just 'from life' but 'true to life', a tribute to the complexities of human existence that afforded her such compelling subject matter. Her photographs of Taylor illuminate Cameron's approach to portraiture, an approach that benefited from her knowledge of the fundamental principles of fine art as well as of her sitter, and that

illustrate her significant efforts to draw out various aspects of her subject within a single frame (plates 12–15, 19–21). Anne Thackeray Ritchie, a frequent visitor to the Cameron home on the Isle of Wight, described the photographer's ability to draw out the character and beauty of her subjects as intuitive, and with that intuition, she found a means through her photography to represent the empathy she shared with her subject.[21] Therefore, her portraits are much more than just records of individual masculine 'genius' or narrowly defined heroism; they also provide evidence of their creative responses to life as articulated through her subjects' prose, poetry and painting. It is 'more than genius', to use Cameron's own words about portraiture in general, that emerges from these photographic portraits.[22]

From portrait photography to typological portraiture

In the Bodleian Library's collection, Henry Taylor not only acts as a subject for Cameron's portraiture but also takes on the roles of various characters from literary and religious history. This typology allowed Cameron to extend meaning beyond the literal or historical identity of her subject, and to ascribe additional significance by drawing on characteristics, or types, ascribed to biblical characters or to those from classical mythology or the British literary canon (plates 27, 28, 31–4). In an amusing recollection, Taylor suggests that his suitability for these roles was due to his tremendous beard, the ultimate result of an asthmatic attack that caused hand tremors, which hindered use of a razor. 'In the last days of that year,' he wrote, 'I notified in a letter to one of my girl friends the small beginnings of what was so

soon to be developed into the phenomenon presented by Mrs. Cameron's art in multiform impersonations of King David, King Lear, and all sorts of Kings, Princes, Prelates, Potentates, and Peers.'[23] His beard apparently did make him the ideal candidate for a number of these roles and, while Tennyson avoided her camera when he could, Cameron writes of Taylor:

> Our chief friend, Sir Henry Taylor, lent himself greatly to my early efforts … he, with greatness which belongs to unselfish affection, consented to be in turn Friar Laurence with Juliet, Prospero with Miranda, Ahasuerus with Queen Esther, to hold my poker as his sceptre, and do whatever I desired of him. With this great good friend was it true that so utterly
>
> > The Chord of self with trembling Passed like music out of sight.[24]

Cameron's portraits of Taylor seem to allude to figures stemming from both the Bible and the British literary canon; but they are also photographs of an individual whose own system of belief was expansive and built on the general principles of Christian love. Taylor believed in God as a spiritual force and, according to Una, did his part to 'provide a temple wherein the sheep, who had lost not only a Shepherd but a Fold, might find, once more, a House of Grace'.[25] She also writes that he was quick to discern the essential behind the trivial:

> Dogma and doctrine had, from his first inquiry into religious faith, made small appeal to his mind. In those later days his attitude remained unchanged. 'I don't want those definitions,' Alice

Taylor records his reply to her statement of some (to her) illuminating theological tenets. 'What I feel and know is that God is the God of Love and I am satisfied.'[26]

Taylor may have also agreed with Watts's description of faith:

> There may be only one truth, as there is only one sun, but man is obliged to build himself a house with many windows. I cannot see that the sun does not shine through all of those turned towards him. As the sun shines through many windows, so the church has many doors; these race and temperament require, and though set at different angles the may all lead to the same altar.[27]

Her portraits of Taylor present the complexity of the subject, the photographer and the Christian culture (albeit one undergoing great change) that shaped their shared experiences. In Taylor, Cameron recognized aspects of a king, prophet, philosopher and Man of Sorrows. They are not capricious portraits taken by an amateur photographer but instead, as their contemporary Frederic W.H. Myers suggests when writing on the Pre-Raphaelites, 'they may be called … the sacred pictures of a new religion; forms and faces which bear the same relation to that mystical worship of Beauty on which we have dwelt so long, as the forms and faces of a Francia or a Leonardo bear to the mediæval mysteries of the worship of Mary or of Christ'.[28]

Cameron's portrait work allowed her to explore fully the typologies that were conveyed through subjects like Taylor, whereby she saw him not just as the poet,

statesman and friend that he was, but also as a type of David, Jeremiah, Friar Laurence and Prospero (plates 32, 33, 27, 28). Taylor is at once the confident Prospero and the grief-stricken David.[29] He holds within himself the potential for patriarchal dominance, but he is also a real man who is a citizen of a society in transition. In all these aspects, he is an exemplar of Cameron's representation of the heroic – expansive and complex. Like Taylor, we cannot help but wonder how Cameron could in some instances depict him as a sympathetic gentle character, evoking an aged man in a Rembrandt painting, and in others show him as a Shakespearean father figure or even as a cruel Italian patriarch. This suggests that, even when (or perhaps specifically by) using the same sitter, Cameron sought to explore the full range of types and characteristics associated with masculinity in this period, from the sympathetic to the pitiless.

However, to describe Taylor as the ultimate patriarch would be simplistic, given the range of types Cameron assigned to him. While he might have subscribed to patriarchal values in general terms, Taylor also seems to have recognized the necessary presence and universal value of both feminine and masculine qualities. This is further evidenced by Taylor's appreciation for the female relationships that shaped his life. It is also suggested in his own perceptive description of Tennyson as having a feminine and a masculine nature, 'as there ought to be in a poet: who should represent humankind rather than mankind'.[30] What we can be certain of is that, in her portraits of Taylor, Cameron is exploring fully the typological potential of her subject. As Mike Weaver writes, this typological approach 'is a serial process in

which one type illustrates another with overtones of meaning accruing to the types as one metamorphosed into another'.[31]

As evidenced by her studies of Henry Taylor, Cameron used portraiture to explore the multiplicity of self, the development of a single character between images, and employed formal devices, including her treatment of the subjects' eyes which were often heavy-lidded or shadowed, to suggest private thoughts and interior transformation.[32] She continues this effort in her portraits of Watts, and in her illustrations of Tennyson's poetry we find the ultimate expression of this accrual of meaning, which morphs into some of the most complex images she would produce.

Her typological portraits thus function not only as interrogations into a single identity, and the many sides of the human and heroic, but they also move towards a Symbolist agenda concerned with the emotive, transpersonal and themes of love and death. She used her camera 'to participate in another person's (or thing's) mortality, vulnerability, and mutability'; however, her interests did not cease with memorializing her subject's mortality.[33] For Cameron, a photograph's poetic potential was best realized through evoking the spiritual latent in the mortal. Armed with such artistic intuition, she established herself as a photographic portraitist unparalleled in her time and unmatched in our own.

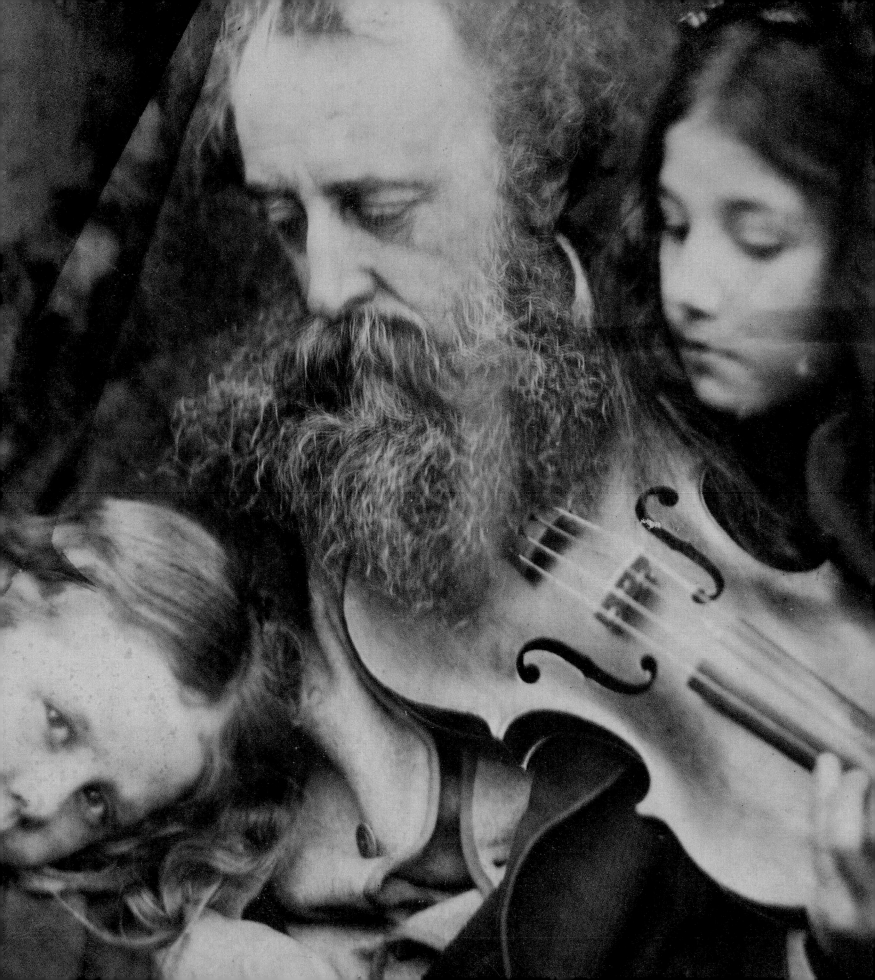

The mesmeric influence possessed by individuals must be possessed by artistic productions. Without this quality they will be cold, and not breathing, will not live always. Those who live by breath a great work hypnotises – a work in which there is life speaking to life.

G.F. Watts[1]

They [my photographs] are not only from the Life, but to the Life, and startle the eye with wonder & delight.

Julia Margaret Cameron[2]

The painter-poet

Julia Margaret Cameron had yet to take up the art of photography when the artist G.F. Watts (1817–1904) first met and fell for her younger sister Virginia Pattle in 1849. Virginia was then living at 9 Chesterfield Street in London with another sister, Sara, and her husband, Thoby Prinsep (plates 22, 23, 78). Having fallen ill, the young Watts came under Sara's watchful care and from then on Sara and Virginia became regular visitors to Watts's Charles Street studio in Mayfair. The Prinseps met Watts's first patrons, Lord and Lady Holland, then living at Holland House in Kensington, London, and

The Whisper of the Muse / Portrait of G.F. Watts, April 1865 (detail of plate 49).

on Christmas Day 1850 the Prinseps signed a twenty-one-year lease for a rambling dower house known as Little Holland House. They moved into the home together with Watts, and later that same year he painted Julia Margaret Cameron's portrait (see p. 6).[3] Thus the foundation was laid for the creation of Sara Prinsep's famous cultural salon at Little Holland House and the relationship that would form between Watts and Cameron. It was a friendship that ultimately resulted in the production of three of the most important collections of Cameron's early photographs, including the 'Signor 1857' album, which emerged out of Cameron's early interest in photography and marked the significance of the relationship the photographer maintained with the artist. Nine of the thirty-five photographs in the album record drawings by Watts. In 1864, the year she began her photographic efforts in earnest, Cameron presented the artist with an album inscribed: 'To the Signor to whose generosity / I owe the choicest fruits of / his Immortal genius. / I offer these my first successes / in my mortal but yet / divine! art of Photography'.[4]

Cameron's relationship with Watts is best understood as one of artistic mentorship and creative exchange; they shared a particular aesthetic sensibility, largely derived from exposure to the work of Italian Renaissance artists through various channels. Well before she picked up her first camera, Cameron shared with Watts an artistic

proclivity furthered through friendship, largely sustained by the social ethos of Little Holland House and, from 1860, at Cameron's home at Dimbola Lodge on the Isle of Wight. Once she took up photography, she turned to him repeatedly for encouragement and advice, which he readily gave. Though engaged in distinctly different media, the painter and photographer shared similar sources of inspiration and found themselves equally committed to the pursuit of beauty and a belief that spiritual redemption could be found in high art. Watts made this clear when he declared, 'I want to make art the servant of religion by stimulating thought high and noble. I want to assert for art a yet higher place than it has hitherto had.'[5] Through this early connection with Watts's artistic practice and philosophy, Cameron's ambition to 'ennoble it [Photography] and to secure for it the character and uses of high art' was emboldened.[6]

Prior to permanently installing himself as the resident artist and one of the most popular attractions at Little Holland House, Watts garnered initial support at the homes of his earliest patrons, the Greek merchant Constantine Ionides and Lord and Lady Holland. Ionides commissioned Watts to make a copy of a family portrait in 1837 and was so impressed that he became the family's portraitist, painting generations of the Ionides family. After winning his first major prize for the mural designs at Westminster Palace in 1843, Watts took his small prize monies and growing confidence and journeyed to Italy, where he painted one of his earliest self-portraits. Early in his artistic career, after only a short period of study at the Royal Academy's school, he decided that educating himself would prove more effective. His first trip to Italy was part of his continued education and there he found the freedom to establish his own artistic aesthetic through careful study of the work of the Renaissance artists Orcagno (1308–1368), Masaccio (1401–1428) and Domenico Ghirlandaio (1448–1494).

According to Watts's biographer Emilie Barrington, 'Italian art … awoke the flavour, the feeling for grace and distinction latent in Watts' nature and gave him the courage to go and do likewise'.[7] It was also through the Hollands' connections in Florence that Watts immersed himself in the world of professional music. His father made musical instruments for a living, but it was in Italy, upon meeting musicians such as Giuseppe Verdi, that Watts spoke so 'enthusiastically of music as to express regret that he had not in early life turned his whole attention to it, rather than to the sister art'.[8] Music and its aesthetic qualities would continue to shape Watts's life and art. Upon his return to England, Watts continued his regular visits to the Ionideses' home, where he first met the Hungarian violinist Joseph Joachim, who was destined to become not only one of his favourite musicians but also the subject of his portraiture, as well as of Cameron's photography.

By the time the Prinseps had established their place at Little Holland House, Watts knew full well the importance of such cultural circles and readily took his place at the centre of it. He lived and worked at Little Holland House and set about transforming it into a kind of temple to art and beauty. He painted the walls and ceilings of the dining hall, filling the arches with seven grand figures based on the Pattle sisters. On the ceilings he painted the firmament in rich, sumptuous blues and traced the orbits of the planets in gold. The young

British artist J.R. Spencer Stanhope assisted in Watts's crusade against empty walls, filling the remaining spaces with reproductions of Flaxman's illustrated version of Dante's *Divine Comedy* and describing the illustrations as perfect in their simplicity of line and form. In a letter to Watts written when the house was being demolished in the 1870s, Henry Taylor, a regular guest, recalled its many frescoes and paintings, 'and wondered whether what was on them could be saved. I know nothing about art as I need not say – but there are none of your works that have left a more living and lasting impression on me.'[9]

Through these doors and passages, the Prinseps invited the many guests who would contribute to the ethos of the place, inspiring the work of Watts and advancing the visual vernacular of Sara's sister Julia Margaret Cameron. Other artists and critics who attended the salons at Little Holland House included the artists and critics William and Dante Rossetti, Edward Burne-Jones, William Holman Hunt, George du Maurier and John Ruskin. Humanistic scholarship was represented by Thomas Carlyle, Thoby Prinsep and Julia Margaret Cameron's husband, Charles; science by John Herschel; and politics by William Gladstone and Benjamin Disraeli. Representatives from the world of music and literature were also welcomed, including Joseph Joachim, Charles Hallé and Alfredo Piatti, as well as figures such as William Thackeray, Alfred Tennyson, Robert Browning, Henry Taylor, George Eliot and Aubrey de Vere. Burne-Jones summed up this unique place: 'Little Holland House represented a gallant experiment, of a kind made all too rarely in England: the world at large might buckle to the forces of philistinism, but here at least the claims of talent and beauty would receive full recognition.'[10] It was in this environment that Watts seemed to serve as both a sanctifying element and a teacher to all who entered its doors. Laura Troubridge, one of the Prinsep granddaughters, recalled that Watts 'taught us values, the beauty of beauty, the joy of joy, the marvel of heroic deeds'.[11]

When Cameron and her husband returned to England in 1848, they made their home at Tunbridge Wells, Kent, but became regular participants in Sara's Sunday salon. Without doubt, the fertile intellectual and artistic climate of Little Holland House nourished the development of both Watts's and Cameron's aesthetic sensibilities. Where Watts had earlier found inspiration in Italy, Cameron's interest in the beautiful and the sublime had been cultivated during her early cosmopolitan education in India and France, and later through Charles's 1835 treatise on the subject, *On the Sublime and Beautiful*. By the time Cameron reached the doorstep of Little Holland House, she was well educated, multilingual, and socially secure in her capabilities as a hostess. One of Cameron's descendants recalls, 'None of the Pattles suffered the "inferiority complex", as it would be called now. Everything they said and thought mattered, according to them … with their superabundant energy, their untempered enthusiasms, their strangle-hold on life, their passionate loves and hates.'[12] If Virginia Woolf satirized Cameron's purported excessive enthusiasm, others, like Woolf's father, Leslie Stephen, called her 'as unselfish and generous as it was possible for a woman to be, and with the temperament, at least, of genius'.[13] Cameron's persistent presence

at Little Holland House ensured that she continued, along with Watts, to move within circles of intellectual, literary, philosophical and artistic influence, all the while contributing her own energies and aesthetic sensibilities to its environs.

Little Holland House was also important for its proximity to the South Kensington Museum, an early iteration of the Victoria and Albert Museum.[14] Cameron was granted the use of rooms at the museum, including a studio space, where she may have produced some of her photographs.[15] Additionally, Lord Eastlake, a relation of Cameron's and another frequent visitor to Little Holland House, was accumulating a collection of paintings that eventually formed the core holdings of the National Gallery. These Italian and German masters were influential in regard to Cameron's artistic vision and practice. So too were the collections held by Lord Overstone and exhibited at the Manchester Art Treasures Exhibition in 1857, and those in the British Museum, including the Parthenon Sculptures. In 1865 Cameron compiled and dedicated an album to Lord Overstone, which included some of the most significant photographs taken by her in the first year and a half of her photographic career. She also included a contents page at the front of the album, which categorized the images as 'Portraits', 'Madonna Groups' and 'Fancy Subjects for Pictorial Effect'.[16] Such categorization by the photographer affirms the growing significance of her sacred pictures, which may be best understood as one of the three principal genres of her *oeuvre*.

In 1860 the Camerons moved to Dimbola Lodge on the Isle of Wight, in part to be closer to the Tennysons. Watts would also find his way to the island, building his own home nearby, though he would continue to travel between London and his home at Freshwater Bay. Cameron soon established her own version of Little Holland House-by-the-Sea at Dimbola Lodge, welcoming all who came to visit, and by 1864 she was fully engaged in her fine-art photography. Like Watts, who was famous for his demanding approach to life and art, Cameron took up photography with the energy and determination she felt her own chosen medium deserved.[17] As soon as she began working as a photographer, she corresponded frequently with Watts. For instance, 'quite divine / G.F. Watts' is copied under the photograph called *The Dream* (plate 36). Regarding some new prints she sent him, he writes: 'A thousand thanks for your last Photographs, which I think are your very best, I don't know which I prefer, all the heads are divine, and the plates very nearly perfect; the tone too is excellent.'[18] Watts urged her on to better work: after praising her in a letter, he notes, 'you must not be satisfied there is more to be done & whilst that is the case we must never think anything done. I know your difficulties but the greatest things have been done under difficulties.'[19]

The Symbolist outcome

Cameron and Watts were also closely tied by their approach to portraiture, which they believed could successfully imbue the real subject with something of their inner self. They shared an appreciation for the poetic potential of their respective arts: Watts's contemporary critics believed his portraits to be an integral part of his reputation as a poet in paint, and it is possible that Cameron recognized and valued

this aspect of his work as well. In 1880 Watts wrote of 'making a poet of the spectator' and we must wonder if there was an element of this same sensibility in Cameron's work, where the ambition in asserting the fine-art aspects of her medium was realized in the poetic space it affords the viewer.[20] She most certainly came to her portraiture from a similar place as Watts, working throughout her career to assert its value as high art. Ultimately, the connection between the photographer and the painter was celebrated, if not explicitly then certainly implicitly, in Cameron's poetry; she may have had Watts in mind when she wrote 'On a Portrait' in 1875, imploring the painter in her poem to 'Tune thy song right and paint rare harmonies'. Though best known at the time for his portrait painting, Watts's later work took on a Symbolist character:

> In some respects Watts reminds us of Blake, the 'Swedenborg of painting' … there is the same love of the mystical and the ideal. Like him he loves more to suggest than to describe, to leave his conceptions to the artistic conscience and imagination to find out what they mean, than to work them out so that they may be plainly and fully revealed. What interests them both is not the technical excellence of their work, but what it teaches.[21]

The same could be said of Cameron who, despite her medium's potential to describe with technical precision, was more interested in what her images might suggest.

As it was for Watts, the pursuit of beauty was central for Cameron. In this it is possible to align her ambitions with those of the early Aesthetic Movement, which was growing in popularity in the second half of the

nineteenth century. However, like Watts, Cameron was equally interested in representing visually the emotive or psychological state of her subject, while also contending with broader themes of love, death, the transcendent and the sublime. In this effort, she aligned herself with the tenets of early Symbolism and with Watts, who claimed that 'art in its highest form has always been symbolic, used as a means to suggest ideas. Like poetry, it must in its best expressions deal with what is noblest and best.'[22] Symbolists – in both art and literature – were principally concerned with the non-material realms of emotion, imagination and the mysterious or spiritual. The Symbolist movement, most often associated with French writers and artists, reached its height late in the late nineteenth and early twentieth centuries.[23] However, Symbolism had early origins in Britain where it 'evolved a distinct tone and technical style', established a new symbolic language and even ascribed associative meaning to the paint surface.[24] Barbara Bryant locates Watts at the heart of Symbolism in Britain, writing that he would come to be known for his 'poems painted on canvas' and his 'dominant role as a father-figure to the movement'.[25]

Both probably evolved as portraitists in response to one another, finding ways to move from the individualized portrait to more generalized images. In a letter written in early 1865, Watts instructed her that 'what would not do in a painting, will not do in a Photograph'.[26] A play on the idea of *ut pictura poesis*, Watts's advice evidently took hold.[27] Cameron's increasing artistic maturity was evident in these portraits, with their intensity of expression and painterly qualities. While obviously void of colour, the material textures

and patterns in many of her photographs evoke the richness of tone we might equate with the colour of the Venetians. Her use of lighting and her dark, receding backgrounds replicate the drama of the art of Velázquez and Rembrandt. It also heralds her increasingly sure-handed compositional style and her manipulation of light and focus, which combined to produce images that a recent observer described as 'luscious, dark and magical'.[28]

In 1863 Emily Tennyson reflected on her portrait by Watts: 'I do not know how such a beautiful picture has come, but you are a subtle alchemist, a great magician.'[29] It is a revealing statement that affirms his commitment to a new type of portraiture, in which the portraits would be valued as works of art in and of themselves: atmospheric, symbolic and poetic. Cameron's ambitions for the portrait were very much in line with Watts's, but equally important was the way in which Watts often blurred the lines between portraiture and subject painting.[30] He had this in common with Cameron and may have encouraged her to explore this blending of genres in her photographic portraits and illustrations, examples of which we have already seen in her images of Henry Taylor photographed as a type of Prospero and of King David, among others. She would continue this effort throughout her illustrations of Alfred Tennyson's poetry, in which she embraced tenets of Symbolism as a means of further exploring the poetic potential of photography.

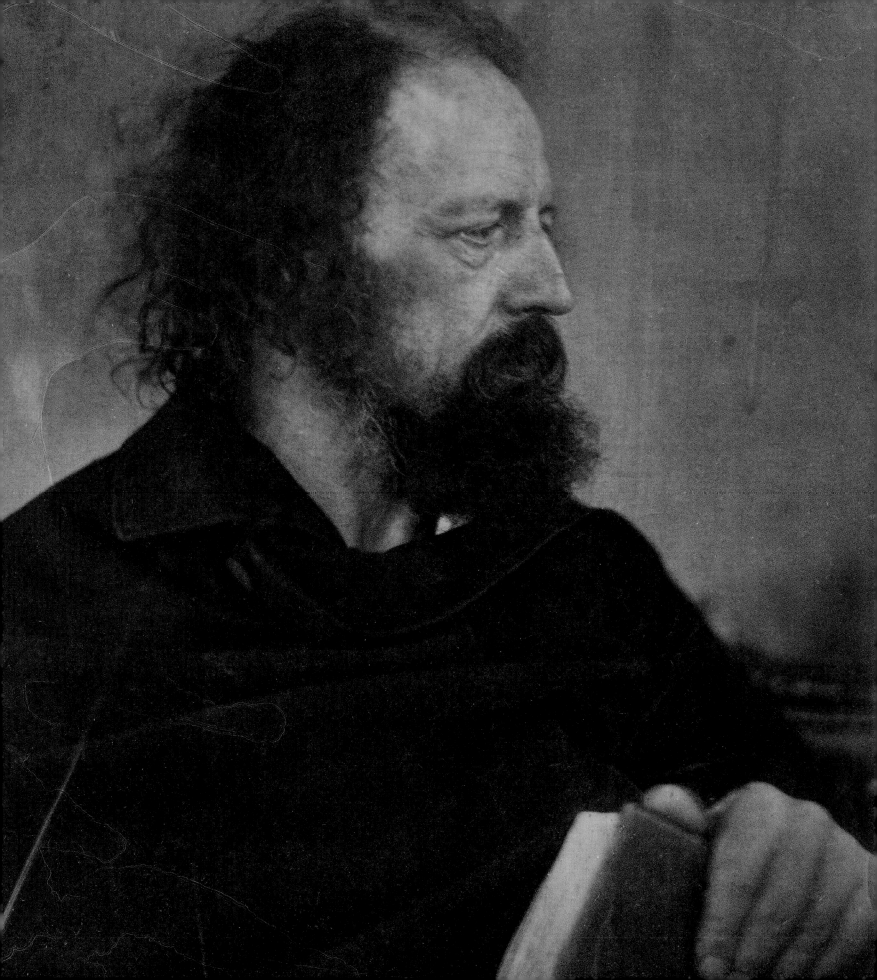

I longed to arrest all the beauty that came before
me and at length that longing has been satisfied.

Julia Margaret Cameron, 'Annals of my Glass House'

The contemplative poet

Julia Margaret Cameron first met Alfred and Emily
Tennyson less than a month before he was named
England's poet laureate. She was visiting the Taylors in
October 1850 while her husband was in Ceylon and, while
there, was introduced to the Tennysons. She shortly after
started what would be an intimate and long-standing
friendship with them; it was Cameron and Alice Taylor to
whom Alfred turned when Emily went into an unexpected
early labour in 1852. The poet was frantic, having lost
their first child, and Cameron went into the city to retrieve
the doctor. Her effort had a happy end: she later attended
their son Hallam's christening. Alfred wrote to her, 'I
shall never till the hour of my death forget your great
kindness in rushing off to Town as you did in the hour of
my trouble. God bless you ever.'[1] Decades later, the poet,
in turn, offered support and comfort to Cameron as her
husband Charles became increasingly unwell.[2]

Tennyson was, for her, an exemplar of the
contemplative poet and, while Cameron maintained
that Taylor was actually the more gifted poet of the two,

Alfred Tennyson, May 1865 (detail of plate 54).

it would be Tennyson's work that eventually drew her
sustained artistic attention in the form of her *Illustrations
to Tennyson's Idylls of the King, and Other Poems*.[3] Preferring
solitude and seclusion, Tennyson was inclined to avoid
the social activity that fuelled Cameron's energies.
Biographical evidence suggests that he had certain
tendencies towards the eccentric and melancholic,
being especially sensitive to anything that interrupted
his peace. That he would maintain a relationship with
Cameron, despite the public attention that he blamed
on her 'confounded' photographs, indicates a certain
proclivity towards a woman who, more socially inclined
than the shy poet, was regularly invited to his late-night
dinner conversations and shared an aesthetic sensibility
not unlike his own.[4] Her long-standing relationship with
Tennyson inspired Cameron's various portraits of the
poet and his family (plates 53–59), and his appreciation
for her artistic endeavours led him to offer her the
opportunity to produce the first ever photographic
illustrations of his serial poem *Idylls of the King* (1859–86),
to which she added nine photographs of his other
major works.[5]

After a decade of experience in photography,
Cameron produced her *Illustrations to Tennyson's Idylls
of the King, and Other Poems*, which number among the
most significant achievements of her career.[6] It has been
variously described as the crowning achievement of her

45

career and as a means of profiting off Tennyson's name to achieve fame and income.[7] In less partial terms, it was her most extended effort in photography before leaving England for the last time for her family's estate, and her final resting place, in Ceylon. In late December 1874 she convinced Henry S. King, Tennyson's publisher, who had pared down the number of her original illustrations to just three woodcuts for the 'People's edition' of Tennyson's work, to produce a volume of only her photographs in their original full size.[8] This folio size edition, which Cameron conceived as a Christmas or wedding gift book, measured approximately eighteen by fourteen inches, and included a portrait of Tennyson and twelve of Cameron's tipped-in photographs. With the book open, a single photograph was mounted on the right-hand page, usually on heavy pale blue paper, with the handwritten title underneath. On the left-hand page were the poem's title and excerpts from the relevant poem, in a lithographic reproduction of Cameron's handwriting. In certain instances, she underlined the text for emphasis. That she took the time to handwrite and then reproduce the manuscript rather than use typesetting may have been driven by cost; it may also speak of a decision to evoke an 'old-fashioned' illuminated manuscript or even to further assert her own 'hand' in the making of the volumes and the photographs.

When Cameron began her illustrations of Tennyson's poetry, she also did so in a nineteenth-century context informed by an increasing interest in the relationship between text and image, in part due to the growing popularity of book illustration. There was a concerted effort by artists to advance narrative painting beyond the classical themes preferred by the Royal Academy in Britain and its equivalents in Europe. The Pre-Raphaelites were particularly invested in this enterprise and frequently took their subjects directly from literary sources, going so far as to inscribe quotes on their picture frames. Lindsay Smith's study of Pre-Raphaelitism further considers the 'particular twinning of the visual and the verbal', noting their aesthetic engagement with Ruskin's own consideration of the relationship between text and image, as well as his reassessment of the unity of visual perception and representation.[9] In this context, Smith proposes an interpretation of *ut pictura poesis* that may illuminate Cameron's own efforts:

> The idea of a perfect equipoise between image and text in [Stephen] Bann's use of translation is apt here. For, as we have found the aesthetic category of *ut pictura poesis* captures a state of suspension in which neither the visual nor the linguistic (picture or poem) is subject to interpretation beyond the gesture of saying to use Horace's coinage: 'as a painting, so a poem'. Such a movement is quite different from that maintaining the resemblance of one thing to another in the sense in which *ut pictura poesis* is often read: a mediation of one mode to another. For, it is an attempt to sustain a careful balancing without resolving it.[10]

As one clearly interested in the challenge of illustrating poetry – especially as presented by Tennyson's epic poem of 'pictured moments', the lyrical sonnets of *The Princess* and his poetic subjects including Maud – Cameron might have found the opportunity to balance word and image, rather than resolve either, especially

compelling. Perhaps this explains why Tennyson did not find fault in her illustrations: they did not attempt to visually narrate his poems described by T.S. Eliot as 'always descriptive … and never really narrative'.[11]

In this effort, Cameron distinguished herself within nineteenth-century advances in printmaking and book illustration, in which text and image were inextricably connected. Although Cameron included sections of text alongside her illustrations, allowing for a relationship between the two, her cinematic reframing of an essentialized subject did not propose a resolution or the completion of the narrative. Instead, she photographed the potential meaning vis-à-vis relating the verbal and the visual by using the tools of poetry and those of photography – including the metaphor that ascribes meaning through association and the mnemonic trace which extends the photograph beyond mere representation. Combining the two invited the viewer (or reader) into a distinct encounter with the suggestive or liminal, and as Arthur Henry Hallam suggested in his assessment of Tennyson's best poetry, challenged them to co-create meaning. Instead, they are carefully selected excerpts that, as Carol Armstrong notes, illustrate Cameron's efforts to control the interpretation of both the text and text image.[12]

The first volume of the *Illustrations* was not the commercial success Cameron had hoped for, but nonetheless she quickly began work on a companion volume, again published by King, in May 1875.[13] It was identical in size and format to the first but was dedicated principally to other major poems authored by Tennyson; only three of the subjects were Arthurian. That Cameron produced both volumes within months of each other and used the same construction, size and layout of text and image suggests that she perceived them to be a unified art object. This is further reinforced by her decision to give them the same title, distinguished only by 'Volume I' and 'Volume II', and the same title page, dedication to the queen, and poetic tribute to beauty by Charles Turner. Her highly curated photographs present the themes she found most compelling in Tennyson's poetry, exhibit her maturity as a photographer and effectively dictate how the viewer or reader is meant to experience the work. Following decades of less than favourable scholarship, Charles Millard's critical work on Cameron's *Illustrations* accounts for their success as representative of her artistic maturation:

> Considered photographically, the *Idylls* illustrations are wholly remarkable, and not merely because of the technical feat they represent in the age of the wet collodion process. The complexity of many of them demonstrates Mrs. Cameron's ability to control a large number of compositional variables, and their success demonstrates her progress as an artist from her earlier, less elaborate work. In the best of them, the broad tonal areas in terms of which she conceived her compositions, and to which the details of those compositions are subordinated, are subtly unified in their softness and their continuity from light to dark. This breadth and unity rank her pictures among the major accomplishments of nineteenth-century photography.[14]

It is the second volume of photographs, a copy of which is held by the Bodleian Library, that extended the pursuit beyond the *Idylls of the King* to include selections from Tennyson's other major works. In the first volume,

Cameron asserts a certain agency in the re-presenting of Tennyson's *Idylls*, particularly by elevating aspects of its female heroes and their development. Her work in the second volume not only sustains but also broadens this interrogation of key themes in Tennyson's poetry, while simultaneously evincing her engagement with the poetic possibilities of her own medium. When read together, the two-volume *Illustrations* offers a comprehensive treatment of Tennyson's poetry and evidence of an ongoing resonance between the aesthetics of the poet and the photographer. Additionally, the second volume achieves the balance of a deliberately wrought cycle of photographs that forms a 'portrait' of the complexities of the human condition and the poetic journey of life. In this effort, traditional definitions of the heroic and sublime are reimagined, gender distinctions commingle, and Cameron's Christian typology shades into Symbolism.

In terms of layout, the second volume begins with the same dedication page and introductory text as in the first. It too includes a portrait of Tennyson, but one decidedly different than the frontispiece in the first volume, often referred to as the 'Dirty Monk' portrait, which focuses on the poet in contemplation, his attention turned away from the closed book he holds in his hand. In the second volume's frontispiece Tennyson sits with an open book on his lap; he is presented as a poet-narrator more actively engaged with the text (plate 60). Then follow twelve photographs inspired by a range of themes explored by Cameron's 'contemplative poet'.[15] The first set of images depicts 'The May Queen'. Next is a triptych of images from 'The Princess', a poem in which Tennyson posits the notions of 'Death in Life',

the 'true-heroic' and the 'true-sublime', and the 'strange diagonal', all of which find renewed interpretations in Cameron's photographs. She also provides an illustration each for 'Mariana' and 'King Cophetua and the Beggar Maid', two additional Arthurian images of Elaine and one more of King Arthur, with the final image taken from Tennyson's brooding poem *Maud*.

Illustrating the *Idylls* and other poems

Tennyson described the *Idylls* as allegorical and spiritual. Cameron responded to this literary approach, and it informed her interpretation of the work as a series of pictured moments.[16] The complete *Idylls* focused on the heroic but human journey of Arthur, whom Tennyson described as 'the Ideal in the Soul of Man' contending with the 'warring elements of the flesh'.[17] Notwithstanding Arthur's prominence, the other characters of the legend were intrinsic to the allegory as a whole. Significantly, Cameron opted to downplay Arthur's experience (he appears just five times in the two-volume *Illustrations*), and bring to the forefront other characters, each representing elements of the human condition. Cameron's strategies for illustrating this broader theme include using pairs of portraits to suggest development within a single character, giving unprecedented attention to the female characters, and training her lens on the inward self. Across her two volumes, the legendary King Arthur and his court are transmuted into distilled meditations on the human (and often very un-legendary) experiences of love, seduction, sorrow, death and redemption. In so doing, Cameron replicates the structural ordering of Tennyson's text as a cycle of poems, presenting a 'cycle' of photographs

that, when read together, create a composite picture of a heroic, if at times difficult, experience of 'the tableland of life'.[18]

In addition to her unorthodox decision to visually elevate the role of the women in the *Idylls*, Cameron disavows the Pre-Raphaelite inclination towards profligate and clinical detail. While her work was illustrative in the sense that it rendered visually particular moments taken from the text, it also surpassed that particularity to plumb the emotive experiences of Tennyson's varied cast of characters. This is evident in her single illustration of 'Mariana', a poetic subject that was also painted by the Pre-Raphaelite painter John Everett Millais (plate 61; fig. 21). Mariana's heavy physical presence, which dominates the image, reflects the lack of action in Tennyson's poem. By eliminating any gesture, the photograph focuses on her dulled and weary expression which matches the following verses: 'She only said, "My life is dreary, / He cometh not", she said; / She said, "I am aweary, aweary, / I would that I were dead"'.[19] It is a poem and a picture of gloomy seclusion. However, it is also an interesting choice of subject by Cameron for its concentration on the emotive and its Symbolist potential. 'Mariana' was among the Tennyson poems most admired by Symbolist poets for its lyricism, especially Stéphane Mallarmé (1842–1898), who translated the text into French in 1874.[20]

As she had done in her Arthurian images, Cameron here distils the meaning (and feeling) of the poem by isolating the subject from all other particularities in the poem. Her subject's expression, the collapsed and compressed physicality of her form, her suggestively frazzled hair and her vacant stare all combine in a visual articulation of the epiphanic phrase used in the title of the photograph: 'I am aweary, aweary …'. Thus the image is a clear departure from anything that might suggest strict allegiance with the Pre-Raphaelites. Instead, Cameron's treatment of Mariana invokes Tennyson's Symbolist tendencies, effected here through his lyrical repetition of words, and results in a portrait similar in sensibility to the two illustrated sonnets from *The Princess*. This close-up portrait of Mariana contorted within the frame replicates the subject's cognitive self-enclosure – a kind of frame within a frame – and, as such, re-enacts the poetic potential of the photographic medium with its limited aperture and selective focus.

Tennyson used suggestive, picturesque language to achieve a particular 'feeling' within his poetry.[21] We might equate that to the 'pictorial' in photography where, as exemplified in Cameron's second volume, the focus is adjusted and minimal details are used in pursuit of a generalized impression of the psychological aspects of various characters, of typological and symbolic equivalences, and of important poetic themes traceable throughout Cameron's *oeuvre*.[22] Like Tennyson, who has been described as a 'poet of sensation', her illustrations are not entirely narrative but also suggestive in the broadest sense, using differential focus and limited details to elevate the emotive sensibility of the image.[23] We might be inclined, thus, to describe the relationship between poet and photographer as analogous rather than as a dynamic inter-artistic relationship, as was the case with Cameron and G.F. Watts.[24] Overall, as Armstrong notes, the individual photographs exhibit a relative stillness. Most are gesture-less and, with few exceptions, decidedly anti-theatrical.[25] As such, her

illustrations might be considered anti-narrative and, according to Helen Groth, are 'self-consciously poetic in their slowing down of time and fascination with duration'.[26]

Gerhard Joseph writes that by 'exploring and complicating the distinction between the focused and the out-of-focus, she parallels the optics of Tennyson's poetry', thereby producing illustrative images that oscillate 'between the post-Romantic aesthetic of particularity and an aesthetic of vagueness'.[27] Cameron's 'parallel optics' are also reflected in a more discrete engagement with Tennyson's interest in the remote in time and space – or the 'far, far away', one of his favourite lines.[28] While nearly all of the images included in this book are close-ups in practice, there is a subtle ambiguity evident in many through their muted expressions and vacant eyes, which allude visually to a sense of the 'far, far away' that is the interior landscape. Such an interest in 'vagueness' (or the sublime) – suggested through Cameron's soft focus and disengaged but inwardly emotive subjects – pushed her ever closer to Symbolism. This interest also corresponds to the inherent characteristics of her medium, itself capable of the mechanical reproduction of the hard-edged particulars but inherently connected to the passage of time and the blurred vagaries of memory that are always distant. Unsurprisingly, nothing could seem more antithetical to many of Cameron's nineteenth-century photographic peers than her attempts to photograph the unphotographable – the emotive self, the mnemonic echo, vacillating notions of the heroic and the temporal yet sublime aspects of life and death.

With a decidedly modern sensibility, she produced just twenty-four images between the two volumes, fifteen of which were dedicated Arthurian subjects. As Barbara Lupack writes, 'with these relatively few photographs in her Arthurian series – fifteen in all, published in two volumes – Cameron managed not only to define photographic illustration, but to introduce a feminist consciousness to the legends, and to ensure her own artistic reputation'.[29] Where her first volume was framed by Tennyson's *Idylls of the King*, the second evidences further agency in her art-making – one that moves towards a visual poetry that takes as its subject the long arc of life. These photographs were unmistakably 'Cameron' in composition, style, technique and suggestive expression. While she appreciated the significance of aligning herself professionally with the Poet Laureate, she boldly asserted her own aesthetic agenda, using his text to narrate and elucidate her photographs. Additionally, her *Illustrations* remind us of efforts consistent with Cameron's portraiture already discussed, in which similar poetic potential was available in a single face. Although Cameron would continue to take photographs after returning to Ceylon, the *Illustrations to Tennyson's Idylls of the King, and Other Poems* were the last significant photographs taken while she was still in England. They function as a type of elegiac tribute to the poetic potential of photography.

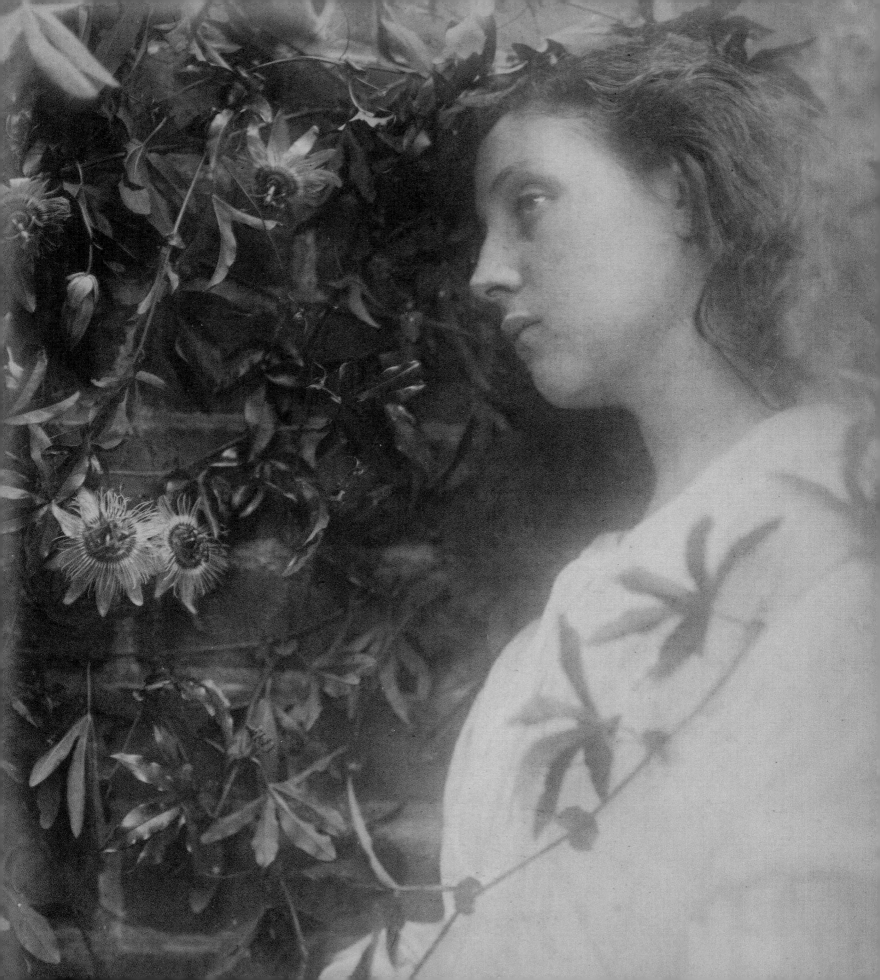

5 A Poetry of Photography

For there is a poetry of photography, as there is for painting and literature.

P.H. Emerson, *Naturalistic Photography for Students of the Art*

Working during the golden age of Victorian illustration, Cameron distinguished herself as an early Pictorialist in principle and practice. Pictorialism began as an effort to establish photography as an art by applying fine-art tenets to the production of an image, and by creating an image deliberatively rather than merely recording the details of a subject. This often involved a softening of focus, a shallow depth of field, chiaroscuro and simplified composition.[1] While Cameron did not explicitly manipulate her photographs for painterly effect, she approached the practice with a greater affinity to a Pictorialist agenda than to so-called straight photography. She aimed to key into its capacity for suggestiveness and symbolism despite photography's mechanized form of production, thereby elevating photography to the status of art. Ultimately, Pictorialism became the vehicle she used to interrogate the possibilities of her typological approach to portraiture. Combined with her Symbolist tendencies, it is most fully realized in her illustrative photography; her particular use of Pictorialism prefigured later developments in

Maud (Mary Ann Hillier), 1875 (detail of plate 72).

the nineteenth and early twentieth centuries when the suggestive or symbolic itself became the principal subject of an image. While she received little encouragement from other contemporary photographers, Cameron took pride in earning the support of artists and critics like Watts and William Michael Rossetti (1829–1919), who also responded positively to her efforts:

> Exceptional in the critical as in the photographic art are those productions which – like the surprising and magnificent pictorial photographs of Mrs. Cameron to be seen at Colnaghi's – well nigh recreate a subject; place it in novel, unanticipable [*sic*] lights; aggrandize the fine, suppress or ignore the petty; and transfigure both the subject-matter, and the reproducing process itself, into something almost higher than we know them to be. This is the greatest style of photography or of criticism; but it undoubtedly partakes of the encroaching or absorptive nature, such as modifies if it does not actually distort the object represented, and insists upon our thinking as much of the operator, and of *how* he has been operating, as of those objects themselves.[2]

This approach is most evident in her illustrations of Tennyson's poetry. Rather than simply document the narrative or action of the story, Cameron created images that centred the emotive aspects of the characters and respected key thematic priorities within the poems. Her

close reading of these poems, and her friendship with their author, enabled her to proceed in such a way as to avoid upsetting Tennyson. More importantly, she created standalone illustrations that also work in pairs, in groups and as an entire series, to elevate salient themes of the text. She set to the task with a characteristic seriousness of purpose, briskly producing the first volume of her *Illustrations to Tennyson's Idylls of the King, and Other Poems* in a matter of months, followed shortly after by the second. Tennyson did not intervene, instead leaving her to work out an approach that distilled the essential themes of each poem. It was an approach Cameron had explored through her earlier portrait work, in seeking to blend the physical characteristics of her subject with the more elusive aspects of their inner selves. Likewise, she strove to render with relative visual simplicity aspects of Tennyson's characters in a way that acknowledged his attention to the evolution of the corporeal and spiritual self.

A Marian cycle

The maturation of Cameron's Pictorialist approach and her evident quest for the poetics available through photography is fully realized in the second volume of the *Illustrations*. The first three photographs form a cycle of images that respond to Tennyson's poem 'The May Queen', which was written in three parts, the first of which was begun in 1833 (plates 63–65). The poem commences with the excitement of the young May Queen (Alice) who, having just learned that she has been chosen for the role, recounts the honour to her mother. The second part, titled 'New Year's Eve', shifts tone as the young Alice realizes the temporality

of her role and even more significantly of her life, as the poem suggests she is suffering from a terminal illness. The third and final segment of the poem, 'The End', reads as a meditation on life after death, and of the May Queen's lingering spiritual presence in the lives of those left behind. The suggestive language and themes of the three parts of the poem provide a sense of cyclical development as the poet describes the naïve, slightly narcissistic youth of the May Queen, her self-actualization as she confronts her mortality and imagines lying alone 'within the mouldering grave', and ends with an articulation of her final day on earth ('New Year's Eve', lines 1–4).[3] Although Cameron had explored the subject of the May Queen in photographs taken as early as 1864, those here represent a concentration on the text's treatment of temporality, and concomitantly demonstrate her methodology of conveying character development across a series of illustrations.

Cameron's treatment of the May Queen as a Marian type in the first and third image advances of her use of typology (plates 63, 65). Both contain allusions to the Annunciation and to the human woman who became the queen of earth and heaven, celebrated for her humanity, and recognized for her sacrifice. She functions as an exemplar of the combination of the sacred and profane. This is not new territory for Cameron; *For I'm to be Queen of the May, Mother, I'm to be Queen of the May* recalls her earlier studies of the Annunciation itself, though here the wreath of flowers stands in for the more commonly used lilies (plate 63). The May Queen photographs in the *Illustrations*, with their overlays of typological association, invite interpretation as an exposition of the Marian cycle.

Being familiar with the paintings of Italian masters Francesco Francia and Perugino, and having titled photographs 'after the manner' of their work, Cameron might well have followed their traditional artistic vernacular and culminated the cycle with a coronation scene as the closing of the traditional celebrations of May, the month of Mary.

Instead, however, she ends the series with a different image of popular devotion, the *Mater Dolorosa*. The suggestion of a halo in *So now I think my time is near* is more clearly represented, and her crossed hands and upward gaze find precedent in Mary as the Mother of Sorrows (plate 65). Although there are no arrows through her heart, the posing of the May Queen recalls Anna Jameson's 1852 description of Mary as mourning mother (fig. 22):

> In which her character is that of the mother of the crucified redeemer; the mother of atoning Sacrifice; the queen of martyrs; the woman whose bosom was pierced with a sharp sword; through whose sorrow the world was saved, whose anguish was our joy, and to whom the Catholic Christians address their prayers as consoler of the afflicted, because she had herself tasted of the bitterest of all earthly sorrow, the pang of the agonised mother for the loss of her child.[4]

This is, for Cameron, a portrait of a woman facing the outcome of the biblical admonition echoed by Tennyson: 'yet His will be done' ('The Conclusion', line 10).[5] It is also the portrait of a woman made 'great thro' love', forged by her encounter with life and death, and the sorrow associated with both.[6] That her subject's hair is

loose in all three images is a subtle suggestion of a third Marian type, Mary Magdalene, an evocative possibility that re-emerges in Cameron's final photograph of the second volume of her *Illustrations*.

The Princess: 'True-Heroic – True-Sublime'

Cameron dedicates another set of three illustrations to the poem in which Tennyson considers the reconciliation of male and female into 'The single pure and perfect animal, / The two-celled heart beating, with one full stroke, / Life' (*The Princess*, lines 287–9) (plates 66–68).[7] She attaches the heroic and sublime to the feminine by using female models, while also continuing her own exploration of the relationship between the real and ideal, or sense (material) and soul (spiritual), which Tennyson identifies in his text as the 'strange diagonal'. The three illustrations in *The Princess* triptych illustrate the photographer's ongoing efforts to draw up what was latent in Tennyson's poetry: its attempt to contend with gender complementarity, its commitment to the suggestive rather than the strictly narrative and its Symbolist attributes.[8] Given the length of the narrative poem, published in 1847, the photographer had ample material from which to draw inspiration. Curiously, she focuses on just three moments, two of which are songs and which function photographically in the elegiac mode.[9]

The first of the three photographs visually invoke female agency and reinforce the poem's emphasis on female education and on gender roles generally (plate 66). In one photograph, Cameron encapsulates the poem by portraying Ida as the central subject, full length and flanked by women reminiscent of the sibyls

and saints, focusing on a defining moment for her while neglecting to represent the concessions (to her father and to marriage) Ida will make as the poem continues. Cameron does not depict these later concerns, focusing instead on an elevation of the female protagonist's heroic aspects while also typologically imbuing her with elements of the sacred. Tennyson presents the defining idea of Ida as 'true-heroic – true-sublime' in the form of a question:

> The women – and perhaps they felt their
> power,
> For something in the ballads which they
> sang,
> Or in their silent influence as they sat,
> Had ever seemed to wrestle with the
> burlesque,
> And drove us, last to quite a solemn close –
> A gallant fight, a noble princess – why
> Not make her true-heroic – true-sublime?
>
> *The Princess*, lines 13–20[10]

Cameron, in contrast, does no such thing. Instead, through composition and the implicit placement of the viewer (and presumably the prince) below the feet of the princess, we look up to Ida and do not doubt that she is *both* true-heroic and true-sublime. It is an unequivocal statement about a woman's capacity to be noble in her active engagement with the world and sublime in her capacity to inspire the contemplation of higher things such as beauty and truth. Transcending this, Cameron positions the princess as a heroic figure who has undertaken an effort neither easy nor free of suffering and sacrifice. The photographer is evidently sympathetic with her subject and willing to further complicate the daring themes of the original text.

Cameron then shifts her attention from a group portrait to two individual portraits of equal significance. The second and third images of *The Princess* triptych move the viewer from a place of veneration to consideration of a melancholic tableau focused on two of Tennyson's songs from the poem, which he had subtitled 'A Medley'. Cameron's musicians are female subjects who create a type of lyrical pause in the visual proceedings much as they do in Tennyson's poem. As Catherine Maxwell suggests, the songs might also be understood as 'sublime fragments, which give the reader [viewer] access to the imaginative recreations of the sublime'.[11] In the first pictured sonnet, Cameron's songstress fills the frame of the photograph, her head slightly tilted as if listening for the sounds of either the bugle or its echoes that repeat the 'dying, dying, dying', excerpted on the preceding page (plate 67). Her hair is loose and flowing and she is turned just slightly, as if listening for an echo of sound as her eyes look out toward the upper edge of the frame. Cameron balances her composition into demarcated sections of light and dark, with the variegated handle of the harp curving down the length of the image and across the songstress's lap. This photograph, much like the next, is a response to the poet's lyricism, which was also the aspect of his work most compelling to later Symbolist poets like Stéphane Mallarmé.[12] Joseph notes that, for the poet,

> sound like sight is most evocative when it is
> experienced at a 'far, far' remove from the original

source, and the appeal of echo over simple sound is that the former gives the impression of having travelled great distances, having bounced off various surfaces on the way to the auditor and of having been rendered numinous in the process.[13]

These descriptions of Tennyson's treatment of sound and its echo could be used in describing Cameron's own engagement with aspects of her art-making, particularly the function of light in the photographic process, which also 'bounces off surfaces' like sound and leaves a trace, or echo, of itself and its subject across the chemically treated plate. Although there is no literal suggestion of sound – Cameron's model is not playing the harp, for example – she isolates the act of listening which, like the instrument, points to the presence of sound, with its mnemonic qualities. Cameron's title for the photograph reinforces her interest in the act of listening – *'O Hark! O Hear!'* – and the echoes of sound which become 'thinner, clearer, farther going'. Her treatment of this subject suggests an enduring consideration of the particularities of her medium and the ways in which they correspond with Tennyson's poetics and the tenets of Symbolism. The photograph as a material object is a presence created from an absence; the echo and trace function in similar ways insofar as they are created from the end (death) of a sound or the passing of light. This fading in and out which, for the poet is realized through his response to the the 'far, far away' and is expressed by Cameron through her management of light and focus, point towards the interest shared by both in the numinous and ineffable.

Cameron's third and final contribution to *The Princess* sequence is also an illustration of lamentation (plate 68).

This photographed sonnet represents some of the most famous lines written by Tennyson, whereby 'Tears from the depths of some divine despair, / Rise in the heart, and gather to the eyes' (*The Princess*, lines 22–3).[14] Tennyson's description of tears and of finding 'the depths of all those tragic woes' also recalls Cameron's 'On a Portrait'. As in her poem, the tears may spring from sorrow caused by the immediate loss of a loved one and/or from the perpetual mourning that occurs as time passes and lived experience becomes memory.[15] Tennyson's second sonnet turns from a meditation on temporality and the sublime in nature to a focus on sorrow, transience and the veneration of memory, an effort described formally by Tennyson as 'Death in Life'.[16] Cameron photographs the speaker's lament for a life lived with the persistent presence of death – of past experience, of love and more literally of friends and family members.

Tennyson wrote of the song that 'the passion of the past, the abiding in the transient, was expressed in "Tears, Idle Tears", which was written in the yellowing autumn-tide at Tintern Abbey, full for me of its bygone memories'.[17] Cameron includes the full text of the poem in her *Illustrations*, with its concluding paradoxical statement, 'O Death in Life, the days that are no more!'[18] Joseph describes the structure of the poem as created from the speaker's repeated epithets as the poet attempts to work out the meaning behind the idle tears: 'Each pairing mingles the joy of remembered life and the sorrow of its passing', and captures the speaker fixed between the present and the past.[19] Cameron's female subject is 'fixed' as well, permanently held in a kind of liminal space afforded by the medium of photography.

The image, its title and the accompanying text also recall John Donne's poetry of sorrow, especially 'A Valediction: Forbidding Mourning', which focuses on the separation of body and soul after death. This was a favourite of Tennyson's, who often recited its stanzas.[20] Cameron would return to similar themes in her own late poem 'Farewell of the Body to the Soul'.[21]

Cameron's treatment of the two sonnets, illustrated around the same time as Walter Pater published his book on the relationship between music and art, also reaffirms her affinities with the Symbolists.[22] She capitalizes on the capacity of photography to preserve life through visual memory, the 'real' subject memorialized through light striking the chemically treated glass plate. In her attention to the sonnets explicitly concerned with dying sound and 'Death in Life', Cameron presents as one who may have understood, well before twentieth-century theorists, that photography was at its core a melancholic art and thereby the best medium to illustrate Tennyson's poetic grappling with mourning that arises from the depths of human experience.[23] Just as the medium was appropriate for illustrating the Arthurian legends of a 'city … built to music', with its inhabitants shading in and out, it proves ideal here for its capacity to optically address the blurred experience of universal loss and its inexpressible causes.[24]

A Return to *Idylls of the King*

Cameron then returns to subjects from Tennyson's *Idylls of the King* in three of the final four illustrations of her second volume. As in her previous illustrations, she convincingly compresses much of the weight of the poem's meaning into the first photograph, which takes Elaine's death as its subject (plate 69). The final words of the text presented on the page before the photograph underline her intent: 'All but her face, and that clear-featured face was lovely, for she did not seem as dead, But fast asleep, as tho' she smiled' ('Lancelot and Elaine', lines 1152–4).[25] Elaine's hair is loosened and cascades over the edge of the barge; a crown of flowers frames her face. Although it is a funereal moment, a death caused by unrequited love, it is not an expression of desperation or angst as we might have seen on other tragic figures such as Ophelia, whose broken heart leads to suicide. Other artists, including Gustave Doré, would address this subject with a similar inclination towards evoking the tragedy of the story, but none focused on Elaine's expression as Cameron did, who seemed specifically interested in representing the peaceful and sleep-like death of the lily maid.

While prior photographs in her *Illustrations* allude to the theme of death, Cameron's second-volume photographs of Elaine are literal funerary scenes. As a paragon of purity and ideal femininity Elaine was a favourite subject among Victorian artists. Cameron does include symbolic suggestions of her purity, including the white flowers, but more noteworthy is her decision to treat Elaine's death explicitly in a style reminiscent of Victorian mortuary photographs. Her model feigns sleep to suggest her physical death, which suggests a transitional space between the real (and alive) subject and her (pretended) death.[26] Her treatment of death – or its somnolent equivalent – here and elsewhere indicates Cameron's awareness of her medium's indexical qualities and its capacity to play upon the temporal division between the material and immaterial.

Cameron's reintroduction of Elaine in the second volume develops new significance in the next two illustrations (plates 70–71). Taken as a pair, they suggest equivalence between Elaine and King Arthur, who is often typologically associated with Christ and so cast in her first volume of the *Illustrations*.[27] This final Arthurian illustration is assuredly informed by the traditional visual vocabulary of the deposition and entombment of Christ. The 'shattered' body of Arthur rests in the lap of the tallest and fairest of the three queens, an evocation of his mother, Mary, and is flanked by two other saintly female figures reminiscent of those often depicted in deposition scenes, traditionally identified as Mary Magdalene and Mary of Cleophas.[28] The three queens in the Arthurian legend represent Faith, Hope and Charity, while their counterparts in classical mythology are the Three Graces.[29] The potential symbolic and typological significance of the three women present in the illustration thus evokes the Arthurian (British), the Christological (biblical) and the Virgilian (classical).[30]

Considering the similarities between the two elegiac images of Elaine and King Arthur, both laid out in barges, destined for a waterborne end and surrounded by mourning figures, we might understand Cameron's photographs of Elaine in the second volume to correspond with Deposition imagery as well. If so, Elaine and Arthur strive in parallel towards heroic dreams of, respectively, an ideal love and an ideal order. That they are of different genders is perhaps less important than what they have in common; the transition between earthly and divine love is considered in both subjects, but Cameron also remains consistent in her evocation of an aesthetic of sorrow. Cameron's

photographs of the dead Elaine are evidence of her interest in creating a female exemplar of the heroic and of the sublime who is on a par with King Arthur himself. Taken as a pair of subjects, Elaine and Arthur help to reinforce the consistent framing of themes key to the poet and photographer – most especially of love and death. They also demonstrate the multifaceted typological interplay that is realized throughout Cameron's photography.

The 'passion-flower at the gate' and the return of a queen

The closing photograph of Cameron's two-volume *Illustrations* is a single portrait of Tennyson's Maud, which includes the inscription 'There has fallen a splendid tear / From the passion-flower at the gate' (plate 72). Not only is this the last image of the second volume, but it is also the final image of the two-volume work as a whole. It is not taken from the Arthurian narratives but from *Maud*, a poetic monodrama published in 1855. Arguably one of Tennyson's most complex poems, and described as one of the finest he had ever written, *Maud* contends with the darker aspects of humanity, including madness and the searing experience of love, in its human and fragile form, as dangerous and violent, and as something easily lost.[31] Despite this, as Tennyson wrote in his notes, *Maud* was fundamentally about the 'holy power of Love'.[32] Henry Van Dyke, who described the poet's famous readings of the text, was

> amazed at the intensity with which the poet felt,
> and the tenacity with which he pursued, the moral

meaning of the poem. It was love, but not love in itself alone, as an emotion, an inward experience, a selfish possession that he was revealing. It was love as a vital force, love as a part of life, love as an influence – nay, *the* influence which rescues the soul from the prison, or the madhouse, of self, and leads it into the larger saner existence.[33]

In addition to privileging love, which was Tennyson's ambition throughout much of his poetry, 'the peculiarity of [the] poem [was] that different phases of passion in one person take the place of different characters'.[34] In *Maud* – as we have seen in many of the other poems Cameron illustrates, such as 'Mariana', the two sonnets from *The Princess* and 'The May Queen', as well as some of her Arthurian images – an individual photographic subject carries the potential for a multiplicity of meaning. As David G. Riede writes,

> rather than being representative of a specific woman known to Tennyson, Maud is a complex allegorical signifier of the Romantic beloved … Like all allegorical emblems, according to [Walter] Benjamin, she is a multivalent signifier, an emblem of beauty, of death … *Maud* is, in short, an allegory of melancholy.[35]

Maud was also the second of Tennyson's two great poems of mourning, the first being his *In Memoriam*, written following the death of his closest friend, Arthur Hallam, and likewise includes a personification of Sorrow as a female figure who whispers, echoes and cries.[36]

Thus, Cameron closes her serial re-presentation of Tennyson's poetical work with a photographic

illustration of the poem which may, in fact, singularly represent her own interests in the poetic themes of love (divine and profane), of sorrow and the sublime. As such, it is situated appropriately as the closing image of her two-volume *Illustrations*, which began with the *Idylls of the King*, also described as an allegory of melancholy. What Cameron focuses on, then, is not the madness of the narrator after he loses Maud, nor the dangers of the Crimean War to which the narrator goes to fight after regaining his senses, nor any of the other explicitly dark themes in Tennyson's poem, such as the narrator's murder of Maud's own brother. In her closing portrait, Maud is paired not with the roses and lilies mentioned in the accompanying text, but instead with the subject of the line – 'There has fallen a splendid tear / From the passion-flower at the gate' (*Maud*, lines 908–9) – in which passionflowers symbolize not earthly love but Christ's holy passion and suffering, expressed initially as weeping in the garden of Gethsemane.[37] On the previous page, the lithographic text begins with the line 'There has fallen a splendid tear' and continues with the verbs 'cries', 'weeps', 'listens' and 'whispers'.[38] Although her model does not literally shed a tear, the text selection reinforces the sorrowful and subdued sensibility of the photograph. It also recalls her third illustration from *The Princess*, with its 'tears from the depths of some Divine despair' and suggests interconnections between the second volume illustrations despite their being from two different Tennyson poems.

Cameron's choice of Mary Hillier as the model – also selected as the queen cradling the dying Arthur's head in the previous illustration and most often cast as the Madonna across her *oeuvre* – also re-presents Maud as

the Queen of Heaven, the embodiment of the triumph of divine love. At the same time, some of Tennyson's lines in *Maud* seem to foreshadow the possibility of resurrection:

> She is coming, my own, my sweet;
> Were it ever so airy a tread,
> My heart would hear her and beat,
> Were it earth in an earthy bed;
> My dust would hear and beat,
> Had I lain for a century dead;
> Would start and tremble under her feet,
> And blossom in purple and red.
>
> *Maud*, lines 916–23[39]

Like the legend of Arthur, which contains elements of life, death and rebirth – that is, of incarnation, crucifixion and resurrection – the poem and photographic portrait of Maud encapsulate a similar narrative trajectory. Cameron's image of Maud is also a type of Mary Magdalene, who was the first 'at the gate' of Christ's tomb to grieve and then witness his victory over death. Although it blends into the vines, Maud's hair is loose – like that of many of the female subjects in the *Illustrations* – keying into Christian iconography that attaches significant meaning to long hair, with its potential to dry Christ's feet and to conceal nakedness. Mary Magdalene, the worldliest of the three Marys at the tomb, and a female hero who bears witness to the miracle of the resurrection, is simultaneously also typologically associated with Christ's passion and suffering, which she witnessed at the foot of the cross.

These layers of allusion made visible through intertwined textual and visual means were also linked to Cameron's knowledge (and that of her contemporary viewers) of late medieval and early Renaissance visual traditions. As we have seen throughout the *Illustrations*, Cameron's choice of photographic subject and its accompanying text take the viewer to the essential core, the ultimate meaning, of the poem while somehow simultaneously destabilizing the notion of its meaning.[40] Her close-up image of Maud freed of particulars allowed her to work in generalities, and opens up possibilities for an advanced typology that moves towards Symbolism. The suppression of detail and the softening or blurring of focus ensure that Cameron's portrait of Maud achieves a 'poetry of photography' that is at once beautiful and sublime. A photograph such as this complicates the idea of a singular meaning and, instead, relies on the distilled emotive potential of a subject that is aptly described as multivalent. Cameron's 'passion-flower at the gate' is the real Mary Hillier, Tennyson's Maud, a type of the Virgin Mary and the Magdalene, and associated with Christ. She is a suggestive combination of sense and soul and an appropriate closing image for a two-volume collection of photographs that drew inspiration from Tennyson's and Cameron's enduring interest in the relationship between the material and the spiritual as expressed, respectively, through text and image.

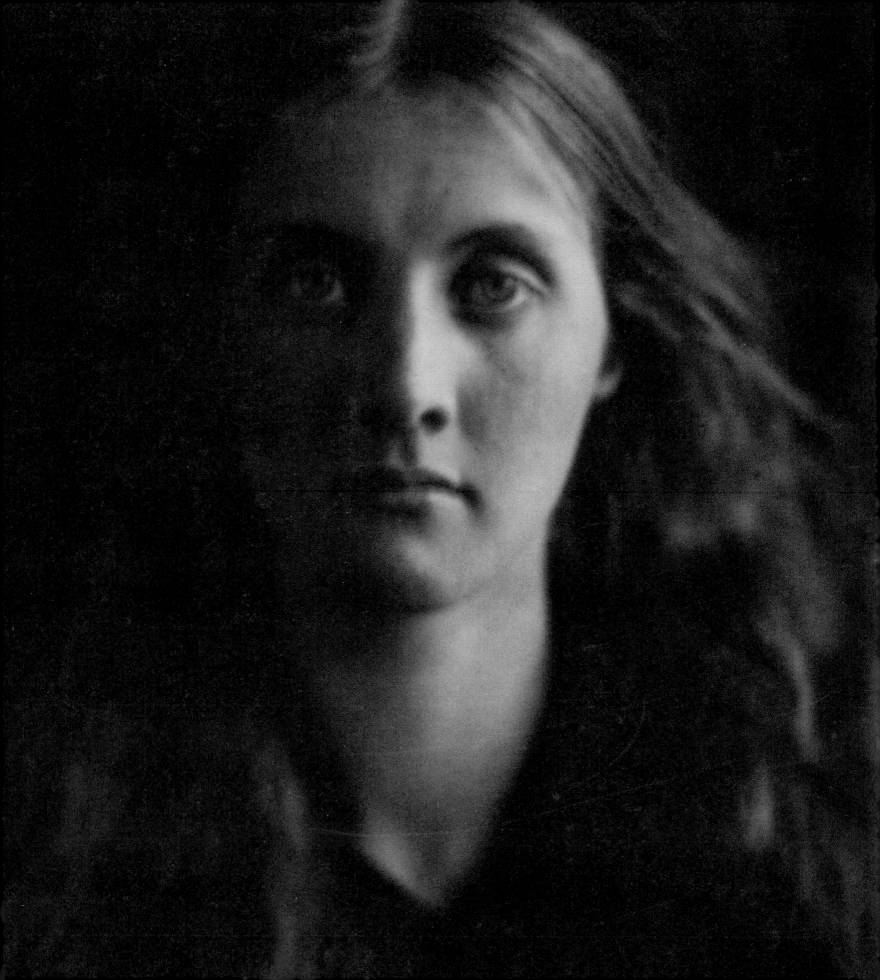

The sun paints the shadow of life, and the human instinct and intelligence bestowed upon this shadow create in it that essence of life and light which is so priceless in a picture.

Anne Thackeray Ritchie, *Lord Tennyson and his Friends*

Julia Margaret Cameron created images that were studies not only of the life poetic but also of the photographic medium itself. Through her portraiture, she began to refine her craft and worked to make photography relevant not just as a means of recording a subject or a moment in time, but also as a viable art form and a way of better accessing the transcendent qualities of beauty, sorrow and sublimity. Her efforts to 'ennoble photography' compelled her significant study of old master paintings, especially those of the Italian and Northern Renaissance.[1] Her exposure to the art works on display in the newly forming collections at the National Gallery and the South Kensington Museum in London, and that of Lord Overstone, as well as through the printmaking of the Arundel Society, made it possible for Cameron's portraiture and poetic illustrations to resonate with allusions to the traditional 'high art' of painting. Her own writing about portraiture not only indicates an appreciation for the act of artistic creation,

Mrs Herbert Duckworth / Julia Jackson, 1867 (detail of plate 76).

but also gives voice to her beliefs about the beautiful and the sublime. Words like 'evocation', 'distillation', 'essential' and 'embodiment', which all appeared in her letters and prose, suggest Cameron's process when engaged in her portrait work, which she seemed to understand from the perspective of one who had spent a good deal of her time looking carefully before she ever picked up a camera. That she seems to have taken dozens of shots before producing one she could describe as 'successful' in 1864 proves that she had cultivated an artistic eye, informed by the principles of fine art and good picture-making, and was thus critical of her first attempts at photography. Cameron's portraiture and illustrative work indicate the seriousness of purpose and the poetic resonances she found in 'painting' with light. She was a self-consciously artistic photographer, perhaps not the first but undoubtedly one of the earliest and most successful.

Selective focus: a further meditation on the sublime

Cameron repeatedly wrote below her photographs that they had been taken '*from* the Life', and in doing so affirmed that, as much as she was recording an individual life, so was she also seeking to capture the animating principle of life in general, which had invested light, shadow and a certain character into

the subject posed before her lens. In this, her work was not just 'from life' but 'true to life', a tribute to the complexities of human existence that afforded her such compelling subject matter. She was also exploring through her photography certain aspects of the sublime as part of her broader pursuit of beauty. Charles Cameron's 1835 essay on the subject provided an early context that influenced Cameron as she consciously and unconsciously built an aesthetic framework for her future photographic endeavours. It was an appreciation for the beautiful and sublime, rooted in eighteenth-century discourse, that also elevated sorrow and suited well Cameron's interest in understanding beauty as nuanced by loss, the passing of time and the mysterious unknowns available in a human face. While artists and authors of the Romantic period associated the sublime primarily with nature and its grandeur, Cameron offers her own interpretation of the subject as no less awe-inspiring, but significantly altered to include a kind of tranquil sorrow, one that could be expressed photographically through the use of 'beautiful shadows' and softened focus.[2] Cameron understood the potential for photography to aid in her pursuit of this beauty, much as William Henry Fox Talbot must have when he patented the photograph in 1841 as the calotype, a word whose origin is *kalos*, the Greek word for 'beautiful'.

If we are to take Cameron's poem 'On a Portrait' as indicative of her aesthetic philosophy and a reflection on her approach to photography, we find an interesting and active language of pursuit. The artist is to turn their attention to the quest for the 'key-note', a journey imbued with sorrow hidden just beneath the surface, a theme Tennyson also considered in much of his

poetry. It seems that, for Cameron, the sublime could be explored as that which is unknown, discomforting but potent in its potential to suggest what is just beyond the edges of a frame or behind the heavy-lidded eyes of a subject. Additionally, sorrow and loss, especially associated with love or an unexpected death, function as elements of the sublime, hence the warning in Cameron's poem to 'Ask not my story, lest you hear at length / Of sorrows where sweet hope has lost its way'. The 'curve' of sorrow described by Charles Cameron gives a beautiful arc to life despite its inherent suffering and finds its way compositionally into Cameron's photographs. It is this sensibility that defines Cameron's aesthetic of sorrow.

The power of the sublime and of the beautiful for Cameron also seems to find affinity with the idea of mystery, the ineffable or the inexpressible. It is in this sense that we find further affinities with Tennyson and an explanation for why she would find his poetry a provocative and challenging subject for her late photographic enterprise. The poet's exploration of the sublime would have been known to Cameron through his early poem, 'The Kraken', published as a part of *Poems, Chiefly Lyrical* in 1830. The sonnet introduces the notion of the sublime as a leviathan-like creature that exists just below the surface of the visible world and is significant as an early example of Tennyson's capacity to engage with mythological, classical, biblical and scientific material to powerful effect. It has also been described as an exploration of the deep self. The notion of the sublime presented in Tennyson's writings is important in ways akin to Cameron's treatment of the subject in her photography, especially her persistent

attempts to realize visually the interior (deep) emotional self in her photographs.

The power of the sublime, as described in 'The Kraken', was in its hiddenness; a presence felt but perilously at risk since once exposed, it would die.[3] The invisible presence of the sublime may be what leaves such an impression upon viewers of Cameron's work.[4] She capitalizes on the capacity of her medium to make visible the real as it exists before her lens, but at the same time infuses her most successful images with a sense of that which exists just below the surface. Julian Cox writes that, when she 'threw herself into its [photography] practice, she was immediately and obsessively consumed by the powers of its black magic'.[5] Although the photographic process is its own kind of scientific mystery, for Cameron, the real magic in her art exists quite apart from any chemical transformation. Her success as a photographer is not only evident in what she makes manifest in print, but also in what she suggests exists just beyond the frame or beneath the surface, aspects only hinted at in her treatment of light and shadow, use of focus, choice of subject or inclusion of descriptive titles or poetic fragments on her photographic mounts. In these aspects of her work, Cameron is very much an early Symbolist, concerned less with the descriptive than with the suggestive.

Cameron intuitively understood that, if she allowed everything to appear in her photographs, not only would she undermine her efforts to elevate photography to an art form but she would also expose the sublime 'to the air' and, in doing so, dissipate its aesthetic impact. W.J.T Mitchell reminds us that 'obscurity is sublime [for Burke] precisely because it is a frustration of the power of vision'.[6] For Cameron, this frustration of vision is particularly generative. The unseen (or unclear), and with it the 'mystery of beauty … secret, swift, and subtle', is evident in Cameron's photographs through the preoccupied gaze in Herschel's unfocused eyes and in our curious willingness to accept Taylor, Worsley and King Arthur as types of Christ figures, especially Christ as the Man of Sorrows (plates 77, 34, 80, 71).[7] It is evident too in the sorrowful visualization of sonnets, in the persistent appearance of 'Death in Life', of memory and of the unrelenting passage of time photographically realized in her illustrations of Tennyson's verse. We also recognize it in the iconic betrayer Iago, in the pathos of Ophelia brought fully 'to Life' in a portrait that nearly escapes the frame, in the disarming gaze of Julia Jackson, in which the viewer is placed firmly in the role of the observed, and in the universalized pose of the Holy Mother Mary (plates 79, 74, 76, 89). Cameron's single and double portraits of children uncommonly gaze unswervingly at the viewer, daring us to recognize in them something not altogether childlike, even if their youthful innocence also invades the picture plane. In her photograph titled *The Return after three days*, the young Freddy Gould as Christ is the only figure in relative focus (plate 90). That selective focus, coupled with his direct engagement with the camera, results in an astonishing image that forces the viewer to contend with the fleshliness of both the incarnation and resurrection narratives, as well as their respective impossibility.

In her photography, especially in select portraiture and in the *Illustrations*, Cameron exercises the very particular strengths of her medium to present the mystery of beauty as both visible and invisible.

She chose to work in a medium that, by its very nature, was a combination of the real subject and the idea it represented. It was an evocative process, with the image seeming to mysteriously appear, rising to the surface through the developer. Cameron did not accept the perceived limits of nineteenth-century photography. At the risk of sharp criticism, she consistently chose to make visible only those aspects of a work necessary to ground an image, while at the same time invoking a sense of the unseen through diffuse lighting and soft focus. As an artist, Cameron also understood the compositional impetus of balancing negative and positive space, of adjusting light and compressing the visual field to dramatic effect. In this, her capacity to handle her camera and to focus selectively and with intention is, effectively, her meditation on the beautiful and the sublime.

Again, the words of Tennyson help to further elucidate the effectiveness of Cameron's approach to photography. In his work *Ulysses*, he writes of the 'untravell'd world whose margin fades' as the Homeric hero engages in his own quest.[8] The language of imprecise boundaries and unseen worlds accurately describes the technical and aesthetic choices made by Cameron as she worked through the challenges of her medium. There was visual impact to be had by softening lines and there was ideology to explore by suggesting that even in photography, a medium celebrated for its precision, the potential for an exploration of the unseen and of mystery was open. Arguably, the practice of nineteenth-century photography was still highly experimental, complicated and demanding. She sought counsel and mentorship from other photographers and

artists and exposed herself to other forms of art, visual and written, to strengthen her capacities behind the lens. Cameron also understood the art of reflective observation and, in doing so, was eventually capable of representing photographically what was in fact unseen. If ever her photography could be described as avant-garde, it is because of the way she pushed the conventional boundaries of the medium and appeared to appreciate its theoretical potential, including both its indexical qualities and its capacity to trouble the notion of a 'real' world.[9]

Cameron produced photographs that suggest she was capable and competent at producing highly clinical photographs when she wished to, as well as studio shots and images suitable for the popular *carte de visite* format. However, in her maturation as an artist she produces portraits of the kind held by the Bodleian Library and Ashmolean Museum, along with images of women and children, exploring a range of typologies related to legendary literary, biblical and classical themes with her characteristic use of focus and softened lines. She uses selective focus well and compels the viewer's attention through manipulating her sources of light effectively and allowing shadow to play its part in equal measure. This visual dissonance, originating with her capacity to deploy such necessary opposites, vivifies her photography with all manner of suggestive possibility. Thus, what was merely suggested, or signified, was as important to the success of the image as the literal subject held within the photographic frame.

At a time when photography was hailed as an exemplar of scientific ingenuity and celebrated for its capacity to describe the visible world, Cameron

was exploring the artistic potential available through this practice of selective focus before it was named as such. In this, she was far more than a pioneering photographer; she was an innovative and visionary artist. Where many of her contemporaries celebrated the limits of photography and hemmed it in with definitions and codes of appropriate practice, she was pushing the medium to significant effect. That she did so in the face of harsh criticism by her photographic peers makes it more noteworthy.[10] Cameron held fast to the belief that this new medium had the potential to 'arrest beauty', fixing it in time just as hyposulphite fixed the image on her large glass-plate negatives. She is among the most influential of the early photographers who explored the artistic potential of the medium, aiming to shift its practice and aesthetics such that it might secure the status of high art and pave the way for a new generation of photographers for whom the symbolic and poetic became imperative.[11]

Cameron appreciated that the study and use of formalist strategies in her art-making would contribute to its success. But, as Emerson remarked, 'there is a poetry of photography, as there is for painting and literature', and the subject or '*motif* must be poetically rendered' and she, perhaps more so than her contemporaries, actively pursued the poetic potential available in photographic portraiture and illustration.[12]

The human face was a repository of lived experience as well as the outward expression of private thoughts and interior selves; the portrait affixed in time the 'real' self, as well its typological and symbolic potential. In her illustrative work, Cameron treated poetic themes related to the human condition, including love and death, gender complementarity and the melancholy associated with the passing of time. In Cameron's hands, photography was the best medium for the pursuit of the poetic, with its power of suggestion through softened focus, economy of detail and dependence on light and shadow. Like no other artistic medium, it blurred the lines between the real and the ideal, made present the absent and memorialized the transient. She understood intuitively that a great photograph was predicated on bringing forth the 'beautiful shadows', both literally and figuratively.[13] Cameron's photography, at its best, was a form of poetry that afforded her the opportunity to 'write with light', tracing the most poetic aspects of her subject across the hypo-covered plate, much as her artistic mentor Watts painted poems on canvas. For Julia Margaret Cameron, photography was a 'mortal, but yet divine! art', located in the material and capable of 'arresting' all beauty while pointing towards the transcendent.[14] Like life, it was messy, it was mysterious and it was poetic.

Plates

PLATE 1

Alethea (Alice Liddell), 1872

Albumen print, 31.8 × 22.4 cm oval
Ashmolean Museum, Oxford, WA2009.177

Towards the later period of her photographic career, Cameron concentrated her attention on women subjects taken from classical mythology and representing the female heroic mode. Among them were images such as this, in which the twenty-year-old Alice Liddell poses as Alethea, a name derived from the Greek word for truth. Liddell also posed in the same year as Pomona, the Roman goddess of fruitfulness and protector of gardens and orchards. Cameron titled images after Aurora, goddess of the dawn, and Ceres, goddess of the harvest. She also produced images of Zoe, heroine of the Greek War of Independence in 1822; Zenobia, queen of Palmyra in the third century CE, who fought against Roman imperialism; Boadicea, the first-century warrior queen of the Iceni tribe in Britain; and a series of images of the classic Sibyls and the Three Graces. She also dedicated three photographs to Sappho, considered one of the greatest lyrical poets of classical Greece, whose verse often took as its subject the love and friendship between women (plate 86; fig. 24). Alongside these subjects are those from biblical narratives, including the tragic heroine Rachel, Rebecca at the well, and Cameron's many photographs of the Virgin Mary and Mary Magdalene. Eventually, she would add to this pantheon of female heroic subjects those from the Arthurian legends as re-presented in her photographic illustrations of Alfred Tennyson's epic poem *Idylls of the King*.

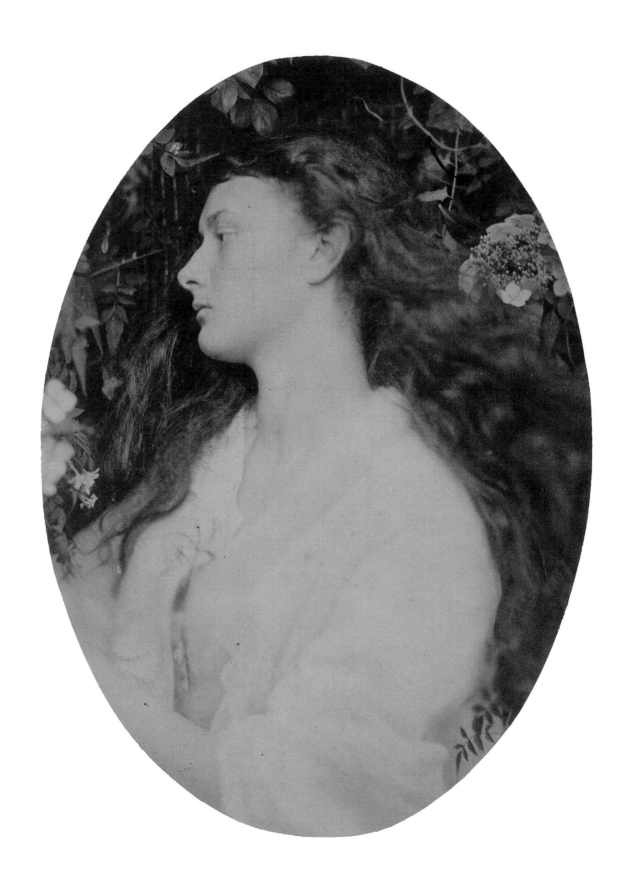

PLATE 2

Charles Hay Cameron, 1864

Albumen print, 25.4 × 19.7 cm
Oxford, Bodleian Library, Arch. K b.12, fol. 44r

The Camerons enjoyed a long, steadfast marriage and Julia's husband, Charles, supported her efforts in photography, posing for her on several occasions. He became reclusive in later life, largely because of his failing health, and separated himself from the commotion of daily life in their home. But, from the beginning, theirs was a partnership built on shared intellectual pursuits, a love of beauty and an abiding respect for one another. Early in their marriage Julia wrote a prayer where she expressed not only the anticipated joys and anxieties of her first pregnancy but also how much she loved Charles and feared for his spiritual well-being.[1] If there was one area where the two remained disparate, it was concerning religion. Charles, like many men of his generation, including Henry Taylor and Alfred Tennyson, wrestled with questions of faith given recent discoveries by Charles Darwin and the significant shifts occurring within the structure of the Anglican Church. Julia's Christianity remained strong and reinforced her devotion to family and friends. But neither was dogmatic in their beliefs and together they approached questions of faith with openness.

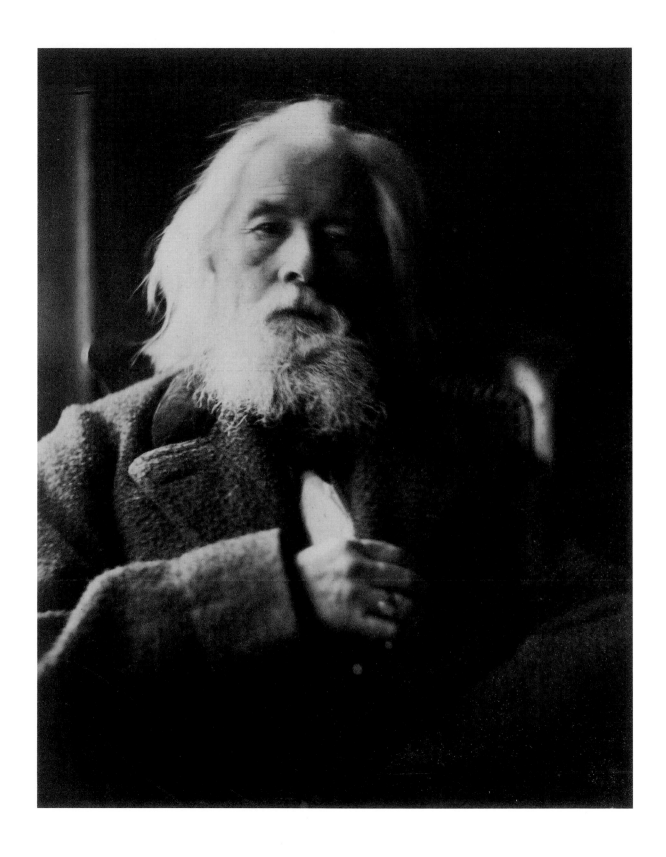

PLATE 3

Annie (Annie Philpot), 1864

Inscription: 'My first success'
Albumen print, 19.1 × 13.5 cm
Oxford, Bodleian Library, Arch. K b.12, fol. 20v

Cameron's first camera held a French Jamin lens with an aperture of f3.6 and focal length of 12 inches, while her second camera was fitted with a Rapid Rectilinear Dallmayer lens. Its aperture was an f8, while its focal length was significantly longer at 30 inches. This second lens allowed her greater depth of field and more control in focusing on her subject. However, early photographic processes required extended exposure times and presented challenges that we no longer face today, making her images even more remarkable. There was significant discussion of Cameron's work by her contemporaries, though admittedly much was levelled as criticism, most especially of her selective softening of focus. Nonetheless, in the work of photographers just after Cameron, we find evidence of her legacy. The British photographer Peter Henry Emerson praised her intentionality of craft and pursuit of beauty, and the American Pictorialist photographer Alvin Langdon Coburn likewise acknowledged the significance of her efforts. Emerson's highly technical description of her working method deserves to be cited in full:

> The 'Jamin' working at F/6 had no small diaphragms, abominations introduced later on by a scientist and invaluable to such a one, but utterly *useless* to the artist – nay fatal, as I have proved scientifically. In addition, though the image appeared sharp on the screen, owing to the positive chromatic aberration, the picture would be out of focus when taken. It was therefore *impossible* for Mrs Cameron to get what is technically known as the 'sharpest focus'. Still, having learnt from this experience, in years after she did not work with the sharpest focus obtainable with the Rapid Rectilinear Lens. Having produced out-of-focus results at first by accident, she was artist enough, and so well advised, that she determined to imitate that effect; a determination fulfilled later on when she became possessed of an 18 by 22 Dallmeyer Rapid Rectilinear Lens – one of the triumphs of Photographic Optics. She used this lens at large aperture, so that her son, an experienced photographer, says it is almost impossible to distinguish the pictures taken with the two instruments as regards the quality of focus – but this I think an error. All her work was taken direct, indeed she claimed that as a merit, and she was right. Enlargements, as I first pointed out, are false in many elemental qualities. Mrs Cameron gave very long exposures, ranging in duration from one to five minutes. This method was brought up against her as a matter of raillery by jealous craftsmen. Unable, with all their appliances, to produce work comparable to hers, the photographers of commerce sought every pretext to belittle her pictures, but all in vain, for many of them possess those undying qualities of art which artists immediately recognized, and after all it is in their hands that the final judgment in such matters rests. All that can be said against her is that she used too short a focus lens for her 15 by 12 plates.[2]

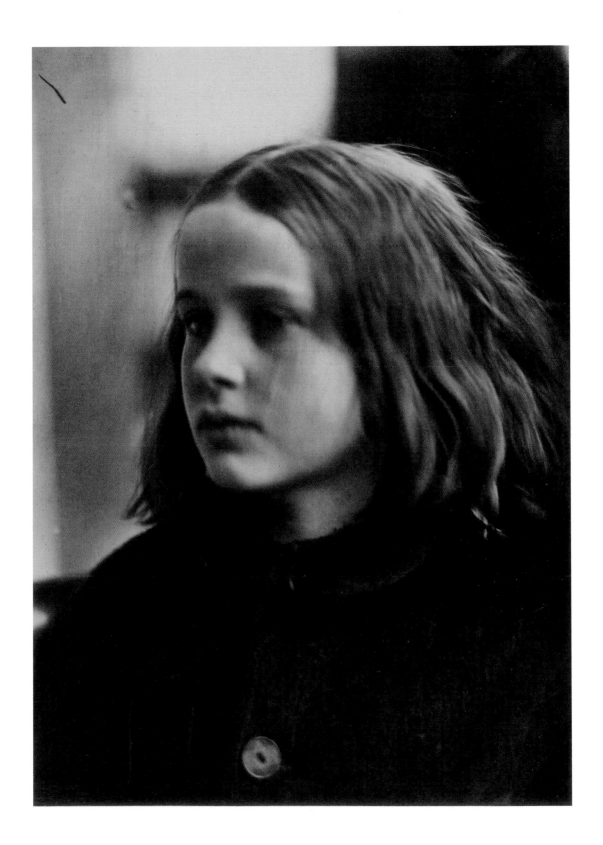

Seraphim and Cherubim (Elizabeth Keown and Freddy Gould), 1864

Albumen print, 12.4 × 9.4 cm
Oxford, Bodleian Library, Arch. K b.12, fol. 25r

Katey (Katey Keown), 1865

Albumen print, 18.0 × 13.5 cm
Oxford, Bodleian Library, Arch. K b.12, fol. 45v

In the early twentieth century, the American photographer Alfred Stieglitz (1864–1946) paid homage to Cameron by publishing select images by her in his journal Camera Work; he also owned a collection of her photographs, including portraits of Ellen Terry, Alfred Tennyson, G.F. Watts, Robert Browning, Thomas Carlyle and Julia Stephen (née Jackson), Cameron's niece and Virginia Woolf's mother.[3] Stieglitz's collection ultimately came into the possession of the American artist Georgia O'Keefe, who later gifted Cameron's photographs to the Art Institute of Chicago, along with a veritable who's who of British and American photography including work by Octavius Hill and Robert Adamson, James Craig Annan, F. Holland Day, Gertrude Käsebier, Heinrich Kühn, Edward Steichen, Paul Strand and Ansel Adams.[4]

By the time she declared the photograph of Annie Philpot her 'first success', Cameron had taken hundreds of images to master her medium and advance its potential. The photographs that followed in rapid succession evidence not only increasing mastery but an intentionality of craft that she would later detail in her brief autobiography 'Annals of my Glass House'.[5] From *Annie* to *The Double Star*, we see Cameron not only making informed aesthetic choices in her photographs but proving her capacity to successfully deploy the principal methods of her medium including the mastery of light, focus, composition and, indeed, trial and error.

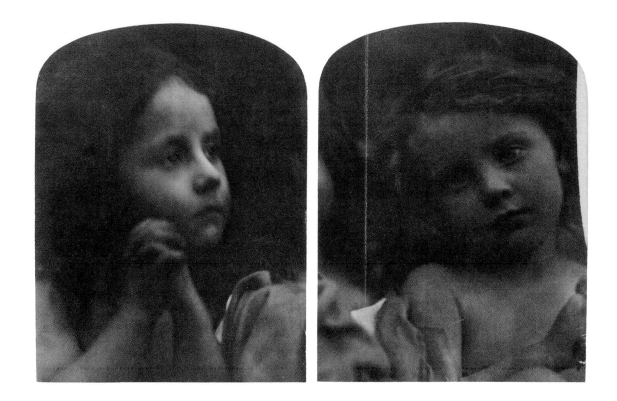

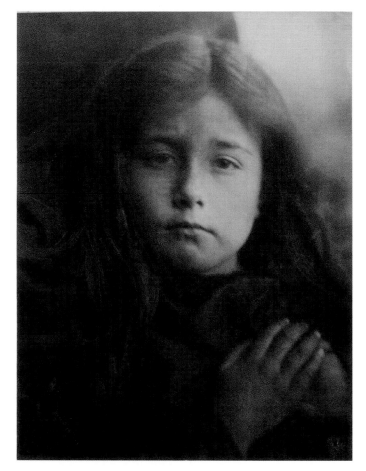

PLATE 6

The Anniversary (Elizabeth Keown), 1865

Albumen print, 26.5 × 21 cm
Oxford, Bodleian Library, Arch. K b.12, fol. 76v

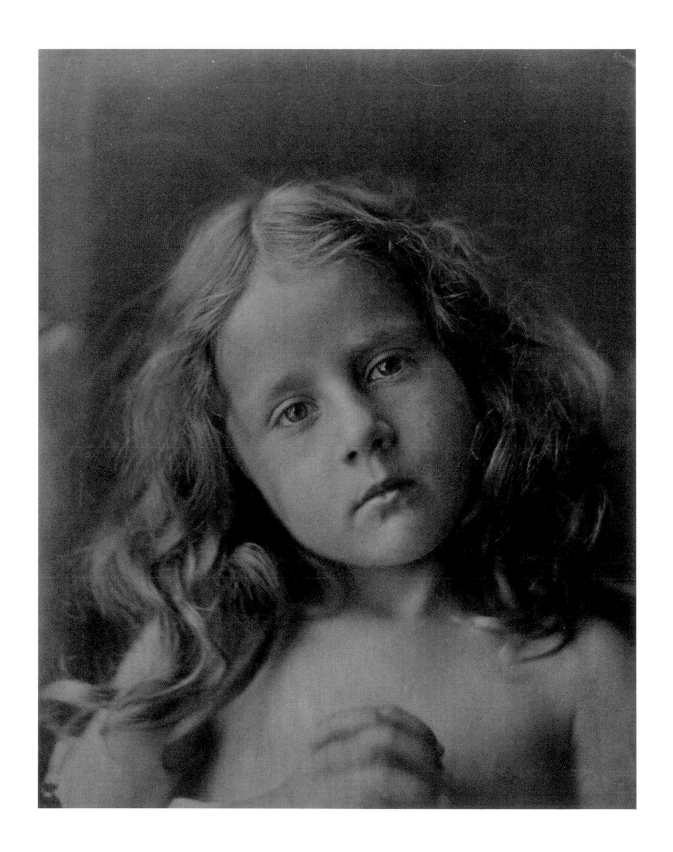

PLATE 7

Julia Jackson, *c.*1864

Albumen print, 25.3 × 19.7 cm
Oxford, Bodleian Library, Arch. K b.12, fol. 70v

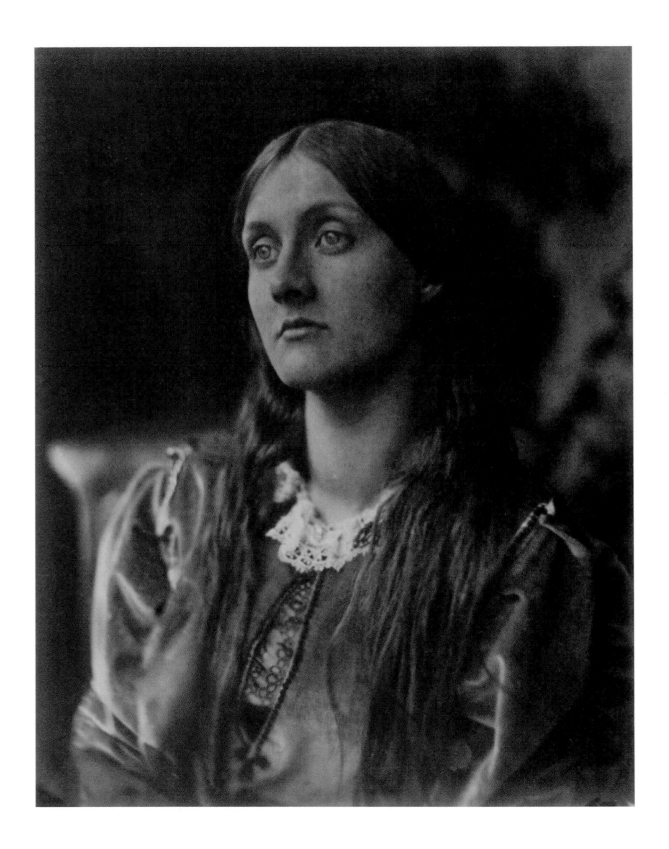

The Kiss of Peace, 1869

Albumen print, 13 × 9.5 cm
Oxford, Bodleian Library, MS.photogr. d. 10, fol. 70v.

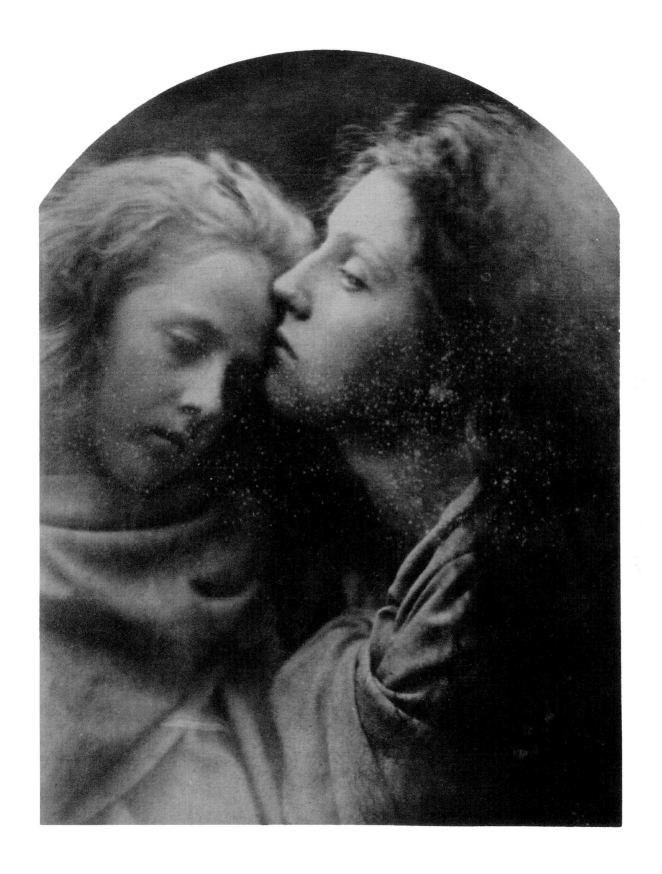

PLATE 9

A Story of the Heavens (Freddy Gould and Elizabeth Keown), 1866

Albumen print, 14 × 18.5 cm
Oxford, Bodleian Library, Arch. K b.12, fol. 21r

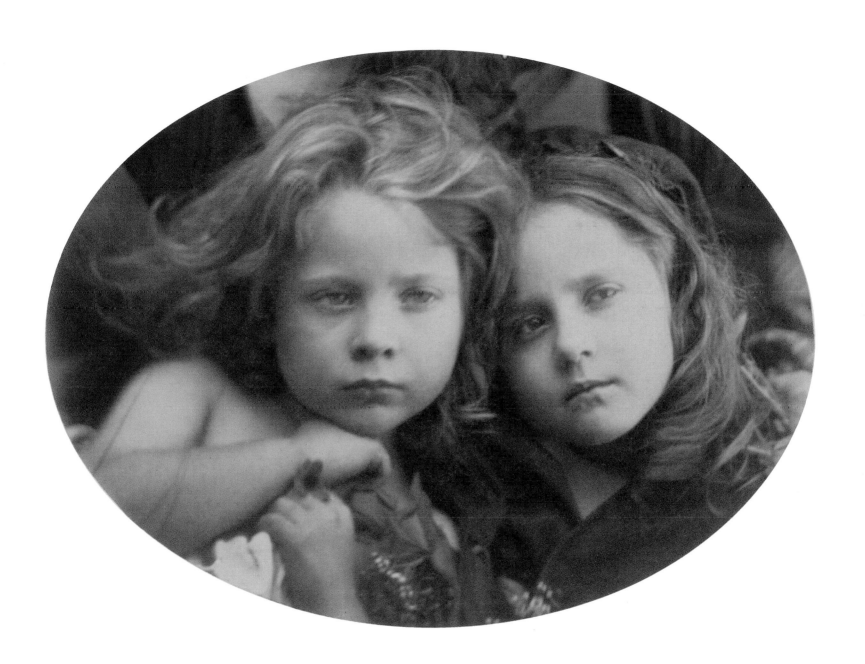

PLATE 10

Iolande and Floss (Mary Ann Hillier and Kate Dore), 1864

Albumen print, 23.1 × 19.5 cm
Oxford, Bodleian Library, Arch. K b.12, fol. 35v

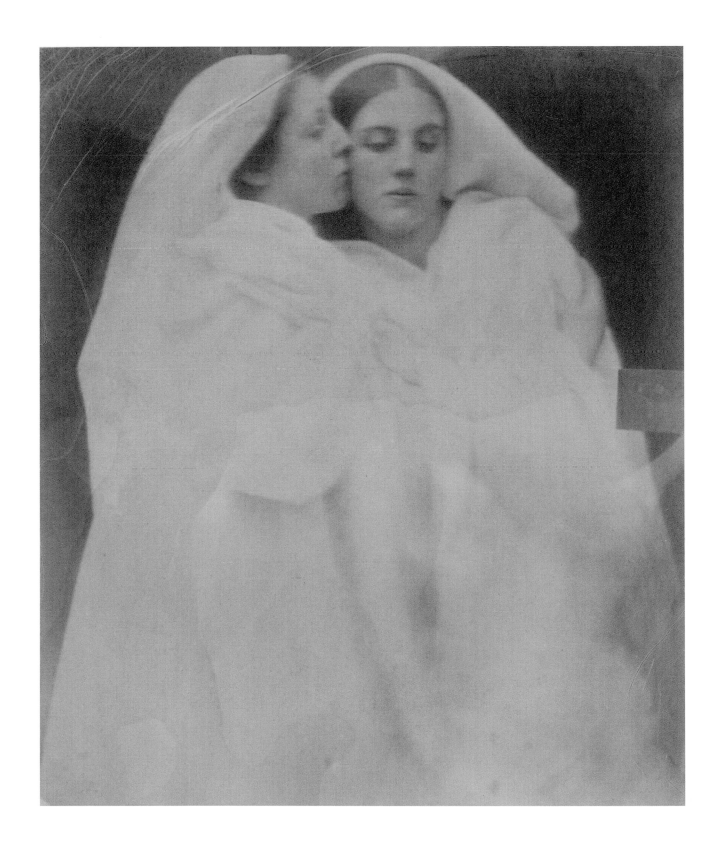

PLATE 11

The Double Star (Alice Keown and Elizabeth Keown), 1864

Albumen print, 25.4 × 19.7 cm
Oxford, Bodleian Library, Arch. K b.12, fol. 58v

Fig. 1
James Mudd or Joseph Cundall (?), *Portrait of Alfred, Lord Tennyson
seated with a book, his wide-awake hat on his knee,* 1857–8
Albumen print, 24 × 25.5 cm
Oxford, Bodleian Library, 17072 a. 7/2, fol. 50r

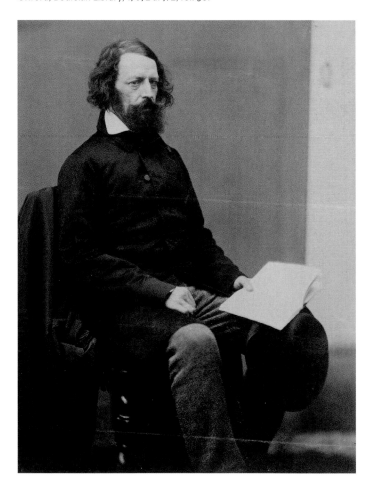

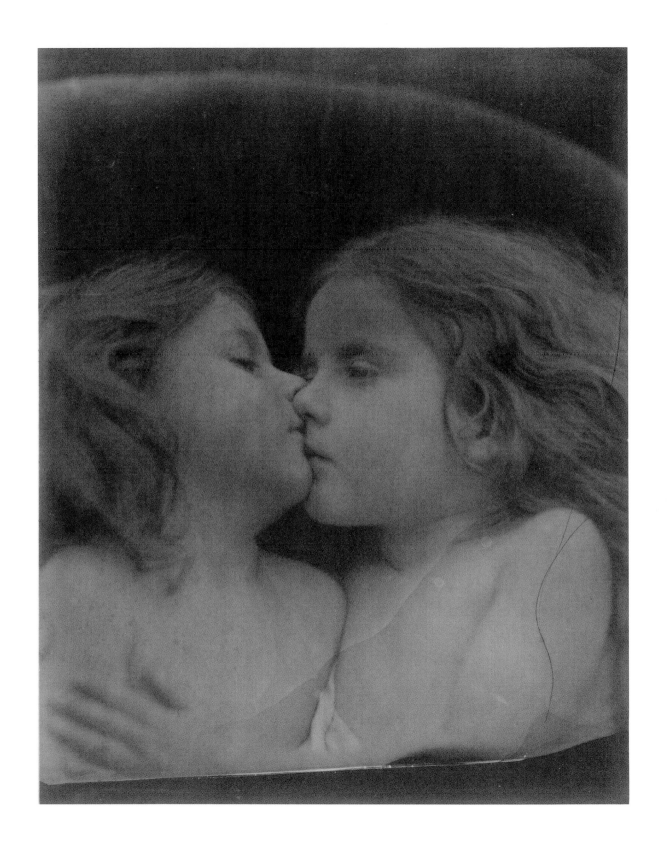

PLATE 12

Henry Taylor, 10 October 1867

Albumen print, 34.4 × 26.7 cm
Ashmolean Museum, Oxford, WA.OA1346

The author and statesman Henry Taylor was one of the most frequently photographed subjects in Cameron's entire body of work. Among the Ashmolean Museum's collection is this 1867 portrait, which illustrates the photographer's ability to capture the essence of her sitter. Here Taylor faces the viewer directly and, while he remains unsmiling, the softening of focus, his tipped head, poet-like cap and more casual pose suggests a less formal side to the poet, dramatist and public servant. Cameron's use of focus allowed her to achieve the photographic equivalent of painterliness, a term afforded to artists who loosened their control of form and line by using gradations in tone, broad brushstrokes and surface manipulation. In the same year, Cameron produced another portrait of Taylor (plate 13). It proves her competence with expedient use of lighting and what, in contemporary photographic practice, was referred to as the three-quarter pose, known to enhance the overall beauty and proportion of the face. The inscription is also significant and associates this image with one of the great masters of portrait painting and of chiaroscuro. Cameron makes an interesting correlation between the work of a photographer and that of a painter, one that is well substantiated by a portrait that is Rembrandtesque in lighting and overall effect. It also exemplifies Cameron's use of titles and inscriptions to evoke old master artists; Taylor is hence transmuted into a figure who is more than himself, and the 'real' of the sitter is overlaid with the ideal of fine art.

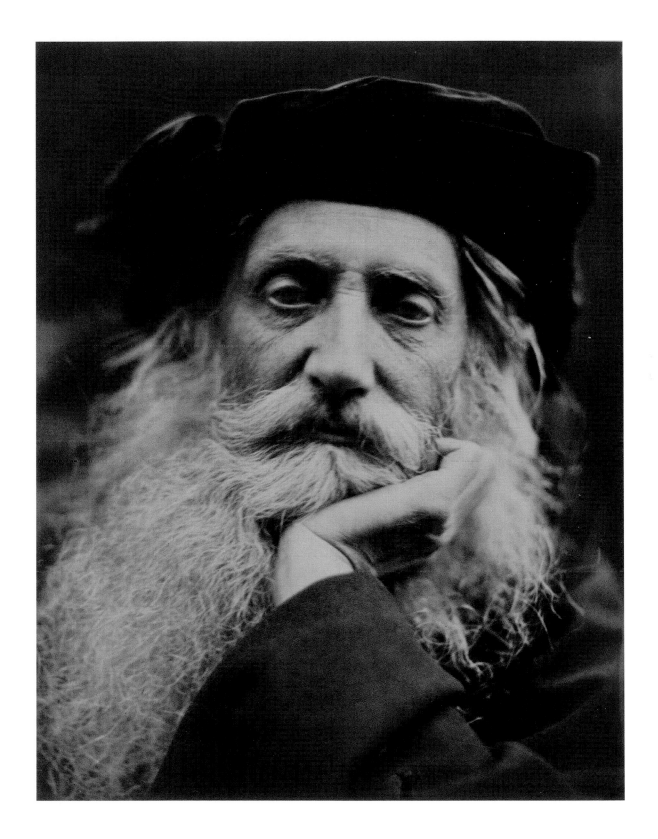

PLATE 13

Sir Henry Taylor, 1867

Inscription: 'A Rembrandt'
Albumen print, 26.7 × 24.9 cm
Getty Museum, Los Angeles

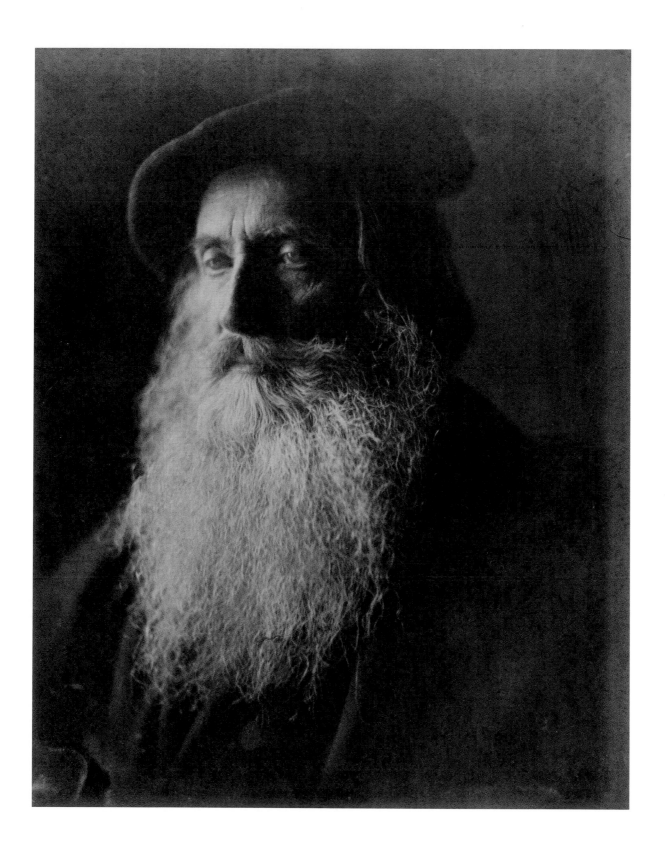

PLATE 14

Henry Taylor, 1867

Albumen print, 31.4 × 24.9 cm
Oxford, Bodleian Library, Arch. K b.12, fol. 1or

In another 1867 portrait, Taylor is positioned
further back in the frame, with the lines of the subtle
background and the draping of his nondescript garment
anchoring him at the centre of the image. Taylor's
clasped hands with their elegant fingers are the key
feature of the image, both in their compositional
centrality and sharpness of focus. They prop up his chin
in a pose that, again, has him facing the viewer. His hair
is slightly unkempt and his beard, acquired over many
years, frames his aged face.[6] There is pensive sensibility
about this picture, particularly given Taylor's hazy eyes.
The pupil of the right eye is entirely shadowed, and both
seem to look slightly askance rather than directly at the
onlooker, despite his pose. This distances him from the
viewer while reinforcing his serious disposition, perhaps
an appropriate sentiment for the author of *The Statesman*,
a controversial satirical essay about the inner workings
of the civil service.

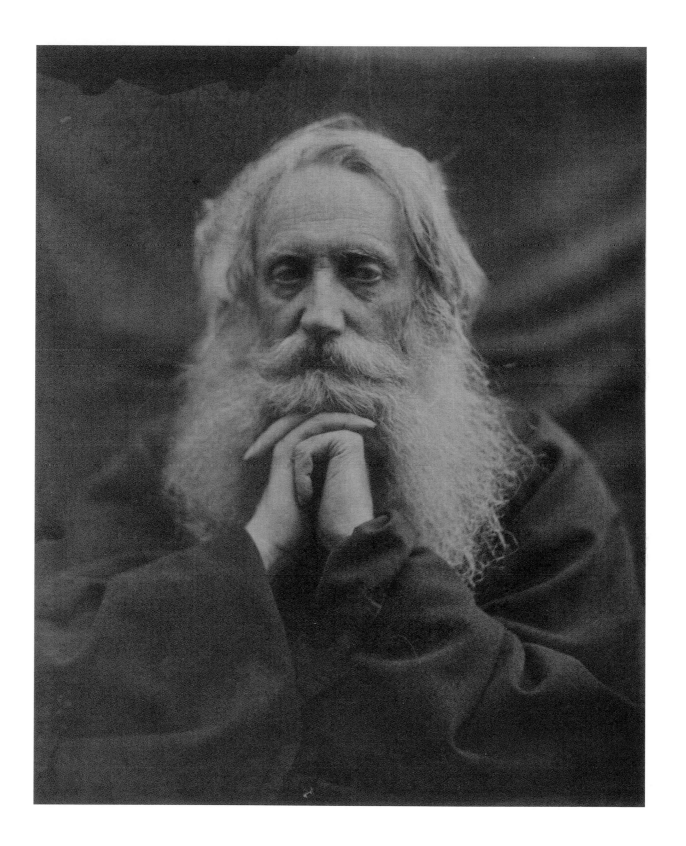

PLATE 15

Henry Taylor, 1864

Albumen print, 25.2 × 20.1 cm
Oxford, Bodleian Library, Arch. K b.12, fol. 12r

Many of the photographs of Taylor in the Bodleian Library's collection are from Cameron's earliest period of production, which makes them even more interesting in their effect.[7] Among the 112 images in the library's collection are images by other photographers who influenced Cameron's early work. These include two portraits of Taylor, both traditional in their pose and currently attributed to Cameron's photographic contemporary, Oscar G. Rejlander (plates 16, 17).[8] By this time an established portrait photographer, Rejlander was pushing his photography towards 'fancy' subjects, drawing upon his previous background in the theatre. Cameron also produced 'fancy pictures', a term commonly used to categorize allegorical or narrative pictures with demonstrable theatricality. However, Rejlander's portraits of Taylor here are sedate and straightforward. An early portrait of Taylor by Cameron, made in 1864, takes its inspiration from Rejlander. Taylor sits in a similar attitude, in full profile, the bulk of his upper body filling the lower left corner of the image and his hands clasped. Unlike Rejlander's portraits, however, hers shows him in a more relaxed pose; he appears to clasp his hands around his left knee, drawn up towards his chest in a fairly modern pose. Taylor's slightly unkempt hair draws the sharpest focus while his facial features and the background remain hazy. She has cut her composition in half, with a clear diagonal line created by the solid black tones of the lower left in contrast to the lighter, more detailed upper right. Regardless of whether this effect was intentional or the result of her initial technical experimentation, the portrait is an early example of the aesthetic direction her photography would take with its blurred lines, minimal detail and chromatic progression from dark to light.

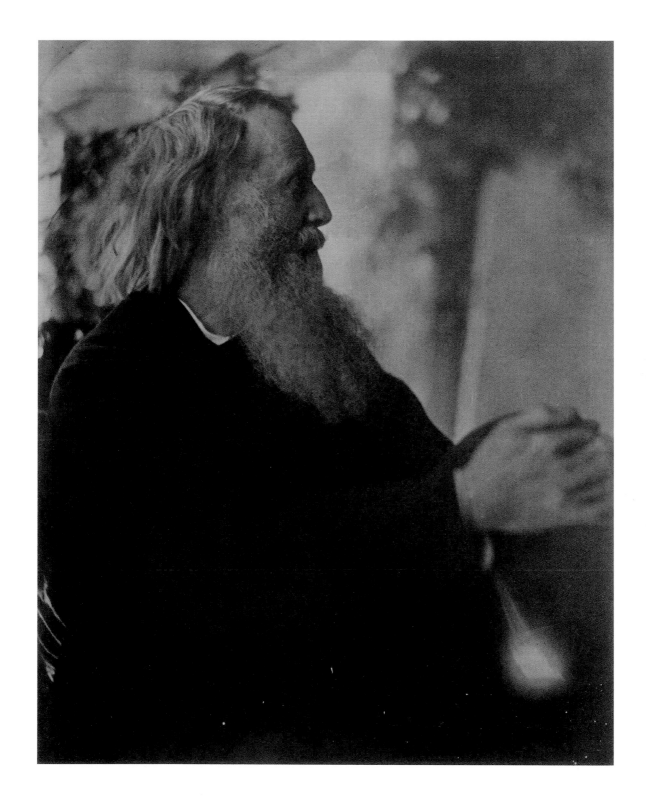

PLATE 16

Henry Taylor, 1862

Unknown photographer (attributed to Oscar G. Rejlander)
Albumen print, 21 × 14.9 cm
Oxford, Bodleian Library, Arch. K b.12, fol. 14r

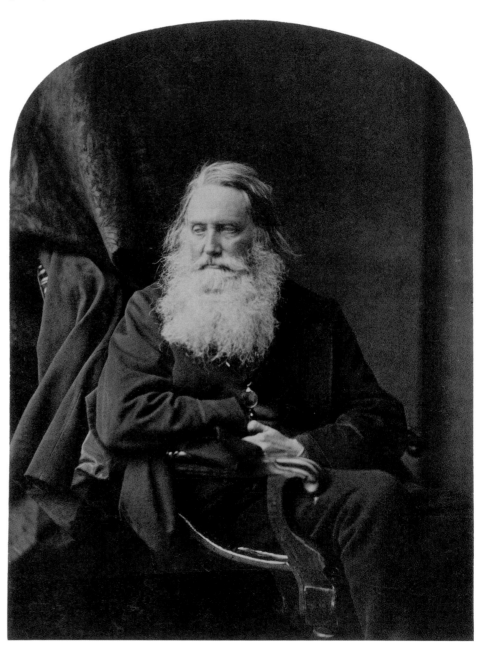

Henry Taylor, 1862

Unknown photographer (attributed to Oscar G. Rejlander)
Albumen print, 18.3 × 12 cm
Oxford, Bodleian Library, Arch. K b.12, fol. 15r

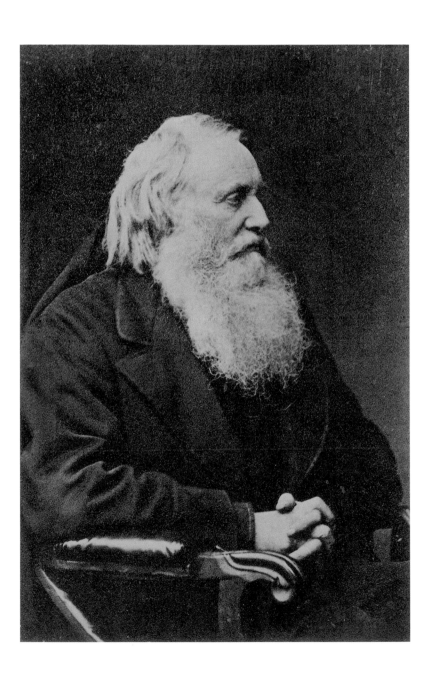

PLATE 18

Henry Taylor, April 1864

Albumen print, 19.1 × 17.3 cm
Oxford, Bodleian Library, Arch. K b.12, fol. 16r

In a disembodied portrait of Taylor taken in April 1864, there is a slightly sinister aspect about the image, achieved by eliminating any indication of his body or background detail. To date, this print appears to exist only in the Henry Taylor collection at the Bodleian Library. A ghostlike apparition, Taylor's head floats out of the black background and compels the viewer to question what Cameron saw in this manifestation of her subject. The painter G.F. Watts's portraits of Taylor achieve a similar effect. Cameron actually pleaded with Watts to paint a portrait of Taylor that 'should honour the Practical Poet and do him immortal honour – even as you have done immortal honour to our contemplative poet [Tennyson]'.[9] An evidently incomplete portrait by Watts is even more like Cameron's spectral portrait insofar as his head floats unattached and his visage is more troubling for its missing eyes (fig. 2). While both artists' portraits 'honour' Taylor on some level, it is Cameron's that function as studies of her subject, with his serious and aged countenance that sometimes verged on the foreboding.

Fig. 2
G.F. Watts, *Sir Henry Taylor*, 1865–70
Oil on canvas, 67 × 53 cm
Watts Gallery, Compton

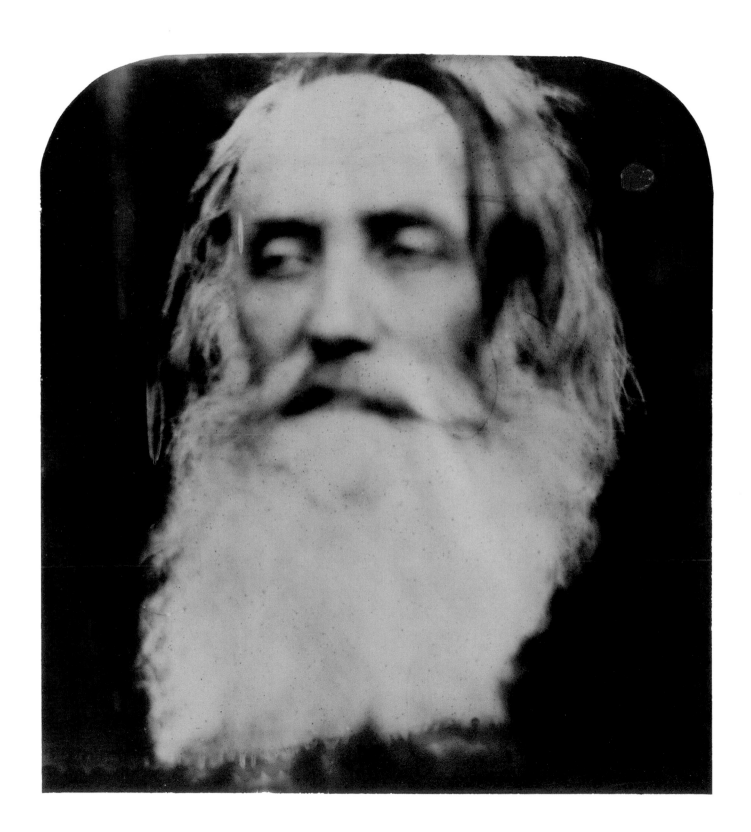

PLATE 19

Henry Taylor, 1864

Albumen print, 24.3 × 19.2 cm
Oxford, Bodleian Library, Arch. K b.12, fol. 47v

The next three portraits taken from the Taylor collection present an entirely different face of the poet and playwright (plates 19–21). All three were likely taken on the same day. In the first two, Cameron explores gradations of light and dark and the way they may be used to draw out important aspects of her subject. In the initial photograph, Taylor's hair and forehead are strongly lit; his head turned in three-quarter profile as he gazes down towards the left of the image (plate 19). A print of this image also appears in the Herschel album, and is inscribed by Cameron as 'Henry Taylor / Philip van Artevelde'.[10] She often referred to Taylor as 'Philip', the leading character in her favourite of his works. Her inscription suggests her association of him with the protagonist of the tragic drama that unfolds in his play *Philip van Artevelde* (1834), the result of nearly six years of labour, which effectively established his name as an English dramatist. The historical drama, Taylor's attempt at Elizabethan blank verse, takes as its subject the tragedy of the fourteenth-century Flemish leader van Artevelde, whose rise to power in the first act is followed by his downfall and death. Cameron admired the text and sent copies to Robert Browning and Matthew Arnold in the hopes of advancing the reception of Taylor's work.

The composition adds to the effect of the image, with Taylor's head carefully centred and little to distract from the details of his face. His eyes are open but heavy-lidded, a common motif throughout Cameron's photography, and associated with the mystical, contemplative and transpersonal.[11] The suggestive chiaroscuro and treatment of Taylor's eyes enhances a sense of the pensive in the poet whose creative intellect Cameron much admired. In the second print, Taylor maintains the same pose but is situated further back in the picture plane; Cameron also darkens the image and blurs its lines significantly (plate 20). Considered as a pair, they might suggest something of a development within her subject, a similar experiment undertaken in her portraits of Tennyson's Arthurian subjects. If the second portrait is also one of Taylor as Philip, which is not implausible given the similarities between the prints, he is represented here as the darker tragic figure whose public downfall leads to his death. The transition between the two portraits is subtle and, while it may have been an experiment with the depth of tone possible in her printing, the pair may also indicate Cameron's interest the capacity of photography to invoke a cast of mind or inward experience.

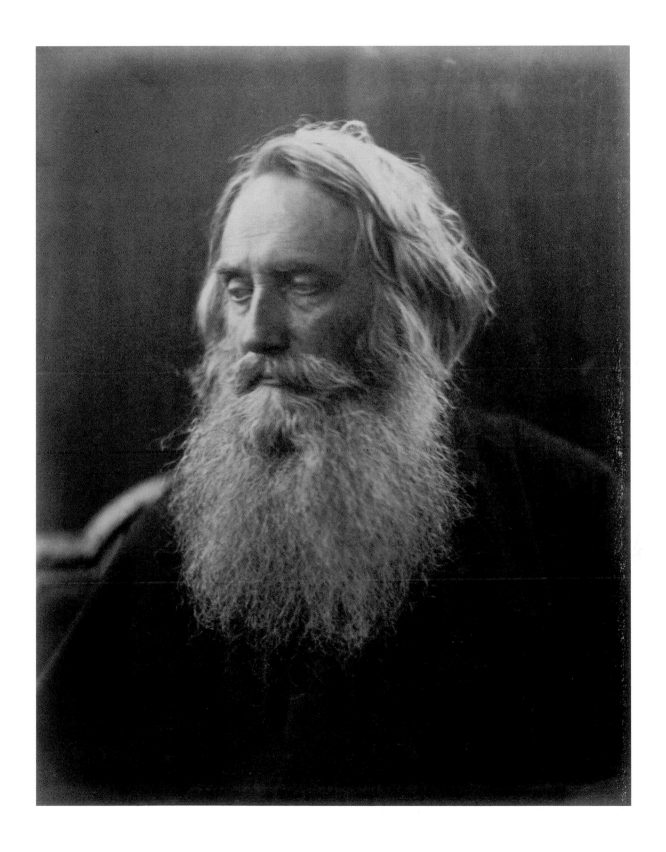

PLATE 20

Henry Taylor (No.1), 1864

Albumen print, 25.5 × 19.8 cm
Oxford, Bodleian Library, Arch. K b.12, fol. 8r

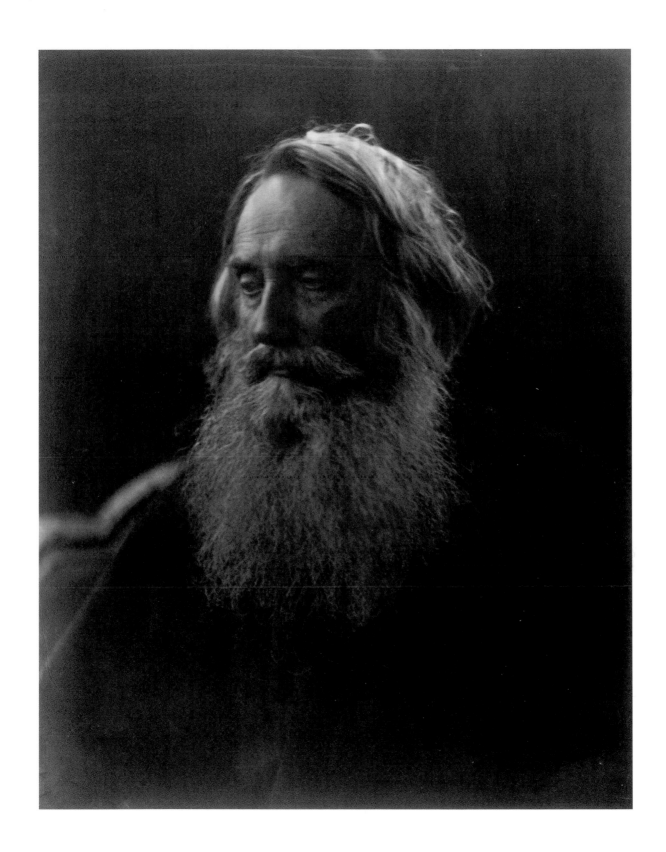

PLATE 21

Henry Taylor, 1864

Albumen print, 25.4 × 19.6 cm
Oxford, Bodleian Library, Arch. K b.12, fol. 6r

In the third image, Cameron once again uses a similar pose and lighting, though here Taylor looks down towards the right and is slightly off-centre. In all three portraits, she captures the horizontal creases that arch across his brow and the dark circles under his shrouded eyes, which reinforce the fatigued introspection and, possibly, sadness of age. His pose and expression have changed from the severity of the disembodied portrait to something more melancholic. In this, her photographs recall the slumped head and body of Christ as a Man of Sorrows, which Cameron would have known through works she encountered in the Overstone Collection and in publications from the 1857 Manchester Art Treasures Exhibition, including that of Guido Reni and Murillo.[12]

In the early portraits of Taylor, Cameron succeeds in representing aspects of the intellectual and creative capabilities of her sitter, with his serious, unyielding expression. Cameron's interest in the multiplicity of her subject finds expression in additional portraits that contain elements of the contemplative and melancholic figure who described wisdom as 'not the same with understanding, talents, capacity, ability, sagacity, sense of prudence … It is that exercise of the reason into which the heart enters – a structure of understanding rising out of the moral and spiritual nature'.[13] Within months of having first picked up her camera, Cameron produced large-format portraits of Taylor, which suggest an intuitive appreciation for her medium and an enhanced capacity to empathize with her subject. In the earliest phase of her career, she met G.F. Watts's artistic charge: 'A portrait should have in it something of the monumental; it is a summary of the life of the person, not a record of accidental position or arrangement of light and shadow. Even the most frivolous pass through dangers and sorrows; there is no living in a Garden of Eden, exempt from storms and vicissitudes.'[14] While Cameron sought the counsel of other photographers, her formal composition, use of light and softened lines and her portraiture provide evidence of a close study of the masters, including Rembrandt, and suggest from early on her capabilities as a fine-art photographer.

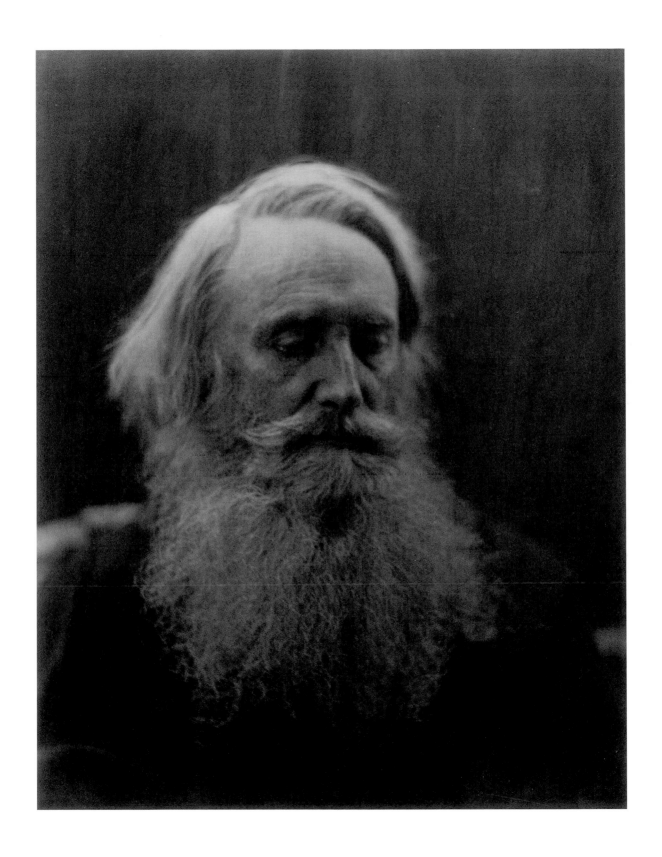

PLATE 22

H.T. Prinsep, 1865

(copyright 19 May 1865)
Albumen print, 25.4 × 19.6 cm
Oxford, Bodleian Library, Arch. K b.12, fol. 64r

Thoby Prinsep, the subject of the following two portraits, married Cameron's sister Sara, and with his wife built the artistic and literary ethos of Little Holland House, welcoming into their home various notables including Watts, who eventually made their home his permanent residence. The Prinseps' son Valentine ('Val') Cameron Prinsep was influenced by the Pre-Raphaelite artists who frequented his parents' home, and joined in their efforts painting the Arthurian-inspired murals of the Oxford Union. Val later became a leading artist of the Aesthetic Movement. In both portraits, Cameron employs a compositional technique that appears in images throughout the Taylor collection. The bearded and white-haired head of the retired statesman and successful businessman fills the upper left corner of the image; he is off-centre both vertically and horizontally. These diverge from those portraits by Cameron that were close-up, with the subject centred and facing the viewer directly, like those of Taylor (plates 12, 14) or Herschel (plate 24). By adjusting the compositional lines, placing her subject off-centre and using negative space as she does in these images of Prinsep, Cameron repositions the viewer while asserting a sense of the meditative through her subject's downcast head and eyes. Here Cameron also blurs the line between strict portraiture and a more typological treatment of her subject. The tilt of Prinsep's head, especially strong in the second image, bows as if in prayer, while the shock of white hair and nearly closed eyes recall aspects of a contemplative cleric or saintly figure. The barely visible white collar, echoed in the white of his cuff, further hints at the possibility of Prinsep being a man of the cloth, which he was not. He is swathed in nondescript, dark robes and holds a closed book in his left hand, which is more noticeable in the second image. Despite the absence of more obvious iconographic cues, the composition of images such as these, with their effective balancing of light and dark, along with negative and positive space, create an emotive effect, and move the interest away from the real subject in the portrait towards the suggestion of a private, interior experience alluded to through the prayer-like action taking place.

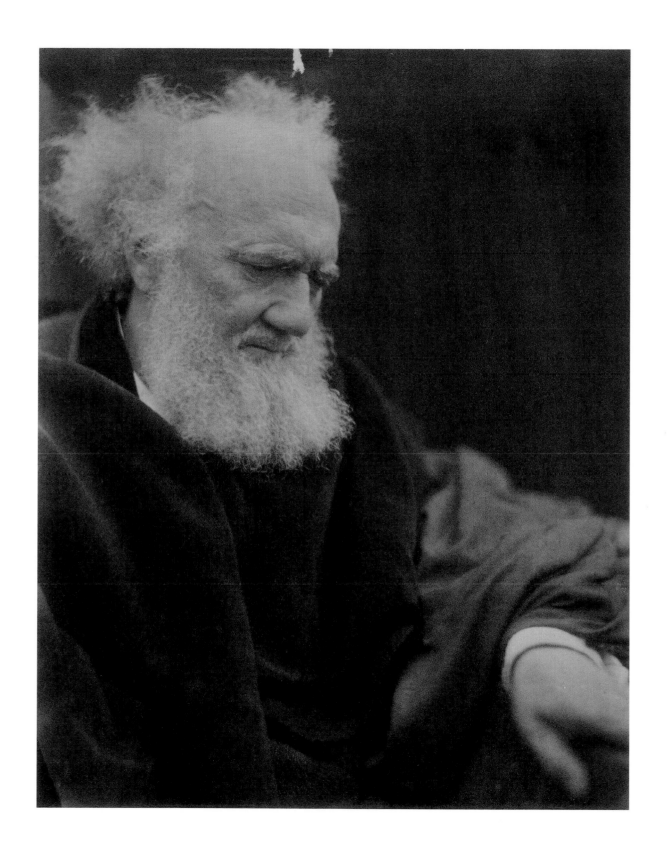

H.T. Prinsep, 1865

(copyright 19 May 1865)
Albumen print, 25.5 × 20 cm
Oxford, Bodleian Library, Arch. K b.12, fol. 65r

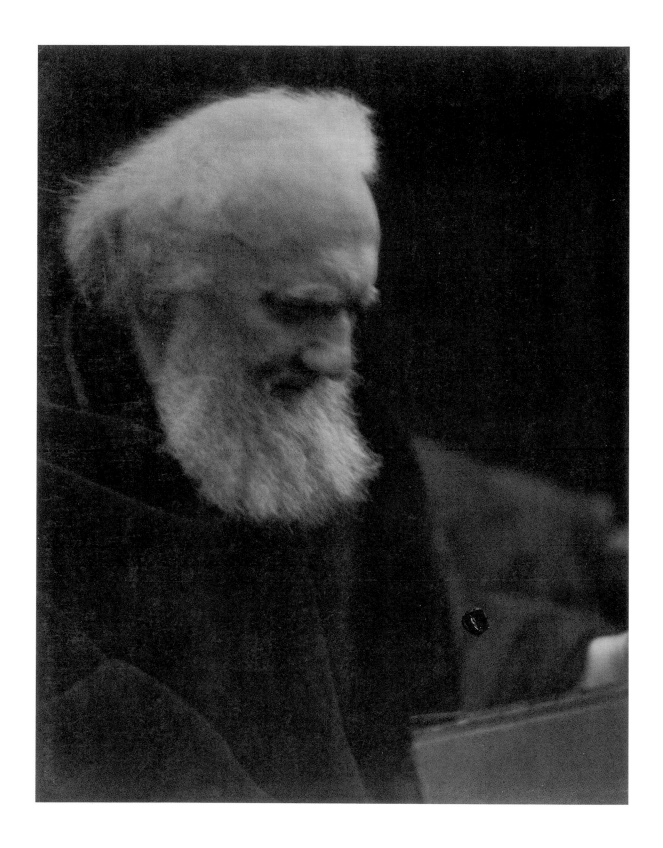

Sir John Herschel, 1867

Albumen print, 30.5 × 23.4 cm
Ashmolean Museum, Oxford, WA2009.180

Considered by Cameron as her 'Teacher and High Priest', the British astronomer Sir John Herschel was also the experimental photographer responsible for first introducing Cameron to the medium.[15] In this portrait, his brow is creased with the indications of a life of study, and he too is wrapped in a nondescript dark cloak with the slightest hint of a white clerical collar. Here Cameron has represented a man of science whose work included an exploration of the mysteries of the universe unavailable to the human eye. Equally suggestive are Herschel's expressly human qualities, complete with the markers of age in the wrinkles, shadowed bags under his eyes and white stubble, which add character and unguarded informality to his face. This portrait exemplifies Cameron's innovative approach, with its close-up and intimate treatment of the subject; in a second portrait taken the same year, his almost transparent eyes turn away from direct engagement with the viewer – an expression consonant with one who has spent a lifetime looking towards the stars (plate 77). Her images are in stark contrast to other photographic portraits of Herschel of the time, such as one by the American portraitist John Jabez Edwin Mayall (né Jabez Meal) (1813–1901) (fig. 3). His portrait presents a somewhat younger Herschel, posed very self-consciously with his head resting on one hand, as an intellectual – indeed, almost as a caricature of an intellectual, with little intimation of the interior solemnity of the scientist.

In her portraits of her friend and mentor of thirty-one years, Cameron has instead succeeded in creating what Taylor described as some of the 'greatest triumphs of photography, and of Mrs. Cameron's gift in that kind, that Sir John Herschel's face … has been perpetuated, so that future generations, as well as the present, may see it … in all its grandeur and dignity'.[16]

Fig. 3
John Jabez Edwin Mayall, *Sir John Frederick William Herschel*, c.1848
Daguerreotype, 86 × 70 mm
National Portrait Gallery, London

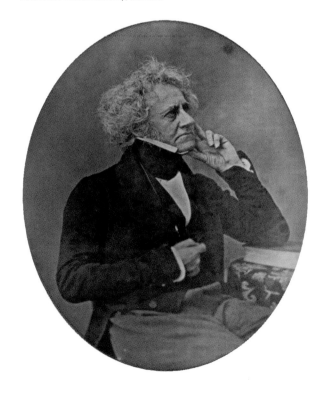

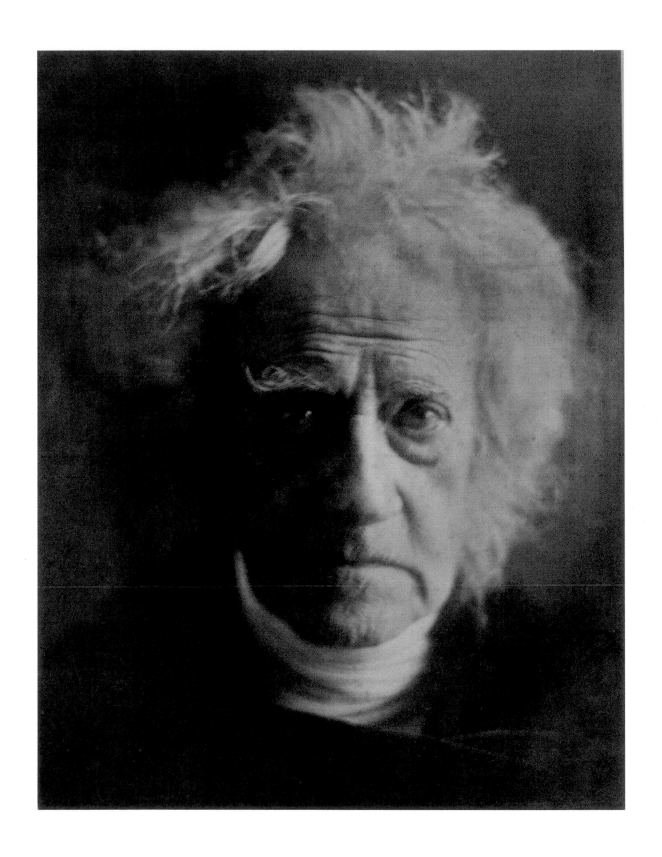

PLATE 25

William Michael Rossetti, May 1865

Albumen print, 24.8 × 19.4 cm
Oxford, Bodleian Library, Arch. K b.12, fol. 67r

The biographer and promoter of the Pre-Raphaelite Brotherhood, William Michael Rossetti, also finds a place amongst Cameron's portraits, capped in a beret, his features softly lit and his face turned three-quarters towards the right of the frame. Again, as with many of the images in the Bodleian's collection, the photographer places her subject slightly off-centre, asserting an intentional divergence from traditional studio portraiture. Cameron has lit only one other feature in the image of Rossetti: his left hand appears in the lower frame of the photograph, which suggests an association between his hands and his creative livelihood. Although he is still a young man, his restrained pose and the lighting remind us of Rembrandtesque portraits of aged men with tilted caps, shadowed faces and lit hands.

The brothers William Michael and Dante Gabriel Rossetti, as well as William Holman Hunt (plate 26), were amongst those who gathered at the salons in Little Holland House, the London home of Cameron's sister. Cameron was not a Pre-Raphaelite herself, having largely circumvented the movement by dint of being born to an earlier generation, and again by initiating her work after its height. Nonetheless, they share certain threads of commonality in subject matter and the new, often experimental, modes of visual exploration.

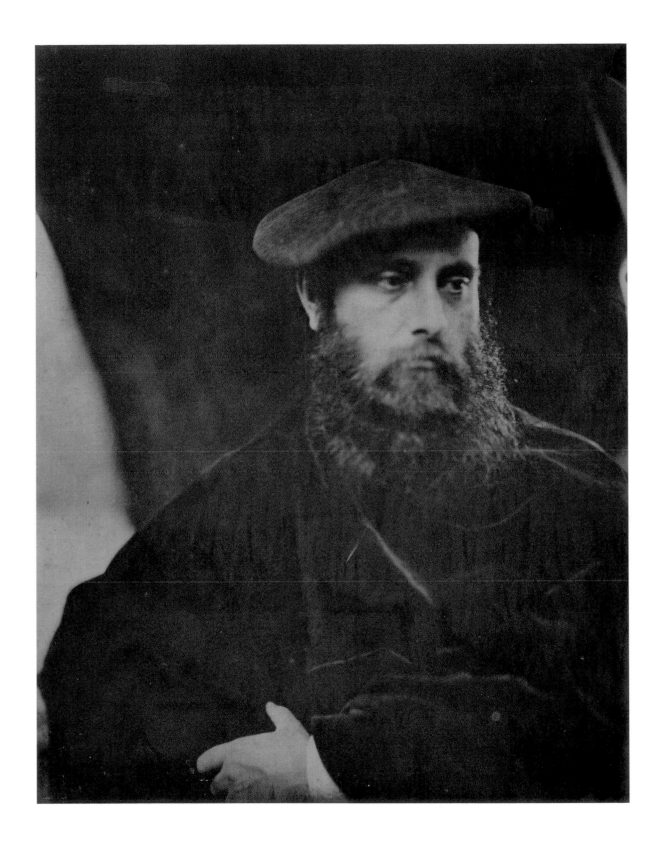

William Holman Hunt, 1864

(copyright May 1865)

Albumen print, 26.3 × 20.1 cm

Oxford, Bodleian Library, Arch. K b.12, fol. 68r

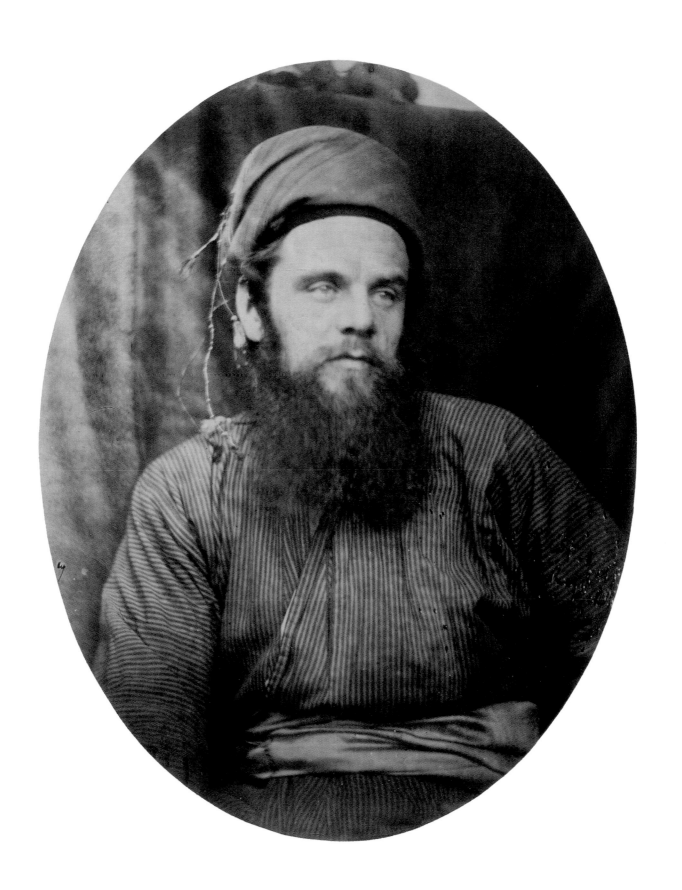

PLATE 27

Friar Laurence and Juliet (Henry Taylor and Mary Ann Hillier), 1865

Albumen print, 29 × 23.4 cm
Oxford, Bodleian Library, Arch. K b.12, fol. 4r

In each of the three Shakespearean-inspired photographs in the collection, Taylor takes on the role of a father figure and presents us with interesting photographic interpretations of the paternal. In the first image, inspired by *Romeo and Juliet*, Taylor, dressed as Friar Laurence, gazes down at Juliet. His forehead is highly lit as if to suggest a source of wisdom, which he then imparts to Juliet, played by Cameron's housemaid Mary Ann Hillier. She receives his instruction even as her own profile radiates in the light that exudes from his face. The darkened background and clothing further contrast with their faces and the vial of sleeping potion passed between them. Friar Laurence is hooded, and Juliet wears a headdress covering her braided hair. She is portrayed as a woman seeking counsel and yet at the same time in control of her emotional state. After a long career of acting in the roles of many of Shakespeare's heroines, the late Victorian actress Ellen Terry, G.F. Watts's first wife and a model for Cameron's photography, suggested in her lectures on Shakespeare that the Friar 'endows Juliet, a very young girl, with the inward freedom which produces this courage ... The Friar does not fail Juliet, but he demands much from her. The success of the remedy he suggests depends on her courage and cunning.'[17] In spite of this courage, there remain certain elements of the paternalistic in their embrace. The intimate posing of the Friar and Juliet creates a strong triangular composition that further heightens the subordinate nature of the

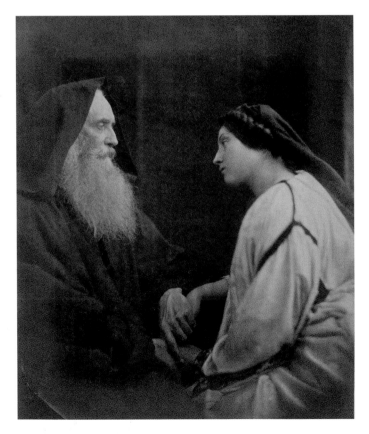

Fig. 4
Friar Laurence and Juliet, 1865 (copyright 11 November 1865)
Albumen print, 31.5 × 26.5 cm
Oxford, Bodleian Library, Arch. K b.12, fol. 78v

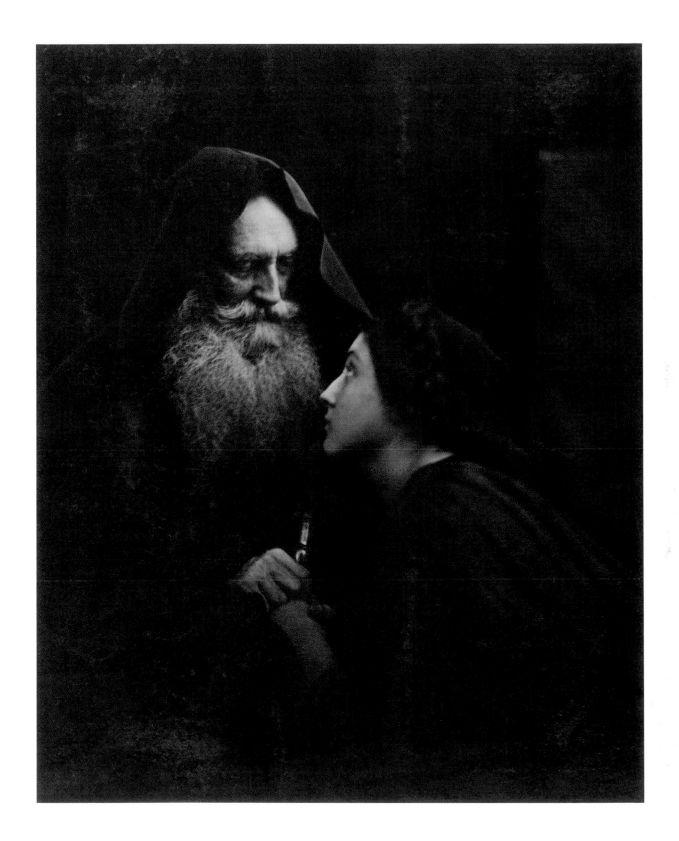

latter's relationship to the former. In addition to the provocative subject matter, Cameron also draws our attention to the intense tonality of this image by writing below it: 'This illustrates the richness of colour that may belong to [pure?] photography aft[er] Doyle said of my early photography that they possessed all of the quality offered of colour which he has never before seen in photog[raphy].'

A second representation of the scene places further distance between the two figures and finds Juliet on an equal visual plane with Friar Laurence (fig. 4). Taylor as the friar is in full profile, his face again fully lit. They clasp hands but the vial is gone and the distance between the two now suggests less of the complicit feeling of the first image. Juliet is now clothed in a white gown, in contrast to the black gown in the first image, its black seams echoing the curving lines of her headdress. The first image seems to suggest a gentle paternalistic relationship between the Friar and Juliet, while in the second the distance between the two suggests a shift in intimacy. Both figures are relatively equal in proportion to one another. Having conceded to Juliet's wishes, the friar seems to release the young woman to her fate. Where the first image of the pair presents something of the gentle father figure acceding to the drama of a young woman's love, the second is a kind of tragic benediction or farewell as he ultimately contributes to her own unhappy end.

PLATE 28

Prospero and Miranda (Henry Taylor and Mary Ryan), 1865

(overleaf)

Writing of her experience in acting the part of many Shakespearian heroines, Ellen Terry suggests that 'Shakespeare is one of the very few dramatists who seemed to have observed that women have more moral courage than men'.[18] Something of that defiance manifests itself in Cameron's photograph of Miranda from *The Tempest*. Anna Jameson admired Miranda explicitly as one of Shakespeare's greatest female characters, 'unequalled as a poetic conception'.[19] In Cameron's photograph, the young woman, played here by another favourite model, Mary Ryan, looks up at Taylor, now acting the part of Miranda's magician father, Prospero. Her gaze is unwavering and, while a physical connection persists in the touch of his left hand to hers clasped on his knees, there is an evident distance between them. Taylor as Prospero looks down his nose at the young girl with a patronizing tilt to his head, and her strained posture adds to an overall tension in the composition. Her white gown, the same as that worn by Juliet in the previous image, wraps around her in tangled folds and she seems on the brink of flight from her overbearing father. Her hair is uncovered and flows down her back. Miranda, insolent yet redeemable, nevertheless remains subservient to her father, seemingly unable to escape the robes that entangle her despite her desire to assert herself. The sympathetic Friar Laurence is replaced by the controlling Prospero, whose magic keeps his female progeny in his life, and indeed one of the few female figures in the play, tightly bound to him.

Notably, in these narrative images, Cameron's embraces what one might call 'stage lighting' advancing notions of 'theatricality' well beyond the subject and their costume. Instead, the photographer uses her increasing competencies with light and dark to strategically illuminate the action of each scene. It is the skilled deployment of such dramatic lighting that creates the 'action' in otherwise static scenes. Cameron would use similar techniques in her later photographic illustrations of Tennyson's poetic dramatizations of the Arthurian legends.

Prospero and Miranda (Henry Taylor and Mary Ryan), 1865

(copyright 11 November 1865)
Albumen print, 31.6 × 26.6 cm
Oxford, Bodleian Library, Arch. K b.12, fol. 13r

Fig. 5
Prospero and Miranda, 1865
Albumen print, 27.8 × 22.7 cm
Oxford, Bodleian Library, MS. 12714 photogr. 1 [item 2]

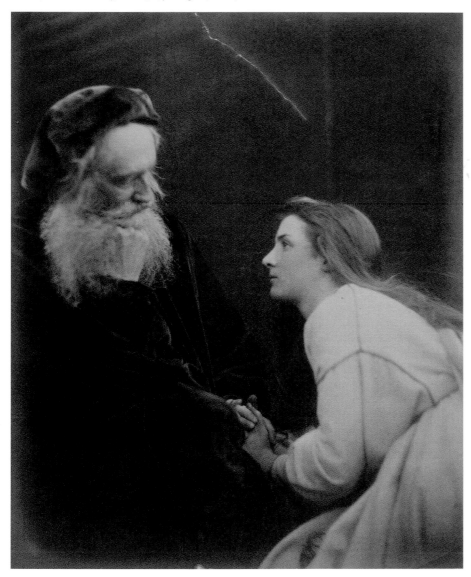

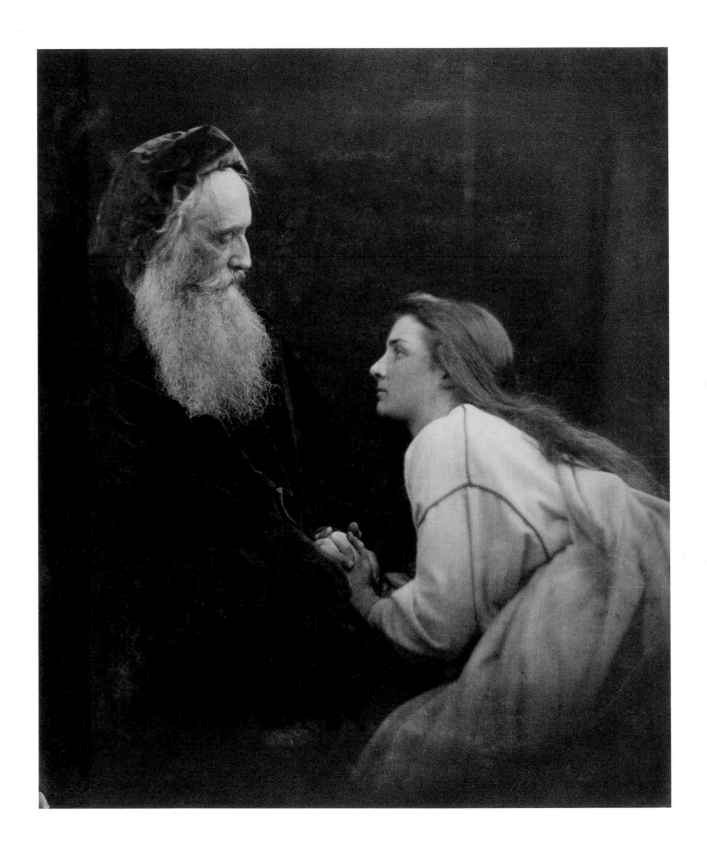

PLATE 29

Henry Taylor, May 1865

Albumen print, 26.6 × 21.2 cm
Oxford, Bodleian Library, Arch. K b.12, fol. 79v

Cameron would represent Taylor as a pensive Christlike figure, even a type of Man of Sorrows, and as a benevolent father figure, but she was also able to allude to the more malevolent side of the patriarch. This is especially apparent in her depiction of Taylor as Prospero and even more evident if we set her study of Beatrice Cenci alongside another portrait of Taylor. In the former, the young woman looks directly at the camera, crowned in the folds of her turban-like headdress and cascade of hair. Her look has something of the defiance, even disdain, of Miranda's gaze at Prospero (plate 30). Only this time she is freed, albeit through violence, from her victimization and turns her gaze back to her audience. The grim Cenci drama was revisited as a literary and artistic theme in the Victorian period largely through the work of Percy Bysshe Shelley's *The Cenci, A Tragedy in Five Acts* (1819) and nineteenth-century reproductions of the painting attributed to Guido Reni.[20] The story of an incestuous relationship between a cruel father and his victimized daughter in sixteenth-century Rome, ending in his murder by the daughter and then her execution for the crime, appealed strongly to the Victorian Gothic sensibility. This additional portrait of Taylor, although not directly linked to her image of the young and vulnerable Cenci apart from both being in the Taylor collection, renders him as threatening, his eyes staring out directly at the viewer (plate 31). The print in the Taylor collection is titled *Caezar Borgia*, after another equally infamous and cruel patriarch from the sixteenth century. It is believed the title was written in Taylor's own hand, which suggests that he was sufficiently unnerved by the image.[21]

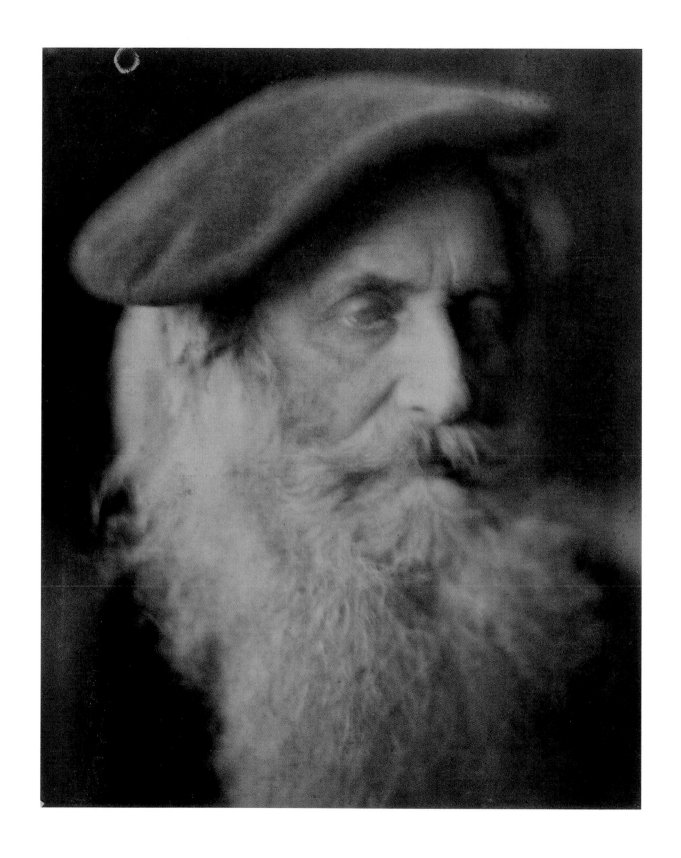

PLATE 30

A Study of the Cenci (May Prinsep), 1870

Albumen print, 34.5 × 27.7 cm
Oxford, Bodleian Library, Arch. K b.12, fol. 62r

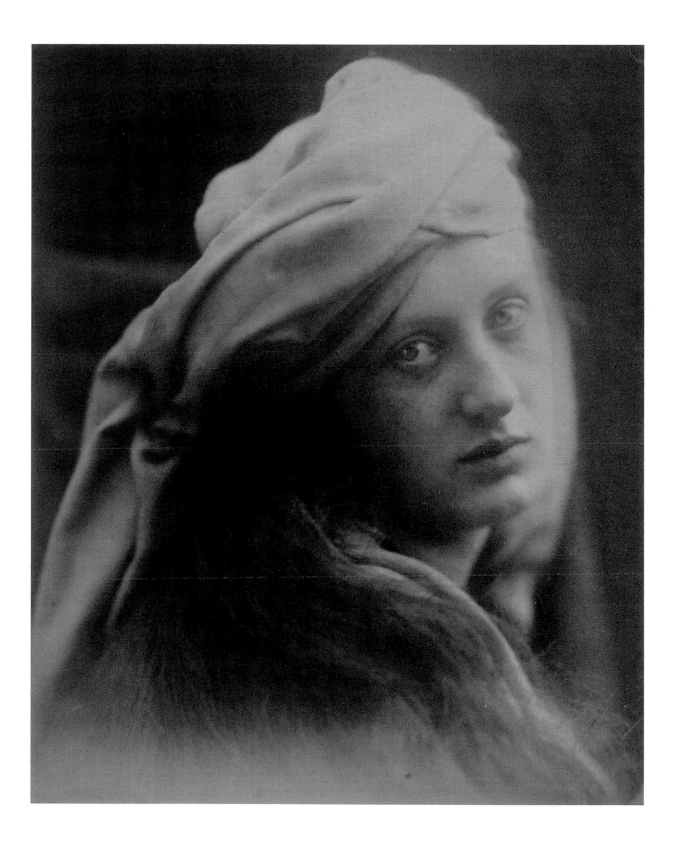

PLATE 31

Caezar Borgia (Henry Taylor), May 1865

Albumen print, 27.5 × 21 cm
Oxford, Bodleian Library, Arch. K b.12, fol. 11r

Fig. 6
Henry Taylor, May 1865
Albumen print, 26.7 × 21.3 cm
Ashmolean Museum, Oxford, WA2009.181

PLATE 32

Henry Taylor / Study of King David, 1865–6

Albumen print, 27.6 × 21.4 cm
Oxford, Bodleian Library, Arch. K b.12, fol. 9r

Three final portraits of Taylor in the Bodleian collection further affirm Cameron's typological approach to portrait photography (plates 32–34). This group of portraits effectively transforms the sitter into a series of composite representations of biblical characters. Benjamin Jowett wrote of a portrait of Taylor in a letter to him dated 1884: 'Many thanks for the beautiful likeness of yourself, which you have sent me. I do not think you look either a Christlike Jove or a jovial Christian, but much better – yourself. I often stop my visitors on the stairs to notice your portrait – the best, I think, of those which our friend, Mrs. Cameron, took with such infinite pains and labour.'[22] In light of such comments by contemporary beholders, it becomes plausible to read photographic portraits such as the present one as generally Christlike or biblical even without a specific title or precise iconographic markers for making such an identification.

One that was explicitly identified as such by Cameron shows Taylor in the guise of King David. Illustrations of the remorseful king were plentiful in the nineteenth century, and engravings from Anna Jameson's *The History of our Lord* (1864) exemplify these popular depictions (fig. 7). In her portrait, Cameron draws on such iconography while maintaining her own aesthetic, especially in treating the emotive significance of the subject. For the historian and philosopher Thomas Carlyle, kingly figures were the ultimate expression of

Fig. 7
Engraving of Nathan and David, from Anna Jameson,
The History of our Lord (1864)
Oxford, Bodleian Library, (OC) 170 k.29 (vol. 1, p. 212, no. 87)

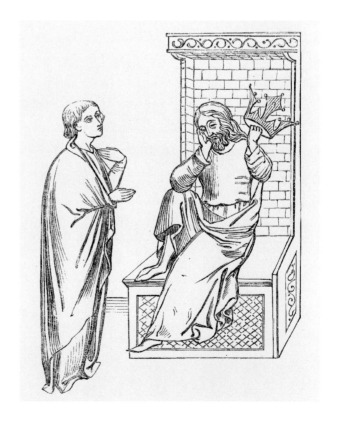

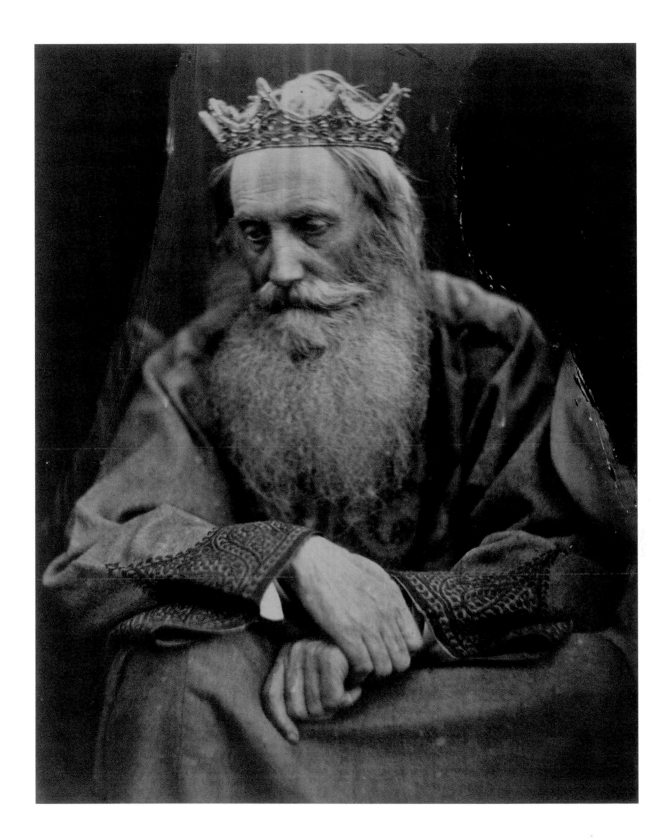

the heroic, 'the summary for us of *all* the various figures of Heroism; Priest, Teacher, whatsoever of earthly or of spiritual dignity'.[23] In Cameron's portrait, by contrast, the mortal king is rendered as a fallen hero, crowned but in a state of shame, presumably in response to the circumstances of his marriage to Bathsheba. He is cloaked in robes with embroidered detail at the cuffs, evocative of royalty, but his shoulders are hunched to evoke the weight of his moral failings. Light falls from above, highlighting his crown and forehead as the source of the king's wisdom, but this is a wisdom that has clearly been insufficient. This light is also in marked contrast to the shadows that darken his face, turned away from the source of light, with eyes cast down to suggest remorse. Although a likely flaw in the negative or print, lines trace the shape of the subject's form, with the top corners darkened significantly. The cutaway effect further focuses the viewer's attention on the downcast frame and remorseful pose of the king.

As the biblical story tells us, the sorrow and regret derive not only from King David's moral failings before God but also from God's retribution for his sin. In an act of selfishness, David wielded his power to ensure his marriage to Bathsheba by spilling the blood of her husband, Uriah. The price David pays for this is the death of their infant son. As Anna Jameson writes in a description of the fallen king, written at roughly the same time that the photograph was taken, the figure of David is not just negative but also potentially a source of comfort or, in her words, 'fertile in warning and consolation for the human race'.[24] Although David had sinned, repentance followed and the line of David would eventually produce the ultimate redemptive figure of Christ the saviour. Cameron chose Taylor to represent the mourning king who, having once been the poet-musician and psalmist of the Israelites, now agonizes as the Old Testament prefiguration of Christ.

PLATE 33

Henry Taylor, 1865

(overleaf)

The theme of grief persists in another portrait of Taylor, still clothed in the robes of the David portrait. His pose has shifted slightly as he rests his chin on his left hand in the classic iconographic pose denoting a melancholic temperament. Cameron focuses on Taylor's face and wiry beard. In this pose, with his chin in his hand, Taylor becomes the lamenting prophet Jeremiah. In a close-up taken two years later, he clutches his beard and chin tightly (fig. 8). The motif of the hand clutching the beard in particular, an ancient symbol of wisdom, is also the subject of an engraving by W. Small printed by the Dalziel brothers, who were leading figures in graphic art production during the nineteenth century (fig. 9). The portrait of Taylor as prophet also recalls Michelangelo's portrayal of Jeremiah on the Sistine ceiling, a composition that Cameron would have known through the work of the Arundel Society and copyists like Cesari Mariannecci. Such well-known, oft-reproduced images reinforce the visual links Cameron made between Taylor and lamenting prophets and philosophers. As his daughter Una recalled, he was sensitive to the suffering inherent in life and 'was essentially a thinker whose outlook, whenever it passed beyond the individual, friend, stranger, or kin concerned itself mainly with the wider aspects of mankind. His *data* was life, its facts; suffering in all its forms.'[25]

Fig. 8
W. Small, *Cushi Brings to David News of the Death of Absalom*
Engraving from *Dalziel's Bible Gallery: Illustrations from the Old Testament*, 1880
Metropolitan Museum, New York, 26.99.1(56)

PLATE 33

Henry Taylor, 1865

Albumen print, 26.6 × 21 cm
Oxford, Bodleian Library, Arch. K b.12, fol. 7r

Fig. 9
Henry Taylor, October 1867
Albumen print, 34.4 × 27cm
J. Paul Getty Museum, Los Angeles

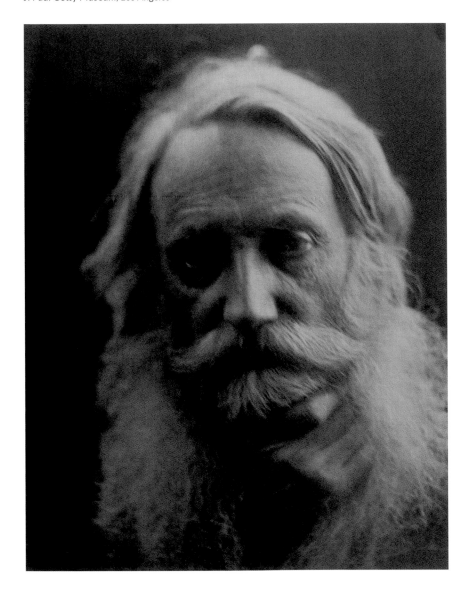

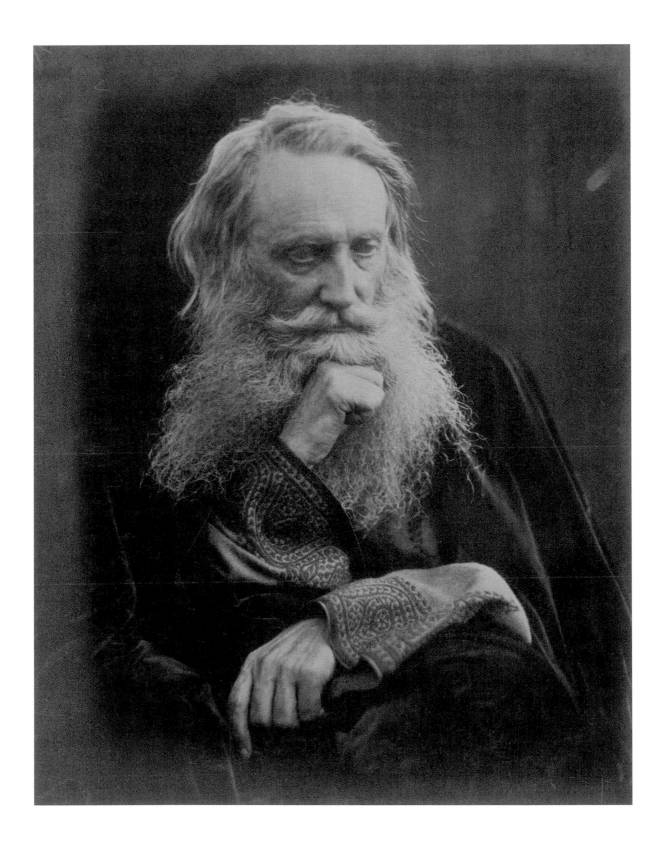

PLATE 34

Henry Taylor, 1864

Albumen print, 27.1 × 22.5 cm
Oxford, Bodleian Library, Arch. K b.12, fol. 5r

There was a distinct melancholic undertow in Cameron's photographic portraiture which reinforces what we might call her aesthetic of sorrow. Like most Victorians, Cameron found beauty in suffering and believed that images of suffering in art could touch the soul and inspire reflection on the subject of humility. She meditates on this theme in another portrait of Taylor with certain biblical and pseudo-biblical themes. Here again there seems to be an allusion to the Man of Sorrows, prefigured in the Old Testament by David and the mourning prophet Jeremiah, and ultimately expressed in the New Testament's redeemer. Taylor's gaze is cast down and most of the details of his face, including his eyes, are shadowed to the point of mere suggestion. While there are no literal iconographic indicators of more traditional depictions of the Man of Sorrows, such as bound hands, bare chest or crown of thorns, Cameron has evoked a *feeling* of sorrow and suffering through his pose and the softening of details. Taylor's slight, downturned head, loose hair and beard recall something of Murillo's treatment of the suffering Christ, an image that Cameron may have encountered in the collection of work held by her friend and family financier, Lord Overstone, or in the publications that followed the Manchester Art Treasures Exhibition in 1857 (fig. 10).[26] It also calls upon the work of Rembrandt, whose portraits of aged male subjects also hung at the exhibition.[27]

Fig. 10
Bartolomé Esteban Murillo, *La Santa Faz* (The Holy Face)
Oil on canvas, 50 × 38 cm
Reproduction from *Catalogue of Pictures forming the Collection of Lord and Lady Wantage at 2, Carlton Gardens, London*, 1902
Bodleian Art, Archaeology and Ancient World Library, Oxford, 908.2 Loy fol., p. 97

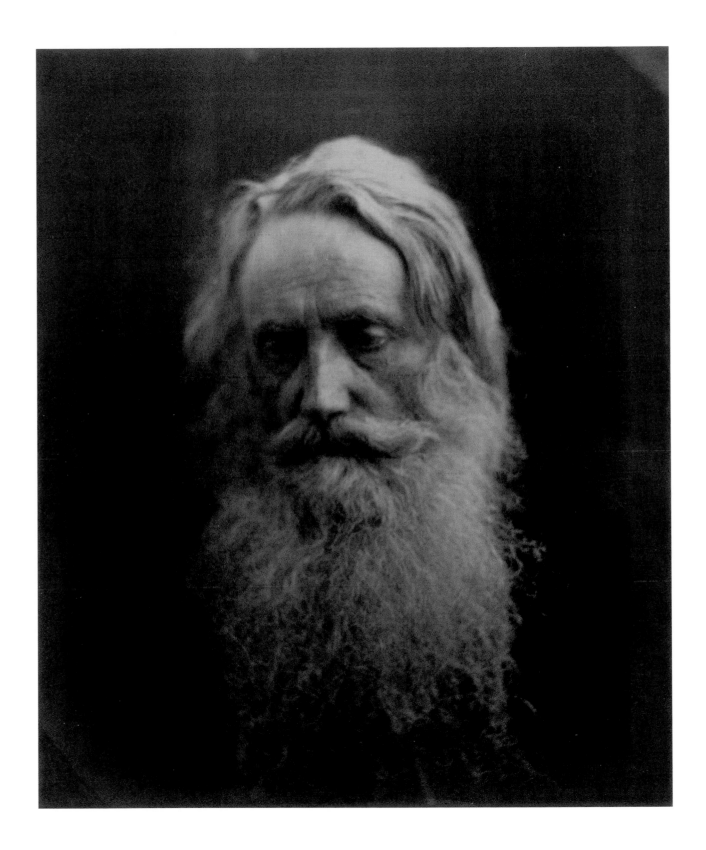

PLATE 35

G.F. Watts, 1864

(copyright 12 December 1864)
Albumen print, 25.4 × 19.7 cm
Oxford, Bodleian Library, Arch. K b.12, fol. 71r

Included in the Bodleian Library's collection are some
of Cameron's most evocative portraits of the artist G.F.
Watts, which indicate her commitment to celebrating her
artistic mentor as an introspective teacher and advocate
of beauty, poetry and 'high art'. In this first portrait of
Watts, his complete costume is not unlike that in his own
self-portrait. But in contrast to Watts's own rendering,
with his straightforward gaze, Cameron's portrait casts
the artist known as England's Michelangelo in a more
pensive pose. Little detracts from his subtly lit face with
its evident age spots and heavy-lidded, downcast eyes.
The strongest light falls on the ruffled cuff that frames
the aged hand of the artist-sculptor.

It is not insignificant that Cameron maintained such
a long-standing relationship with an artist who would
come to be recognized as one of England's pre-eminent
nineteenth-century portraitists. Of his approximately
800 paintings, 300 were portraits.[28] Watts and Cameron
approached the art of portraiture in much the same
way, with every effort given to representing the complete
character of the subject. If we compare Watts's self-
portrait of 1862–3 with Cameron's 1864 portrait,
the similarities are evident (fig. 11, plate 35). In both
images, the artist is wearing a dark coat and his broad-
brimmed day hat; the lighting in each reinforces his
unique features, particularly his beard and the slight
peak in his nose. But, where Watts paints himself as
looking directly out at the viewer, Cameron works to

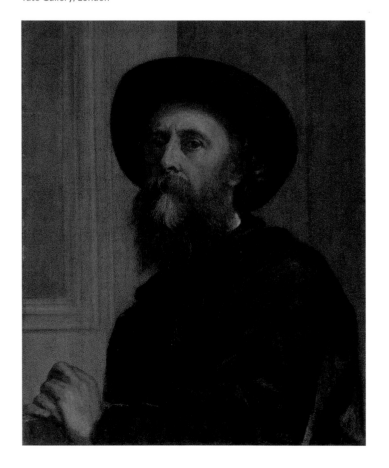

Fig. 11
G.F. Watts, *Self Portrait*, 1862–3
Oil on canvas, 64.8 × 52.1 cm
Tate Gallery, London

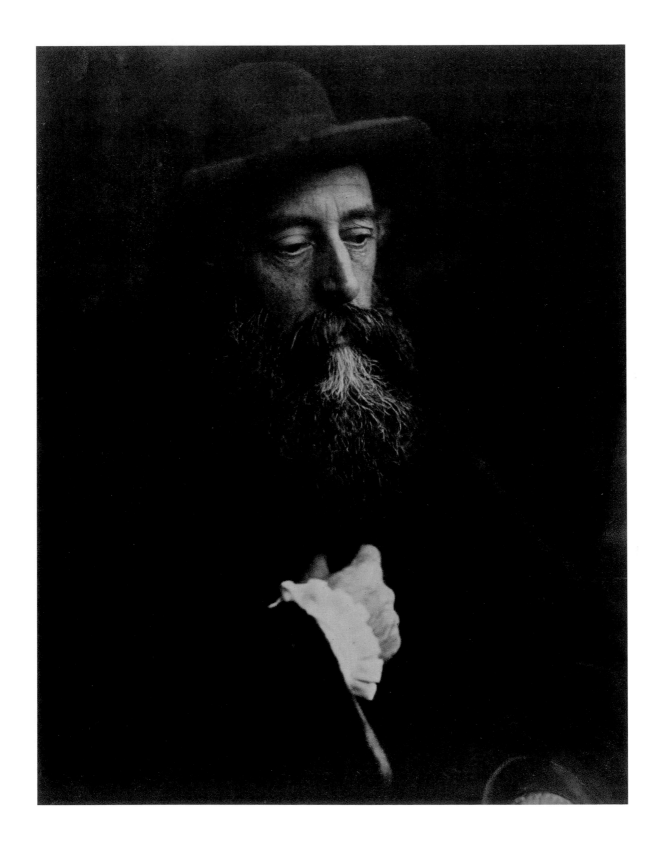

PLATE 36

The Dream, April 1869

Inscription: 'quite divine / G.F. Watts'
Albumen print, 30.4 × 24.3 cm
Ashmolean Museum, Oxford, WA.OA1347

evoke elements of the brooding aesthete in her portrait. The subject's body is positioned slightly off-centre, while the highlighted face and hand are the central focus. Cameron relies on an economy of detail and an effective deployment of chiaroscuro to enhance the slight turn of head, cast of eyes and grasp of hand suggestive of an artist who was also something of a poet and mystic. In her letters, Emilia Russell Gurney recalled that Watts 'never rested satisfied with reproducing what was generally apparent to the outer eye; he always studied the character until he could work out the inner self as much as possible'.[29] In 1886 the artist further detailed his approach to understanding his sitters so that he could paint a successful portrait: 'In my imaginative work I consider myself perfectly free as to detail so long as I do not violate any law; but not so, of course, in portrait-painting, when while giving my mental faculties full play so as to seize my sitter's intellectual characteristics, I observe equally the physical minutiae. To assist myself, I converse with him, note his turn of thought, his disposition, and I try to find out, by inquiry or otherwise (if he is not a public man, or is otherwise unknown to me), his character and so forth; and having made myself master of these details, I set myself to place them on the canvas, and so reproduce not only his face, but his character and nature.'[30]

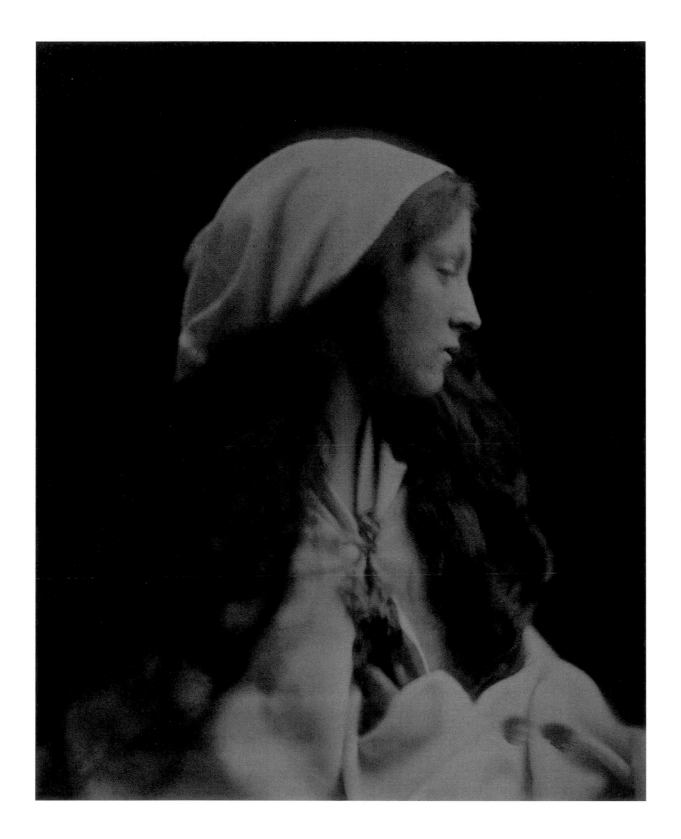

PLATE 37

La Madonna Aspettante / Yet a little while (Freddy Gould and Mary Ann Hillier), 1864–5

Albumen print, 24.4 × 20.1 cm
Oxford, Bodleian Library, Arch. K b.12, fol. 30r

When Watts secured his first exhibition in 1837, there was virtually no history of Italian Renaissance art in England that constituted any significant advancement on Giorgio Vasari's *Lives of the Artists*. Allen Staley reminds us that, in the second half of the nineteenth century, 'Realism was old and the Renaissance was new.'[31] By the time Cameron took her first 'successful' photograph in 1864, Giovanni Battista Cavalcaselle and Joseph Archer Crowe had published their seminal three-volume survey of Italian painting, *A History of Painting from the Second to the Sixteenth Century* (1853). The National Gallery, which in the 1830s held relatively few fifteenth- and sixteenth-century Italian paintings, soon became the largest repository of Renaissance art outside of Italy. Victorian England experienced a significant increase in the popular appreciation of art in the mid-nineteenth century due to the great success of the Manchester Art Treasures Exhibition, along with the establishment of the National Gallery and the National Portrait Gallery. Through these channels, Watts and Cameron were exposed to significant works of Renaissance art, but they did not directly copy or attempt an unalloyed revival of the art of this period in their respective efforts. Instead, the art of both the Northern and Southern Renaissance contributed to an aesthetic that also drew on ancient Greek models such as the Parthenon Sculptures and on medieval Christian art, both subjects of renewed interest more generally in the nineteenth century

In addition to subject material, this ensured that Cameron was also familiar with formal techniques including composition, the use of line and texture, and the effective deployment of light and shadow, which in her medium functioned as colour did for painting. Additionally, Cameron had much to gain from studying the efforts of earlier artists, particularly those of the Renaissance, to translate three-dimensional reality into two dimensions while still preserving the lifelike and poetic qualities of a subject. A significant portion of her body of work was focused on sacred subjects, particularly Marian imagery (plates 37–39, 40–45). It was her efforts to represent Mary – as Madonna, Annunciate, Mother and Queen of Heaven – that demonstrate her careful study of the masters and reinforce her own personal beliefs, as well as her interest in Christian typology.

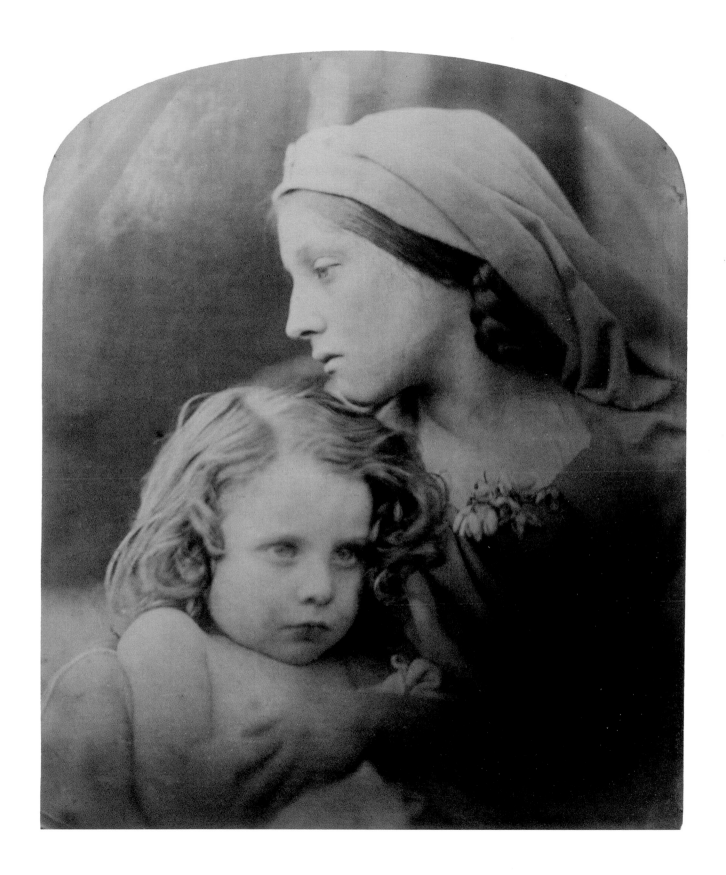

PLATE 38

Repose (Freddy Gould and Mary Ann Hillier), 1864

Albumen print, 25.2 × 19.7 cm
Oxford, Bodleian Library, Arch. K b.12, fol. 28r

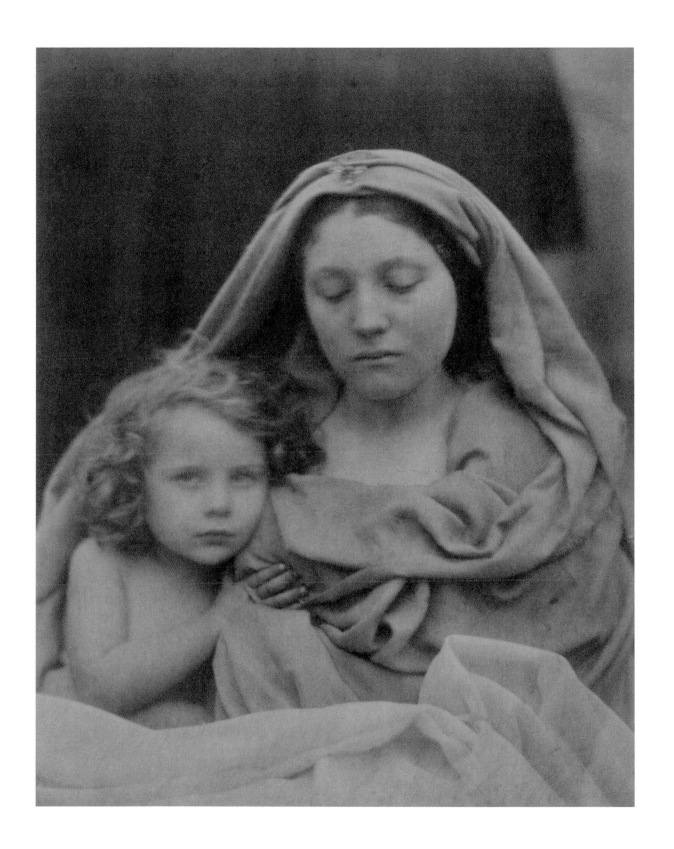

PLATE 39

'My grandchild Archie aged 2 years & 3 months', here captioned 'Master Cameron', 1865

Albumen print, 17.9 × 23.1 cm
Oxford, Bodleian Library, Arch. K b.12, fol. 35r

Fig. 12
Rest on the Flight into Egypt, etching by Valentin Lefèvre, 1682, based on original attributed to Titian
Engraving from Anna Jameson, *Legends of the Madonna*, 1852, p. 342
Oxford, Bodleian Library (OC) 170 k.26

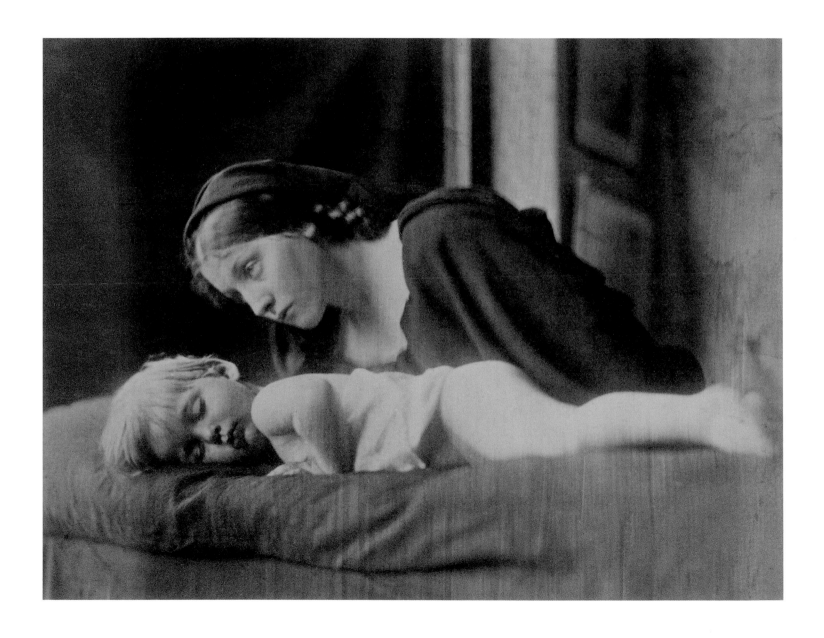

PLATE 40

La Madonna Addolorata / Patient in Tribulation, 1864

Albumen print, 25.4 × 20 cm
J. Paul Getty Museum, Los Angeles

PLATE 41

The Annunciation / A Study – after the manner of Francia, 1865–6

Albumen print, 25.5 × 21.3 cm
Victoria and Albert Museum, London

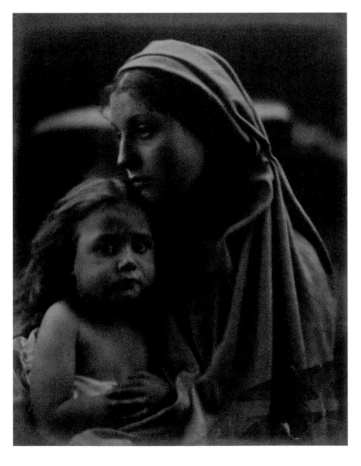

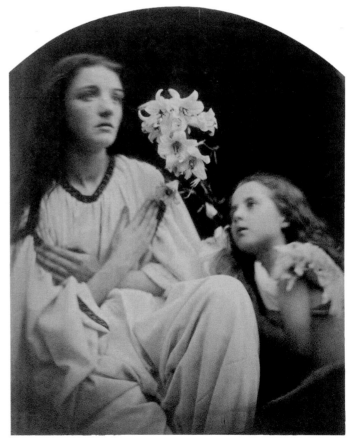

The Wanderer / after the manner of Leonardo, 1864–5

Albumen print, 26.3 × 19.9 cm
Gernsheim Collection, Harry Ransom Center, Austin, TX

A Study, after Perugino / The Annunciation, 1865–6

Albumen print, 34.4 × 26.4 cm
The Metropolitan Museum of Art, New York

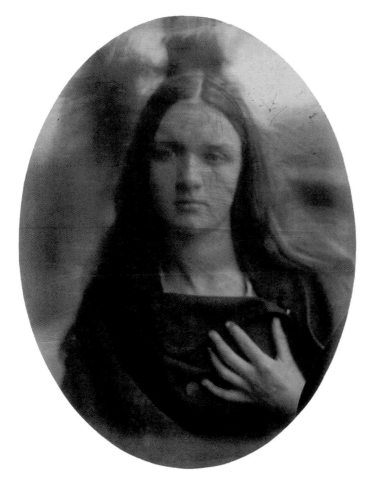

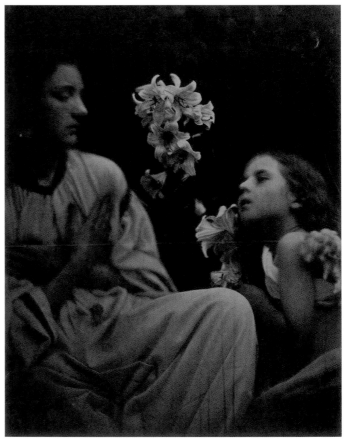

149

PLATE 44

After the manner of Perugino, 1864

Albumen print, 27.2 × 12.9 cm
Oxford, Bodleian Library, MS. Photogr c. 175, fol. 399

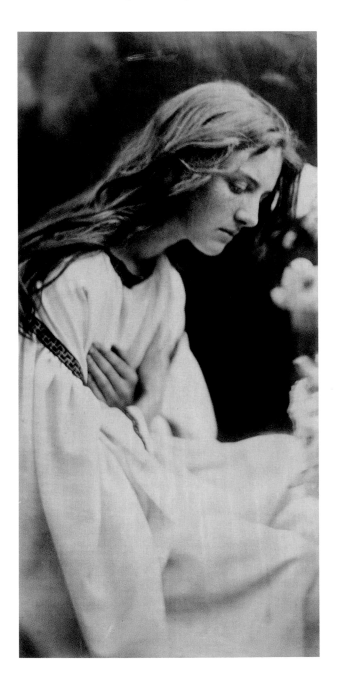

Where Watts had been introduced to Greek and Italian art *in situ* during his early travels, Cameron encountered it later through Watts, through her engagement with the Arundel Society and through Lord Overstone, a family friend who helped the Camerons financially over an extended period. In 1851 Overstone became a commissioner for the Crystal Palace Exhibition and a trustee of the National Gallery, London.[32] From the early 1830s, Overstone had been acquiring Dutch paintings and continued to add to his collection the work of Italian, French and Spanish artists; by the time Cameron gave Overstone an album of her photographs in 1865, he was one of the most prodigious of English collectors of early modern art. The Overstone collection

Fig. 13
Guido Reni, *Santa Maria Vergina*, n.d.
Engraving from Anna Jameson, *Legends of the Madonna*, 1852, p. 93
Oxford, Bodleian Library, (OC) 170 k.26

PLATE 45

The Salutation / after the manner of Giotto,
1864

Albumen print, 25.2 × 19.2 cm
Gernsheim Collection, Harry Ransom Center, Austin, TX

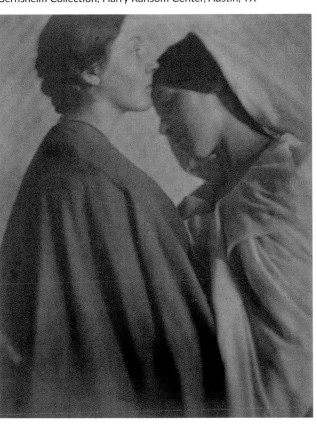

included works by Guido Reni, Bronzino, Salvator Rosa, Carlo Dolci and Parmigianino. The Venetian School was also well represented, including three works by Titian and later acquisitions of Tintoretto, Francesco Guardi and Palma Vecchio.[33] Lord Overstone was vice president of the 1857 Manchester Art Treasures Exhibition, and the names of some of the artists and works he loaned to the exhibition give an indication of the scale of his collection and the type of work Cameron would have encountered in his holdings. These included paintings by Rembrandt, Perugino, Jacob van Ruisdael, Joshua Reynolds, Claude Lorrain, George Stubbs, Lorenzo di Credi, and Murillo (for whom Overstone had an especial fondness). According to the accompanying exhibition catalogues from Manchester, the work of Spanish masters, including the famous *La Santa Faz (The Holy Face)* by Murillo, hung alongside the work of Perugino and Rembrandt (fig. 10).[34] Cameron was also familiar with engravings of Renaissance art, such as those used to illustrate Anna Jameson's scholarly books on sacred art (figs. 12, 13).[35] It is not surprising, therefore, to find numerous photographs by Cameron titled in the kind of language also used by Jameson, such as *La Madonna Addolorata / Patient in Tribulation* (plate 40), or associated with Italian masters, as in *A Study – after the manner of Francia* (plate 41), *The Wanderer / after the manner of Leonardo* (plate 42), *A Study, after Perugino / The Annunciation* (plate 43), *After the manner of Perugino* (plate 44), and *The Salutation / after the manner of Giotto* (plate 45).

151

PLATE 46

George Frederic Watts, 1865

Albumen print, 25.4 × 19.7 cm
National Portrait Gallery, London

In 1865 Cameron photographed Watts, cast in profile and sitting at the base of his large-scale painting of St George and the Dragon, a legend that gained popularity through the revival of medieval narratives in the nineteenth century (plate 46). The painted saint faces outwards from the canvas while Watts, heavily draped, poses in a manner that echoes the princess at St George's side. Here Cameron's artistic mentor is posed in such as a way as to suggest the burden of his convictions that as an artist he was called to help redeem the world through art and beauty. For Watts, 'the aims of art are not different from the aims of life in general, which should be to add as much as possible to the good of the world [and until] the love of beauty is once more alive amongst us there can be little hope for art. It is a universal language – everything we use or wear is an expression of it, or of the absence of it. The art that exists only in pictures and statues is like the religion kept only for Sundays.'[36]

The overall composition of the photograph is enhanced by curving lines, represented in this image by the slope of Watts's shoulders and neck, echoed in the bend of the princess's body. The visual rhythm created by the directional lines resonates with Watts's belief that the superior line does not return to itself, but leads the eye on to something available beyond the frame and completes itself outside the limits of the design.[37] Watts's contemplative sensibility is evident in Cameron's 1864 portrait, in which the use of foreshortening and a limited depth of field creates a sense that the artist's physicality is both pushing out of the frame and fading away (plate 47). She has stripped all detail from the background, allowing the softened focus and tonality to work its suggestive magic.

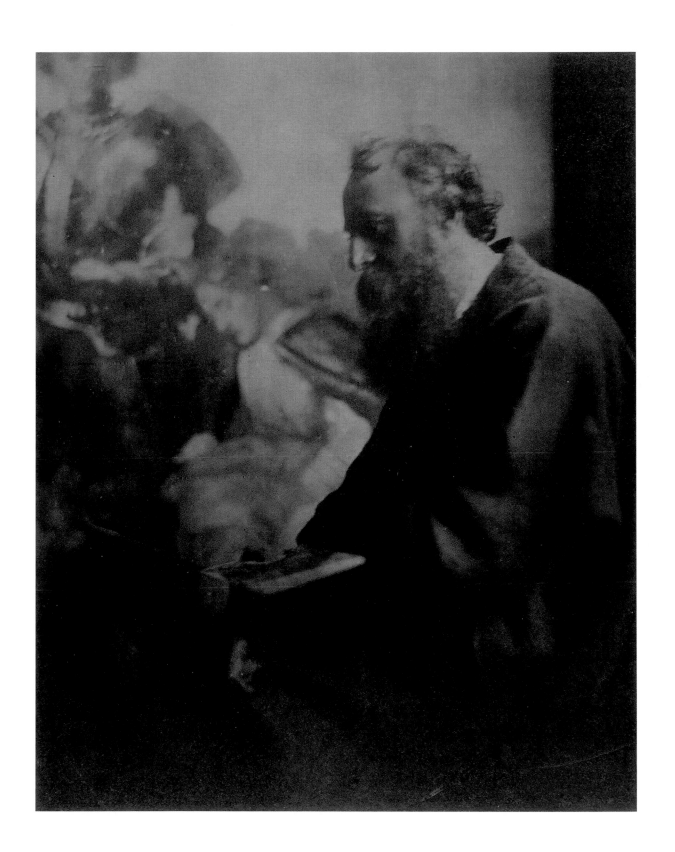

George Frederic Watts, 1864

Albumen print, 24.3 × 19.3 cm
Oxford, Bodleian Library, Arch. K b.12, fol. 72r

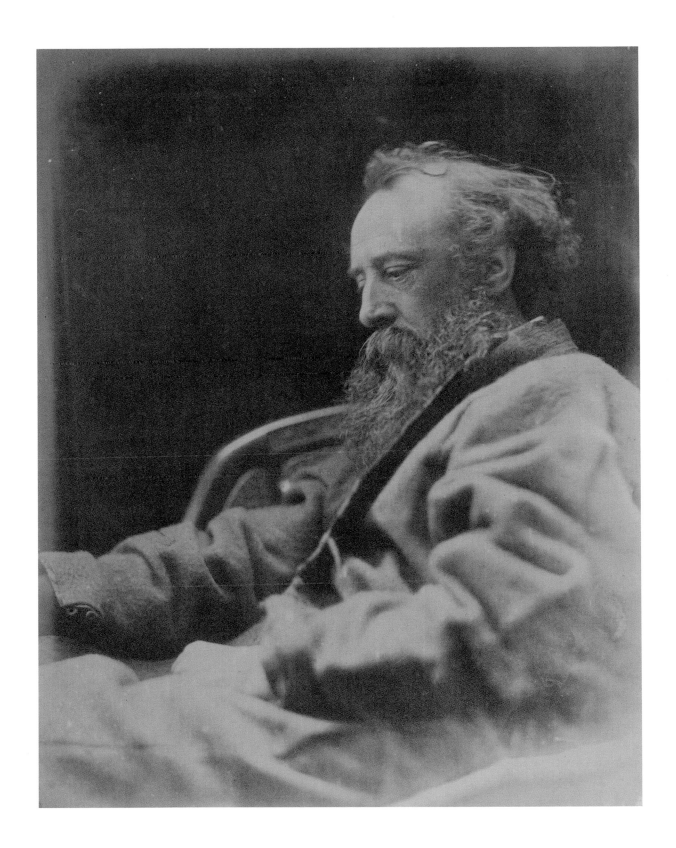

PLATE 48

Whisper of the Muse (George Frederic Watts), 1865

Albumen print, 26.7 × 21.2 cm
Oxford, Bodleian Library, Arch. K b.12, fol. 70r

Two of Cameron's most well-known portraits of Watts, completed between 1864 and 1865, are of the artist as a musician (plates 48, 49). They are Symbolist in their composition and choice of subject matter. Cameron expanded her typological treatment of portraits inspired by the word, be it scripture, poetry or literature, to include that which existed beyond the limits of language and found expression in music. As Michael Bartram notes, the exploration of musical themes arose out of their milieu: 'at no other time would musical images have so clearly signalled the mysteries of life, the aspiration towards otherwise incommunicable profundities.'[38] In the first image, the violin is ready for playing, the bow resting on the instrument (plate 48). Although Cameron titled both portraits *Whisper of the Muse*, it is in the first that the whispering is most suggestive. Here Watts appears to listen intently to the muse-like child positioned above his shoulder in the upper right corner of the frame. Though her role as muse is to inspire, it is also possible to interpret the presence of both children in this image as reinterpretations of the putti of Renaissance art. Cameron is taking poetic, typological licence in equating the twin cherubs or putti of love with the equally symbolic messengers of divine inspiration from Ovid's classical poem *Metamorphoses*. In this first portrait, with its graduated tonalities and blurred focus, the form of the artist blends into the shadows while the 'act' of

inspiration – the whisper of the muse – functions as the focal point of the image, with highlights cast across the artist's forehead and the face of the child leaning into his ear. In his exploration of the mysteries of music, Thomas Carlyle (Watts and Cameron's contemporary) wrote: 'A *musical* thought is one spoken by a mind that has penetrated into the inmost heart of a thing; detected the inmost mystery of it, namely the *melody* that lies hidden in it; the inward harmony of coherence which is its soul,

Fig. 14
Whisper of the Muse (George Frederic Watts), 1865
Albumen print, 25.1 × 21.6 cm
Ashmolean Museum, Oxford, WAHP33137

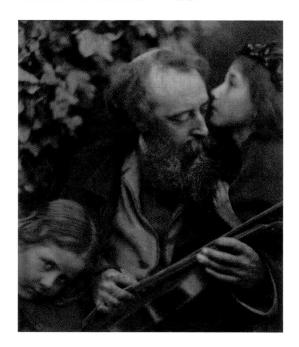

whereby it exists, and has a right to be, here in this world. All inmost things, we may say, are melodious; naturally utter themselves in Song. The meaning of Song goes deep. Who is there that, in logical words, can express the effect music has on us? A kind of inarticulate unfathomable speech, which leads us to the edge of the Infinite, and lets us for moments gaze into that!'[39]

Describing the musical paintings of Titian, E.T. Cook writes: 'it is "all ear," the expression is evanescent as the sounds – the features are seen in a sort of dim *chiaroscuro*'.[40] Something similar could be said about this portrait, in which Cameron has highlighted the artist's inward experience of something akin to Carlyle's 'musical thought'. Here Watts is 'all ears'; his brow furrows from the strain of listening, his eyes and head are cast down to reinforce the private interiority of a moment awash in subtle tonalities.

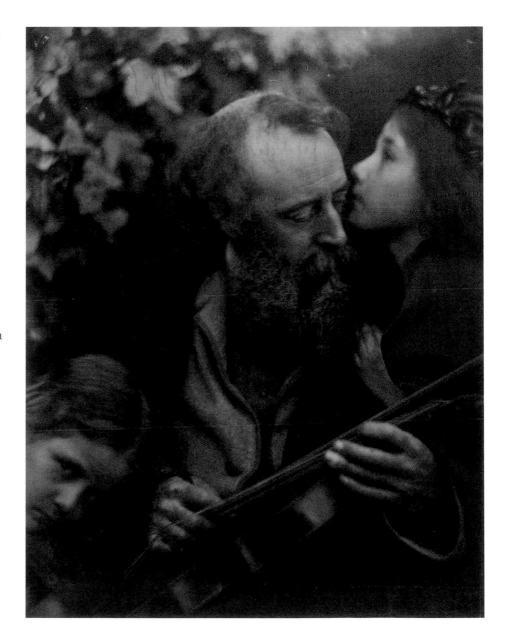

PLATE 49

The Whisper of the Muse / Portrait of G.F. Watts, April 1865

Inscription on print in the Victoria and Albert Museum, London: 'Freshwater April 1865 / The Whisper of the Muse /
Portrait of G.F. Watts / a Triumph!'
Albumen print, 25.4 × 19.7 cm
Oxford, Bodleian Library, Arch. K b.12, fol. 27v

Cameron considered her second portrait of Watts 'a Triumph'. In it he holds the violin to his chin, fingers on the strings and bow in hand, perhaps in anticipation of commencing play. The composition is compressed and the lighting sharp, in contrast to the previous portrait. The curving S shape of the violin's body and soundboard is repeated subtly throughout the composition, giving the image a lyrical quality and affirming its Symbolist aspects. The instrument plays an active and significant role as a subject in itself. In Music and Morals, Hugh Haweis, an amateur musicologist and avid historian of the violin, describes the eternal allure of the instrument: 'Indeed, it is difficult to contemplate a fine old violin without something like awe: to think of the scenes it has passed through long before we were born, and the triumphs it will win long after we are dead. To think of the numbers who have played on it, and loved it as a kind of second soul of their own; the great works of genius which have found in it a willing interpreter; the brilliant festivals it has celebrated; the solitary hours it has beguiled; the pure and exalted emotions it has been kindling for perhaps two hundred years: and then to reflect upon its comparative indestructability.'41

Watts's beard covers the top of the instrument, rather than being tucked underneath as one might expect; the hairs connect to the strings suggesting an organic relation between the instrument and the artist as musician. Sharp lighting falls across the crown of Watts's head and seems to conjure up the hidden upper curve of the instrument while also highlighting the faces of both children. The child at the lower left gazes out directly at the viewer, while Watts and the second child look just past her towards something beyond the frame of the photograph. One hand on the strings, the other firmly grasping the bow, the artist is now ready to play. Taken as a pair of portraits, distinguished by Cameron's use of chiaroscuro and moderate adjustments in composition, they suggest Watts's interior transformation from a listening subject to one poised for action.

Both artists' engagement with musical motifs prefigures Walter Pater's treatise on the symbolic and anagogical nature of music which, according to Pater, sought independence from mere intelligence and aimed to become pure perception. He believed it was 'the art of music which most completely realises this artistic ideal, this perfect identification of matter and form … In music, then, rather than in poetry, is to be found the true type or measure of perfected art'.42 Described by G.K. Chesterton as a mystic, Watts appreciated that music, the most noble of the arts, was often best comprehended through the mere suggestion of its possible meaning.43 Where Pater used the language

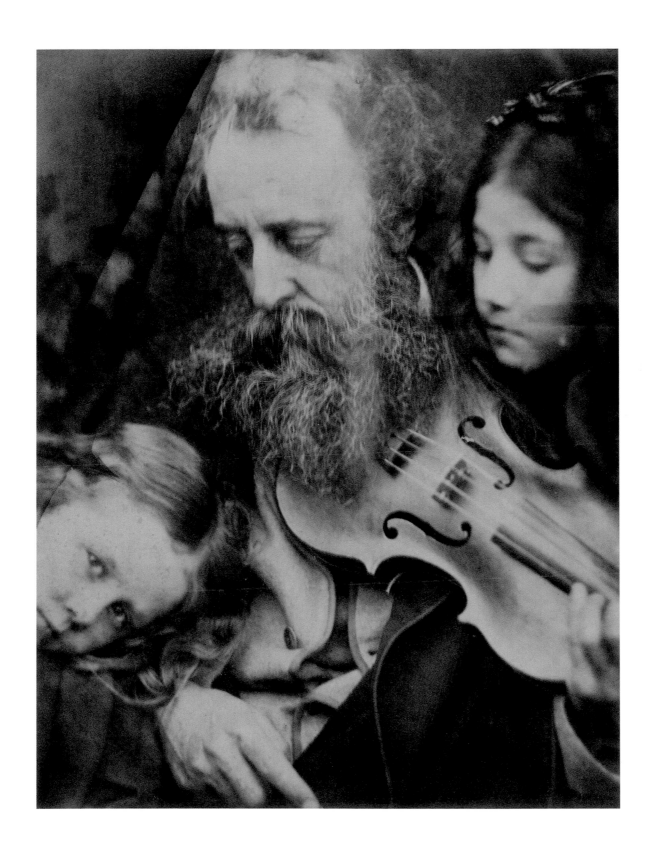

of pure form and perception, Watts intended his art to 'represent ideas too far off, taking one outside experience. I want them to take you as music might, and lead your further even then I myself intended.'[44] In these portraits of Watts, the synaesthetic, transcendent nature of music represents the creative intuition of the painter and sculptor. Cameron depicts her noble painter turned towards his muse as he searches for 'the key-note of those melodies, / To find the depths of all those tragic woes', as she herself put it in her poem 'On a Portrait'.[45] The use of musical iconography in these two portraits is one of the first intimations of Cameron's Symbolist tendencies, and it is significant that she would cast Watts in such a role. Music – and its Symbolist attributes - reappears in Cameron's illustrations of Tennyson's poetry.

In contrast to her more overtly symbolic portraits of Watts, Cameron also produced professional studio-

Fig. 15
Herr [Joseph] Joachim, 1868 (copyright 3 April 1868)
Albumen print, 29.5 × 24.3 cm
The Metropolitan Museum of Art, New York

Fig. 16
Joachim, *c.*1868
Albumen print (*carte de visite*), 6 × 8.5 cm
Oxford, Bodleian Library, Arch. K b.12, fol. 41r

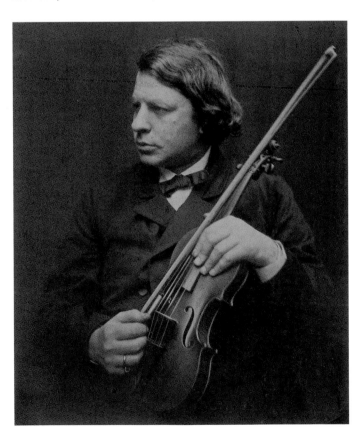

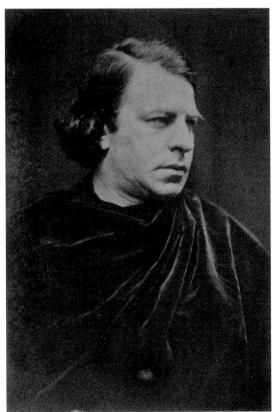

type portraiture, like those of one of the most beloved violinists of the time, Joseph Joachim (1831–1907). Joachim was described as 'the greatest living violinist; no man is so nearly to the execution of music what Beethoven was to its composition. There is something massive, complete and unerring about M. Joachim that lifts him out of the list of great players, and places him on a pedestal apart'.[46] In Cameron's studio-style portrait, the musician poses with his instrument, the source of his livelihood; his face, body, hand and instrument are evenly lit and in equally sharp focus (fig. 15). In a second portrait, which is quite different in terms of both Cameron's technique and its emotional tone, the musician is portrayed without his instrument, wrapped in dark cloth with his chin slightly tilted (fig. 16). The strong gradations of light and dark, the comparative lack of focus, Joachim's highly lit face set against the blackness of the background, and the highlighted folds of the velvety cloth reinforce a sense of the unerring presence of the musician. At Joachim's right shoulder, just below the chin that usually holds the instrument, rise bands of light in subtle scale-like formations drawing the eye back up towards the musician's shoulder and chin. Stripped of all indications of Joachim's own art – his hands and his instrument – Cameron reduces the portrait to a feeling or evocation of the man and his music, a subtle suggestion that would not have been lost on Joachim's contemporaries and that is very different

from the approach seen in her other, more studio-like portrait of the musician.

In Cameron's portraits of Joachim and Watts, it is possible to see in visual form something similar in her intentional building up of each portrait, first as a representation of the literal subject – the 'man of dust and breath' – and then as a subject possessed by an unseen creative force.[47] In the portraits of Watts as a musician in particular, Cameron seems to conjure up the auditory imagination of the painter, who heard in his head combinations of instruments, which he called orchestral effects. As Alison Smith notes, the artist was 'influenced by the Wagnerian concept of synaesthesia, it was [his] ambition that his paintings communicate in symphonic terms, with different components sustaining each other in totalling one grand statement'.[48] Watts claimed that he ought to have been a musician rather than a painter because he 'heard melodies and harmonies without conscious thought, whereas only one picture had come to him in a vision'.[49] Cameron and Watts celebrated the mystery of music, later described by the British poet Arthur Symons as 'a simple thing, its native air; and the art of the musician has less difficulty in its evocation than the art of the poet or the painter … Music can never wholly be detached from mystery, can never wholly become articulate, and it is in our ignorance of its true nature that we would tame it to humanity and teach it to express human emotions, not its own'.[50]

PLATE 50

Daphne, 1866–8

Albumen print, 35.2 × 27.2 cm
Ashmolean Museum, Oxford, WA.OA1354

From the late 1860s onwards, Watts explored in sculpture and paint a variety of mythical themes, including that of Daphne, who fled from a besotted Apollo and was saved by the river god Peneus by being turned into a laurel tree. In Watts's bust of Daphne, her head is turned in profile and gazes down (fig. 17). Her torso is slightly twisted, and laurel leaves wrap around her nude upper body, while her wavy hair is pulled away from her face. Cameron also took inspiration from the Daphne myth. As in Watts's treatment of the subject, Cameron's print shows Daphne's face turned away from the viewer, her eyes cast down. A similar composition is seen in several other works by Cameron, such as her slightly later photograph titled The Dream, a reference to Milton's Sonnet XXIII, in which the speaker sees his dead wife in a dream, and which was inscribed by Watts as 'Quite Divine' (plate 36). As with both the sculpted and photographic treatments of Daphne, the torso and turned face of this subject are the photograph's principal focus, and the downcast eyes suggest the subject's preoccupation with inward thought.

For Cameron, eyes acted as emblems of ambiguity and paradox and were often key components of her compositions.[51] In many of her photographs, eyes are hidden, blurred or hooded, which not only suggests a kind of mystical humanism but also universalizes the subject by removing any direct visual encounter between a specific sitter and the outside beholder. In her poem

'On a Portrait' Cameron evokes eyes 'full of fervent love', masked by lids 'behind which sorrow's touch / Doth press and linger'. This melancholic language also appears in an unpublished poem Cameron sent to Arthur Clough's widow, where she writes of the 'sad and serious eye' that pays tribute to the sensual, musical cadence of Clough's poetry.[52] In the portraits both of and by Watts, a similar treatment of the eyes is also evident. Watts himself often painted the eyes last, leaving empty sockets until a later stage in the painting process because he felt that their depiction was of such importance to the final likeness and character of his sitter.[53] In one known instance, the artist never

Fig. 17
G.F. Watts, *Daphne*, 1870
Marble, 71.1 × 61.0 × 38.1 cm
Tate Gallery, London

completed the eyes, which resulted in a strange image of the poet Henry Taylor (fig. 2). The empty sockets wait in perpetuity for the expression Watts intended; their absence demands that we understand them even more as windows to the soul.[54] The treatment of eyes in Watts's *Daphne* and other paintings, as well as in Cameron's *Daphne* and *The Dream*, also recalls Cameron's portraits of Watts himself, who in many instances looks down, eyes hooded or shadowed.

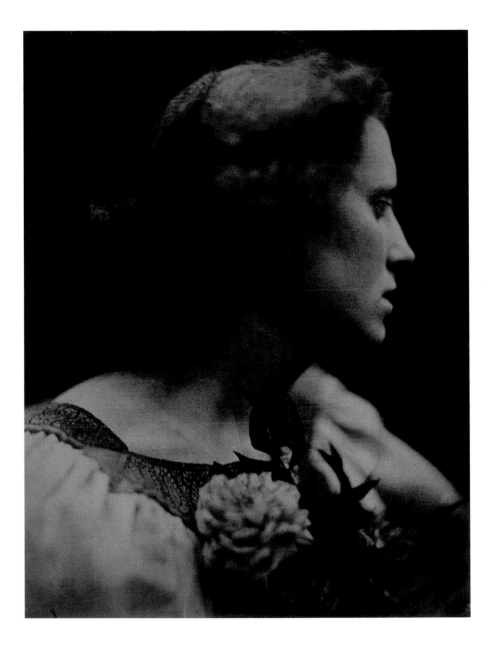

PLATE 51

The South West Wind (Ellen Terry, shortly after marriage to G.F. Watts), 1864

Albumen silver print, 19.3 × 19.1 cm
Oxford, Bodleian Library, Arch. K b.12, fol. 22v

As G.F. Watts's first muse, the young Ellen Terry was
cast in marble and paint, sometimes recognizably
herself and at other times part of a composite
representation of both longing and sorrow. Watts
portrays Terry in profile in *Choosing: Portrait of Dame
Ellen Terry* (fig. 18). They married in February 1864,
and in the portrait she wears her wedding gown,
specially designed for her by William Holman Hunt. It
has been suggested that Watts conceived of the work as
a marriage portrait, and he must have begun it shortly
after their wedding. Completed for the Royal Academy
by April 1864, the painting illustrates the early phase
of Watts's relationship with Terry. But it also alludes
to Terry's youthful naivety, much in the same way as
Cameron's photograph of her, taken the same year in
which she challenges the viewer with her direct gaze
and windswept hair (plate 51).

Fig. 18
G.F. Watts, *Choosing: Portrait of Dame Ellen Terry*, 1864
Oil on strawboard, 47.2 × 35.2 cm
National Portrait Gallery, London

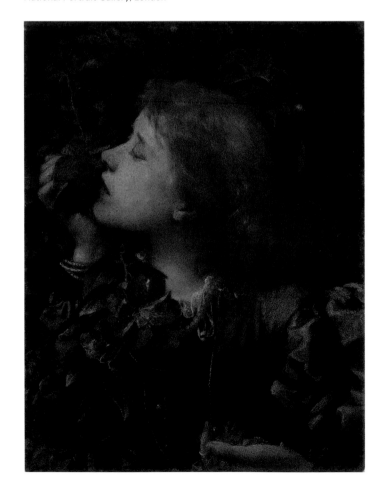

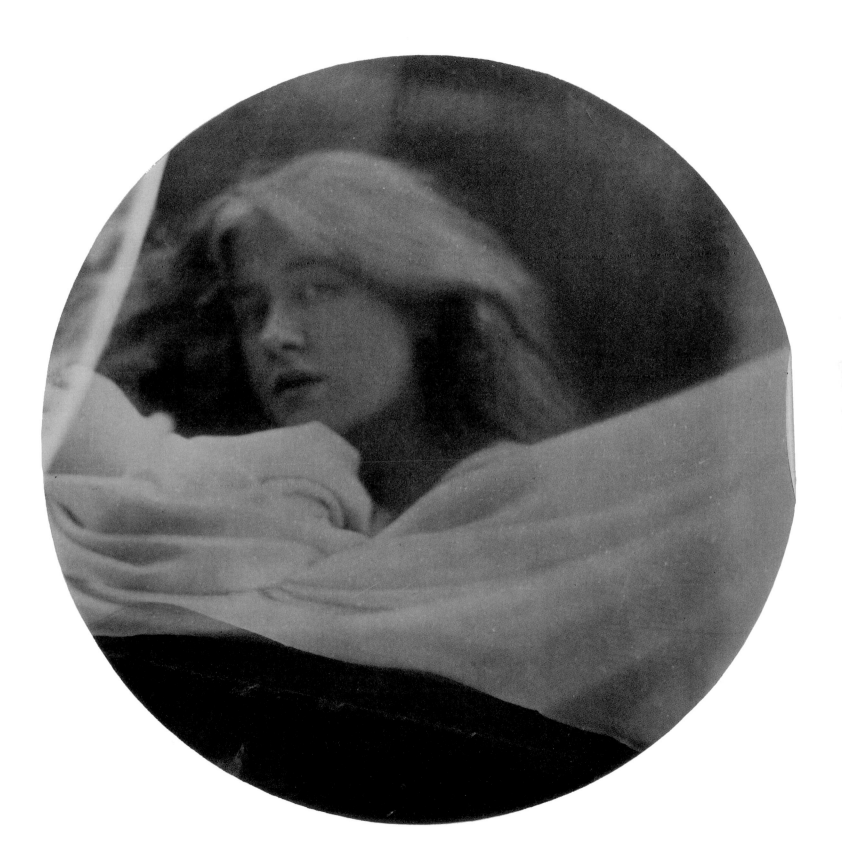

PLATE 52

Sadness (Ellen Terry), 1864

Carbon print, 24.1 × 24.1 cm
J. Paul Getty Museum, Los Angeles

However, another photograph of Terry, titled *Sadness*, portrays the young woman, head turned and eyes gazing down, clutching at her necklace and indirectly at her heart. The floral motif in the pattern of the wallpaper that Terry leans against in Cameron's image echoes the living flowers in Watts's painting. In the painted portrait by Watts, she reaches for the scarlet camellia blossoms while turning from the sweet violets she holds in her left hand, a sign of turning away from youth and towards worldliness. Terry would go on to become one of England's most highly acclaimed Shakespearean actresses. But Cameron achieves a decidedly different sensibility in her photograph. The depth of field is slightly skewed as if to reinforce a feeling of disassociation or imbalance within the frame. The blurring around the edges of wallpaper and behind Terry's head focuses the attention entirely on Terry's profile, exposed shoulders and affecting pose of the hand. Her hair falls loose down her back and the white gown reinforces the colour of the wallpaper while setting off the tones of her skin. The only suggestion of a relationship is the ring on her finger, but the pathos of the image, encapsulated by a circular frame that reinforces the sense that one is looking in on Terry's private pain, is unequivocally portrayed. Where Watts's painting is of a youthful girl drawn to the heady scent of flowers, a painting ultimately conjured up by the feelings and imagination of the artist himself, Cameron's portrait is of a young girl in the grip of heartbreak. Cameron overcomes the perceived indexical limitations of the photographic medium and presents here a subject who is at once herself but also represents the feeling of sadness. Even if Cameron had not provided us with a suggestive title, we would probably still feel as though we had unwittingly encountered a private moment of pain. Terry thus becomes in this image sadness personified and an example of Cameron's aesthetic of sorrow.

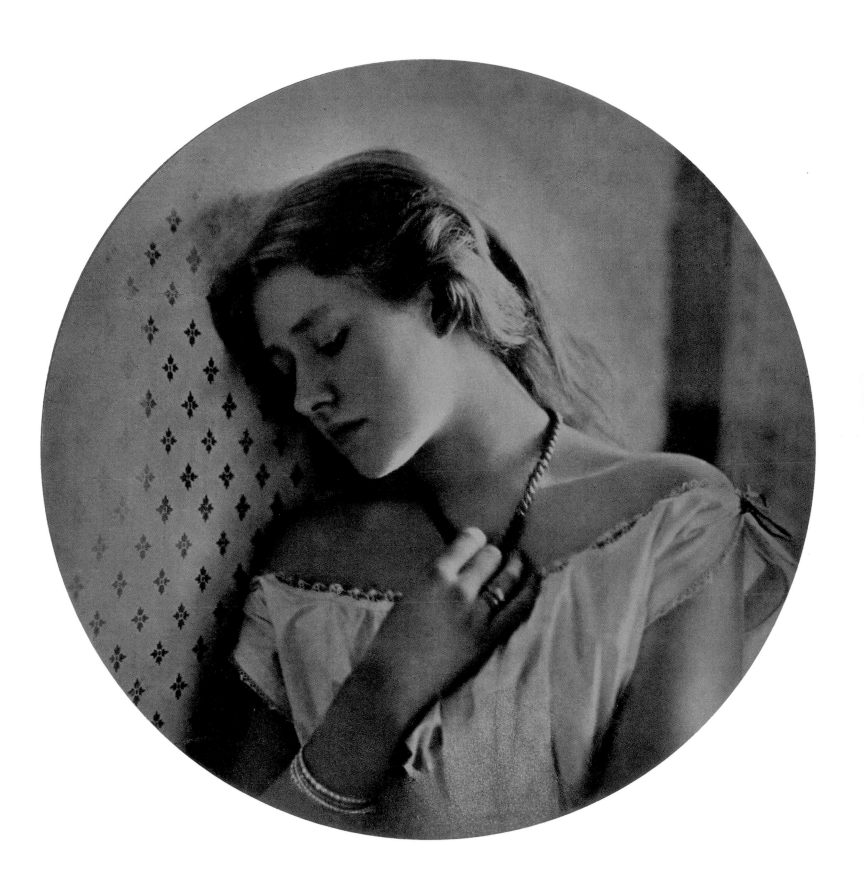

PLATE 53

Alfred Tennyson, May 1865

Albumen print, 25.4 × 19.8 cm
Reproduced as frontispiece to *Illustrations to Tennyson's Idylls of the King, and Other Poems*, vol. II, 1875
Bodleian Library, Oxford, Arch. K b.12, fol. 76r

Cameron produced several portraits of Tennyson between 1864 and 1867. Cameron's 1865 portrait of Alfred Tennyson serves as the frontispiece of the second volume of her *Illustrations to Tennyson's Idylls of the King, and Other Poems*. The placement of this photograph suggests that the artist intentionally interrupted the narrative scenes between the two volumes with this depiction of the poet.[55] She has placed Tennyson, literally and figuratively, in a role surpassing that of author; here he is cast, at a particular moment in the telling of the tale, as a *participant* in the unfolding storyline, acting as the storyteller of and within his own text. Significantly, the poet himself employs a similar tactic in his poem *The Princess*, which features a narrator who becomes a participant in the story. The porous narrative boundary that enables this incursion aligns with what Gerhard Joseph has identified as the 'strange diagonal' in the work of Tennyson, an implied fluidity between the material and spiritual, between the author and his text and, in the case of *The Princess*, between genders.[56]

Cameron would take this aspect up in her own illustrations of *The Princess*.

Cameron's portrait depicts Tennyson as a narrator, looking down at a book open on his lap. In keeping with her tendency to simplify a scene to focus attention on its key elements, he is draped in dark robes, while his face and a single page of the open text are highlighted. A pinned double fold of cloth in sharp focus aligns his face with the open left page of the text, while his out-of-focus and oversized right hand holds the weight of the book in his lap. The picture suggests a man of the cloth reading from a sacred book, or perhaps even a sibylline figure with an open volume in hand, echoing those that decorated Michelangelo's Sistine Chapel ceiling. More affirmatively, Tennyson appears as a reader, a narrator and even an interlocutor between the first volume of Cameron's images and the second. Apart from the suggestion of reading or narrating, there is no outward expression of declamation; instead, somber stillness effectively represents Cameron's 'contemplative' poet.

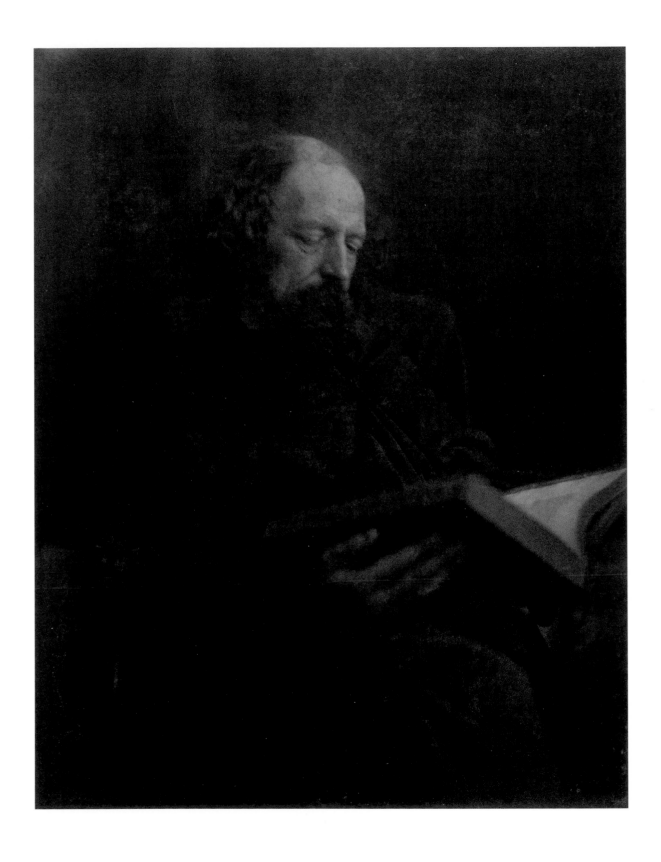

PLATE 54

Alfred Tennyson, May 1865

Albumen print, 25.4 × 19.8 cm

Reproduced as frontispiece to Cameron, *Illustrations to Tennyson's Idylls of the King, and Other Poems*, vol. I, 1874

Oxford, Bodleian Library, Arch. K b.12, fol. 78r

Cameron's more famous portrait taken that same year, which Tennyson half-jokingly called 'The Dirty Monk', sees him portrayed in a more meditative state. She records Tennyson's reception of the image in her 'Annals of my Glass House':

> Meanwhile I took another immortal head, that of Alfred Tennyson, and the result was that profile portrait which he himself designates as the 'Dirty Monk'. It is a fit representation of Isaiah or of Jeremiah, and Henry Taylor said the picture was as fine as Alfred Tennyson's finest poem. The Laureate has since said of it that he likes it better than any photograph that has been taken of him except one by Mayall, that 'except' speaks for itself. The comparison seems too comical. It is rather like comparing one of Madame Tussaud's waxwork heads to one of Woolner's ideal heroic busts.[57]

That he should prefer the portrait by Mayall to hers distressed her at the time, but in comparing the two portraits it is obvious that the artists had divergent approaches to their craft (fig. 19). Mayall's portrait was, perhaps, preferable to Tennyson in that it bespoke an august formality expected from Britain's Poet Laureate. In contrast, Cameron's photograph was at once an achievement in early Pictorialist portraiture, an indication of her appreciation for the poetic possibilities of the medium and expressive of a long-standing friendship in which each supported the other's higher creative pursuits.[58]

The details of the portrait capture the real physicality of Tennyson, as well as an unkemptness that seemed befitting of the poet, one who lived a life of unwavering commitment to his craft even if it meant neglecting his appearance. In her portraiture success was defined as representing both the ideal and the real, even if the latter meant a thinning hairline, an untrimmed beard and heavy wrinkles around the eyes. Cameron would amplify this effect by generally

Fig. 19
John Jabez Mayall, *Alfred Tennyson*, 1864
Albumen print, 19 × 13 cm
National Portrait Gallery, London

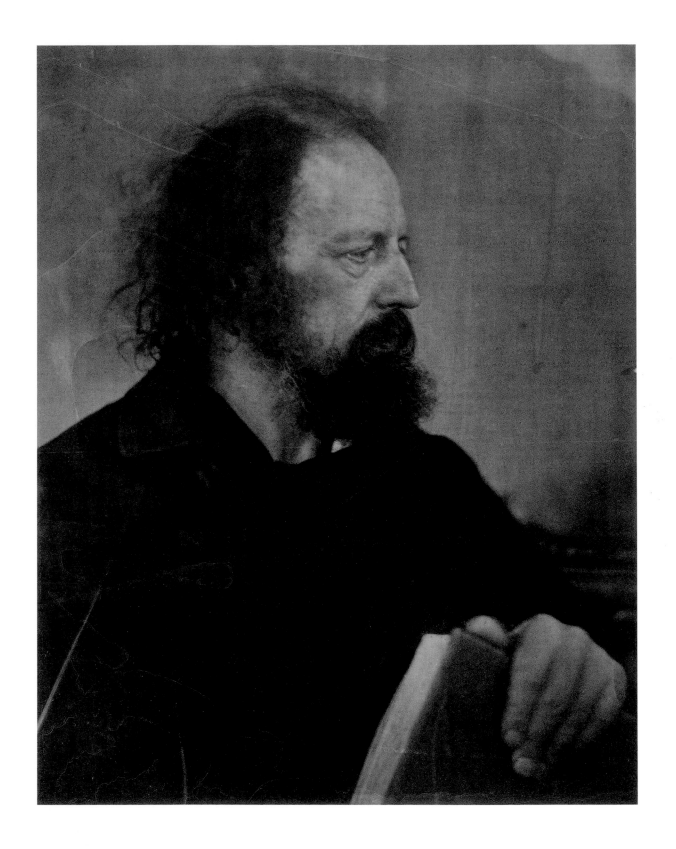

PLATE 55

Alfred Tennyson, August 1865

Albumen print, 25.2 × 20 cm
Oxford, Bodleian Library, Arch. K b.12, fol. 74r

refusing to touch up her glass plates and accepting the imperfections of her negatives as integral parts of the finished product. This, in combination with her use of soft focus and atmospheric tonality, successfully suggest the personality or essential character of her sitter. Her portrait of Tennyson is a response to his lived life, scruffy and slightly weather-beaten, and a tribute to the more stoic, contemplative aspects of the poet that she had come to recognize. Interestingly, the 'Dirty Monk' serves as the frontispiece of the first volume of her *Illustrations*. The book in Tennyson's hands is as yet unopened, in contrast to the portrait placed midway through the two volumes. He is a type of poet-aesthete who, as Anna Jameson claimed, provided the best possible subject for the artist, 'where the first thing demanded has been the absence of beauty and the absence of colour? Ascetic faces, attenuated forms, dingy dark draperies, the mean, the squalid, the repulsive, the absolutely painful … these seem the most uncongenial materials, out of which to evolve the poetic, the graceful, and the elevating.'[59] In other words, this was (or wished to appear to be) an image taken '*from* the Life'.[60]

In the next two portraits, Tennyson donned a soft velvet cap and a dark cloak in a treatment like Cameron's portraits of William Michael Rossetti and Henry Taylor (plates 25, 12, 13). Her soft focus and diffused lighting present Tennyson in an otherworldly frame 'whose margin fades', to use the poet's words.[61] Before the advent of the camera flash and the accoutrements of modern-day photography, Cameron manages to illuminate with precision the poet's profile and to draw out a tiny catchlight in Tennyson's eyes, animating his corporeality. However, as in the 'Dirty Monk' portrait (plate 54) these stand out as testament to Cameron's commitment to approaching her subject like a painter while embracing the particular attributes unique to her medium.

Ultimately, Cameron's portraits present Tennyson as a man who, according to G.K. Chesterton 'cannot be identified with any one of the many tendencies of the age, but has affinities with all … he is the mirror in which the age contemplates all that is best in itself'.[62] Cameron understood Tennyson as a type of seer invested in understanding himself in relation to his own times, while also interested in exploring the universal (and Symbolist) themes of death and love, the passing of time and the melancholic – all themes that she too would entertain in her art. It was also Tennyson the contemplative poet and interpreter of the age, who 'loved beauty more in its collected form in art, poetry, and sculpture', that she captured in her portraits.[63]

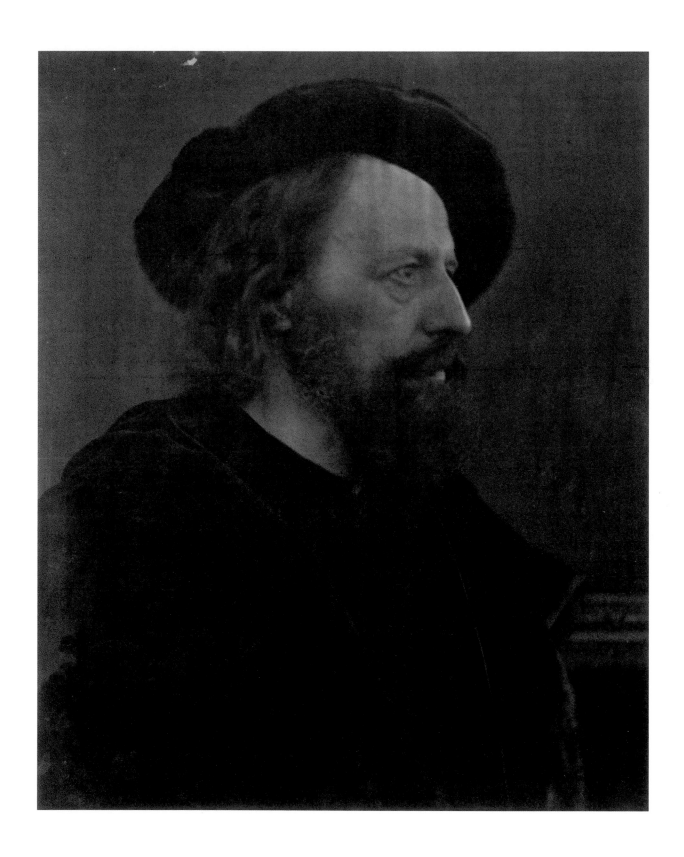

PLATE 56

Alfred Tennyson, 1864

Albumen print, 26.9 × 22.6 cm
Oxford, Bodleian Library, Arch. K b.12, fol. 77r

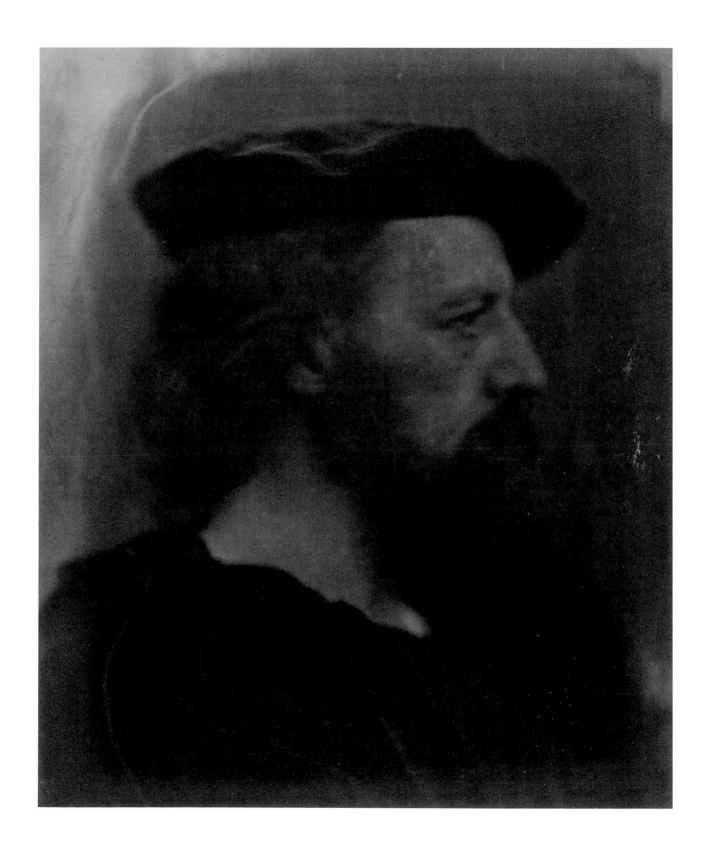

PLATE 57

Alfred Tennyson, 1867

Albumen print, 25.4 × 19.7 cm
Oxford, Bodleian Library, Arch. K b.12, fol. 71v

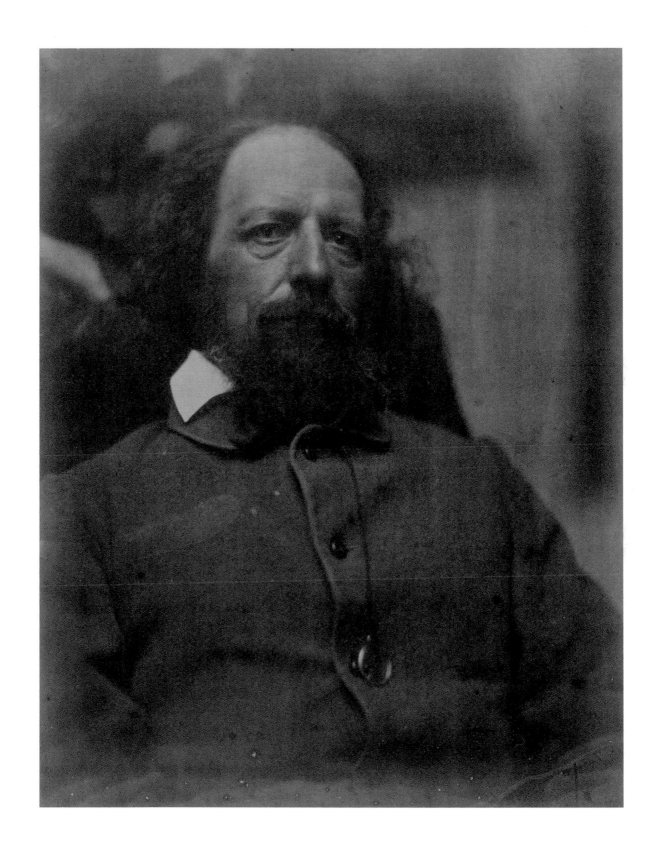

PLATE 58

Hallam Tennyson, Alfred, Lord Tennyson, and Lionel Tennyson, 1865

Albumen print, 25.4 × 19.9 cm

Oxford, Bodleian Library, Arch. K b.12, fol. 75r

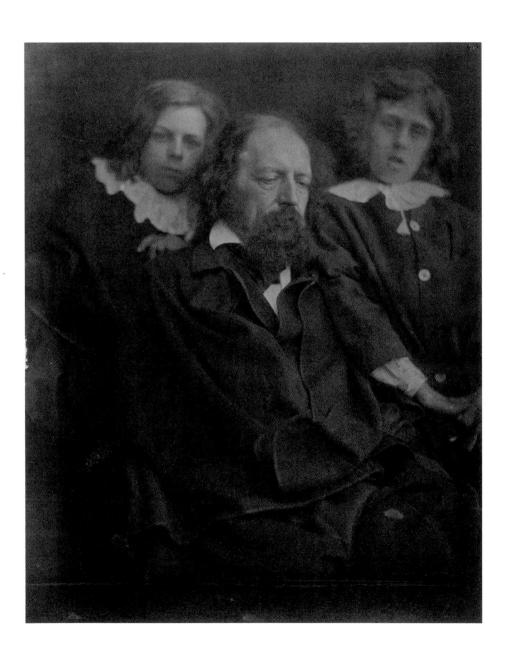

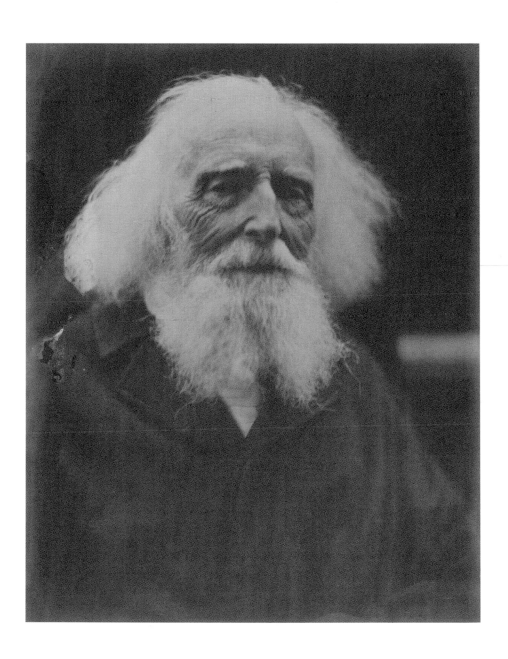

PLATE 59

Henry Sellwood, Mrs Tennyson's father, 1864–5

Albumen print, 25.4 × 19.7 cm
Oxford, Bodleian Library, Arch. K b.12, fol. 79r

PLATE 60

Alfred Tennyson, 1875

Frontispiece and title page from *Illustrations to Tennyson's Idylls of the King, and Other Poems*, vol. II, 1875
Oxford, Bodleian Library, Arch. K b.18

Tennyson's poetry served as an inspiration for artists throughout much of the second half of the nineteenth century, especially the Pre-Raphaelites, who considered his work an important source of material, alongside that of Dante, Chaucer, Shakespeare and Milton. The resurgence of Arthurian imagery in the popular arts was also tied to the general public's reacquaintance with the legendary tales. The republication of Malory's *Le Morte d'Arthur* in 1816 initiated this trend, but it was Tennyson's retelling of the legends at mid-century that reclaimed a place for the tales of Camelot in the British popular imagination.[64] His *Idylls of the King* gave the Victorians their own Arthuriad and resulted in an Arthurian revival that flourished in the latter half of the century. When, in 1874, the poet suggested to Cameron that she illustrate the Cabinet or People's Edition of his *Idylls*, she did so knowing well the attempts at illustrating his poetry that had preceded her own.[65] Among them were those of notable artists and illustrators including Dante Gabriel Rossetti (1857), Daniel Maclise (1857) and Gustave Doré (1867–9).[66] However, it was arguably the Moxon Tennyson, an illustrated edition of his *Poems* published in 1857 by Edward Moxon, that was of greatest significance for Cameron. Rossetti, William Holman Hunt and Maclise provided illustrations for this edition, among others.[67] Hunt's illustration for 'The Lady of Shalott' drew criticism from Tennyson, who did not approve of the approach Hunt took in interpreting the poem, declaring that he did not understand the wildness of her hair nor the sentiment of the image (fig. 20).[68] The 1857 Moxon edition met with mixed critical success and Tennyson was generally disappointed with the results, but its impact as a collection of illustrations influenced book design for the remainder of the century.

Fig. 20
Wood engraving of William Holman Hunt's *The Lady of Shalott* by J. Thompson, 1857
From Tennyson's *Poems* (Moxon edition)
Oxford, Bodleian Library, Dunston B, 1795, p. 67

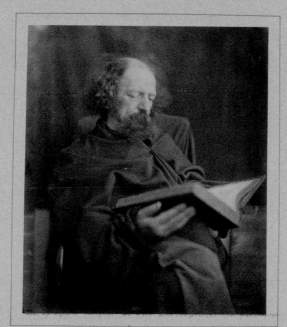

ILLUSTRATIONS

TO TENNYSON'S

IDYLLS OF THE KING,

AND OTHER POEMS.

BY

JULIA MARGARET CAMERON.

HENRY S. KING & Co.,
65, CORNHILL, AND 12, PATERNOSTER ROW, LONDON.
1875.

PLATE 61

Mariana (Agnes Mangles), 1875

Inscription: 'My life is dreary / He cometh not, she said / She said, I am aweary, aweary / I would that I were dead'
Albumen print, 35.2 × 28.2 cm
From *Illustrations to Tennyson's Idylls of the King, and Other Poems*, vol. II, 1875
Oxford, Bodleian Library, Arch. K b.18, no. 8

'Mariana', Tennyson's poem of unrequited love and melancholic isolation, is based on a character from Shakespeare's *Measure for Measure*. The poem inspired John Everett Millais's well-known 1851 painting of the same name. While each artist isolates Mariana as the subject, Cameron's photograph narrows the focus exclusively to the psychological state of her subject. Millais's *Mariana* demonstrates the priorities of the Pre-Raphaelites, namely, the treatment of colour, a fascination with (pseudo-)medieval sources and a focus on detail (fig. 21). Millais was also interested in the emotional and psychological state of his subject, but his Mariana is less engaged with the viewer. She turns away from the implied beholder and faces the window, her back arched in a distinctly sensual pose. While taking inspiration from Tennyson's poem, Millais' unequivocally Pre-Raphaelite agenda arguably works against success in illustrating the poem's pathos and sense of desperate isolation, especially when compared with Cameron's photograph. Millais presents his figure in a chamber in the 'moated grange' large enough to afford her space to stretch and move in, as well as a garden upon which to gaze. In contrast, Cameron's subject fills the compositional space, which appears so limited as to force Mariana to bend her body to fit within the restrictive boundaries of the frame.

She is hemmed in, much like Tennyson's character, a woman virtually imprisoned in a derelict and claustrophobic setting:

> With blackest moss the flower-plots
> Were thickly crusted, one and all:
> The rusted nails fell from the knots
> That held the pear to the gable-wall.
> The broken sheds look'd sad and strange:
> Unlifted was the clinking latch;
> Weeded and worn the ancient thatch
> Upon the lonely moated grange.
> She only said, 'My life is dreary'
> …
> She drew her casement-curtain by,
> And glanced athwart the glooming flats.
> She only said, 'The night is dreary'.
>
> ('Mariana', lines 1–9, 19–21)[69]

While the poem exhibits aspects of John Ruskin's 'pathetic fallacy', with its description of 'sad' sheds and the 'lonely' grange used to suggest something of the human condition, Cameron has stripped all literal suggestion of the room or the grange from the image.[70] The only prop is the ornately carved bench that supports the weight of Mariana, her left arm reaching across its back to cushion her head. The physical and psychological enclosure and sense of isolation also arise from Cameron's strategy of framing the figure tightly

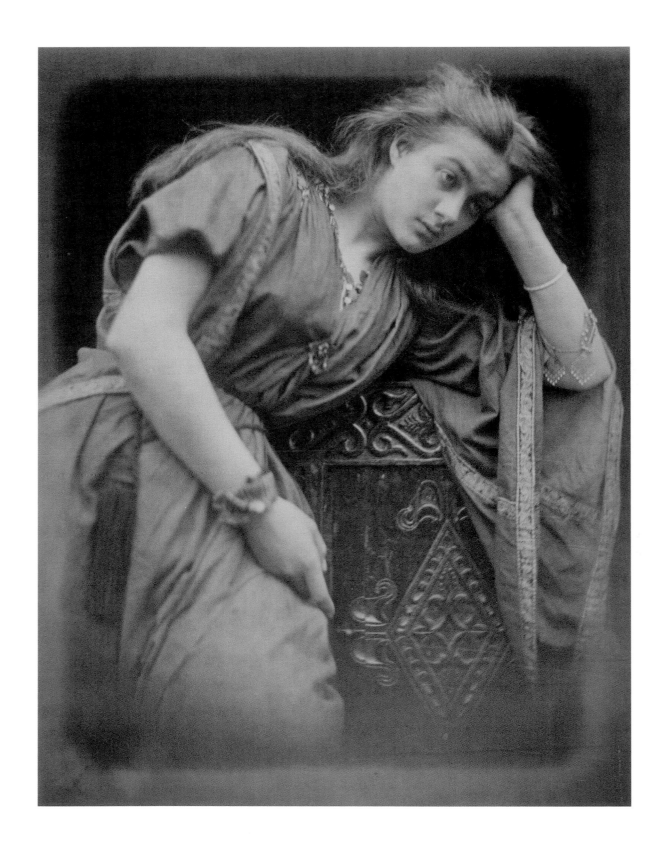

within the boundaries of the composition. Doubling the effect, orchestrating Mariana's own self-enclosed pose, suggests both the figure's physical and psychological enclosure and isolation. Where Millais's painting is constructed around the movement of his subject as she stands and stretches in front of the window, Cameron's subject is static.

Cameron effectively employs shadow and muted tones in the photograph, with soft light exposing half of Mariana's face and limp right arm. Significantly, the sitter's expression is not one of acute emotion, but rather suggests apathy and stultified sensibilities. As the poem details, Mariana realizes that her lover will not return and, in her lament, slips in and out of a dreamlike state. Love, or the lack of it, has overtaken Mariana such that she can no longer register the passing of time. In the poem, Tennyson describes a double vision: a waking state contrasted with hazy dreamlike visions that are reinforced through a language of hopelessness; 'I wish that I were dead,' Mariana muses. Morning and evening become confused and the space in which she exists is described as a casement, an enclosure that is shaped not by light but by the darkness of night. In contrast to Millais's painting, Cameron's illustration contends with the subject's psychological sense of in-betweenness, of fading in and out: Mariana is neither dead nor fully alive; she is not grieving nor is she joy-filled. Her expression is rather flat, her life reduced to a state of apathy as she gives up waiting for the absent lover. It is a picture of pathos and, like Cameron's exploration of the state of internal emotional flux in her Arthurian images and in *The Princess*, it functions as a further exploration of Tennyson's melancholic themes (plates 67, 68).

Fig. 21
John Everett Millais, *Mariana*, 1851
Oil on mahogany, 59.7 × 49.5 cm
Tate Gallery, London.

PLATE 62

King Cophetua and the Beggar Maid, 1875

Albumen print, 31.5 × 24.2 cm
From *Illustrations to Tennyson's Idylls of the King, and Other Poems*, vol. II, 1875
Oxford, Bodleian Library, Arch. K b.18, no. 9

Cameron then turns her attention from the subject of Mariana to that of Tennyson's 1833 short poetic interpretation of the legend of the African King Cophetua and the impoverished maid who draws his attention, simply called 'The Beggar Maid'. It is a story of love at first sight which, according to the legend, resulted in a successful lifelong partnership. Cameron includes the entire poem in facsimile as an accompaniment to her single photographic illustration of the text.[71] It was also a subject famously treated by the Pre-Raphaelite painter Edward Burne-Jones. Both artists made similar decisions to set the scene in an enclosed space. Burne-Jones's painting was completed in 1884, over a decade after Cameron's photograph; in his painting, he portrays the king as subject-like, sitting below the maid. Cameron's treatment captures an extended moment in the narrative of the king and maid observed from the outside; Burne-Jones would follow suit. Cameron's viewfinder frames subjects who are boxed in and enclosed, more literally than Mariana had been, by a diorama-like stage-set. This illustration, more so than others by Cameron, asserts elements of the theatrical, particularly in its composition. Typically, she manages to encapsulate key themes in Tennyson's poetry in a single illustration, focusing on the moment when the king sees the maid and, despite the socio-economic gulf that separates them, hopes she will be his queen.

Cameron uses the enclosure created by the false walls and drapery to reinforce the actual framing of the image. King Cophetua, so the legend goes, had been trapped in a kind of self-inflicted lovelessness, to be freed only by his encounter with the impoverished servant. The king (posed on a pile of thick cloth) stands taller than the maid, and the significant discrepancy in height suggests that, at this point in the narrative, a real connection has not yet occurred.

The extreme artificiality of the staging and the absence of gesture abet Cameron's intent to fix upon a single moment within the narrative schema. Additionally, it isolates the individual figures, whose disconnection is expressed through the space between them and implied with the maid's refusal to look at the king. Her treatment of King Cophetua and the beggar-maid may claim inspiration from early Renaissance portrayals of the Madonna enthroned. Although Cameron's beggar-maid is caught at a slightly earlier moment in the narrative than Burne-Jones's, before she has been elevated to the role of queen, the figure glowing in white with her arms crossed over her heart, just as in the final image of the May Queen series, is poised to become the centre of the king's attention. Cameron's photograph of the beggar-maid stands in the second volume of the *Illustrations* as exemplary of her interest in the different facets of love, responding to Tennyson's poem by fixing on the moment of the king's encounter with a woman who represents an unexpected but redemptive love.

PLATE 64

'They call me cruel hearted I care not what they say' (Emily Peacock and Lionel Tennyson), 1875

Albumen print, 35 × 27.5 cm
From *Illustrations to Tennyson's Idylls of the King, and Other Poems*, vol. II, 1875
Oxford, Bodleian Library, Arch. K b.18, no. 3

The complexity of Tennyson's poem, rich in Marian symbolism, but also more broadly concerned with the temporal cycles of life, is further treated in Cameron's second illustration, which was accompanied by all the verses of the poem's second segment, 'New Year's Eve', written in the photographer's script and presented in facsimile on the page before the photograph. The image's title comprises three lines from the poem – 'He thought of that sharp look / Mother I gave him yesterday, / They call me cruel hearted I care not what they say' ('The May Queen', line 16)[77] – which refers to the May Queen's refusal of her betrothed, Robin, whom she bypasses like a ghost in the first segment of the poem.[78] Cameron portrays both Alice and Robin meeting on the bridge below a hazel tree; he grasps the railing with both hands while she is posed in profile. While the image addresses certain portions of the narrative, the May Queen is neither ghostlike nor passing by, and Robin, although dispirited, gazes beyond Alice rather than at her with a 'sharp look'. This second portrait of Alice addresses her realization of mortality and impending earthly death, which was relayed by Tennyson in grim detail. Although both subjects are clothed in white, they are not physically connected and, while they are embowered by a hazel tree – symbolic of devoted love and reconciliation – this is the end of a relationship, which by all counts had never fully formed.

The tree itself is stripped of springtime foliage and the sharp lines created by the tangle of branches reinforces a sense of fracturing between the couple. Viewed once again through a paradigm of Christian imagery, the May Queen's refusal of Robin is significant for its intimation of the abnegation of earthly love in favour of the divine or spiritual love demanded of a Marian type.

Like the photograph, the second portion of the poem is one of transition, of midlife versus naive youth. Indeed, our narrator seems to be coming into a moment of maturity and the language of the poem focuses on the movement of time – 'the good old year', 'the dear old time', 'before the red-cock crows' – interspersed with suggestions of the changing seasons, notably the absence of foliage and the frost on the pane.[79] It is a wintertime poem, declaring the end of a year along with the end of a life.[80] Alice gives away some of her earthly possessions, asks that a rose be planted in memorial and continues to admonish her mother to wake her early on the days just before her death so as not to miss a moment. Although the text of 'New Year's Eve' reads as a contemplative reflection of someone who is ill and aware that her end is near, Cameron's photograph emphasizes a sense of continuity and movement within the sequence. The character development suggested among the May Queen illustrations recalls Cameron's treatment of her Arthurian subjects in her first volume, particularly Enid,

Elaine and Guinevere. Additionally, while there is little gestural action in any of the individual May Queen photographs, the transition from youth (across the bridge) to maturity and end of life carries from picture to picture and reinforces the progression from life to death to the afterlife. It is Cameron's treatment of the passage of time that establishes a 'temporal congruence' between her photography and Tennyson's poetry, and we find this expressed subtly in her May Queen cycle.[81]

PLATE 65

'So now *I think my time is near, I trust it is. I know / The blessèd music went that way my soul will have to go*' (Emily Peacock), 1875

Albumen print, 35 × 25 cm
From *Illustrations to Tennyson's Idylls of the King, and Other Poems*, vol. II, 1875
Oxford, Bodleian Library, Arch. K b.18, no. 4

The third image of the May Queen cycle is another close-up of Emily Peacock as the May Queen but with a decidedly different effect. Here the subject's gaze is directed upwards. She is wearing another dress; gone are the youthful ruffles and in their place is a regal gown with a brocade bodice and mutton sleeves. Although her eyes gaze upwards, her posture is straight and squarely in the centre of the picture space. With its muted detail and brim tracing an arc around her head, her hat is suggestive of a halo and her hands cross over her chest. In this third pictured moment, the absence of background reinforces the sense of pathos expressed on the May Queen's face. Although it represents a tragic moment in the poem, Alice's bearing and composed expression suggest dignity more than fear. Thus Cameron produces a portrait evocative of the sensibilities of a subject who anticipates or even longs for death, as described in verse by Tennyson:

> I thought to pass away before, and yet alive I am;
> And in the fields all around I hear the bleating of
> the lamb.
> How sadly, I remember, rose the morning of the
> year!
> To die before the snowdrop came, and now the
> violet's here.
>
> O, sweet is the new violet, that comes beneath the
> skies;
> And sweeter is the young lamb's voice to me that
> cannot rise;
> And sweet is all the land about, and all the flowers
> that blow;
> And sweeter far is death than life, to me that long
> to go.
>
> 'Conclusion [The End]', lines 1–8[82]

Fig. 22
Mater Doloroso, 1852
Engraving
From Anna Jameson, *Legends of the Madonna*, 1852
Oxford, Bodleian Library, (OC) 170 k.26, p. 39

Cameron entitles the third written fragment in her volume 'The End', while Tennyson titled it 'Conclusion'. She transcribes the full account of the May Queen's last hours on earth, a text which reads as her last rites and describes the winter of her death as offset by the coming spring, a reminder that life goes on. The third portion of the poem reinforces the temporal while also alluding to the continued spiritual existence of the soul. Additionally, the motifs of life, death and memorial create a sense of the melancholic. Likewise, in this cycle dedicated to the May Queen we see two of Cameron's artistic preoccupations: an ongoing engagement with an aesthetic of sorrow and its relation to the sublime, and an affinity for Tennyson's notion of 'Death in Life', the sorrowful longing for 'days that are no more', a motif she would revisit later in her second volume.

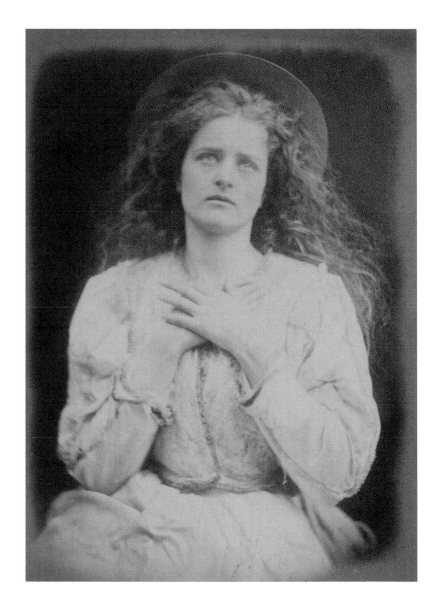

PLATE 66

The Princess (Miss Johnson, Miss Johnson, Unknown Woman and Mary Ann Hillier), 1875

Albumen print, 32 × 25 cm
From *Illustrations to Tennyson's Idylls of the King, and Other Poems*, vol. II, 1875
Oxford, Bodleian Library, Arch. K b.18, no. 5

Cameron's first photograph in this group of three images dedicated to Tennyson's *The Princess* envisions a significant moment for the prince who, upon seeing Ida ('that strange Poet-princess with her grand / Imaginations') and her companions, slipped into a weird seizure in which all things appear as if in a dream state.[83] In the moments just before he loses his faculties, he describes Princess Ida as columnar and stately: 'She stood / Among her maidens, higher by the head' (*The Princess*, lines 162–3).[84] It is this vision of the princess that Cameron photographs. Clothed in a white gown with vertical folds that emphasize her regal height, Ida holds a book in her hands and some kind of stylus, indicating the scholarly pursuits undertaken at the women's college, which is the primary setting of the narrative. She appears a head taller than her three companions, who flank her on all sides. Two hold books and the third, who remains partially blocked from view by Ida, could also be reading, as suggested by her downcast eyes. Ida wears a decorated headdress, which holds back her flowing hair, while her three companions are fully capped.

The grouping may be an allusion to a *sacra conversazione*, a Renaissance compositional style, which grouped saints around the Virgin. A one-dimensional, vertical shape (described in the text as a pillar) appears directly behind the princess and may also equate pictorially to the Virgin's cloth of honour and suggests her transformation into a Madonna-like figure. Additionally, in *Sacred and Legendary Art*, Anna Jameson describes the *sacra conversazione* in art as a devotional image of sacred subjects which functions as neither portrait nor history.[85] No action is represented; instead, the arrangement signifies the communion between subjects and, in the case of this photograph, between viewer and subject. Cameron took certain liberties in the production of this photograph, elevating her model on a stool to add to her statuesque appearance and possibly scratching in the outline of a shoe, alluding to Tennyson's line about the princess's foot controlling one of her tame leopards, the latter symbolized in Cameron's photograph by an animal rug: 'Her back against the pillar, her foot on one / Of those tame leopards. Kittenlike he rolled' (*The Princess*, lines 164–5).[86]

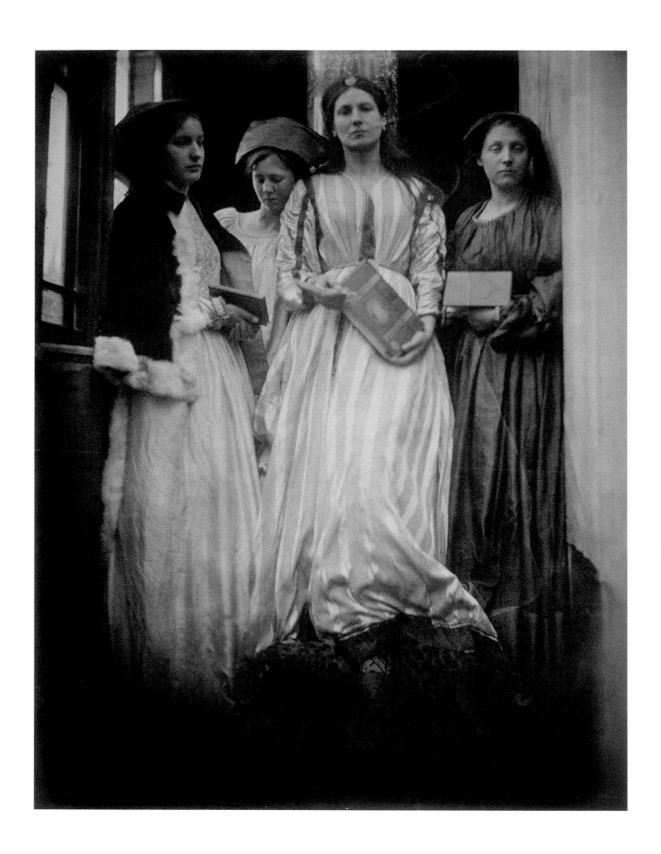

PLATE 67

'O hark! O hear! how thin and clear / And thinner clearer farther going', 1875

Albumen print, 34.6 × 28.2 cm

From *Illustrations to Tennyson's Idylls of the King, and Other Poems*, vol. II, 1875

Oxford, Bodleian Library, Arch. K b.18, fol. 6

Cameron then shifts her attention from a group portrait to two individual portraits of equal significance. The second and third images of *The Princess* triptych move the viewer from a place of veneration to a consideration of a melancholic tableau focused on two of Tennyson's songs from the poem, which he subtitled 'A Medley'.[87] Cameron's musicians are female subjects who create a type of lyrical pause in the visual proceedings much as they do in Tennyson's poem. The first of these lyrical illustrations is titled *'O hark! O hear! How thin and clear, / And thinner, clearer, farther going'.*[88] The sonnet provides a picture of the setting sun's effect on the landscape and exhibits the poet's uses language and poetic construction to suggest the picturesque, giving an impression of the movement of light and its consequent beauty: 'The splendour falls on castle walls / And snowy summits old in story; / The long light shakes across the lakes, / And the wild cataract leaps in glory' (*The Princess*, sonnets III–IV, lines 1–4).[89] Light and its ever-changing qualities are a significant preoccupation of the poem, much as light functions as a principle concern for the photographer. The poet juxtaposes the sublime as found in the natural world, itself inexorable and griefless in death, against the fragility of humanity. Tennyson also presents the permanence of nature – with its 'snowy summits old in story', 'the wild cataract', and its 'long lights' and 'purple glens' – against the impermanence of the bugle's echoes from 'soul to soul'.[90] It is a sonnet about transcendence, the permanence and impermanence of life as expressed in nature and human existence. That the sun is setting reminds one of Tennyson's uses of geographical time as a device to create movement in the poem, and to suggest the cycles of life.[91]

Cameron makes an interesting choice in including the harp rather than the bugle of Tennyson's poem. Given her industriousness, one might expect that she could have found a horn to represent more literally the text she includes in the excerpt, but instead she opts for the stringed instrument. It may have been a compositional choice given the instrument's curves and the pleasing form it makes in alignment with her subject's body. But its sound may have played a role as well, in that the song of the harp would more readily create the 'thin and clear' echo described in the poem and highlighted by Cameron's choice of title for the photograph. The harp is also the instrument associated with the biblical David and his Psalms, written as songs of praise and lamentation. Equally significant are classical references to the musician and poet Orpheus, whose music-making with a stringed instrument was seen as responsible for awakening the unconscious. Thus, Cameron uses the harp, with its quality of sound and symbolic potential, to reinforce the musicality of the text and signify the poetic potential of the lament, a response to the sublime mysteries of love, death, and sorrow.

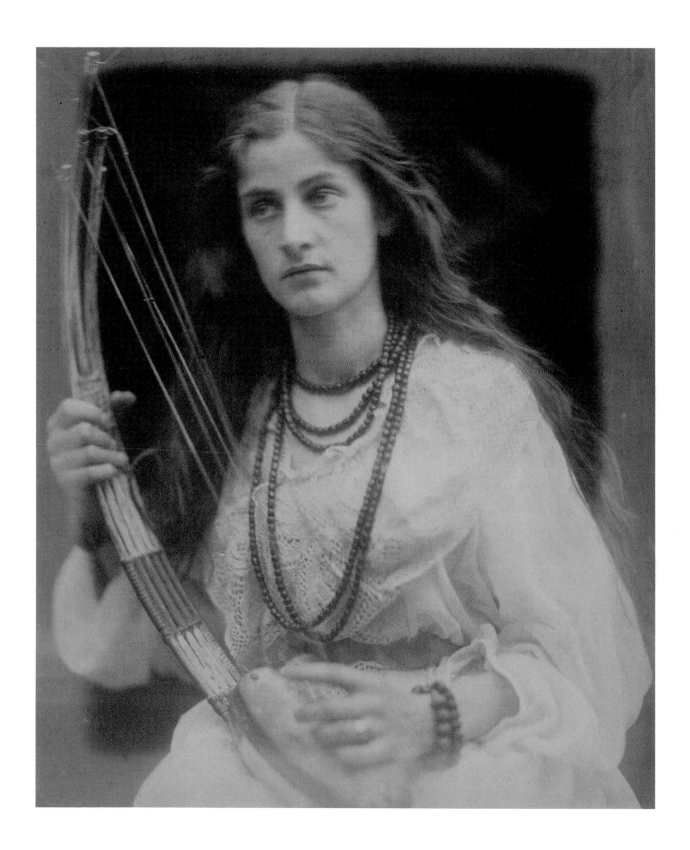

PLATE 68

'Tears from the depths of some divine despair / Rise in the heart and gather in the eyes' (May Prinsep), 1875

Albumen print, 32.9 × 22.1 cm
From *Illustrations to Tennyson's Idylls of the King, and Other Poems*, vol. II, 1875
Oxford, Bodleian Library, Arch. K b.18, no. 7

In keeping with the overall schema of *The Princess*, a woman is once again the focal point of the third image in the triptych, standing erect and facing the viewer directly. Although Cameron is, in part, responding to the narrative of the poem, she makes a deliberate choice by portraying this second lyrical break. As in the previous image, her subject is stilled without any gestural indication of playing or listening. Cameron's subject simply holds the instrument, hand across the strings, with her mouth closed. But the suggested clear and thin echoes of the previous interlude change tone vis-à-vis the appearance of Cameron's model. In contrast to the previous subject clothed in a light gown, the model in this illustration is dressed in a dark costume with a heavy chain and cross around her neck, appearing as a kind of mourning minstrel who emerges from a dark, receding background. She is presented with heavy-lidded eyes and a sober countenance and, as such, becomes lamentation personified. As Carol Hanbery MacKay points out, Cameron's overall project was 'akin to using photographs to give us a series of silent soliloquies – providing us with access to a kind of imaginary internal discourse'.[92] In combination with the text, Cameron's illustration presents just such an internal soliloquy, as the subject contemplates 'the days that are no more'.

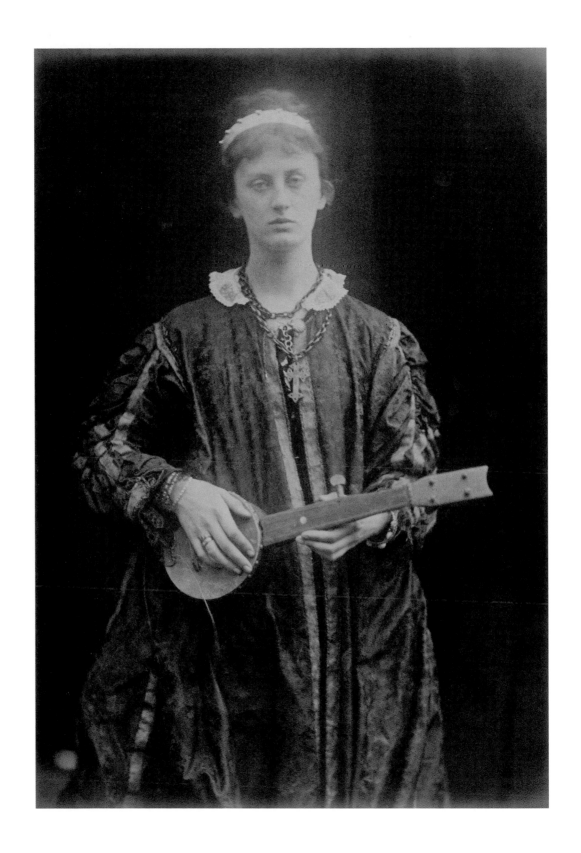

PLATE 69

Elaine, 1875

Inscription: 'and the dead / Oar'd by the dumb went upward with the flood'
Albumen print, 36 × 27.2 cm
From *Illustrations to Tennyson's Idylls of the King, and Other Poems*, vol. II, 1875
Oxford, Bodleian Library, Arch. K b.18, no. 10

A lengthy excerpt from 'Lancelot and Elaine', detailing Elaine's final wishes and her death, accompanies Cameron's first photograph of the closing series of related images in her second volume. Having determined the ultimate outcome of her life and unrequited love, Elaine compels her father to accept her final wishes in clear and definitive terms. There is no evidence of panic or mania in the text; rather, in calm and decisive language Elaine's death, a process that took ten days, is recounted. Her decline was first marked by a misleading cheerfulness, but then her situation becomes increasingly grim:

> She ceased: her father promised; whereupon
> She grew so cheerful that they deemed her death
> Was rather in the fantasy than the blood.
> But ten slow mornings past, and on the eleventh
> Her father laid the letter in her hand,
> And closed the hand upon it, and she died.
>
> ('Lancelot and Elaine', 1123–8)[93]

Cameron's style remains consistent here; the space is compressed and her use of focus pinpoints the most significant aspects of the composition. She replicates parts of the excerpted verse carefully, incorporating the double doors of the palace, to which Elaine's body is rowed in a barge, and the shield cover she was embroidering for Lancelot, which now hangs above her. In so doing Cameron devises a compositional strategy that draws upon the simple staging and architectural framing used in early Renaissance frescoes, which she would have known in reproduction through her involvement with the Arundel Society.

The boxy space, with minimal detail, focuses the viewers' attention on the individual characters. Charles Cameron plays the old man who accompanies Elaine's body on the barge. The angle of the light leads the viewer's eye from him across her outstretched body to her face, and finally upwards to the embroidered shield cover overhead. Elaine is clothed in a light-coloured gown, over which is draped a dark coverlet strewn with small white blossoms. A glowing arrangement of flowers serves as a focal point between the faces of Elaine and the barge attendant. White flowers frame her head, and the lily-like flower Elaine appears to grasp, along with a floral motif repeated in the embroidery above her head, harken back to earlier references of Elaine as the 'lily maid' of Astolat, who herself bears typological associations with the Virgin Mary and Eastertide. Cameron deftly holds focus on both the old man's and Elaine's faces, a difficult feat given the distance between the subjects and the constraints of the lighting and long exposure times. The attendant's face, slightly tilted and looking across at the dead maiden, reinforces the pitiable aspects of the scene. Elaine's letter to Lancelot is not present, though it will make a central appearance in the following illustration.

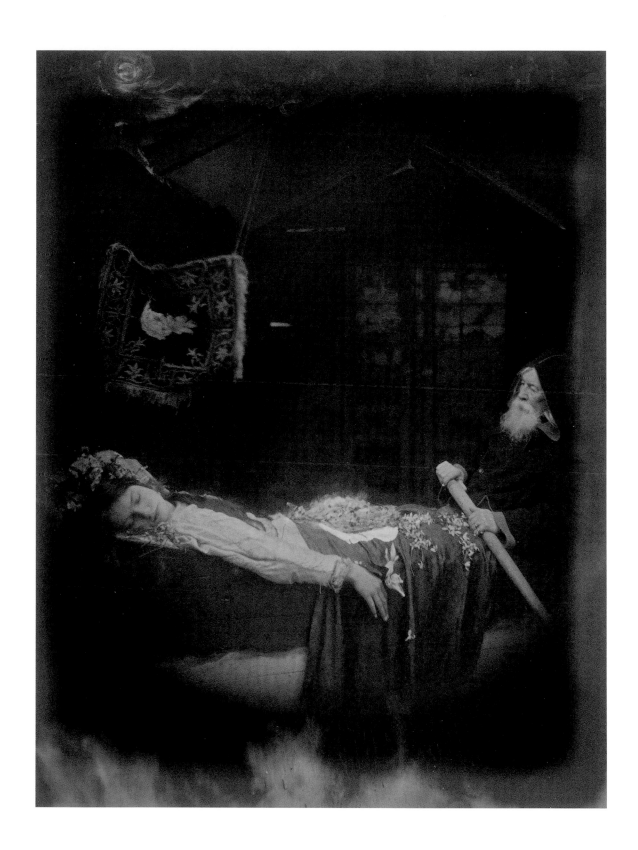

PLATE 70

'*And reverently they bore her into the hall*', 1875

Albumen print, 34.5 × 28.3 cm
From *Illustrations to Tennyson's Idylls of the King, and Other Poems*, vol. II, 1875
Oxford, Bodleian Library, Arch. K b.18, no. 11

The illustration titled 'And reverently they bore her into the hall' is the only image in the two-volume set that includes both Arthur and Elaine, among others in attendance. The latter's body lies in full repose, extending the width of the image, cutting the composition nearly in half. A lily-like flower appears again near her right hand. Charles Hay Cameron returns as the aged attendant, standing nearest to her head, eyes cast down. As in the previous image, Elaine and the old man are the most brightly lit and are in relative focus compared to the other figures. Arthur stands upright, holding above Elaine's torso the opened letter, with its message of her unrequited love for Lancelot and last request that her body be presented to the court of Camelot. Guinevere appears in profile, eyes cast down at Elaine, positioned between Arthur and Lancelot. Elaine retains her stilled expression from the previous image; Tennyson's text describes the onlookers as gazing from Arthur's face to Elaine's, imagining, as Arthur reads her letter, that Elaine's own lips stirred: 'To hers which lay so silent, and at times, / So touched were they, half-thinking that her lips, / Who had devised the letter, moved again' ('Lancelot and Elaine', lines 1277–79).[94]

In Cameron's image the letter functions as a visual analogue to the literary device of prosopopoeia, providing the dead Elaine with a voice, this being particularly akin to photography's ability to reincarnate someone or something from the past.[95] Here her lips do not literally move, but the letter functions as a personification of Elaine and signifies her presence despite the obvious absence created by her death. Cameron preserves the relationship between King Arthur and Elaine described in Tennyson's text by positioning him near the centre of the image with the letter in hand. However, he and the other figures are shadowed and appear secondary to the relationship between the maid, still holding her lily, and the old attendant, who looks on with the grief one might expect of a father figure. Again, Cameron may have found inspiration in visual precedents: the picture's composition seems to allude to well-known renditions of the death of the Virgin in late medieval and early Renaissance art. Elaine, the Lily Maid of Astolat as presented in this image is no longer a type of the Virgin Annunciate, but possibly the dead Queen of Heaven, the archetype of ideal, divine love.

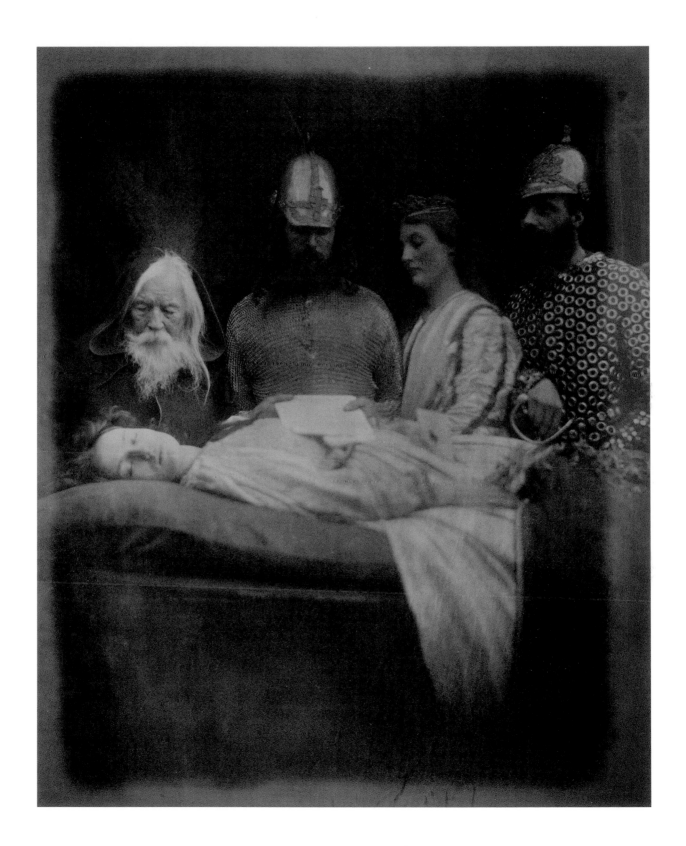

PLATE 71

'So like a shatter'd column lay the King', 1875

Albumen print, 35.2 × 27.8 cm
From *Illustrations to Tennyson's Idylls of the King, and Other Poems*, vol. II, 1875
Oxford, Bodleian Library, Arch. K b.18, no. 12

In this image, Cameron illustrates the imminent death of King Arthur himself, who is similarly laid in a barge. In *'So like a shatter'd column lay the King'* Cameron replicates the composition of the previous two images of Elaine, with the visual plane divided horizontally by a reclining body. King Arthur, not yet dead, stares out of the photograph at the viewer, his head resting in the embrace of one of three women dressed in white. Significantly, the model at the front of the barge holding Arthur's head is Mary Ann Hillier, who was frequently used by Cameron as her favourite model for her Madonna images. A second woman places her hand on Arthur's arm and a third stands robed and veiled at the end of the barge. The crowned 'queens,' as Tennyson describes them, raise their voices in a lament shrill like the wind, 'a cry that shiver'd to the tingling stars' ('The Passing of Arthur', line 367).[96] Tennyson's queens recall those of Virgil's *Aeneid* and exemplify his ability to interweave Malory's Arthurian legends with elements of Virgil, Homer and Milton.[97] Notably, contradicting Tennyson's text, Cameron's queens lament with mouths shut in suggested silence, perhaps engaged in a mourning that draws from depths beyond sound, that is the reverberating echo of grief.[98]

More in keeping with Tennyson's poem, behind the queens are three black-hooded figures who turn away from the scene, evoking those described in the lines: 'That all the decks were dense with stately forms, / Black-stoled, black-hooded, like a dream' ('The Passing of Arthur', lines 364–5).[99] Using the hooded figures to create a sense of receding depth, Cameron extends the effect of the darkened background further with lines of what may be masts and some type of roofline. All serve to accentuate Arthur and the three queens, with the focus on the king in particular capturing detail in the links of his chainmail and his unfocused gaze. At the bottom of the image, Cameron includes folds of cloth to indicate the waters and mists of the lake to which Arthur's body will return. As with her treatment of Elaine, Cameron draws on late medieval and early Renaissance compositions, especially in the arrangement of the figures around Arthur.

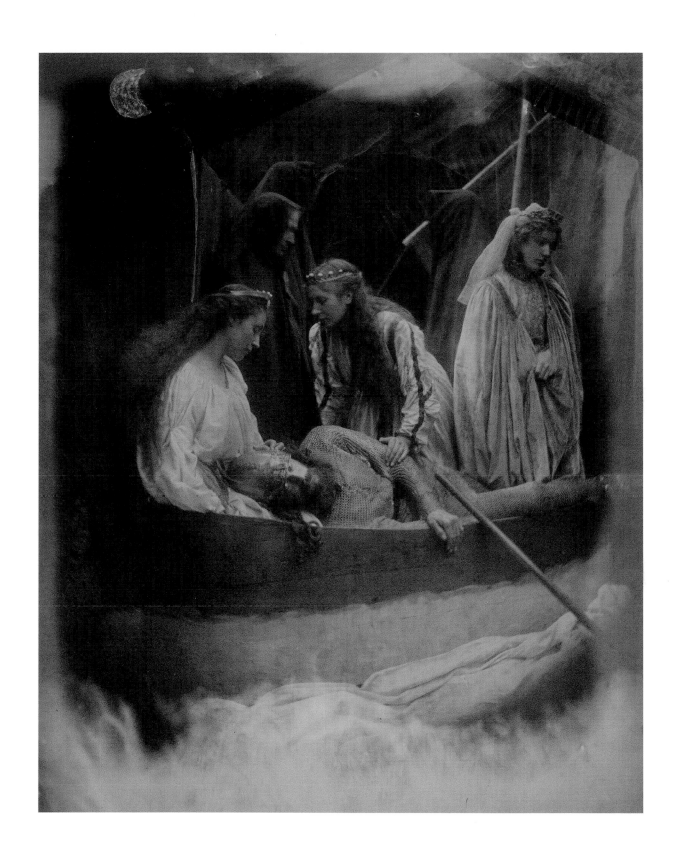

PLATE 72

Maud (Mary Ann Hillier), 1875

Inscription: 'There has fallen a splendid tear / From the passion-flower at the gate / She is coming my dove, my dear / She is coming my life my fate'
Albumen print, 33.5 × 27.5 cm
From *Illustrations to Tennyson's Idylls of the King, and Other Poems*, vol. II, 1875
Oxford, Bodleian Library, Arch. K b.18, no. 13

Cameron's final image of the volume takes as its subject one of the principal characters in Tennyson's *Maud*. Mary Ann Hillier again poses, standing in profile pressed against a garden gate. She wears a light-coloured gown free of all detail and her hair is loose, flowing away from her face and out of the frame. Her face is softly lit and her expression is of pensive melancholy. The frame is divided diagonally in half: a wall of tangled vines counterbalances Maud's hazy form, which itself appears wrapped and crowned in vines. Significantly, Cameron's lens focuses on two fully formed passionflower blossoms that are directly in line with Maud's heart, near the left-hand portion of the image. The blooms are captured by the camera in almost clinical detail, as is a third blossom on the same level as Maud's forehead. The sheen of the leaves reinforces the vigour of the vines that seem to embrace Maud, even as she appears as a kind of strangely lit and almost ghostly apparition.

The significance of Cameron's portrait of Maud can also be understood in connection with the symbolism of the flowers referenced in the accompanying text. The red rose of sensual earthly love is paired with a white rose symbolizing purity, while the lily recalls the divine love of the Virgin. Considered alongside the final image of King Arthur at the end of Cameron's first volume (fig. 23), the symbolic potential of the passionflower, portrayed prominently in the photograph of Maud and

cited in the verse handwritten on the mount below, becomes apparent. The final image of the first volume depicted the tragic, Christlike hero of Camelot looking to our right; Maud, associated in the text with roses and lilies but linked in this photograph most prominently with the passionflower symbolic of Christ's sacrificial death, becomes a kind of *Mater Dolorosa*, a female counterpart who faces to our left as if to mirror Arthur both compositionally and typologically.[100]

Fig. 23
The Passing of King Arthur, 1874
Albumen print, 34.7 × 25.5 cm
From *Illustrations to Tennyson's Idylls of the King, and Other Poems*, vol. I, 1874
Harry Ransom Center, Austin, TX

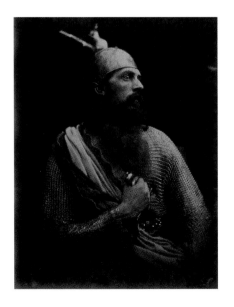

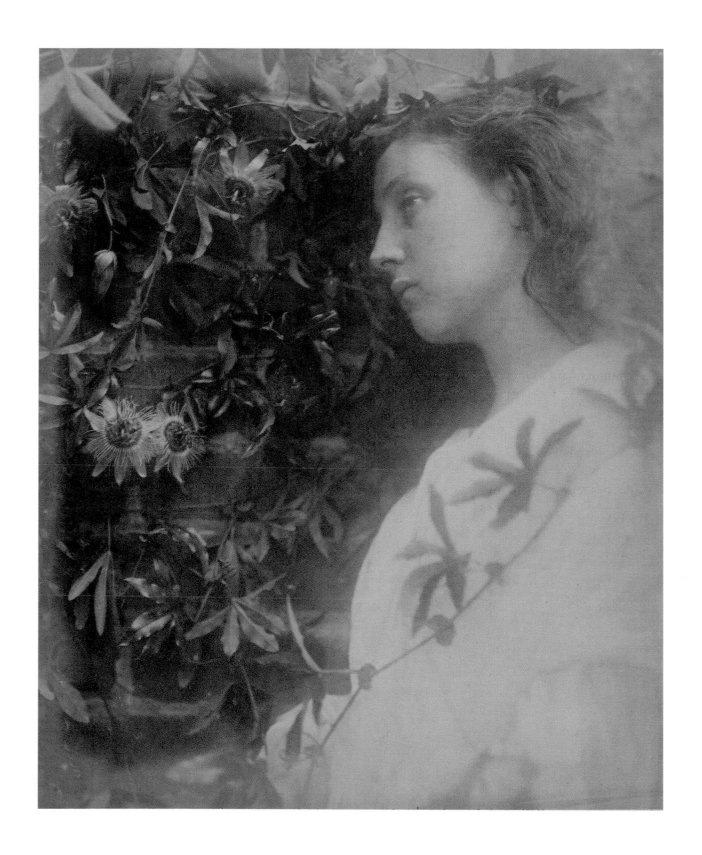

PLATE 73

Photographic reproduction by Carlo Naya of Venice of
Giovanni Bellini's *Madonna & Child*, (1430), n.d.

26 × 34.9 cm

Inscription: "Riproduzione tratta dall' originale", da C.NAVA fotografe di S.M. il Re d'Italie

Oxford, Bodleian Library, Arch. K b.18, no. 14

PLATE 74

Ophelia (Mary Pinnock), 1867

Albumen print, 35.7 × 25.5 cm
Ashmolean Museum, Oxford, WA2009.178

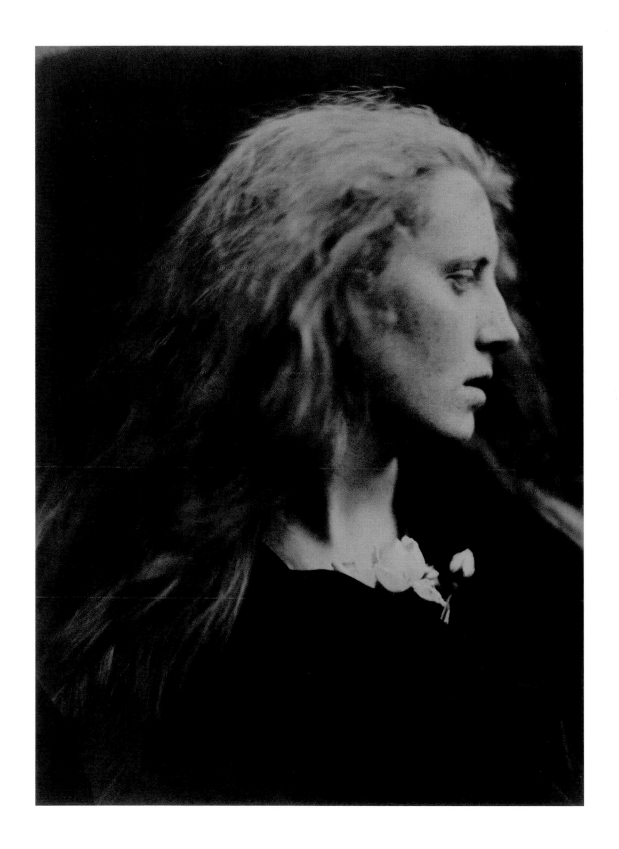

PLATE 75

Julia Jackson, 1867

Albumen print, 29 × 23.2 cm
Oxford, Bodleian Library, Arch. K b.12, fol. 7v

Cameron's portraits of her beloved niece Julia Prinsep Stephen, née Jackson (1846–1895) further elucidate the poetic potential of her art and demonstrate the photographer's command of the medium. Cameron took dozens of pictures with almost all dedicated exclusively to Julia as herself, rather than being appropriated to represent classical, biblical or literary subjects in her illustrative photographs. She thus joined Henry Taylor and Mary Ann Hillier as the most frequently photographed across Cameron's short but productive career. Julia had drawn the early attention of British artists, including the sculptor Thomas Woolner (1825–1892) and the Pre-Raphaelite painter William Holman Hunt, whom she likely met through her parents' salons at Little Holland House. Her second husband, the biographer Leslie Stephen, accounted for Julia's allure, as did their daughter, Virginia Woolf, who cast her mother as Mrs Ramsay in *To the Lighthouse*, of whom she wrote: 'One wanted fifty pairs of eyes to see with … Fifty pairs of eyes are not enough to get round that one woman with.'[101] Her youthful beauty matured quickly into something altogether fascinating for Cameron, whose wide-ranging depictions included wedding portraits taken in 1867 to sobering images taken after the sudden loss of Julia's first husband, Herbert Duckworth, just three years later.

Among the portraits included in the Bodleian Library's Taylor collection, that full range is expressed in two portraits of Julia. They also showcase the rapid maturity of the photographer's skill, with the first portrait nearly perfect compositionally. Julia's centred profile fills the frame and light expertly traces the outline of her face. The detail of her lace color anchor the image and from it rises a strong, sculptural neck reminiscent of those cast in stone by classical and Renaissance artists. The deep contrasting tones concentrate the viewer's attention on the curving lines of Julia's decidedly contemplative pose, as well as the receding shadows that create the allusion of pulsing dimensionality. In a second image, taken the same year, Julia stares directly at the viewer, hair loose and only half her face emerging from an inky background.[102] Cameron had once described taking a portrait of Sir John Herschel as an 'embodiment of a prayer' (plate 77); here that analogy is extended further still to include notions of soulfulness.[103] Stripped of nearly all detail, this second photograph of Julia presents something of what Susan Sontag meant when she later wrote that a 'painter constructs, while the photographer discloses'.[104] We are left to wonder, eye to eye with Julia, what is being disclosed.

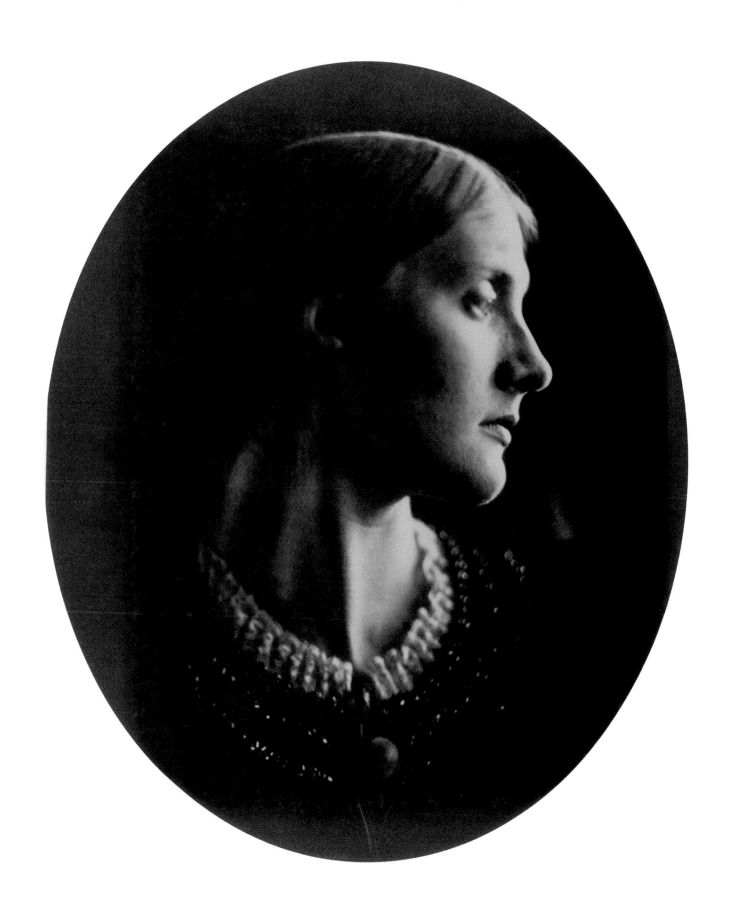

PLATE 76

Mrs Herbert Duckworth / Julia Jackson, 1867

Albumen print, 25.2 × 19 cm
Oxford, Bodleian Library, Arch. K b.12, fol. 23v

Photographs like these represent the skill of their maker and may also provide a view into what elements must persist in the creation of an exceptional photograph. It seems that the success of Cameron's two portraits of Julia are predicated on the capacity of the photographer to first open herself to the humanity presented before her lens, to receive whatever message is conveyed and to reduce it to only what is necessary to convey meaning. Such an act is made possible through the kind of empathy described by Violet Paget, writing as Vernon Lee, in her *The Beautiful* (1913), in which she complicates the frequently misused word by returning to the original German term *Einfühlung*, or 'feeling into'.[105] As Paget argued, the capacity to 'feel oneself into something' was not, in fact, predicated on a single moment of comprehending another's experience; instead, it was made possible through the accumulation of observation, thought and emotion over time, which then 'rose up' in the act of beholding.

When Cameron 'met' Julia through her lens in photographs like these, she was not merely empathizing with her subject. She was beholding something of Julia's presence, reflecting on that presence and bringing to bear on her picture-making the accumulation of life's bittersweet joys, sorrows and vicissitudes. She was also engaged in the active reflection that her husband, Charles, described as necessary when contemplating the beautiful and sublime.[106] This kind of reflection, coupled with the notion of 'receiving' a picture, or truly beholding a subject, stands in certain contradiction to our contemporary idea of 'taking' pictures, often done so instantaneously with little attention paid to the subject or what it evokes in its maker.

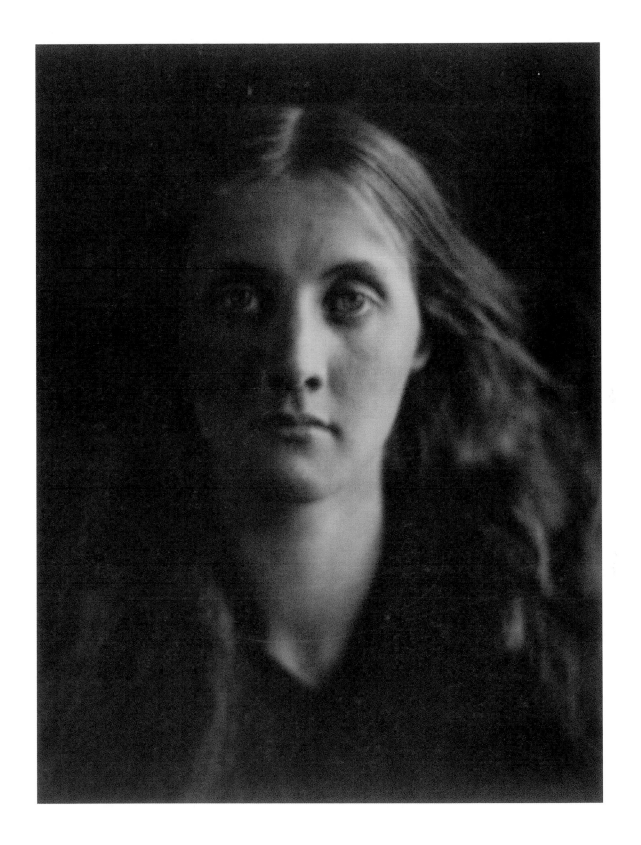

Sir John Herschel, April 1867

(copyright 9 April 1867)
Albumen print, 29 × 23.4 cm
Oxford, Bodleian Library, Arch. K b.12, fol. 53r

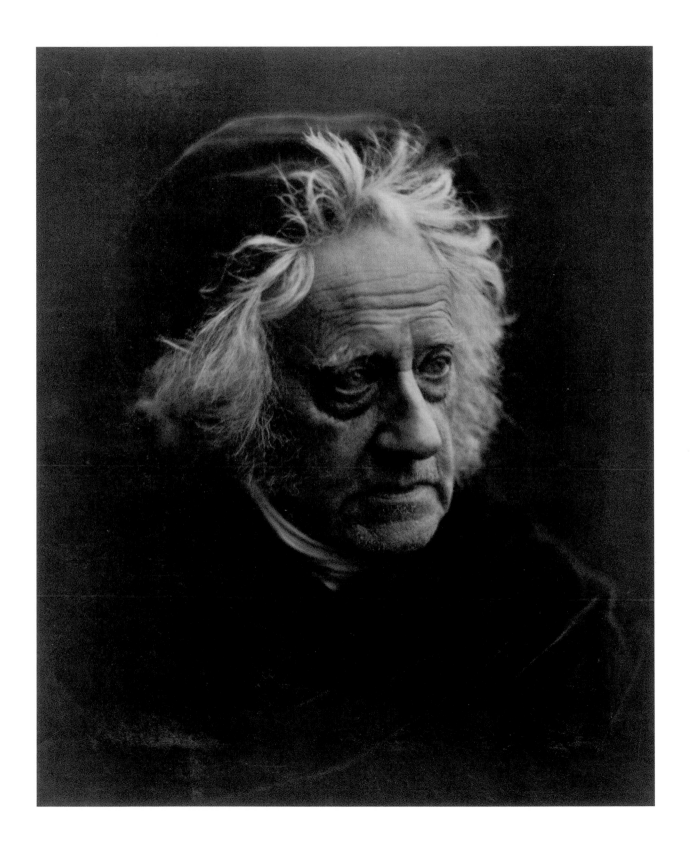

PLATE 78

H[enry] T[hoby] Prinsep, 1866

Albumen print, 36.7 × 28.4 cm

Ashmolean Museum, Oxford, WA1969.181

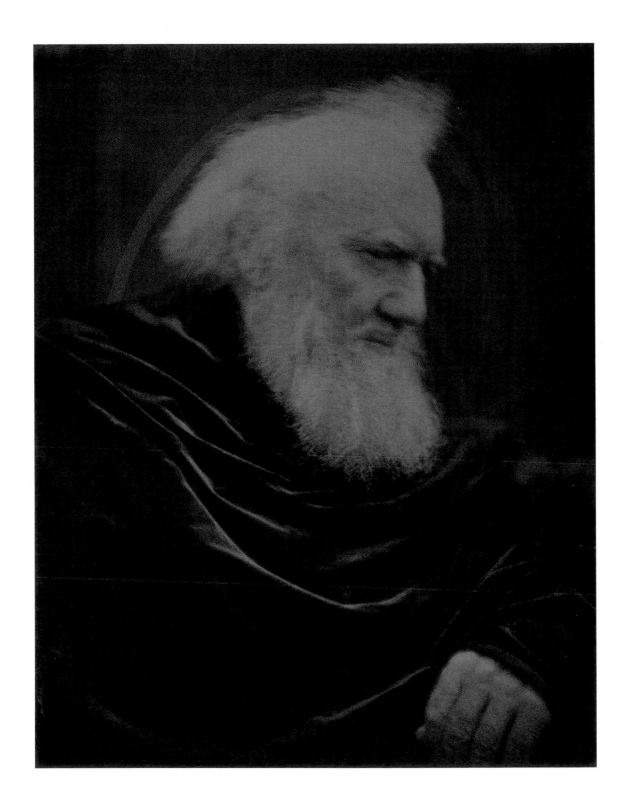

PLATE 79

Iago, Study from an Italian, 1867

Albumen print, 33.4 cm × 24.8 cm
National Science and Media Museum, Bradford

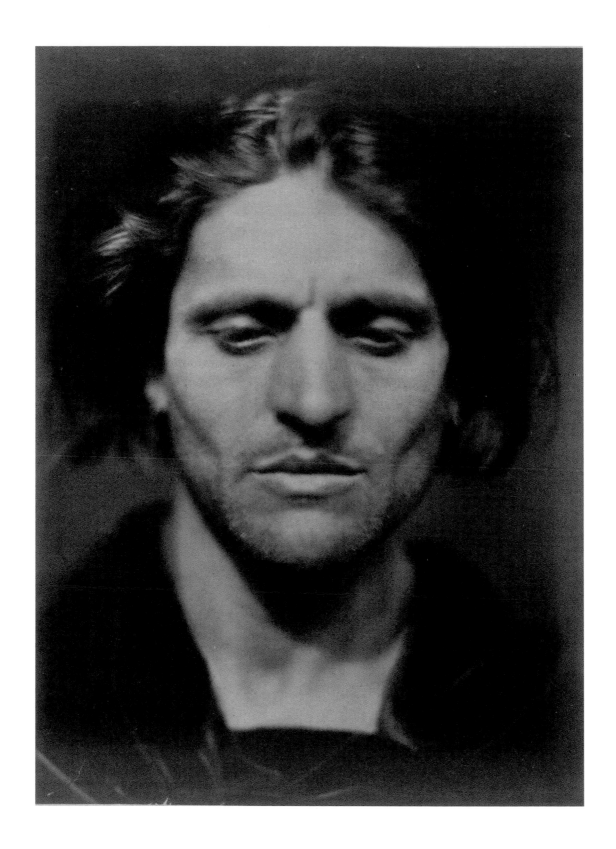

PLATE 80

Philip Stanhope Worsley, 1866

Albumen print, 30.4 × 25 cm
The Metropolitan Museum of Art, New York

One of Cameron's lesser-known portraits, an image of Philip Stanhope Worsley (1835–1866) produced in 1866, captured the heroic travail of suffering, while at the same time offering a visual indictment of the frailty of the human body. Worsley was a well-known English poet who published a translation of the *Odyssey* in 1861 and then undertook an unfinished translation of the first twelve books of the *Iliad*, both utilizing Spenserian verse.[107] Cameron cared for Worsley when he was diagnosed with tuberculosis at the age of thirty. 'I have been for 8 weeks nursing poor Philip Worsley on his dying bed,' she wrote to Henry Cole in 1866. 'The heart of man cannot conceive a sight more pitiful than the outward evidence of the breaking up of his whole being.'[108] Cameron's portrait was taken in the same year, which was also that of his death. There is a haunted sensibility to the image, created by Cameron's composition and tonality. The close-up head of the dying poet is partially framed by what one assumes are his white bed sheets. His skeletal facial features, with eyes looking just past the camera, function as both the central

subject and the visual transition between the dark, nearly opaque bottom left corner and the lighter right side. His disembodied head both floats, spectral-like, and recedes into the shadows, with only half of his face and part of one eye fully visible. Worsley's mortality is on display, 'breaking up' as Cameron writes, and hovering halfway between life and death. While not a mortuary portrait in the strictest sense, it is an elegiac portrayal of the life of a poet slipping towards death. In her *Illustrations* she later explores Tennyson's notion of 'Death in Life', a theme that contends with the irretrievability of the past, the perpetual risk of loss and universal sorrow. In this encounter with Worsley, Cameron is participating in his death while memorializing him through a medium that at once records his literal presence and anticipates his absence. Formally, the picture's darkened corner heightens a sense of resignation, of giving in to death and slipping away into shadow. Worsley, very much like Henry Taylor and King Arthur, became for Cameron a type of universal Man of Sorrows and, for her, there was beauty to be found in the shadows of sorrow.

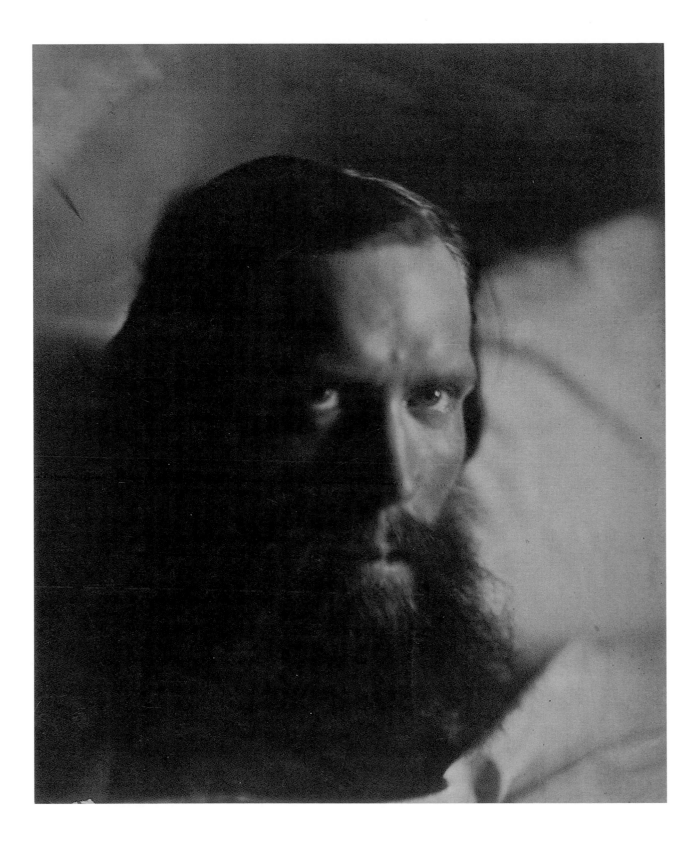

PLATE 81

Paul and Virginia (Freddy Gould and Elizabeth Keown), 1864

Albumen print, 25.4 × 19.9 cm
Oxford, Bodleian Library, Arch. K b.12, fol. 31r

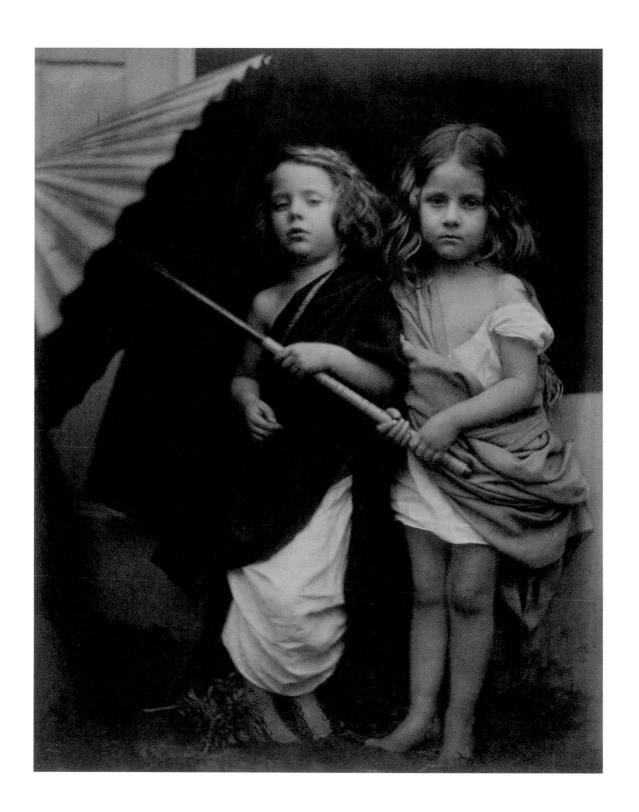

PLATE 82

Alice du Kane, 1864

Albumen print, 25.4 × 19.9 cm
Oxford, Bodleian Library, Arch. K b.12, fol. 36r

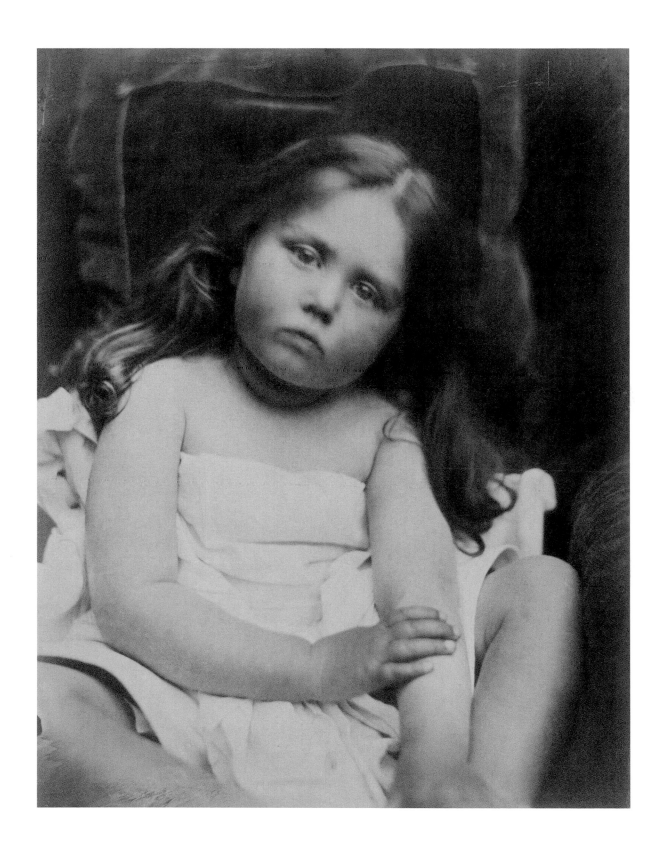

PLATE 83

Portrait of Christabel (May Prinsep), 1866

Albumen print, 25.4 × 20.2 cm
Ashmolean Museum, Oxford, WAHP48555

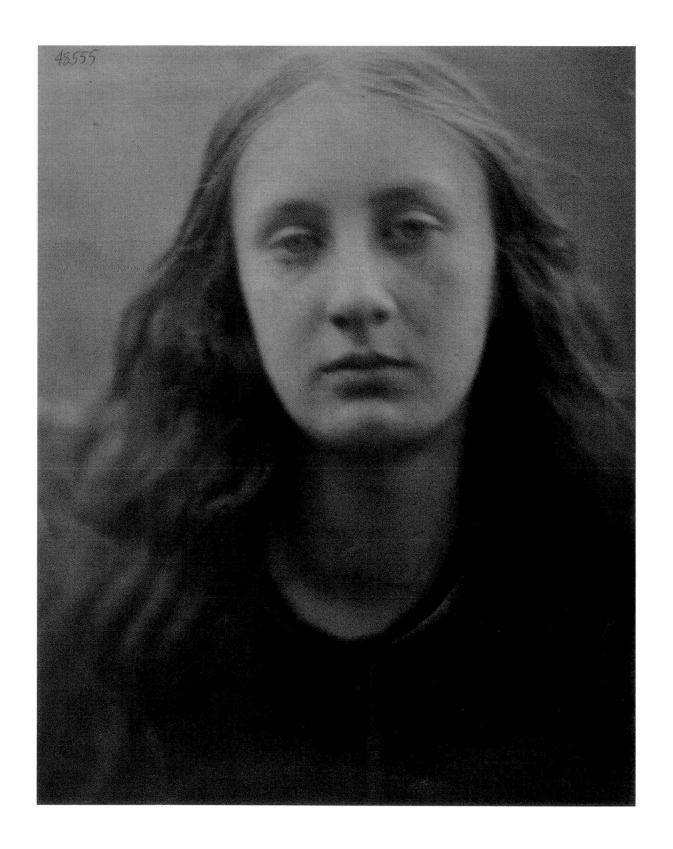

PLATE 84

Head of St. John (May Prinsep), 1866

Albumen print, 32.7 × 27 cm
Ashmolean Museum, Oxford WA2009.184

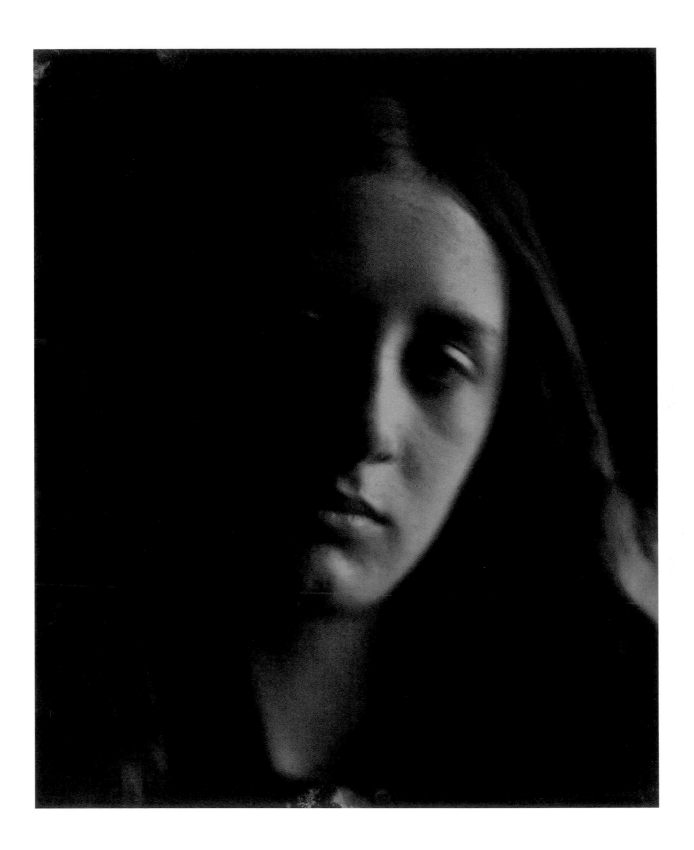

PLATE 85

Memory (Marie Spartali), 1868

Albumen print, 36.1 × 23.7 cm
Oxford, Bodleian Library, Arch. K b.12, fol. 40r

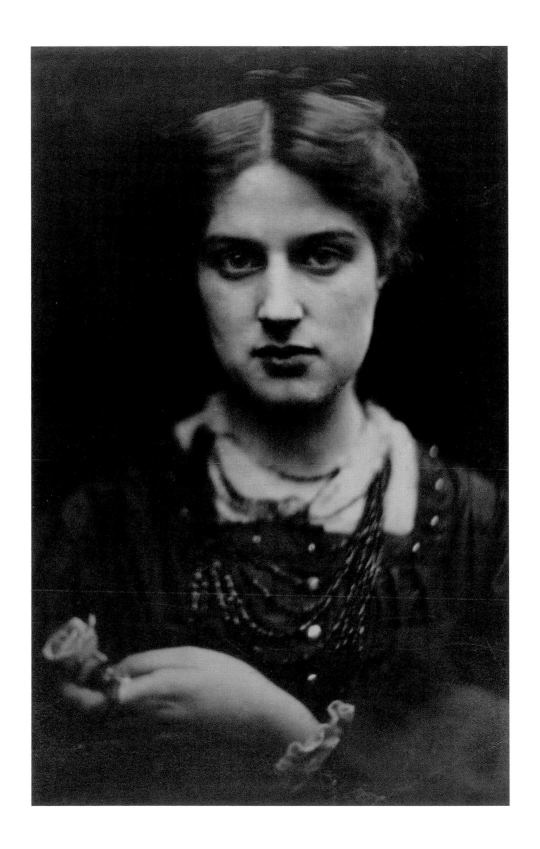

PLATE 86

Sappho (Mary Ann Hillier), 1865

Albumen print, 34.8 × 27.4 cm
Oxford, Bodleian Library, MS. 12714 photogr. 1 [item 1]

In 'Annals of my Glass House', Cameron writes of her relationship with Mary Ann Hillier (1847–1936), the model who is frequently described as Cameron's muse. Hillier posed for myriad Madonna photographs and as classical sybils, Christian saints and Arthurian and other literary figures, as well as for Cameron's depiction of Maud, Tennyson's 'passion-flower at the gate'. Cameron reflects on Hillier's significance as an active participant in her photographic process: 'one of the most beautiful and constant of my models, and in every manner of form has her face been reproduced, yet never has it been felt that the grace of the fashion of it has perished. This last autumn her head illustrating the exquisite Maud is as pure and perfect in outline as were my Madonna studies ten years ago, with ten times added pathos in the expression. The very unusual attributes of her character and complexion of her mind, if I may so call it, deserve mention in due time, and are the wonder of those whose life is blended with ours as intimate friends of the house.'[109] Cameron's suggestive closing comment indicates the significance of Hillier, who arrived at their Isle of Wight home to work at the age of fourteen, in her and her family's lives. She was the only model who spanned the entirety of Cameron's career in England and proved to be a partner in the photographer's artistic enterprise.

In two early images of Hillier in the Bodleian Library's collection, she poses as Sappho, an identity made clear in Cameron's titling of both images (plate 86; fig. 24). It is a compelling choice of subject; Sappho was regarded as one of the greatest lyric poets of ancient Greece, often referred to as the 'Tenth Muse' or 'the Poetess'. She is also known as the symbol of love

Fig. 24
Sappho (Mary Ann Hillier), 1865
Albumen print, 22.5 × 16.7 cm
Oxford, Bodleian Library, Arch. K b.12, fol. 77v

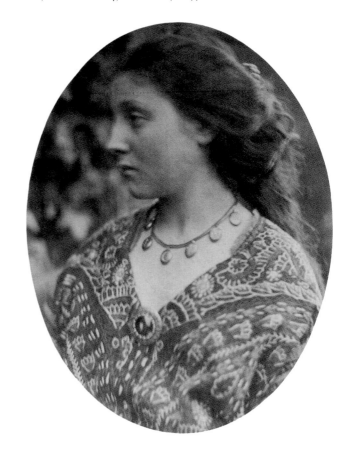

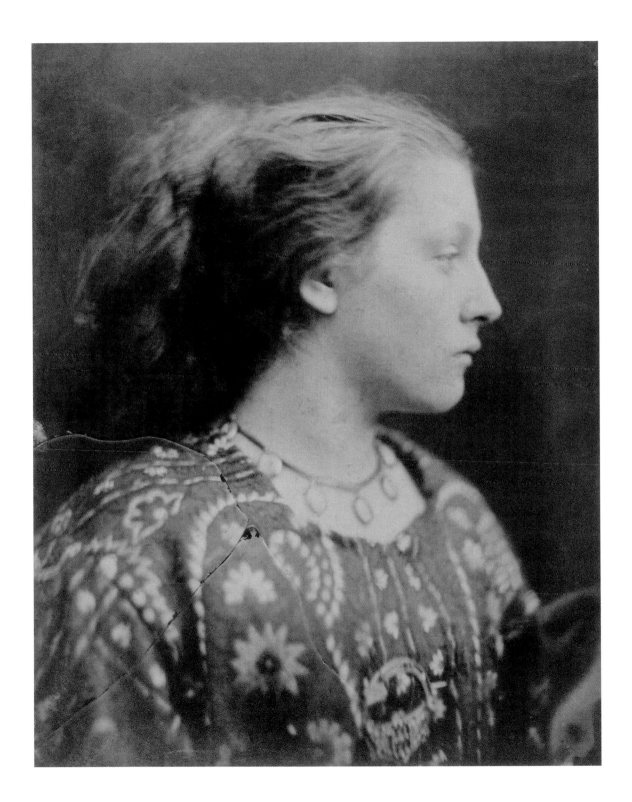

PLATE 87

Cupid and Psyche (Elizabeth Keown and Mary Ann Hillier), 1865

Albumen print, 28 × 22.6 cm
Oxford, Bodleian Library, Arch. K b.12, fol. 65v

and desire between women. Much of Cameron's work celebrates women and champions the intimacy between them. Provocative depictions of the three Marys, images such as *The Kiss of Peace* (plate 8) and pairings of classical literature or the British literary canon with her body of work suggest an intuitive appreciation not strictly for the physical beauty of her subjects but also for their complexity of character and capacity for human relations. Her photographs of women have received significant attention from both art and photo historians as evidence of her pursuit of beauty, and as counterpoints to her portraits of men, which risks reducing the ways in which she explored both her male and her female subjects. Her photographs of Henry Taylor and Mary Ann Hillier can be taken together as representing an abiding interest in the dimensionality of a personhood that might at once be Prospero and King David, the Virgin Mary and Sappho. In both subjects, she found typological potential made possible, in part because of their willingness to sit for an extraordinary number of photographs.

What was unique to Hillier, and what appealed to Cameron as an early student of photography and then as a practised artist, was her capacity to maintain a similar expression across most of the photographs. She is frequently photographed in profile, head slightly tilted downwards, eyes soft or partially closed, and her expression is often stoic and unchanged. By her own admission, Hillier's aesthetic was something that the Cameron found particularly beautiful and timeless. It is possible that this 'timelessness', admittedly touched by a kind of melancholy, allowed for her favourite model to successfully take on so many personas. Little distracts from the possibility that Hillier, wrapped in a veil or embracing Freddy Gould as the Christ child, might be the Virgin Mary (plates 89, 90), or with her hair loosed may be Tennyson's Maud and a type of Mary Magdalene (plate 72).

236

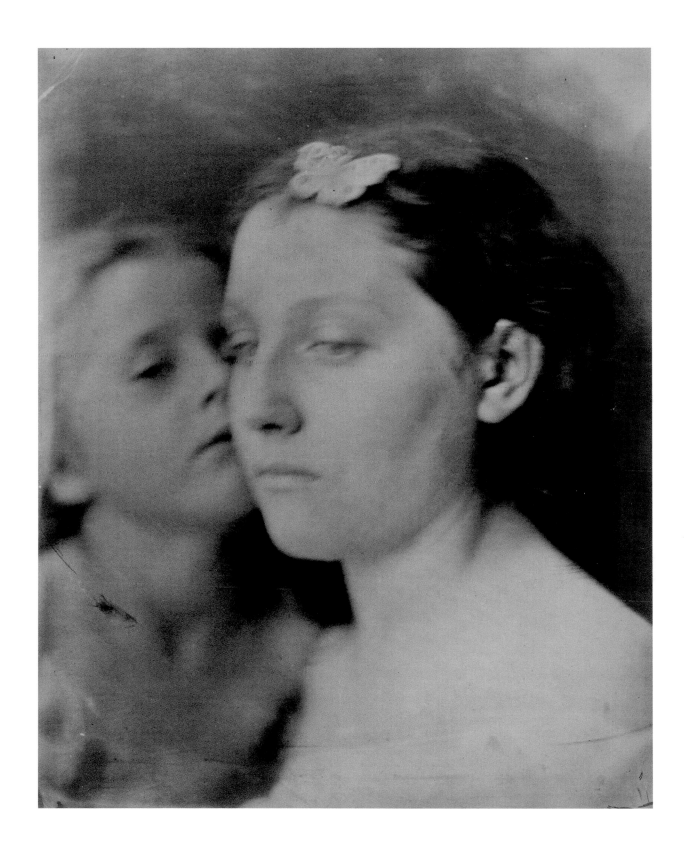

PLATE 88

'The Vestal' (Mary Ann Hiller),
captioned *G. F. W. [George Frederic Watts] Pilgrim*, 1864

Albumen print, 25.2 × 19.9 cm
Oxford, Bodleian Library, Arch. K b.12, fol. 58r

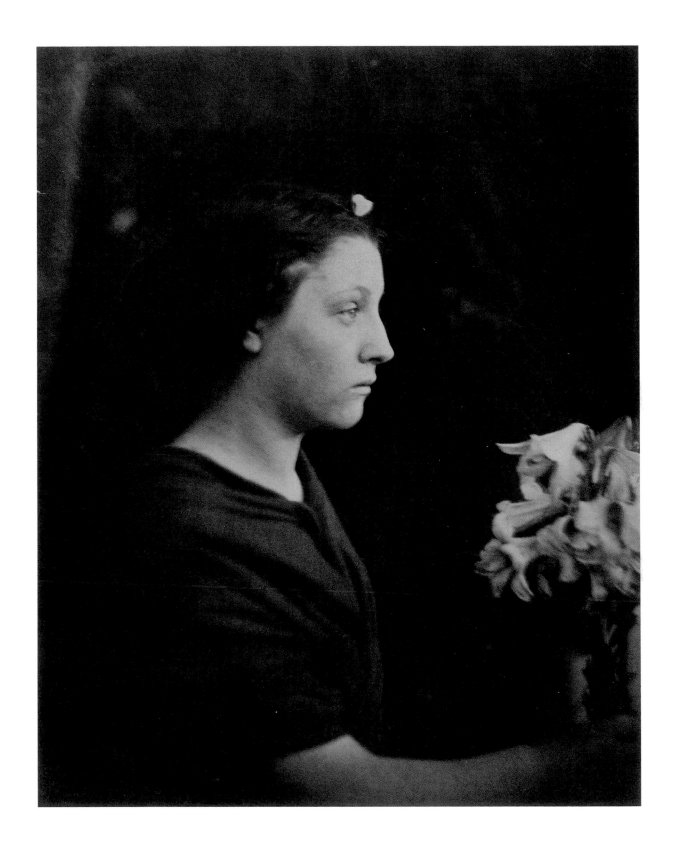

Mary Mother, 1867

Albumen print, 34.9 × 27.1 cm
Presented by Dr Acland
Ashmolean Museum, Oxford, WA.OA1351

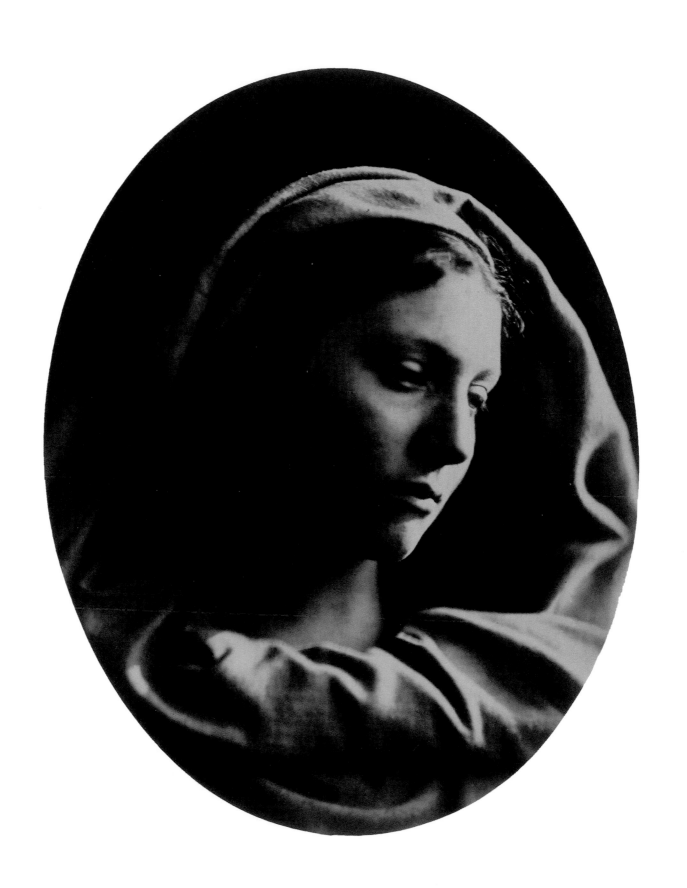

PLATE 90

The Return after three days (Mary Kellaway, Mary Ann Hillier, Freddy Gould and Mary Ryan), 1865

Albumen print, 29.1 × 24.4 cm
Oxford, Bodleian Library, Arch. K b.12, fol. 24r

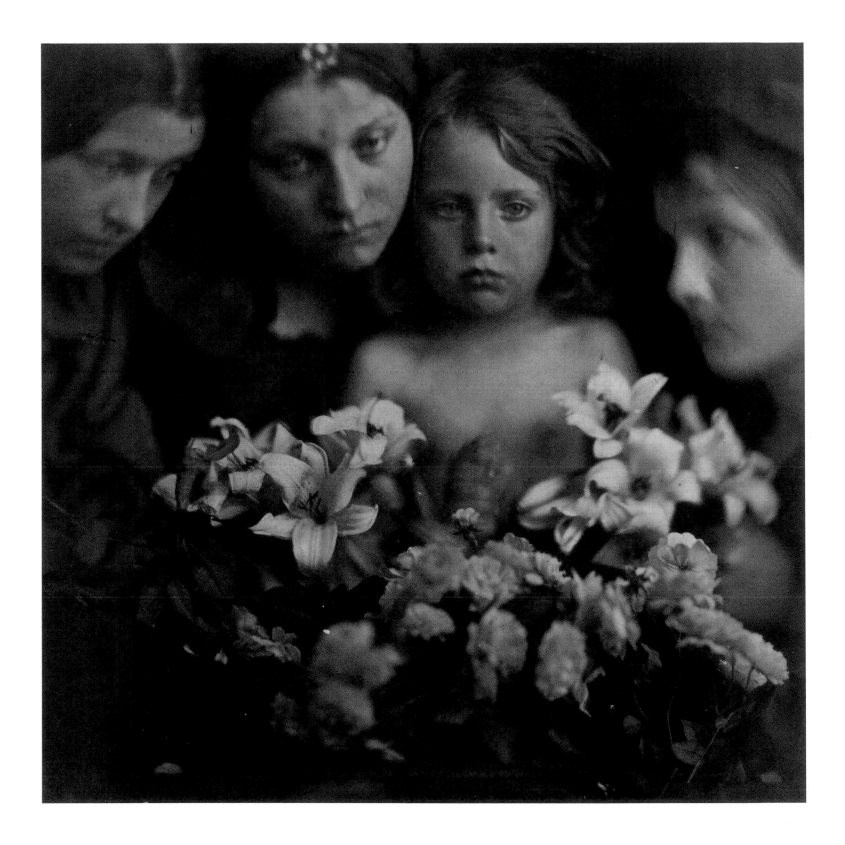

PLATE 91

The Flower Girl (Mary Ann Hillier), 1865

Albumen print, 17.3 × 20 cm
Oxford, Bodleian Library, Arch. K b.12, fol. 21v

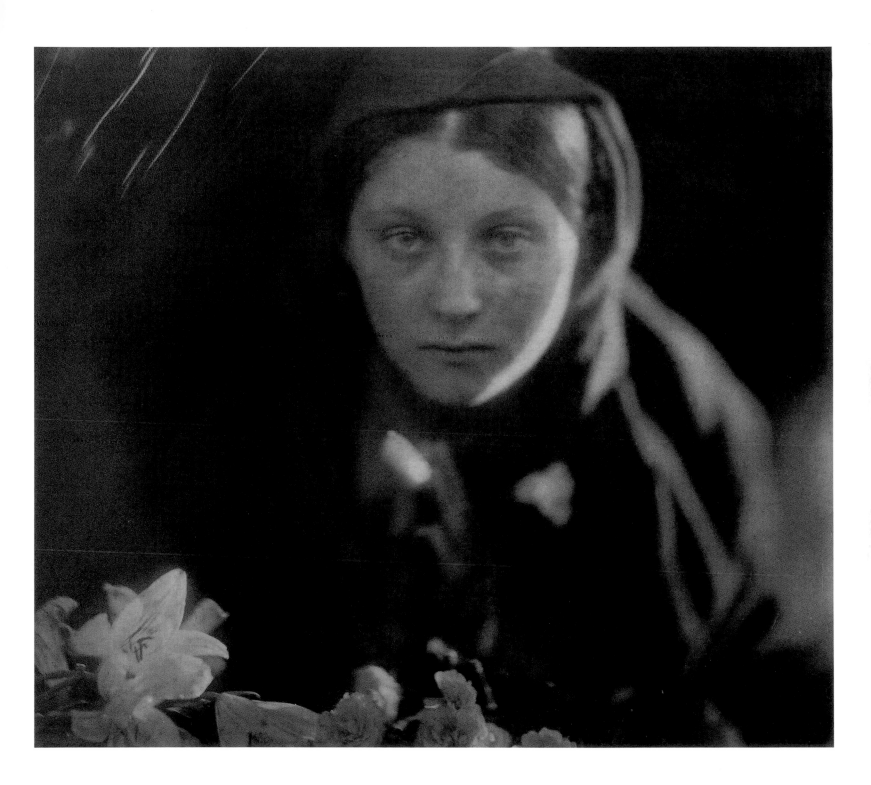

PLATE 92

Call I Follow, I Follow, Let Me Die (Mary Ann Hillier), 1867

Carbon print, 35.1 × 26.7 cm
Victoria and Albert Museum, London

Cameron's 1867 portrait of Hillier as Tennyson's Arthurian character Elaine stands as an unequivocal achievement in photographic portraiture. Having studied Hillier extensively as a subject, Cameron produced a photograph with all the hallmarks of her best art-making: well-executed chiaroscuro, limited depth of field and a twisting composition that is almost sculptural in effect conspire to lift the subject off the picture plane. *'Call I Follow, I Follow Let Me Die'* is a stand-alone portrait of Elaine, taken before Cameron embarked on her illustrations of *Idylls of the King*, and presents an entirely different representation of Elaine (and Hillier). Symbolic drama is also evident in this photographic illustration of Tennyson's poetic lines in which Elaine sings about the relief of death in lieu of the pain of her unrequited love for Lancelot:

> Sweet love, that seems not made to fade away,
> Sweet death, that seems to make us loveless clay,
> I know which is sweeter, no, not I.
> I fain would follow love, if that could be;
> I needs must follow death, who calls for me;
> Call and I follow, I follow! Let me die.
>
> 'Lancelot and Elaine', lines 1006–1011[110]

Instead of the lily maid dressed in white, she is pictured here in profile and draped in 'blackest samite'.[111] Her dramatically lighted face is tilted upwards, while the tension in her muscular neck and her slightly lowered eyelids suggest a look of resolve. The narrative of Elaine as Cameron represents it here becomes heroic and sublime: she illustrates in a photographic portrait a tale of the tragedy of love and of the sweetness, even glory, of surrendering to death. While Tennyson's *Idylls* concentrated more on Elaine as the paragon of Victorian womanhood, Cameron focused instead on the broader themes of love and death; in this photograph Elaine was the mistress of her fate, having decided that it was, indeed, 'better to have loved and lost, Than never to have loved at all' (*In Memoriam, A.H.H.*, xxvii.15–16).[112] In her two photographs of Elaine in volume two of her *Illustrations*, Cameron presents a particular type of fractured beauty born of bittersweet unrequited love (plates 69–70). In contrast, this portrait of Elaine presents a character who evokes the words of Cameron's 'On a Portrait', in which she describes the 'head is borne so proudly high, / The soft round cheek, so splendid in its bloom, / True courage rises thro' the brilliant eye, / And great resolve comes flashing thro' the gloom'. Despite Lancelot's rejection, this Elaine is in control of her mortality and proud of her martyrdom, fully realized in the fulfilment of her final wish that her body be presented at court.

Hillier takes on the role of another female archetype, as she had often done before. But, as Mike Weaver suggests, we find here the fullest expression of Cameron's capacity to combine Arthurian legend with Christian typology and English poetry.[113] Her iconic portrait of

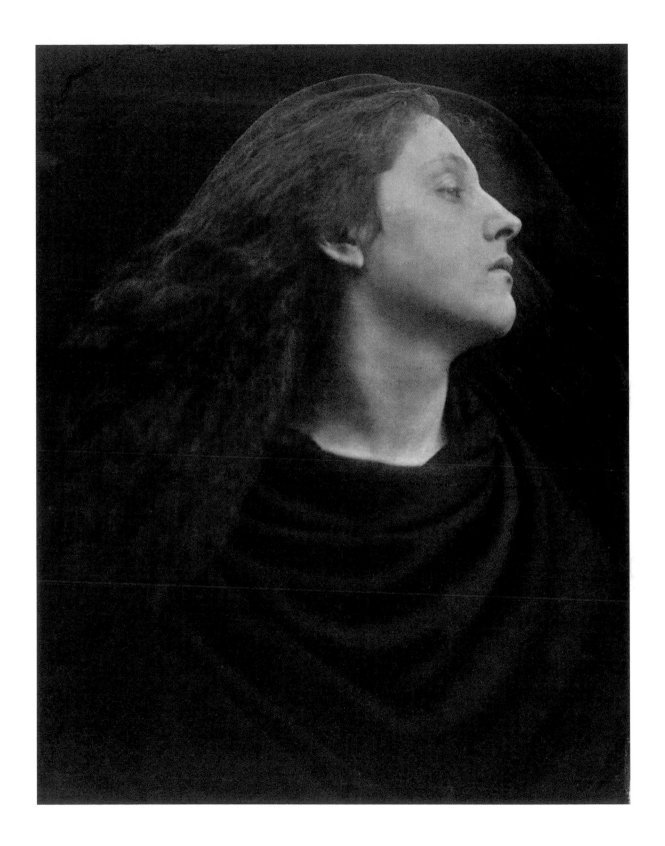

Elaine as an emboldened mistress of her fate also has
something of the Magdalene, suggested by the long
flowing hair. She is, moreover, a type of the Virgin Mary,
with the latter evoked by a halo that is only just suggested
by the curves of light tracing the edges of the hood that
frames her face. This kind of symbolic and typological
interplay seems to be, in Weaver's words, an 'attempt
to get the balance between the Madonna elements
and those of the Magdalene exactly right in pictorial
effect'.[114] There are overtones of the heroic in this image
of Elaine, who asserts control over her own mortality,
and it exemplifies Cameron's interest in themes of love
and death, which are prevalent in Tennyson's poetry and
expressly tied to Symbolism. Ultimately, in this image
Hillier becomes the vehicle by which the photographer
collapses traditional definitions of her art: like Cameron's
illustrative photographs, *'Call, I Follow, I Follow'* also
requires us to rethink categories such as 'portrait' and
'narrative'. This image is neither one nor the other but,
rather, partakes of both genres, a quality that makes
Cameron's photographs not only unusual but also
particularly riveting. Such qualities drew the admiration
of future photographers, including the Symbolist Alvin
Langdon Coburn who owned a print of this photograph
and later wrote in response to Cameron's work that
'above all I believe the strongest incentive of the artist
photographer is the storing up of the contemporary truth
of beauty for posterity'.[115]

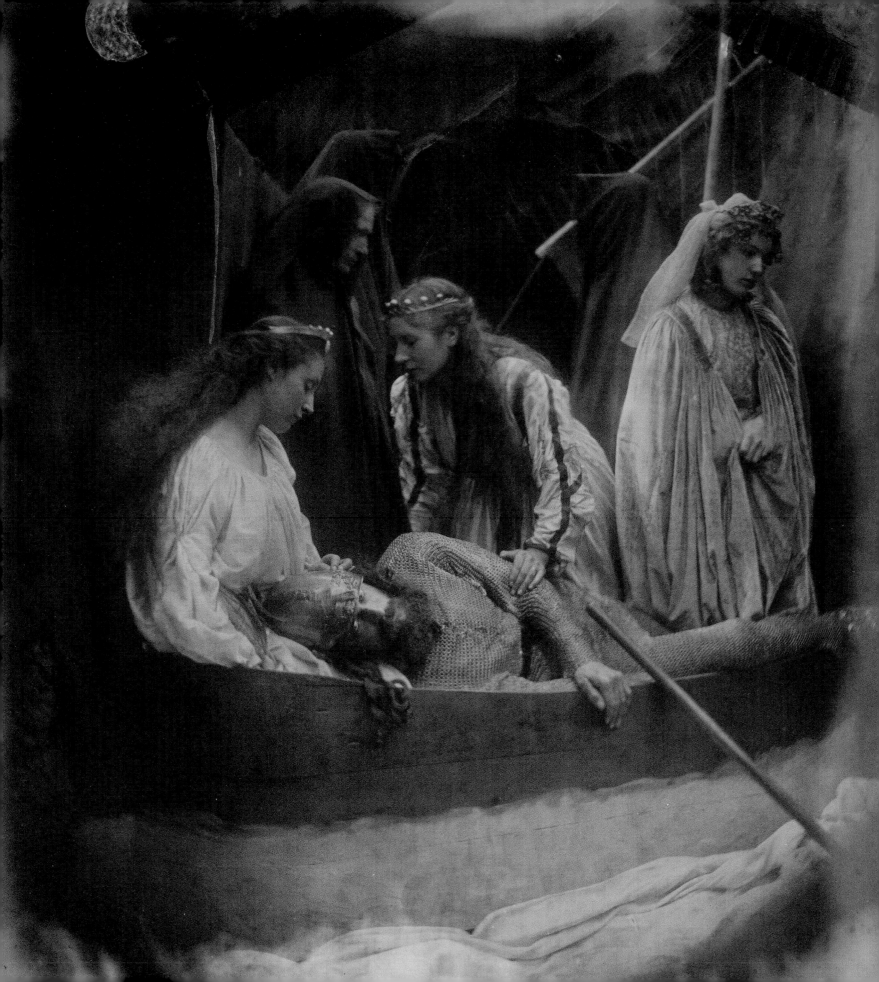

Appendix

On a Portrait[1]

Oh, mystery of Beauty! who can tell
Thy mighty influence? who can best descry
How secret, swift, and subtle is the spell
Wherein the music of thy voice doth lie?

Here we have eyes so full of fervent love,
That but for lids behind which sorrow's touch
Doth press and linger, one could almost prove
That Earth had loved her favourite over much.

A mouth where silence seems to gather strength
From lips so gently closed, that almost say,
'Ask not my story, lest you hear at length
Of sorrows where sweet hope has lost its way.'

And yet the head is borne so proudly high,
The soft round check, so splendid in its bloom,
True courage rises thro' the brilliant eye,
And great resolve comes flashing thro' the gloom.

Oh, noble painter! More than genius goes
To search the key-note of those melodies,
To find the depths of all those tragic woes,
Tune thy song right and paint rare harmonies.

Genius and love have each fulfilled their part,
And both unite with force and equal grace,
Whilst all that we love best in classic art
Is stamped forever on the immortal face.

Farewell of the Body to the Soul[2]

Sweet soul of mine! my closest dearest Friend
Forgive me ere we part all injury done
All warfare now between us has an end

Thy frail companion now his race has run
How oft when soaring with a wish divine
I've dragged thee down, and laid thee in the dust
Tricked with false promise glorious hopes of thine
Dwarfed all thy stature, made thy brightness rust

And thou didst ne'er resent, but oft and oft
In the night watches would'st invoke me still
In accent loud and strong – or sweet and soft
To give thee liberty to have Thy will

How oft in playful combat we would strive
If sweet cajolery would win the race
Now thy pure essence free of me shall live,
We part sweet soul! Smile on my pallid face.

Thou wing'st thy flight, art thou of me so tired?
Let us be friends at least – oh why that start?
Thou find'st thy freedom oft so much desired –
Forgive and love me – flown – distinct – apart –

opposite 'So like a shatter'd column lay the King', 1875 (detail of plate 71)

251

**From Julia Margaret Cameron to Blanche
Shore Smith Clough, 20 July 1862[3]**

But eighteen months ago – and here he stood
Warm as the summer air in fullest June
Pouring all learning like a golden flood –
Now – all is vanished – too soon – too soon

Who has not marked, who ever saw him oft –
The music of his sad and serious eye
Winning listener with persuasion soft
Thro' fields of asphodel, and pathless sky –

And the home picture, – that with sacred touch
Can be but sketched, tho' faithful to the life
His children for his leisure coaxing much
His labour shared, and sweeten'd by his Wife

She, like an echo, by his side would sit
And as a bird catch mid-air, and flies
With treasure caught to line its nest found fit
So with sweet instinct, she, did all the Wise

And fugitive fancies fix – and now the Nest
To us the mourners – us his friends is given
The tender questionings of a wild unrest
Of noble soul – souring towards Home and Heaven –

Glossary

Albumen prints were made through a process of coating paper with an emulsion of egg white and salts. This was a favourite early printmaking technique in photography because it produced rich tones and a glossy surface.

Aperture: The aperture is the space, or opening, through which light enters a camera. It controls the brightness of the image as it moves through the camera lens and onto its sensor.

Chiaroscuro refers to the treatment of light and dark portions of a pictorial work of art. It can be used to create the perception of depth in a two-dimensional image and is often used to suggest a relationship between dissimilar qualities, such as mood or character. It also refers to the interplay of light and shadow as they appear on a surface. The term originates from the combination of the Italian terms *chiaro* (clear, light) and *oscuro* (obscure, dark). Italian and Northern Renaissance artists, including Leonardo da Vinci and Rembrandt, used chiaroscuro in their painting. In the absence of colour, chiaroscuro becomes a key element in photography.

Depth of field is the term given to the area in front of and behind the subject that is in focus. A small f-number, or shorter focal length, in photography results in a very narrow depth of field and throws the background and foreground out of focus. This is especially effective in portrait photography.

Focal length: The focal length (f-number, or f-stop) determines how much of a scene is captured in a photographic image. Lenses with shorter focal lengths are also called wide angle lenses because they allow for a wider view in one image. Cameron used a wide aperture (small focal length number) for her close-up photographs.

Indexical: In photography, indexicality (or the indexical) refers to physical relationship between the object photographed and the resulting image. It has become an area of theoretical discussion, particularly around accuracy and 'truthfulness' in representation. In linguistics, semiotics and the philosophy of language, the indexical or indexicality refers to the phenomenon of a sign pointing towards or indexing an object in context. The modern notion originates with the semiotic theory of Charles Sanders Peirce as one of the three signs in his theoretical system: icon, index and symbol.

Leitmotif is the term given to a recurrent theme throughout a literary, musical or artistic composition.

Multivalent is another way to describe something that may have many interpretations, meanings or value.

Pictorialism was the general term used to describe a movement in photography that focused on aligning photography with the fine arts, particularly painting. It became popular during the nineteenth and early twentieth centuries. It hoped to promote the photograph to the status of an art object. Its earliest practitioners applied fine-art tenets to the production of a photograph. This often involved a softening of focus, a shallow depth of field, chiaroscuro and simplified composition to deliberately create an image or enhanced effect rather than simply record a subject. In 1869 Henry Peach Robinson published his *Pictorial Effect in Photography Being Hints on Composition and Chiaro-oscuro for Photographers*. Towards the end of the nineteenth century, Pictorialism advanced significantly, further sublimating the descriptive to the emotive or suggestive and thereby advancing the belief that a photographic image could engage with

feelings and the symbolic, and concern itself with beauty and not simply fact. For further scholarship on the history of Pictorialism, see Naomi Rosenblum, *A World History of Photography* (New York, 1989); Peter Bunnell, *A Photographic Vision: Pictorial Photography, 1889–1923* (Salt Lake City, UT, 1980) and Mike Weaver, *The Photographic Art: Pictorial Traditions in Britain and America* (London, 1986).

Sublime is a term used to describe anything that causes the impression of awe, grandeur, veneration or wonder. It can also suggest the unknown, which can be associated with fear or uncertainty, or that which exceeds description. Ideologically, it formed the basis of the Edmund Burke's eighteenth-century writings and informed the aesthetics of the Romantic movement in art, poetry and music.

Symbolist/Symbolism: Symbolists – in both art and literature – were principally concerned with the non-material realms of emotion, imagination and the mysterious or spiritual. The Symbolist movement, most often associated with French writers and artists, reached its height late in the late nineteenth and early twentieth centuries. However, Symbolism had its early origins in Britain where it evolved into a distinct style. Characteristics of Symbolist painting include soft focus, blurred edges and reduction of detail in the service of the emotional or psychological aspects of the image. Instead of relying on description, Symbolists like G.F. Watts were fundamentally concerned with revealing the world of ideas and the transcendent through suggestion. Cameron's use of differential or soft focus, as well as her economy of detail and use of light and dark, contribute to a Symbolist aesthetic that ascribed value to the sublime, or unseen, in her photographs. The world of private thoughts proved a compelling subject for the Symbolists and, similarly, preoccupied Cameron. She explored the subject through her portraiture as well as in her illustrations of Tennyson's poetry, where she explored the themes of love and death, which were equally revered by Symbolists as among the most mysterious powers that dominate human existence. Music was also a common theme among Symbolist artists and photographers. In photography, the term 'Symbolist' and 'Pictorialist' are often interchangeable.

Typology: In general terms, typology is the systematic classification of types of symbols, religions, cultures or people according to common characteristics. Typology allowed for Cameron to extend meaning beyond the literal or historical identity of her subject, and to ascribe additional significance to them by drawing on characteristics or types ascribed to biblical characters or those from classical mythology or the British literary canon. Mike Weaver identifies Cameron's approach to photography as typological as opposed to allegorical, which is concerned primarily with suggesting a message or narrative.

Wet collodion process: Cameron used an early photographic process called the wet collodion process, which required mixing silver halides (bromide and iodide) in a collodion binder and pouring that across a glass plate prior to placement in the camera and exposure. The entire process had to be completed while the collodion was still wet, making it messy and temperamental. The chemicals were also toxic.

Notes

Chapter 1

1. P.H. Emerson, *Naturalistic Photography for Students of the Art*, London, 1899, p. 30.

2. Anne Thackeray Ritchie, *Lord Tennyson and his Friends, with a series of 25 portraits and frontispiece in photogravure from the negatives of Mrs Julia Margaret Cameron and H.H.H. Cameron*, London, 1893, p. 13.

3. Letter from Henry Taylor on behalf of Charles Cameron, 11 June 1861, Oxford, Bodleian Library MS. Eng. lett. d. 12, fols 17–18.

4. Quoted in Hester Thackeray Fuller, *Three Freshwater Friends: Tennyson, Watts and Mrs. Cameron*, ed. Elizabeth Hutchings, 3rd edn, Newport, Isle of Wight, 1992, pp. 31–2.

5. Mary Seton Watts, *George Frederic Watts: Annals of the Artist's Life*, London, 1912, vol. I, pp. 204–5.

6. Caldesi and Montecchi, *Photographs of the Gems of the Art Treasures Exhibition*, Manchester, 1857.

7. Mike Weaver, *Whisper of the Muse: The Overstone Album and Other Photographs by Julia Margaret Cameron*, Los Angeles, CA, 1986, p. 23.

8. Julian Cox and Colin Ford, *Julia Margaret Cameron: The Complete Photographs*, Los Angeles, CA, 2003, pp. 96–8; Sotheby's, 'The "Signor 1857" Album', L12408, lot 65, 12 December 2012, https://www.sothebys.com/en/auctions/ecatalogue/2012/english-literature-history-l12408/lot.65.html (accessed 14 February 2023).

9. Quoted in Colin Ford, *Julia Margaret Cameron: 19th Century Photographer of Genius*, London, 2003, p. 70.

10. Recorded in the catalogue of Tennyson's library are additional relevant texts given to Tennyson by Julia Margaret Cameron: *Prospectus and Specimen of an Intended National Work Intended to Comprise the Most Interesting Particulars Relating to King Arthur and His Round Table*, by William Whistlecraft and Robert Whistlecraft, 1842 edn, with inscription on the title page, 'Alfred Tennyson from Julia Cameron. 1 Oct. '55'); *Goblin Market and Other Poems*, with two designs by D.G. Rossetti, 1862 edn, with 'Julia Margaret Cameron' written on the title page; *The Princes' Progress, and Other Poems*, with two designs by D.G. Rossetti, 1866 edn, with inscription, 'Given by Christina Rossetti to Alfred. Julia Margaret Cameron'; *Fine Art, Chiefly Contemporary*, by William Michael Rossetti, 1867 edn, with 'Julia Margaret Cameron 1867' on the title page (Catalogue of Tennyson's Library, Tennyson Research Centre, Lincoln, n.d., TRC/N/24).

11. Virginia Woolf and Roger Fry, *Victorian Photographs of Famous Men and Fair Women by Julia Margaret Cameron*, London, 1926, p. 6.

12. Julia Margaret Cameron, 'Annals of my Glass House', *The Photographic Journal*, vol. XVII, July 1927, pp. 296–301, repr. in Mike Weaver, *Julia Margaret Cameron, 1815–1879*, p. 155.

13. Ibid.; Cox and Ford, *Julia Margaret Cameron: The Complete Photographs*, p. 30.

14. Ford, *Julia Margaret Cameron: 19th Century Photographer of Genius*, p. 38.

15. Cameron writing to Sir Edward Ryan (Gilman Paper Company), 18 December 1874, cited in Cox and Ford, *Julia Margaret Cameron: The Complete Photographs*, p. 53.

16. Letter from Julia Margaret Cameron to John Herschel (Royal Society), 18 February 1866, quoted in Cox and Ford, *Julia Margaret Cameron: The Complete Photographs*, p. 65.

17. In an unpublished letter from Cameron to John Herschel dated 26 February 1864, quoted in Cox and Ford, *Julia Margaret Cameron: The Complete Photographs*, p. 46, Cameron acknowledges having one photography lesson with Wynfield.

18. Philip Prodger, *Victorian Giants: The Birth of Art Photography*, London, 2018, p. 18.

19. Marta Weiss, *Julia Margaret Cameron: Photographs to Electrify You with Delight and Startle the World*, London, 2015, p. 18.

20. Ibid. 19.

21. Mirjam Brusius, 'Impreciseness in Julia Margaret Cameron's Portrait Photographs', *History of Photography*, vol. 34, no. 4, 2010, pp. 342–55.

22. Mike Weaver, *Julia Margaret Cameron, 1815–1879*, p. 141.

23. Letter from Julia Margaret Cameron to Sir John Herschel, 31 December 1864, Heinz Archive and Library (Autograph Letter Series), National Portrait Gallery, London, NPG 201, fol. 6.

24. Prodger considers at length this debate on beauty in 'Ugly Disagreements: Darwin and Ruskin Discuss Sex and Beauty', in Barbara Larson and Fae Brauer (eds), *The Art of Evolution: Darwin, Darwinisms, and Visual Culture*, Hanover, NH, 2009, pp. 40–58.

25. Mary Seton Watts, *George Frederic Watts*, vol. I, p. 230.

26. In addition to Brusius's discussion on Cameron's impreciseness (especially whether it was intentional), see Weiss, *Julia Margaret Cameron*.

27. Carol Armstrong, *Scenes in a Library: Reading the Photograph in the Book, 1843–1875*, Cambridge, MA, 1998, p. 368.

28. Cameron, 'Annals of my Glass House', p. 157.

29. Mary Seton Watts, *George Frederic Watts*, vol. III, p. 35.

30. Weaver, *Julia Margaret Cameron, 1815–1879*, p. 136. According to the Catalogue of Tennyson's Library held by the Tennyson Research Centre in Lincoln, the poet's library included a copy of Burke's complete treatise on the sublime and beautiful given to him by Charles Cameron.

31. Charles Hay Cameron, *Two Essays: On the Sublime and Beautiful, and On Duelling*, London, 1835, pp. 4–5.

32. In *On Photography*, Susan Sontag writes, 'The painter constructs, while the photographer discloses' (New York, 1973, p. 92). It seems Cameron prefigured this assertion when she writes in 'Annals of my Glass House', 'when I have had such men before my camera my whole soul has endeavoured to do its duty towards them in recording faithfully the greatness of the inner as well as the features of the outer man' (p. 157).

33. C.H. Cameron, *Two Essays*, pp. 28–9.

34. Henry Taylor, *Notes from Life in Six Essays*, London, 1848, p. 141.

35. Cameron, 'On a Portrait' [September 1875], *Macmillan's Magazine*, vol. XXXIII, February 1876, p. 372. See the Appendix for a full transcription of the poem.

36. Cameron, 'Annals of my Glass House', p. 155.

37. Letter from Julia Margaret Cameron to Sir John Herschel, 31 December 1864, Heinz Archive and Library (Autograph Letter Series), National Portrait Gallery, London , fol. 6.

38. Alvin Langdon Coburn, 'The Old Masters of Photography', *The Century Magazine*, October 1915, p. 920.

39. Cox and Ford, *Julia Margaret Cameron: The Complete Photographs*, p. 4.

40. Gottfried August Bürger, *Leonora*, trans. J.M. Cameron, illus. D. Maclise, London, 1847. In addition to her poem 'On a Portrait', Cameron wrote a poem in honour of the poet Arthur Clough, which she sent to his widow on 20 July 1862 (Oxford, Bodleian Library, MS. Eng. lett. d. 178, fol. 75). Late in her life, she also wrote a poem called 'Farewell of the Body to the Soul'. According to Mike Weaver, this poem, now in the Getty Collection, was preserved in an envelope dated 19 March and postmarked 'Ceylon March 1876' (*Whisper of the Muse*, p. 61).

41. Arthur Henry Hallam, 'On Some of the Characteristics of Modern Poetry, and On the Lyrical Poems of Alfred Tennyson', *The Englishman's Magazine*, vol. 1, 1831, pp. 620–21.

42. H.M. McLuhan, 'Tennyson and Picturesque Poetry', in John Killham (ed.), *Critical Essays on the Poetry of Tennyson*, London, 1960, p. 71.

43. Cameron, 'Annals of my Glass House', p. 155.

44. The ongoing struggle between sense and soul, the flesh and the spirit, was a prevalent theme through much of Tennyson's poetry and was realized fully in the narrative arc of the *Idylls*, where Arthur and his court are engaged in a lifelong struggle between material existence (the flesh) and the quest for spiritual actualization (the spirit or soul). The poet, his characters and indeed all of humanity constantly move in a 'strange diagonal' between such dialectics of experience.

45. Gerhard Joseph, *Tennyson and the Text*, Cambridge, 1992, p. 84.

46. Ibid. 85.

47. Susan Sontag describes the photograph as 'both a pseudo-presence and a token of absence' in *On Photography*, p. 16. This is echoed by Carol Armstrong when she writes that Cameron's photography 'relies on the photograph's status as an ephemeral image whose every effect of presence is made out of absence' (*Scenes in a Library*, p. 418). It is a conception shared by Carol Mavor who writes that it is 'only with photography … that what was once before the artist/ camera … was there and is no longer there' (*Pleasures Taken: The Performance of Sexuality and Loss in Victorian Photographs*, Durham, NC, 1995, p. 4). For a broad overview of the theory of photography underlying its indexical properties, see Geoffrey Batchen, who writes, in response to Allan Sekula's dialectical theory of photography, that 'as an index the photograph is never itself but always, by its very nature, a tracing of something else' (*Burning with Desire: The Conception of Photography*, Cambridge, MA, 1997, p. 9).

48. Mary Ann Caws and Gerard Joseph, 'Naming and Not Naming: Tennyson and Mallarmé', in Valentine Cunningham (ed.), *Victorian Poets: A Critical Reader*, Chichester, 2014, p. 393.

49. Tennyson describes the encounter between sense and soul explicitly in the epilogue of the *Idylls*, in which he writes: 'Not for itself, but through thy living love / For one to whom I made it o'er his grave / Sacred, accept this old imperfect tale, / New-old, and shadowing Sense at war with Soul, / Ideal manhood closed in real man' ('Epilogue: To the Queen', lines 34–8, in *Tennyson: A Selected Edition*, ed. Christopher Ricks, Harlow, 2007, p. 974).

50. Robin Kelsey, *Photography and the Art of Chance*, Cambridge, MA, 2015, p. 77. This method contrasts significantly with the salt-paper prints of William Fox Talbot and other earlier photographers who aimed for the relative perfection afforded by the more industrial processes capable of capturing detail with more precise focus. Kelsey also persuasively argues that Cameron could have easily resolved the issue of focus had she wished given her access to expertise and her evident engagement with the science behind photographic practices. Instead, she remained steadfast in her refusal to concede to technical expectations.

51. Amelia Scholtz, 'Photographs before Photography: Marking Time in the Tennyson's and Cameron's *Idylls of the King*', *Literature Interpretation Theory*, vol. 24, 2013, p. 135. The use of 'always already' is an intentional combination of words by Scholtz to suggest the constant 'pastness' of the mythical city of Camelot and its inhabitants. This destabilizing interplay between what is and was, now and then, or alive and dead is part of what theoretically connects death and photography. Susan Sontag famously treats this connection in her text *On Photography* when she describes all photographs as 'memento mori' (p. 15).

52. Marina Warner, *Phantasmagoria: Spirit Visions, Metaphors, and Media into the Twenty-first Century*, Oxford, 2006, p. 215. Warner is referring here to Frank Kermode's broader discussion of time and endings in literature in his 1967 text, *The Sense of Ending: Studies in the Theory of Fiction with a New Epilogue*, Oxford, 2000. In Scholastic philosophy, the *aevum* is a third order of existence experienced by angels and saints; more generally, it refers to the state that lies between the timelessness of God and the temporal experience of humanity.

Chapter 2

1. Letter from Julia Margaret Cameron to Sir John Herschel, 31 December 1864, Heinz Archive and Library (Autograph Letter Series), National Portrait Gallery, London, fol. 6. All direct quotes from Cameron's letters and other writings include the original emphasis, punctuation and capitalization.

2. The Taylor collection comprises 112 images. It was presented to the Bodleian Library at the University of Oxford in 1930 by Ida Ashworth Taylor, the eldest daughter of Sir Henry Taylor. The collection was digitally archived in 2006, and until that point had not undergone significant study. The images are of varying sizes and mounts, all presented on blue cloth-covered boards. The album measures approximately 38.5 × 33.5 cm. The principal subject of the

collection is Henry Taylor, but it also includes portraits of George Frederic Watts, Alfred Tennyson, Benjamin Jowett, Julia Jackson, John Herschel, Mary Hillier and May Prinsep, along with literary, religious and classically themed illustrations.

3. Mike Weaver writes, 'hitherto, Cameron's photographs have been seen as vaguely allegorical but they are more properly described as typological or typical – illustrative in a profound, biblical sense' (*Julia Margaret Cameron, 1815–1879*, p. 15).

4. In his *Notes from Life in Six Essays* Taylor writes, 'Let it [the life poetic] not be too contemplative for action, nor too active to afford room and space for contemplation' (p. 141). In his chapter on the 'Life Poetic' he notes, 'for the cultivation of the highest order of poetry, it is necessary that he should be conversant with life and nature at large, and … that his poetry should spring out of his life and that his life should abound in duties, as well as in contemplations' (p. 142).

5. Una Taylor, *Guests and Memories: Annals of a Seaside Villa*, London, 1924, pp. 209–10.

6. Henry Taylor, *Autobiography of Henry Taylor, 1800–1875*, London, 1885, vol. I, p. 23.

7. Ibid. 34.

8. Ibid. 26.

9. Ronald Chapman, *The Laurel and the Throne: A Study of G.F. Watts*, London, 1945, p. 76.

10. Henry Taylor, *Autobiography*, vol. I, p. 146.

11. Jowett had taken particular interest in furthering Aubrey's education, and evidence suggests that the Taylors' daughters were also intellectually gifted and well educated. Una Taylor published her memoirs and went on to write extensively on the Belgian Symbolist poet Maurice Maeterlinck. Their eldest daughter, Ida Alice Ashworth Taylor, also became an author, best known for her biographies of prominent women, including Lady Jane Grey and Madame Roland.

12. Henry Taylor, *Autobiography*, vol. II, p. 253.

13. Henry Taylor, *Autobiography*, vol. I, p. 37.

14. Henry Taylor, *Autobiography*, vol. II, pp. 54–5.

15. Ibid. 50.

16. Letter from Julia Margaret Cameron to Henry Taylor, 1 July 1877, Oxford, Bodleian Library, MS. Eng. lett. d. 13, fol. 79.

17. The collection, catalogued as Arch. K b.12, is sometimes referred to as the '(Henry) Taylor album'. Colin Harris believes that the collection of loose photographs was bound by the Bodleian Library. The cover and mounts are in keeping with Bodleian archival practices of the period.

18. Henry Taylor, *Autobiography*, vol. II, p. 197.

19. Letter from Julia Margaret Cameron to Samuel G. Ward, 16 June 1869, unpublished, Houghton Library, Harvard, cited in Victoria Olsen, *From Life: Julia Margaret Cameron and Victorian Photography*, London, 2003, p. 4.

20. Una Taylor, *Guests and Memories*, pp. 218–19.

21. Anne Thackeray Ritchie, *Lord Tennyson and his Friends*, p. 12.

22. 'On a Portrait' (see Appendix).

23. Henry Taylor, *Autobiography*, vol. II, p. 197.

24. Cameron, 'Annals of my Glass House', p. 156.

25. Una Taylor, *Guests and Memories*, p. 348.

26. Ibid.

27. Mary Seton Watts, *George Frederic Watts*, vol. III, p. 326.

28. F.W.H. Myers, 'Rossetti and the Religion of Beauty', in David G. Riede (ed.), *Critical Essays on Dante Gabriel Rossetti*, New York, 1992, pp. 52–3.

29. Una Taylor, *Guests and Memories*, p. 210. John Everett Millais also saw something of Moses in Taylor's countenance and wrote to request that he sit for a sculpture of the Old Testament figure (cited in Colin Ford, *Julia Margaret Cameron: A Critical Biography*, Los Angeles, CA, 2003, p. 51).

30. Una Taylor, *Guests and Memories*, p. 221.

31. Mike Weaver, *Julia Margaret Cameron, 1815–1879*, p. 15.

32. Carol Hanbery MacKay writes extensively about the importance of eyes throughout Cameron's work; see especially *Creative Negativity: Four Victorian Exemplars of the Female Quest*, Stanford, CA, 2001, pp. 17–55.

33. Sontag, *On Photography*, p. 15.

Chapter 3

1. Quoted in Mary Seton Watts, *George Frederic Watts*, vol. II, p. 2.

2. Letter from Julia Margaret Cameron to John Herschel, 18 February 1866 (Royal Society), quoted in Cox and Ford, *Julia Margaret Cameron: The Complete Photographs*, p. 65.

3. Little Holland House was a smaller, secondary home belonging to Lord and Lady Holland who occupied the larger estate in Kensington.

4. The earliest of the three albums dedicated to G.F. Watts, the 'Signor 1857' album, was auctioned at Sotheby's in 2012 and has the potential to offer further insights into Cameron's early study of photography and her relationship with the artist (see Sotheby's, 'The "Signor 1857" Album', L12408, lot 65). It is currently in a private collection. In the 2003 *catalogue raisonné*, *Julia Margaret Cameron: The Complete Photographs*, Julian Cox and Colin Ford mention both the 'Signor 1857' album and a third, smaller, album of sixteen photographs held by the Library of Congress in Washington, DC. The latter is titled by the library the 'Cameron–Rejlander album of portrait photographs' (1860–65) even though the inscription on the first page of the album reads 'G.F.W. from JMC' and, like the 'Signor 1857' album, it includes photographs of drawings by the artist. Also relevant is the George Eastman House's Watts album, which contains thirty-nine of Cameron's earliest photographic prints, dating from January to February 1864, and which is dedicated expressly to the painter.

5. Mary Seton Watts, *George Frederic Watts*, vol. I, p. 194.

6. Letter from Julia Margaret Cameron to Sir John Herschel, 31 December 1864, Heinz Archive and Library (Autograph Letter Series), National Portrait Gallery, London, fol. 6.

7. Emilie Barrington, *G.F. Watts: Reminiscences*, London, 1905, p. 29.

8. Ibid. 70. Watts was born on the same day as George Frideric Handel, after whom he was named.

9. Oxford, Bodleian Library, Letter from Henry Taylor to G.F. Watts, 5 September 1880, Bodleian Library MS Eng. lett. d. 14, fols 246–47.

10. Edward Burne-Jones, *The Little Holland House Album*, North Berwick, 1981, p. 7.

11. Laura Troubridge, *Memories and Reflections*, London, 1925, p. 23.

12. Elizabeth French Boyd, *Bloomsbury Heritage: Their Mothers and their Aunts*, London, 1976, p. 10.

13. Frederic William Maitland, *The Life and Letters of Leslie Stephen*, London, 1906, p. 335.

14. From 28 November 2015 to 14 February 2016, the Victoria and Albert Museum exhibited a large number of works by Cameron from its collection and offered a close examination of her relationship with Sir Henry Cole, founding director of the museum and the first to exhibit her work. The accompanying catalogue, *Julia Margaret Cameron*, was by the curator Marta Weiss.

15. In a letter dated 7 April 1868 Cameron acknowledges the significance of the museum director Henry Cole in her photographic efforts: 'Lord Essex will do the same & all this I tell you to show you that thro your generous loan of those two rooms I am likely now to acquire fortune as well as fame for as I told you and you gave me entire sympathy a woman with sons to educate cannot live on fame alone! I owe the start to you and I hope I shall win a good race & win a diadem as well as a laurel crown' (Victoria and Albert Museum, London, NAL 55.BB. Box 8).

16. Cox and Ford, *Julia Margaret Cameron: The Complete Photographs*, Los Angeles, CA, 2003, p. 2.

17. Anne Thackeray Ritchie recalls, 'Mrs Cameron stays up till two o'clock in the morning over her soaking photographs, Jowett's lamp also burns from casement … Mr. Prinsep wears a long veil and a high-coned hat and quantities of coats. Minny [Annie's sister] goes and reads Froude to him' (Hester Thackeray Fuller and Violet Hammerslay, eds, *Thackeray's Daughter: Some Recollections of Anne Thackeray Ritchie*, Dublin, 1952, pp. 125–7).

18. Letter from G.F. Watts to Julia Margaret Cameron, Friday, n.d., Heinz Archive and Library, National Portrait Gallery, London, GFW/1/12/37, fol. 81.

19. Letter from G.F. Watts to Julia Margaret Cameron, n.d., Heinz Archive and Library, National Portrait Gallery, London, GFW/1/12/37, fol. 83.

20. G.F. Watts, 'The Present Conditions of Art', *The Nineteenth Century*, vol. VII, no. 36, 1880, p. 251.

21. Hugh Macmillan, *The Life-Work of George Frederic Watts*, London, 1903, p. 44.

22. Mary Seton Watts, *George Frederic Watts*, vol. II, p. 130.

23. There is a significant body of literature on the Symbolist movement in art and literature. For material principally concerned with G.F. Watts, see Andrew Wilton and Robert Upstone (eds), *The Age of Rossetti, Burne-Jones and Watts: Symbolism in Britain, 1860–1910*, London, 1997.

24. Andrew Wilton, 'Symbolism in Britain', in Wilton and Upstone (eds), *The Age of Rossetti, Burne-Jones and Watts*, p. 13.

25. Barbara Bryant, 'G.F. Watts and the Symbolist Vision', in Wilton and Upstone (eds), *The Age of Rossetti, Burne-Jones and Watts*, p. 65.

26. Letter from G.F. Watts to Julia Margaret Cameron, n.d., Heinz Archive and Library, National Portrait Gallery, London, GFW/1/12/37 , fol. 82.

27. The Latin phrase *ut pictura poesis* was an analogy first introduced by Horace in *Ars Poetica*, in which he compared the art of painting to poetry. Literally translated 'as is painting, so is poetry', the idea took on further meaning when, in the nineteenth century, John Ruskin and late Romantic writers applied it to their conception of art as it moved from imitation to expression. In his seminal text *Modern Painters*, Ruskin writes, 'Both painting and speaking are methods of expression. Poetry is the employment of either for the noblest purposes' (*Modern Painters*, London, 1907, vol. IV, p. 14). Cameron would employ similar language in her own poem 'On a Portrait' and in a letter to Herschel of 31 December 1864, where she asserts that photography is a fine art through its alignment with poetry and beauty (Heinz Archive and Library (Autograph Letter Series), National Portrait Gallery, London, fol. 6).

28. Martin Barnes, 'Bonhams to Sell Julia Margaret Cameron's Intimate Image of Virginia Woolf's Mother, Julia Jackson', *Art Daily*, 2015, https://artdaily.cc/news/51344/Bonhams-to-sell-Julia-Margaret-Cameron-s-intimate-image-of-Virginia-Woolf-s-mother--Julia-Jackson#.Y77YknbP1aQ (accessed 1 March 2015).

29. Emily Sellwood Tennyson, *The Letters of Emily Lady Tennyson*, ed. James O. Hoge, University Park, PA, 1974, p. 174.

30. W.B. Yeats, writing in 1898 of the previous forty years of artistic avant-garde summarized this blended effort as follows: 'All Art that is not mere story-telling, or mere portraiture, is symbolic … A person or a landscape that is a part of a story or a portrait, evokes but so much emotion as the story or the portrait can permit without loosening the bonds that make it a story or a portrait; but if you liberate a person or landscape from the bonds of motives and their actions, causes and their effects, and from all bonds of your love, it will change under your eyes, and become a symbol of an infinite emotion, a perfected emotion, a part of the Divine Essence' ('Symbolism in Painting', in *Ideas of Good and Evil*, 1903, republished as *Essays*, London, 1924, p. 183).

Chapter 4

1. Tennyson, Emily Sellwood, *Lady Tennyson's Journal*, ed. James O. Hoge, Charlottesville, VA, 1981, p. 37. Agnes Weld, Alfred Tennyson's niece, affirmed the relationship between the photographer and poet in her recollection that Julia Margaret Cameron was one of the few women outside his own relations whom he called by her Christian name and vice versa.

2. Agnes Grace Weld, *Glimpses of Tennyson and of Some of his Relations and Friends*, New York, 1903, pp. 75–6.

3. Letter from Julia Margaret Cameron to G.F. Watts, 3 December 1860, Heinz Archive and Library, National Portrait Gallery, London, GFW/1/4/87, fol. 276.

4. Tennyson complained, 'I can't be anonymous by reason of your confounded photography' (cited in Helmut Gernsheim, *Julia Margaret Cameron: Her Life and Photographic Work*, London, 1975, p. 35).

5. In his biography, Hallam Tennyson recalls that his father studied the legends of King Arthur in earnest; some portions of the poem were begun as early as 1832, but it was not until 1855 that he decided upon the final shape of *Idylls of the King* (Hallam Tennyson, *Alfred Lord Tennyson: A Memoir by his Son*, London, 1897, vol. II, p. 125). In 1859 he published the first instalment of

the poem including 'Geraint and Enid', 'Merlin and Vivien', 'Launcelot and Elaine' and 'Guinevere'. The final version of 'The Holy Grail' was published in 1869, along with 'The Coming of Arthur', 'Pelleas and Ettarre' and 'The Passing of Arthur'. In 1872 'Gareth and Lynette' and 'The Last Tournament' were published, followed in 1885 by 'Balin and Balan', completing the 'twelve books' of the *Idylls*.

6. From here forward, I shall refer to Cameron's *Illustrations to Tennyson's Idylls of the King, and Other Poems* (London, 1874–5; Oxford, Bodleian Library Arch. K b.18) as *Illustrations* and to Alfred Tennyson's *Idylls of the King* (ed. Hallam Tennyson, London, 1908) as *Idylls*. The following is a list of the known copies of Cameron's *Illustrations to Tennyson's Idylls of the King, and Other Poems*, London, 1875: Bodleian Library, Oxford, vol. II; Harvard University Library, Cambridge, MA, vols I–II; George Eastman House, Rochester, vols I–II; J. Paul Getty Museum, Los Angeles, CA, double set of vols I–II; The Metropolitan Museum of Art, New York, vol. I; Harry Ransom Research Center, University of Texas, Austin, vols I–II; the Harry Ransom Center also holds a rare miniature album of reduced photographs called *Illustrations by Julia Margaret Cameron of Alfred Tennyson's Idylls of the King and Other Poems: Miniature Edition* (1875?); Tennyson Research Centre, Lincoln, vols I–II; Victoria and Albert Museum, London, vols I–II. Charles Millard notes that in December 1875 Cameron wrote to Frances W. Fox of Bristol, 'I have had the pleasure to despatch your Book to you – today –. It is the first copy issued and I am quite pleased to think that the Bristol Art-Society will so soon see my Book and that you should possess it' ('Julia Margaret Cameron and Tennyson's *Idylls of the King*', *Harvard Library Bulletin*, vol. XXI, no. 2, 1973, p. 189). Millard also contends that there may have been more volumes than are now known by virtue of the number of individual prints from the *Illustrations* that appear to be from unbound books.

7. Cox and Ford, *Julia Margaret Cameron: The Complete Photographs*, p. 467; Millard, 'Julia Margaret Cameron and Tennyson's *Idylls of the King*', p. 201; Gernsheim, *Julia Margaret Cameron*, p. 42.

8. As she had taken over 200 photographs in pursuit of the final twelve in the first volume, her disappointment was significant when just three were used as sources for wood engravings for the final 'People's edition'. A portrait of Arthur, an engraved copy of Elaine with Lancelot's shield and the image of Maud were the only illustrations included in King's volumes that were based on photographs by Cameron. Reporting to Sir Edward Ryan, she wrote: 'Alfred Tennyson <u>asked</u> me to illustrate his Idylls <u>for this people's edition</u> and when I had achieved my beautiful large pictures at such a cost of labour, strength & money, for I have taken 245 photographs to get to these 12 successes, it seemed such a pity that they should only appear in the very tiny reduced form in Alfred's volume (where I gave them only as a matter of friendship), that he himself said to me "Why don't you bring them out their actual size in a big volume at your own risk" and I resolved at once to do so' (Letter from Julia Margaret Cameron to Sir Edward Ryan, 4 December 1874, unpublished, quoted in Gernsheim, *Julia Margaret Cameron*, p. 46).

9. Lindsay Smith, *Pre-Raphaelitism: Poetry and Painting*, Tavistock, 2013, p. 45.

10. Ibid. 64.

11. T.S. Eliot, 'In Memoriam', in Killham (ed.), *Critical Essays on the Poetry of Tennyson*, p. 209.

12. Armstrong, *Scenes in a Library*, p. 365. Armstrong goes on to write, 'this is most evident in her manner of excerpting from Tennyson's text ... As if to emphasize her own process of selection from Tennyson's text, that these excerpts are her choices, corresponding to her reading of the *Idylls* and her photographic process of excerpting from it, she underlined part of the citation the referred directly to the image, underscoring the way the citation referenced the photograph rather than the other way around.'

13. It remains unclear how much, if any, income was earned from the *Illustrations*. Charles Millard notes that the illustrations appear to have been neither widely distributed nor popular ('Julia Margaret Cameron and Tennyson's *Idylls of the King*', p. 189).

14. Ibid. 200.

15. Cameron referred to Tennyson as a 'contemplative poet' in a letter to G.F. Watts (Letter from Julia Margaret Cameron to G.F. Watts, 3 December 1860, Heinz Archive and Library, National Portrait Gallery, London, GFW/1/4/87, fol. 276).

16. As Karen Hodder notes in her edition of *The Works of Alfred Lord Tennyson*, London, 2008, an 'idyll', which Tennyson pronounced 'idle', being sensitive to its Greek etymology, is a short descriptive poem (p. 463). The term is derived from the Greek *eidyllion*, meaning 'little picture'. Each of Tennyson's idylls tell an individual story from the Arthurian legends but they are all connected by a central theme.

17. According to Tennyson's son, the poet said of the *Idylls*: '"Poetry is like shot-silk with many glancing colours. Every reader must find his own interpretation according to his ability, and according to his sympathy with the poet ... The whole", he said, "is the dream of man coming in practical life and ruined by one sin" ... My father said on his eightieth birthday: "My meaning in the *Idylls of the King* was spiritual. I took the legendary stories of the Round Table as illustrations. I intended Arthur to represent the Ideal in the Soul of Man coming into contact with the warring elements of the flesh"' (Hallam Tennyson, *Alfred Lord Tennyson*, vol. II, p. 127).

18. In his description of Arthur's journey in the *Idylls*, Alfred Tennyson says, 'Birth is a mystery and death is a mystery, and in the midst lies the tableland of life, and its struggles and performance. It is not the history of one man or of one generation but of a whole cycle of generations"' (quoted in Hallam Tennyson, *Alfred Lord Tennyson*, vol. II, p. 127).

19. Alfred Tennyson, 'Mariana', in *The Works of Alfred Tennyson*, ed. Hodder, p. 16.

20. Caws and Joseph, 'Naming and Not Naming', p. 392.

21. T.S. Eliot, 'In Memoriam', in Harold Bloom (ed.), *Alfred Lord Tennyson*, New York, 1985, p. 13. Eliot also goes on to describe the uniqueness of the poet: 'Tennyson's surface, his technical accomplishment, is intimate with his depths: what we most quickly see about Tennyson is that which moves between the surface and the depths, that which is of slight importance. By looking innocently at the surface we are most likely to come to the depths, to the abyss of sorrow. Tennyson is not only a minor Virgil, he is also with Virgil as Dante saw him, a Virgil among the Shades, the saddest of all English poets' (p. 18).

22. Catherine Maxwell suggests that Tennyson himself was 'a pictorialist who is none the less always obsessed by the focal point which defies or frustrates full vision, the elusive point of inspiration which found vision and which

23. Hallam, 'On Some of the Characteristics of Modern Poetry, and On the Lyrical Poems of Alfred Tennyson', pp. 620–21; McLuhan, 'Tennyson and Picturesque Poetry', p. 72.

24. Joseph, *Tennyson and the Text*, pp. 75–87.

25. Armstrong, *Scenes in a Library*, p. 410.

26. Helen Groth, *Victorian Photography and Literary Nostalgia*, Oxford, 2003, p. 151.

27. Joseph, *Tennyson and the Text*, p. 83.

28. Hallam Tennyson recalls his father's words: 'Before I could read, I was in the habit on a stormy day of spreading my arms to the wind, and crying out "I hear a voice that's speaking in the wind", and the words "far, far away" had always a strange charm for me' (*Alfred Lord Tennyson*, vol. I, p. 11).

29. Barbara Tepa Lupack, with Alan Lupack, *Illustrating Camelot*, Woodbridge, 2008, p. 42.

Chapter 5

1. The British photographer Henry Peach Robinson is considered to have been the first to use the term 'pictorial' in relation to photography in *Pictorial Effect in Photography Being Hints on Composition and Chiaro-oscuro for Photographers* (Philadelphia, PA, 1881, first published in 1869).

2. William Michael Rossetti, 'Mr. Palgrave and Unprofessional Criticisms in Art', *Fine Arts Quarterly Review*, 1866, pp. 333–4, cited in MacKay, *Creative Negativity*, p. 46.

3. *The Works of Alfred Tennyson*, ed. Hodder, p. 90.

4. Anna Brownell Jameson, *Legends of the Madonna as Represented in the Fine Arts*, London, 1852, pp. 37–8.

5. 'It seem'd so hard at first, mother, to leave the blessed sun, / And now it seems as hard to stay, and yet His will be done' ('Conclusion', lines 9–10, in *The Works of Alfred Tennyson*, ed. Hodder, p. 91).

6. Letter from Julia Margaret Cameron to Henry Taylor, 1 July [1876?], Oxford, Bodleian Library MS. Eng. lett. d. 13, fol. 81.

7. *Tennyson: A Selected Edition*, pp. 324–5.

8. T.S. Eliot observes that Tennyson's 'poems are always descriptive, and always picturesque; they are never really narrative' ('In Memoriam', in Bloom, ed., *Alfred Lord Tennyson*, p. 13).

9. The elegiac mode in poetry has its origins in classical Greece and is constructed in iambic couplets. It was later popularized by Thomas Gray's 1751 'Elegy Written in a Country Churchyard', and commonly involved the poet meditating on death. It can also take a more generalized form that aims to create a sense of solemnity or tranquillity. For further insight into Tennyson's use of the elegiac mode in his effort to express the inexpressible, see Joseph, *Tennyson and the Text*, especially chs 2 and 3.

10. *Tennyson: A Selected Edition*, p. 328.

11. Maxwell, *The Female Sublime from Milton to Swinburne*, p. 110.

12. For an extended discussion on Tennyson and his influence on Symbolist poets,

including Mallarmé, see Caws and Joseph, 'Naming and Not Naming', pp. 390–410.

13. Gerhard Joseph, 'The Echo and the Mirror *en abîme* in Victorian Poetry', in Valentine Cunningham (ed.), *Victorian Poets: A Critical Reader*, Chichester, 2014, p. 18.

14. *Tennyson: A Selected Edition*, pp. 266–7.

15. Cameron experienced at first hand tragedy of this type with the premature death of her only daughter, Julia Hay Norman, in 1873; Tennyson likewise suffered the early death of Arthur Hallam, his closest friend and to whom his poem *In Memoriam* is dedicated, as well as the death of his son Lionel. Gerhard Joseph suggests that the 'idle-tears' are not limited to a single individual speaker; instead, 'they are rather a cosmic principle, the Virgilian lacrimae rerum of which any specific loss is an instance but never a meaningful explanation. When one loses a friend like Arthur Hallam or a son such as Lionel, or a daughter named Julia, "We know not, and we know not why we moan." The mystery of human suffering is deepened, as well as exemplified, by individual losses' (*Tennysonian Love: The Strange Diagonal*, Minneapolis, MN, 1969, p. 157).

16. Tennyson, *The Princess*, in *Tennyson: A Selected Edition*, p. 267. Tennyson constructed the notion of 'Death in Life' to suggest a kind of human sorrow so significant as to become elevated into a divine or universal despair.

17. Hallam Tennyson, *Alfred Lord Tennyson: A Memoir by His Son*, vol. I, p. 253.

18. Tennyson, *The Princess*, in *Tennyson: A Selected Edition*, pp. 266–7.

19. Joseph, *Tennysonian Love*, p. 153.

20. Hallam Tennyson, *Alfred Lord Tennyson*, vol. II, p. 503. Donne's poem offers insights into the human condition of love, its connection to the soul and of the separation between body and soul caused by death. It is considered one of his most spiritual poems. In addition to poetry by Donne, Tennyson had a copy of Robert Burton's *Anatomy of Melancholy* in his library and held Milton and Petrarch in high esteem; all of it reinforced Tennyson's own tendency to celebrate sorrow.

21. The full text of 'Farewell of the Body to the Soul' is included in the Appendix.

22. Walter Pater, *Studies in the History of the Renaissance*, London, 1873, p. 140.

23. Susan Sontag famously considered the relationship between photography and death: 'Photography is an elegiac art, a twilight art. Most subjects photographed are, just by virtue of being photographed, touched with pathos. An ugly or grotesque subject may be moving because it has been dignified by the attention of the photographer. A beautiful subject can be the object of rueful feelings, because it has aged or decayed or no longer exists. All photographs are *memento mori*. To take a photograph is to participate in another person's (or thing's) mortality, vulnerability, mutability. Precisely by slicing out this moment and freezing it, all photographs testify to time's relentless melt' (*On Photography*, p. 15). Roland Barthes would contend with similar themes in his *Camera Lucida: Reflections on Photography*, New York, 1981.

24. Joseph, *Tennyson and the Text*, pp. 84–5. The city of Camelot is 'therefore never built at all, / And therefore built for ever' ('Gareth and Lynette', lines 273–4, in *Tennyson: A Selected Edition*, p. 701).

25. *Tennyson: A Selected Edition*, p. 866.

26. Jordan Bear, 'The Silent Partner: and Agency Absence in Julia Margaret Cameron's Collaborations', *Grey Room*, vol. 48, 2012, p. 94. Bear connects the Victorians' fascination with death and the promise of 'liminality', a term analogous to Tennyson's 'Death in Life', to a developing lexicon that 'evokes [a] new permeability attributed to the two states: trance, coma, syncope, catalepsy, insensibility, suspended animation, human hibernation, mesmerism, and anesthesia, all products of the Victorian sensibility' (pp. 95–6).

27. Joanne Lukitsh suggests that, in addition to being a parallel figure to Arthur, Elaine also stands out as an important figure in her own right, with the photographs suggesting that she is the author of her own immortality ('Julia Margaret Cameron's Photographic Illustrations to Alfred Tennyson's *Idylls of the King*', *Arthurian Literature*, vol. 7, 1987, p. 157).

28. 'Now there stood by the cross of Jesus His mother, and His mother's sister, Mary [the wife] of Cleophas, and Mary Magdalene' (John 19:25). The models used by Cameron in both photographs were all named Mary; the titles of each image therefore suggest both the real Mary Kellaway, Mary Ryan and Mary Hillier, while typologically referring to the Marys of biblical scripture.

29. Edgar Wind provides an extended assessment of the iconographic relationship between the classical and Christian graces (*Pagan Mysteries in the Renaissance*, New Haven, CT, 1958).

30. Joseph, *Tennyson and the Text*, pp. 161–3.

31. In his memoir, Hallam Tennyson accounts for Tennyson's description of the poem as 'a little Hamlet', and goes on to describe his father's work as 'the history of a morbid poetic soul, under the blighting influence of a recklessly speculative age. He is the heir of madness, an egoist with the makings of a cynic, raised to sanity by a pure and holy love which elevates his whole nature, passing from the height of triumph to the lowest depth of misery, driven into madness by the loss of her whom he has loved, and, when he has at length passed through the fiery furnace, and has recovered his reason, giving himself up to work for the good of mankind through the unselfishness born of his great passion' (*Alfred Lord Tennyson*, vol. I, p. 396).

32. Hallam Tennyson, *Alfred Lord Tennyson*, vol. I, p. 404.

33. Henry Van Dyke, 'The Voice of Tennyson', *Century Magazine*, vol. XLV, 1893, p. 540.

34. Hallam Tennyson, *Alfred Lord Tennyson*, vol. I, p. 396.

35. David G. Riede, 'Tennyson's "Little Hamlet"', in Valentine Cunningham (ed.), *Victorian Poets: A Critical Reader*, Chichester, 2014, p. 269. Riede is referring here to Walter Benjamin's treatment of symbol and allegory.

36. Tennyson, *In Memoriam A.H.H.*, in *Tennyson: A Selected Edition*, pp. 346–9.

37. *Tennyson: A Selected Edition*, p. 563.

38. Ibid.

39. Ibid.

40. Amelia Scholtz discusses at length Cameron's photography and its resonance with later visual and linguistic theories, particularly the work of Charles Sanders Peirce and Jacques Derrida, and further elucidated in photographic terms by Geoffrey Batchen in 'Photographs before Photography: Marking Time in Tennyson's and Cameron's *Idylls of the King*', *Literature Interpretation Theory*, vol. 24, no. 2, 2013, pp. 112–37.

Chapter 6

1. Letter from Julia Margaret Cameron to Sir John Herschel, 31 December 1864, Heinz Archive and Library (Autograph Letter Series), National Portrait Gallery, London, fol. 6.

2. Mike Weaver asserts that Cameron was a 'photographer of the sublime' (*Julia Margaret Cameron, 1815–1879*, pp. 136–41). Anne Thackeray Ritchie describes Cameron's great love for the 'world of beautiful shadows' (*Lord Tennyson and his Friends*, p. 15).

3. 'Winnow with giant arms the slumbering green. / There hath he lain for ages and will lie / Battening upon huge sea worms in his sleep, / Until the latter fire shall heat the deep; / Then once by man and angels to be seen / In roaring he shall rise and on the surface die' ('The Kraken', in *Tennyson: A Selected Edition*, p. 18). Gerhard Joseph writes, 'For in Tennyson's "fables of emergence" [like "The Kraken"] when the deep self thrusts itself onto the surface of expression, it dies painfully into the inadequate meditation of language' (*Tennyson and the Text*, p. 24).

4. Caws and Joseph offer the following assessment of the 'impression' left by Tennyson's poetry, a description that could apply equally to Cameron's work: 'what we remember of a great poet is the so-called impression of sublimity he has left, by and through his work, rather than the work itself, and this impression, veiled in human language, pierces through in even the most common translations' ('Naming and Not Naming', p. 394).

5. Julian Cox, '"To … startle the eye with wonder & delight": The Photographs of Julia Margaret Cameron', in Cox and Ford, *Julia Margaret Cameron: The Complete Photographs*, p. 41.

6. W.J.T. Mitchell, *Iconology: Image, Text, Ideology*, Chicago, IL, 1986, p. 126.

7. Cameron, 'On a Portrait' (see Appendix).

8. The complete refrain by Tennyson reads, 'I am a part of all that I have met; / Yet all experience is an arch wherethro' / Gleams that untravell'd world whose margin fades / For ever and forever when I move' ('Ulysses', lines 18–21, in *Tennyson: A Selected Edition*, p. 142).

9. Geoffrey Batchen discusses the indexicality of photographs and the potential for understanding its theoretical possibilities through the application of Charles Sanders Peirce's semiotics in *Burning with Desire*.

10. A statement made by *The Photographic Journal*, in reviewing Cameron's submission to the Photographic Society of Scotland in 1865, exemplifies the criticism levelled by her contemporaries: 'Mrs. Cameron exhibits her series of out-of-focus portraits of celebrities. We must give this lady credit for daring originality, but at the expense of all other photographic qualities. A true artist would employ all the resources at his disposal, in whatever branch of art he might practise. In these pictures, all that is good in photography has been neglected and the shortcomings of the art are prominently exhibited. We are sorry to have to speak thus severely on the works of a lady, but we feel compelled to do so in the interest of the art' (cited in Malcolm Daniel, 'Julia Margaret Cameron (1815–1879)', Heilbrunn Timeline of Art History, 2004, http://www.metmuseum.org/toah/hd/camr/hd_camr.htm, accessed 30 April 2015).

11. The next generation of Pictorialist and Symbolist photographers included artists like Alfred Stieglitz, Alvin Langdon Coburn, Edward Steichen, Gertrude Käsebier and Frederick Hollyer, among others. Cameron's influence is still recognizable today in the work of photographic artists such as Sally Mann.

12. P.H. Emerson, *Naturalistic Photography for Students of the Art*, p. 30.

13. Ritchie, *Lord Tennyson and his Friends*, p. 15.

14. Cameron, dedication in the Watts album (cited in Cox and Ford, *Julia Margaret Cameron: The Complete Photographs*, p. 503). In her 'Annals of my Glass House', Cameron wrote, 'I longed to arrest all beauty that came before me, and at length the longing has been satisfied. Its difficulty enhanced the value of the pursuit.'

Appendix

1. Julia Margaret Cameron, 'On a Portrait', dated September 1875, first published in *Macmillan's Magazine*, vol. XXXIII, February 1876, p. 372.

2. According to Mike Weaver, this poem, now in the Getty Collection, was preserved in an envelope dated 19 March and postmarked 'Ceylon March 1876' (*Whisper of the Muse*, p. 61).

3. Letter from Julia Margaret Cameron to Blanche Shore Smith Clough, 20 July 1862, Papers of A.H. Clough, 1829–1900, Oxford, Bodleian Library MS. Eng. lett. d. 178, fol. 75.

Notes to captions

1. Mike Weaver, 'Julia Margaret Cameron: The Stamp of Divinity', in Mike Weaver (ed.), *British Photography in the 19th Century: The Fine Art Tradition*, Cambridge, 1989, p. 156.

2. P.H. Emerson, 'Mrs Julia Margaret Cameron', *Sun Artists*, 1890, p. 37. Alvin Langdon Coburn wrote about Cameron's proficiency as a portraitist in 'The Old Masters of Photography', *The Century Magazine*, October 1915, pp. 908–20.

3. Alfred Stieglitz, *Camera Work*, no. 41, January 1913.

4. For further information on the Alfred Stieglitz Collection at the Art Institute of Chicago, see 'The Alfred Stieglitz Collection and the Art Institute of Chicago', https://archive.artic.edu/stieglitz/about (accessed 18 January 2023).

5. Julia Margaret Cameron, 'Annals of my Glass House', written in 1874, *The Photographic Journal*, vol. XVII (NS), July 1927, pp. 296–301, repr. in Mike Weaver, *Julia Margaret Cameron, 1815–1879*, London, 1984, p. 155.

6. Henry Taylor, *Autobiography of Henry Taylor, 1800–1875*, London, 1855, vol. II, p. 197.

7. All of the portraits of Henry Taylor in the Bodleian Library's collection date from 1864 to 1867.

8. Fig. 20 is similar to another portrait of Taylor in Cameron's Mia Album, which has been attributed to Rejlander. The Mia Album is currently held privately by Michael Mattis and Judith Hochberg.

9. Letter from Julia Margaret Cameron to G.F. Watts, 3 December 1860, Heinz Archive and Library, National Portrait Gallery, London, GFW/1/4/87, fol. 276.

10. Colin Ford, *The Cameron Collection: An Album of Photographs by Julia Margaret Cameron Presented to Sir John Herschel*, Wokingham, 1975; Julian Cox and Colin Ford, *Julia Margaret Cameron: The Complete Photographs*, Los Angeles, CA, 2003, p. 351.

11. Carol Hanbery MacKay, *Creative Negativity: Four Victorian Exemplars of the Female Quest*, Stanford, CA, 2001, pp. 25–6.

12. *Catalogue of the Art Treasures of the United Kingdom, Collected at Manchester in 1857*, 2nd edn, London, 1857; *Catalogue of Pictures forming the Collection of Lord and Lady Wantage at 2, Carlton Gardens, London*, London, 1902, p. 154; Caldesi and Montecchi, *Photographs of the Gems of the Art Treasures Exhibition*, Manchester, 1857.

13. Henry Taylor, *Notes from Life in Six Essays*, London, 1848, p. 95.

14. Mary Seton Watts, *George Frederic Watts: Annals of the Artist's Life*, London, 1912, vol. III, p. 35.

15. Julia Margaret Cameron, 'Annals of my Glass House', p. 157.

16. Henry Taylor, *Autobiography*, vol. II, pp. 67–8.

17. Ellen Terry, *Four Lectures on Shakespeare*, London, 1932, pp. 138, 146.

18. Ibid. 137–8.

19. Anna Brownell Jameson, *Shakespeare's Heroines: Characteristics of Women, Moral, Poetical, and Historical*, London, 1897, p. 220. Jameson's book on Shakespeare's heroines was first published in 1832.

20. For a general accounting of the Cenci myth and its representation in art and literature, see Belinda Jack, *Beatrice's Spell*, New York, 2005.

21. Weaver, *Julia Margaret Cameron, 1815–1879*, p. 110.

22. *Letters of Benjamin Jowett, MA, Master of Balliol College, Oxford*, ed. Evelyn Abbot and Lewis Campbell, London, 1897, vol. II, p. 268.

23. Thomas Carlyle, *On Heroes and Hero Worship*, in *Sartor Resartus: The Life and Opinions of Herr Teufelsdröckh, Heroes and Hero Worship and the Heroic in History* (New York, 1897), p. 216.

24. Anna Brownell Jameson, *The History of our Lord as Exemplified in Works of Art*, completed by Lady Eastlake, London, 1864, vol. I, p. 212.

25. Una Taylor, *Guests and Memories: Annals of a Seaside Villa*, London, 1924, p. 254.

26. From the catalogue description of Murillo's *La Santa Faz*, 'the features are noble and refined, and express the deep mental, rather than physical suffering of Christ, the Man of Sorrows' (*Catalogue of Pictures forming the Collection of Lord and Lady Wantage*, p. 154; see also Caldesi and Montecchi, *Photographs of the Gems of the Art Treasures Exhibition*).

27. *Catalogue of the Art Treasures of the United Kingdom, Collected at Manchester in 1857*, p. 53.

28. Watts also produced thousands of drawings and studies. The first in-depth study of his drawings has been published by Chloe Ward in partnership with the Watts Gallery, *Drawings of G.F. Watts*, London, 2015.

29. *The Letters of Emilia Russell Gurney*, ed. Ellen Mary Gurney, London, 1902, p. 34.

30. Cited in M.H. Spielmann, 'The Works of Mr. George F. Watts, R.A., with a Complete Catalogue of his Pictures', *Pall Mall Gazette* ('Extra'), no. 22, 1886, p. 34.

31. Allen Staley (ed.), *The Victorian High Renaissance*, Minneapolis, MN, 1978, p. 19.

32. Mike Weaver discusses the significance of Overstone's relationship with Cameron in *Whisper of the Muse: The Overstone Album and Other Photographs by Julia Margaret Cameron*, Los Angeles, CA, 1986.

33. A complete list of the contents of the collections of Lord Overstone and of Lord and Lady Wantage (the latter collection is generally referred to as the Wantage Collection) can be found in the *Catalogue of Pictures forming the Collection of Lord and Lady Wantage*.

34. Murillo's *La Santa Faz* was purchased in 1836 from Richard Ford and was also exhibited at the British Institution in 1851 and at the Manchester Art Treasures Exhibition in 1857. The Wantage collection catalogue includes a description of Murillo's 'Man of Sorrows' and confirms that Perugino's panels of *St Sebastian and St Jerome* and Rembrandt's *Portrait of an Old Lady* were among those selected to hang at the Manchester exhibition (*Catalogue of Pictures forming the Collection of Lord and Lady Wantage*, pp. 154, 15–25). Elizabeth Pergam's *The Manchester Art Treasures Exhibition of 1857* (Farnham, 2011) gives a full account of the works on display at the exhibition, as do the *Catalogue of the Art Treasures of the United Kingdom, Collected at Manchester in 1857* and Caldesi and Montecchi, *Photographs of the Gems of the Art Treasures Exhibition*.

35. Anna Brownell Jameson, *Legends of the Madonna as Represented in the Fine Arts*, London, 1848, and *Sacred and Legendary Art*, 2 vols, London, 1883.

36. Mary Seton Watts, *George Frederic Watts*, vol. II, pp. 39, 53–4.

37. Emilie Barrington, *G.F. Watts: Reminiscences*, London, 1905, p. 50.

38. Michael Bartram, *The Pre-Raphaelite Camera: Aspects of Victorian Photography*, Boston, MA, 1985, p. 146.

39. Carlyle, *On Heroes and Hero Worship*, in *Sartor Resartus*, pp. 311–12.

40. E.T. Cook, *A Popular Handbook to the National Gallery*, 8th edn, London, 1922, p. 53.

41. Hugh Haweis, *Music and Morals*, London, 1871, pp. 375–6.

42. Walter Pater, *Studies in the History of the Renaissance*, London, 1873, p. 144.

43. G.K. Chesterton, *G.F. Watts*, London, 1975, pp. 24–5.

44. Mary Seton Watts, *George Frederic Watts*, vol. II, p. 257.

45. Julia Margaret Cameron, 'On a Portrait' (see Appendix).

46. Haweis, *Music and Morals*, p. 504.

47. Arthur Symons, 'The Art of Watts', *The Fortnightly Review*, 1900, p. 188. Symons describes the significance of Watts's portraits: 'At first a blank, then an animal intelligence, then will, then the desire of beauty, or knowledge, or power, then the consciousness of self, then personality unconscious even of its own presence, then the passion of an idea, into which the whole man passes, more visibly than in life … or the soul itself, fluttering a faint body as a flame is fluttered by the wind … the portraits grow before us, building up man of dust and breath, as in the first creation. And always hand and soul move forward together.'

48. Alison Smith, 'The Symbolic Language of G.F. Watts', in Veronica Gould (ed.), *The Vision of G.F. Watts O.M. R.A.*, Salisbury, 2004, pp. 24–5. 'Synaesthesia' refers to the creation of a sense impression relating to one sense by stimulating another sense. In her 'Annals of my Glass House', Cameron cites an example of Tennyson's poetic synaesthesia in two lines from his *Locksley Hall*: 'the chord of self with trembling / Passed like music out of sight'. Cameron also uses it to describe the English poet Arthur Hugh Clough and the 'music of his sad and serious eye', as well as in her poem 'On A Portrait', when she compels the painter to 'tune thy song right and paint rare harmonies'.

49. Emilie Barrington, *G.F. Watts: Reminiscences*, p. 94.

50. Arthur Symons, *Plays, Acting, and Music*, New York, 1909, pp. 242–3.

51. MacKay, *Creative Negativity*, p. 25.

52. Julia Margaret Cameron to Blanche Shore Smith Clough, 20 July 1862, Oxford, Bodleian Library MS. Eng. lett. d. 178, fol. 75. Cameron's poem written in memory of Arthur Clough can be found in the Appendix.

53. M.H. Spielmann, 'The Portraiture of George Frederic Watts,' *The Nineteenth Century*, vol. LXXIII, 1913, pp. 1–32.

54. Regarding the portraits, Cosmo Monkhouse commented that 'the special aim of his art has been to make the face the window of the mind' ('The Watts Exhibition', *Magazine of Art*, vol. 5, 1882, p. 178).

55. Sotheby's, 'The "Signor 1857" Album', L12408, lot 65, 12 December 2012, https://www.sothebys.com/en/auctions/ecatalogue/2012/english-literature-history-l12408/lot.65.html (accessed 14 February 2023). As part of the initial study of Cameron's 'Signor 1857' album undertaken for Sotheby's by Joanne Lukitsh and Juliet Hacking, careful consideration was given to the handwritten numbering of the album's pages. This suggests design and intentionality on the part of the photographer in constructing even her earliest albums and heralds a practice that she continued in both volumes of the *Illustrations*.

56. While Tennyson himself was reticent to acknowledge any autobiographical aspects in his work, Joseph suggests that where connections may be most readily found between subject and poet in *The Princess*: 'It is one of the few works in which Tennyson (or a narrator in the frame who is almost identical with him) appears alongside in a tale. And these characters have transparent thematic connections with the frame's narrator. When these links are thoroughly explored, it becomes clear not only that Tennyson was a consummate craftsman but also that he reached a subtle understanding … of the changes that were going on within himself' (*Tennysonian Love: The Strange Diagonal*, Minneapolis, MN, 1969, p. 76).

57. Julia Margaret Cameron, 'Annals of my Glass House', p. 157.

58. In her 1903 memoir, Agnes Grace Weld, Emily Tennyson's niece, described the relationship between Tennyson and Cameron: 'It was not lightly that Tennyson valued Mrs Cameron's criticism and praise, for he would bring his new poems and plays down to "Dimbola Lodge" before they were published and read them aloud … while Mrs Cameron listened from her own arm-chair, and the boys were seated in reverential silence on the floor. To estimate the depth of friendship and affection that subsisted between the Tennysons and the Camerons we must turn from these scenes of everyday life, when the poet, invaded by the irrepressible photographer in search of autograph signatures for a bundle of her portraits of him would say, "Julia Cameron, Julia Cameron, you are a dreadful woman"; or when his friend obtaining some less cordial reception than she desired … would say, "Alfred, you are a bear." We must turn, I say, from these scenes to the picture of the great poet with large tears in his eyes, gently patting the hand, and comforting the heart of her whose husband was reported sick unto death in distant Ceylon, and not expected to reach home alive' (*Glimpses of Tennyson and of Some of his Relations and Friends*, New York, 1903, pp. 75–6).

59. Anna Brownell Jameson, *Legends of the Monastic Orders as Represented in the Fine Arts*, London, 1852, p. xviii.

60. In 1866 Cameron wrote to Herschel about her life-size portraits, proclaiming 'they are not only *from* the Life, but *to* the Life, and startle the eye with wonder & delight' (Letter from Julia Margaret Cameron to John Herschel, 18 February 1866 (Royal Society), cited in Cox and Ford, *Julia Margaret Cameron*, p. 65).

61. 'Ulysses', in *Tennyson: A Selected Edition*, ed. Christopher Ricks, Harlow, 2007, p. 142: 'I am a part of all that I have met; / Yet all experience is an arch wherethro' / Gleams that untravell'd world whose margin fades / Forever and forever when I move' (lines 18–21).

62. G.K. Chesterton, *Tennyson*, London, 1903: 'Ask for the composition which of all contemporary compositions bears the Victorian stamp most unmistakably, which tells us most respecting the age's thoughts respecting itself, and there will be little hesitation in naming "Locksley Hall". Tennyson returns to his times what he has received from them, but in an exquisitely embellished and purified condition; he is the mirror in which the age contemplates all that is best in itself' (p. 17); 'Tennyson is essentially a composite poet. Dryden's famous verses, grand in expression but questionable in their application to

Milton, are perfectly applicable to him; save that, in making him, Nature did not combine two poets but many' (p. 20).

63. Ibid. 4.

64. The first edition of Malory's *Le Morte d'Arthur* to appear in 1816, by Alexander Chalmers, was illustrated by Thomas Uwins. Joseph Haselwood produced a second edition, also in 1816. Julia Margaret Cameron gave Tennyson a three-volume edition of Malory edited by Thomas Wright (London, 1858), now held by the Tennyson Research Centre.

65. The publisher Henry S. King & Company expressed interest in producing an affordable twelve-volume Cabinet Edition of Tennyson's poetry. The poet was deeply critical of previous attempts to illustrate his poems but believed Cameron capable of providing appropriate images.

66. Daniel Maclise had also provided the steel engraved illustrations for Cameron's translation of Gottfried August Bürger's *Leonora*, London, 1847.

67. The 1857 Moxon edition of Tennyson's *Poems* contained poems from the earlier 1830 and 1832 editions, including 'The Lady of Shalott' and 'Mariana'. The Moxon Tennyson included thirty woodcut illustrations designed by a variety of artists including those named here, as well as John Callcott Horsely, Thomas Creswick, John Everett Millais and William Mulready. The wood engravings were produced by W.J. Linton, J. Thompson, T. Williams and the Dalziel brothers.

68. The discussion about Hunt's illustrations of 'The Lady of Shalott' occurred in Cameron's London home: 'After some general talk he [Tennyson] said, "I must now ask why did you make the Lady of Shalott, in the illustration, with her hair wildly tossed about as if by a tornado?" Rather perplexed, I [Hunt] replied that I had wished to convey the idea of the threatened fatality by reversing the ordinary peace of the room and of the lady herself: that while she recognized the moment of the catastrophe had come, the spectator might also understand it. "But I didn't say that her hair was blown about like that. Then there is another question I want to ask you. Why did you make a web wind round and round her like the threads of a cocoon?" Now, I exclaimed, "surely that may be justified, for you say – 'Out flew the web and floated wide!'" Tennyson insisted, "But I did not say it floated round and round her." My defence was, "May I not urge that I had only half a page on which to convey the impression of weird fate, whereas you had about fifteen pages to give expression to the complete idea?" But Tennyson laid it down that an illustrator ought never to add anything to what he finds in the text' (William Holman Hunt, *Pre-Raphaelitism and the Pre-Raphaelite Brotherhood*, London, 1905, vol. II, pp. 124–5).

69. 'Mariana', in *Tennyson: A Selected Edition*, pp. 3–4.

70. John Ruskin, *Modern Painters*, New York, 1907, pp. 166–83 (part IV, 'Of Many Things'). Ruskin writes of the problem of attaching human emotions to the inanimate: 'The foam is not cruel, neither does it crawl. The state of mind which attributes to it these characters of a living creature is one in which the reason is unhinged by grief. All violent feelings have the same effect. They produce in us a falseness in all our impressions of external things, which I would generally characterize as the "pathetic fallacy"' (p. 170). Ruskin was concerned about the emotive in art and poetry as an invitation for excessive subjectivity; it is, perhaps, for this reason that he may have found Cameron's photography, with its interest in the emotive, troublesome and excessive.

71. *The Works of Alfred Lord Tennyson*, ed. Karen Hodder, London, 2008, p. 211.

72. The nosegay is the English version of the garland of roses, which often surrounds the Virgin Mary in Renaissance paintings.

73. For an extended discussion on Cameron's (Anglo-Catholic) Christian inheritance and its influence on her photography, see Weaver's *Julia Margaret Cameron, 1815–1879* and *Whisper of the Muse*.

74. *The Works of Alfred Tennyson*, ed. Hodder, p. 89.

75. Carol Hanbery MacKay attends to eyes in Cameron's photographs, arguing that in almost every case they are important to the composition. Additionally, she suggests that the figures rarely face the camera directly (*Creative Negativity: Four Victorian Exemplars of the Female Quest*, Stanford, CA, 2001, pp. 17–55). Therefore, that the May Queen is both fully upright and looking directly at the camera implies the photographer's intent to compel more direct engagement with her audience.

76. The month of May includes two Marian liturgical celebrations and is often referred to as 'Mary's Month' in the liturgical calendar. During May, the Visitation and Annunciation, and the Coronation and Ascension are celebrated. The line 'Queen of May' is also included in songs sung to Mary as a part of the May liturgy.

77. 'The May Queen', in *The Works of Alfred Tennyson*, ed. Hodder, p. 89.

78. 'He thought I was a ghost, mother, for I was all in white, / And I ran by him without speaking, like a flash of light. / They call me cruel-hearted, but I care not what they say' ('New Year's Eve', lines 19–21, in *The Works of Alfred Tennyson*, ed. Hodder, p. 89).

79. Ibid. 90–91.

80. John D. Rosenberg suggests that 'Tennyson's single overriding theme [is that of] … loss … the "Passion of the Past" ('Tennyson and the Passing of Arthur', in Christopher Baswell and William Sharpe, eds, *The Passing of Arthur: New Essays in the Arthurian Tradition*, New York, 1988, p. 230). It is a theme that persists throughout the *Idylls*, as well as the additional poems Cameron treats in her second volume, particularly those about the May Queen and the songstresses of *The Princess*.

81. Amelia Scholtz, 'Photographs before Photography: Marking Time in Tennyson's and Cameron's *Idylls of the King*', *Literature Interpretation Theory*, vol. 24, no. 2, 2013, p. 113.

82. As evident in this passage and throughout the three sections of the May Queen poem, Tennyson refers to the changing seasons by detailing nature's rhythms as it moves from spring to summer to fall to winter.

83. Tennyson, *The Princess*, lines 256–7, in *Tennyson: A Selected Edition*, p. 261.

84. In his notes on the poem, Hallam Tennyson writes: 'the poet who created her considered her as one of the noblest among his women. The stronger the man or woman, the more of the lion or lioness untamed, the greater the man or woman tamed. In the end we see this lioness-like woman subduing the elements of her humanity to that which is the highest within her, and recognizing the relation in which she stands toward the order of the world and toward God' ('Notes', in Alfred Tennyson, *The Princess and Maud*, London, 1908, p. 268, n. 44).

85. Anna Brownell Jameson, *Sacred and Legendary Art*, vol. 2, p. xxv.

86. *Tennyson: A Selected Edition*, p. 259.

87. Tennyson uses musical references throughout the *Idylls*, a theme that Cameron carries through the first volume of the *Illustrations* in her photographs of the lullaby scene with Gareth and Lynette, of Enid's song about Fortune's Wheel, the novice who musically chides Guinevere, and in an earlier image by Cameron of Elaine that was not included in the *Illustrations* but is significant for its suggestion of love, sorrow and death. The references to music in Cameron's second volume turn autumnal and plaintive, first in her two photographs of the sonnets in *The Princess*. J.M. Gray describes song as one of the subtlest devices used in the *Idylls* (*Thro' the Vision of the Night: A Study of Source, Evolution and Structure in Tennyson's Idylls of the King*, Edinburgh, 1980, p. 96). Music plays a significant role in Cameron's work, as can be seen in her *Illustrations* and in her portraits of G.F. Watts, and is an indication of her engagement with the tenets of Symbolism.

88. The title is taken directly from *The Princess*, sonnet III–IV, 7 (*Tennyson: A Selected Edition*, p. 265).

89. Ibid.

90. Ibid.

91. The sonnet's description of long light-casting shadows across the landscape is framed by the following lines of *The Princess*: 'Amygdaloid and trachyte, till the Sun / Grew broader toward his death and fell, and all / The rosy heights came out above the lawns' and 'There sinks the nebulous star we call the Sun, / If that hypothesis of theirs be sound' (lines 345–7, 1–2, ibid. 264–5).

92. MacKay, *Creative Negativity*, p. 26.

93. *Tennyson: A Selected Edition*, p. 866.

94. Ibid. 870.

95. Jordan Bear, 'The Silent Partner: Agency and Absence in Julia Margaret Cameron's Collaborations', *Grey Room*, vol. 48, 2012, p. 96. Prosopopoeia is formally defined as a rhetorical device or figure of speech in which an imaginary or absent person speaks, acts or communicates with the audience through another object or person.

96. *Tennyson: A Selected Edition*, p. 970.

97. For example, Virgil writes: 'The echoing halls resounded through and through with a keening of women, whose wails and shrieks beat at the golden stars' (*The Aeneid*, trans. C. Day Lewis, Oxford, 1986, p. 50).

98. Gerhard Joseph claims that 'The Passing of Arthur' includes one of the most compelling uses of the echo in Tennyson's poetry ('The Echo and the Mirror *en abîme* in Victorian Poetry', in Valentine Cunningham, ed., *Victorian Poets: A Critical Reader*, Chichester, 2014, p. 19). Tennyson describes the wails of the three queens: 'Then from the dawn it seemed there came, but faint / As from beyond the limit of the world, / Like the last echo born of a great cry, / Sounds, as if some fair city were one voice / Around a king returning from his wars' (*Tennyson: A Selected Edition*, p. 972).

99. *Tennyson: A Selected Edition*, p. 970.

100. Frederic Shoberl (ed.), *The Language of Flowers, with Illustrative Poetry*, Philadelphia, PA, 1839, p. 271. See also Carol Mavor's chapter, 'To Make Mary: Julia Margaret Cameron's Photographs of Altered Women', in *Pleasures Taken: Performances of Sexuality and Loss in Victorian Photographs*, Durham, NC, 1995, pp. 43–69.

101. Virginia Woolf, *To the Lighthouse*, San Diego, CA, 1929, p. 198.

102. Sylvia Wolf describes Cameron's interest in exposing the many sides of her niece; for example, in Plate 76, she did so by flipping or reversing its negative, along with a second similar photograph, in order to create slight variations of the image (*Julia Margaret Cameron's Women*, Chicago, IL, and New Haven, CT, 1998, pp. 70–74).

103. Julia Margaret Cameron, 'Annals of my Glass House', p. 156.

104. Susan Sontag, *On Photography*, New York, 1973, p. 92.

105. Vernon Lee, *The Beautiful: An Introduction to Psychological Aesthetics*, Scotts Valley, CA, 2012, p. 56. She based her philosophical writings on empathy on the work of the German philosopher and aesthetician Theodor Lipps, and is credited with introducing the concept of empathy into the English language, which was a significant though largely neglected contribution to the field of aesthetics.

106. 'The mere presence, then, of Sublime or Beautiful feelings in the mind is not of itself sufficient to ensure the perception of their sublimity and beauty; for, unless the power of reflection is exerted, there can be no such perception' (Charles Hay Cameron, *Two Essays: On the Sublime and Beautiful, and On Duelling*, London, 1835, pp. 4–5).

107. Homer, *The Odyssey*, trans. P.S. Worsley, 2 vols, Edinburgh, 1861, and *The Iliad*, trans. P.S. Worsley and J. Conington, 2 vols, Edinburgh, 1865, 1868. Worsley translated the first twelve books of *The Iliad*, and Conington completed the translation after Worsley's death.

108. Letter from Julia Margaret Cameron to Sir Henry Cole, 21 February 1866, Victoria and Albert Museum, London, NAL 55.BB.Box 8.

109. Julia Margaret Cameron, 'Annals of my Glass House', p. 156. On Hillier as a model, see Mavor, *Pleasures Taken*, pp. 43–69.

110. *Tennyson: A Selected Edition*, p. 862. The song is literally titled 'The Song of Love and Death'.

111. 'Blackest samite' refers to the textual description of the heavy fabric that drapes the barge in which Elaine's dead body is laid before being sent down river to Camelot. 'Full-summer, to that stream whereon the barge, / Palled all its length in blackest samite, lay' (xxvii.1134–5, in *Tennyson: A Selected Edition*, p. 866).

112. 'I hold it true, what'er befall; / I feel it, when I sorrow most; / 'Tis better to have loved and lost / Than never to have loved at all' (xxvii.13–16, ibid. 371).

113. Weaver, *Julia Margaret Cameron, 1815–1879*, p. 24.

114. Weaver, *Whisper of the Muse*, p. 45.

115. Weaver, *Julia Margaret Cameron, 1815–1879*, p. 63; Coburn, 'The Old Masters of Photography', p. 920.

Selected bibliography

Alfred Stieglitz Collection, 'The Alfred Stieglitz Collection and the Art Institute of Chicago', https://archive.artic.edu/stieglitz/about, accessed 18 January 2023

Andrew, Aletha, *An Annotated Bibliography and Study of the Contemporary Criticism of Tennyson's Idylls of the King, 1859–1886*, New York, 1993

Anon., 'Fine Arts,' *Illustrated London News*, no. 1250, 19 March 1864, pp. 269–92

Armstrong, Carol, *Scenes in a Library: Reading the Photograph in the Book, 1843–1875*, Cambridge, MA, 1998

Atkinson, J.B., 'The Royal Academy and Other Exhibitions', *Blackwood's Magazine*, July 1867

Auerbach, Nina, *Private Theatricals: The Lives of the Victorians*, Cambridge, MA, 1990

Barnes, Martin, 'Bonhams to Sell Julia Margaret Cameron's Intimate Image of Virginia Woolf's Mother, Julia Jackson', *Art Daily*, 2015, https://artdaily.cc/news/51344/Bonhams-to-sell-Julia-Margaret-Cameron-s-intimate-image-of-Virginia-Woolf-s-mother--Julia-Jackson#.Y77YknbP1aQ (accessed 1 March 2015)

Barringer, Tim, Jason Rosenfeld and Alison Smith, *Pre-Raphaelites: Art and Design*, London, 2012

Barrington, Emilie, *G.F. Watts: Reminiscences*, London, 1905

Barrington, Emilie, *The Life, Letters, and Work of Frederick Leighton*, London, 1906

Barthes, Roland, *Camera Lucida: Reflections on Photography*, New York, 1981

Bartram, Michael, *The Pre-Raphaelite Camera: Aspects of Victorian Photography*, Boston, MA, 1985

Batchelor, John, *Tennyson: To Strive, to Seek, to Find*, New York, 2013

Batchen, Geoffrey, *Burning with Desire: The Conception of Photography*, Cambridge, MA, 1997

Batchen, Geoffrey, 'Photographs before Photography: Marking Time in Tennyson's and Cameron's *Idylls of the King*', *Literature Interpretation Theory*, vol. 24 , no. 2, 2013, pp. 112–37

Bear, Jordan, 'The Silent Partner: Agency and Absence in Julia Margaret Cameron's Collaborations', *Grey Room*, vol. 48, 2012, pp. 78–101

Berenson, Bernhard, *The Venetian Painters of the Renaissance*, 3rd edn, London, 1897

Bills, Mark and Barbara Bryant, *G.F. Watts: Victorian Visionary*, New Haven, CT, 2008

Bloom, Harold (ed.), *Alfred Lord Tennyson*, New York, 1985

Boyce, Charlotte, Páraic Finnerty and Anne-Marie Millim, *Victorian Celebrity Culture and Tennyson's Circle*, Basingstoke, 2013

Boyd, Elizabeth French, *Bloomsbury Heritage: Their Mothers and their Aunts*, London, 1976

Brogan, T.V.F., and J.E. Congleton, 'Idyll', in Green, Roland, Stephen Cushman and Clare Cavanagh (eds), *The Princeton Encyclopedia of Poetry and Poetics*, Princeton, NJ, 2012, pp. 659–660.

Brusius, Mirjam, 'Impreciseness in Julia Margaret Cameron's Portrait Photographs', *History of Photography*, vol. 34, no. 4, 2010, pp. 342–55

Bryant, Barbara, *G.F. Watts Portraits: Fame and Beauty in Victorian Society*, London, 2004

Bryant, Barbara, 'G.F. Watts and the Symbolist Vision', in Andrew Wilton and Robert Upstone (eds), *The Age of Rossetti, Burne-Jones and Watts: Symbolism in Britain, 1860–1910*, London, 1997, pp. 65–82

Bryden, Inga, *Reinventing King Arthur: The Arthurian Legends in Victorian Culture*, Abingdon, 2005

Bunnell, Peter, *A Photographic Vision: Pictorial Photography, 1889–1923*, Salt Lake City, UT, 1980

Bürger, Gottfried August, *Leonora*, trans. J.M. Cameron, illus. D. Maclise, London, 1847

Burke, Edmund, *A Philosophical Enquiry into the Origin of our Ideas of the Sublime and Beautiful*, Oxford, 1990

Burne-Jones, Edward, *The Little Holland House Album: Facsimile of an Album of Eight Poems Transcribed and Illustrated by Edward Burne-Jones and Presented to Sophia Dalrymple in 1859*, North Berwick, 1981

Burne-Jones, Georgiana, *Memorials of Edward Burne-Jones*, 2 vols, London, 1904

Burton, Robert, *The Anatomy of Melancholy*, trans. from 1651 edn by Democritus Jr, London, 1840

Caldesi and Montecchi, *Photographs of the Gems of the Art Treasures Exhibition*, Manchester, 1857

Cameron, Charles Hay, *Two Essays: On the Sublime and Beautiful, and On Duelling*, London, 1835

Cameron, Julia Margaret, 'Annals of my Glass House', *The Photographic Journal*, XVII (NS), July 1927, pp. 296–301, repr. in Mike Weaver, *Julia Margaret Cameron, 1815–1879*, London, 1984

Cameron, Julia Margaret, A Collection of 112 original photographs taken by J.M. Cameron, *c*.1865, Oxford, Bodleian Library, Arch. K b.12

Cameron, Julia Margaret, *Illustrations to Tennyson's Idylls of the King, and Other Poems*, London, vol. I, 1874, vol. II, 1875, Oxford, Bodleian Library, Arch. K b.18

Cameron, Julia Margaret, 'On a Portrait' [dated September 1875], *Macmillan's Magazine*, vol. XXXIII, February 1876

Cameron, Julia Margaret, Poem sent to Arthur Clough's widow, 20 July 1862, Oxford, Bodleian Library, MS. Eng. Lett. d. 178, fol. 75

Carlyle, Thomas, *Sartor Resartus: The Life and Opinions of Herr Teufelsdröckh and Heroes and Hero Worship and the Heroic in History*, New York, 1897

Carolsfeld, Julius Schnorr von, *The Bible in Pictures; or Scripture history illustrated in a series of one hundred and eighty engravings, from original designs by Julius Schnorr von Carolsfeld, with descriptive notice of each picture*, London, 1869

Catalogue of the Art Treasures of the United Kingdom, Collected at Manchester in 1857, 2nd edn, London, 1857

Catalogue of Pictures forming the Collection of Lord and Lady Wantage at 2, Carlton Gardens, London, London, 1902

A Catalogue of the Pictures in the National Gallery, MDCCCXLI, London, 1841

Caws, Mary Ann and Gerard Joseph, 'Naming and Not Naming: Tennyson and Mallarmé', in Valentine Cunningham (ed.), *Victorian Poets: A Critical Reader*, Chichester, 2014, pp. 390–410

Chapman, Ronald, *The Laurel and the Throne: A Study of G.F. Watts*, London, 1945

Chesterton, G.K., *G.F. Watts*, London, 1975

Chesterton, G.K., *Tennyson*, London, 1903

Christ, Carol, *The Finer Optic: The Aesthetic of Particularity in Victorian Poetry*, New Haven, CT, 1975

Coburn, Alvin Langdon, 'The Old Masters of Photography', *The Century Magazine*, October 1915, pp. 908–20

Cook, E.T., *A Popular Handbook to the National Gallery*, 8th edn, London, 1922

Cox, Julian and Colin Ford, *Julia Margaret Cameron: The Complete Photographs*, Los Angeles, CA, 2003

Crane, Walter, *An Artist's Reminiscences*, London, 1907

Crowe, J.A. and G.B. Cavalcaselle, *The Life and Times of Titian: With Some Account of His Family*, 2nd edn, 2 vols, London, 1881

Crowe, J.A. and G.B. Cavalcaselle, *A New History of Painting in Italy*, vols I–III, London, 1864–6

Dalziel, George and Edward Dalziel, *Dalziels' Bible Gallery. Illustrations from the Old Testament*, London, 1880

Daniel, Malcolm, 'Julia Margaret Cameron (1815–1879)', Heilbrunn Timeline of Art History, 2004, https://www.metmuseum.org/toah/hd/camr/hd_camr.htm (accessed 30 April 2015)

Descriptive Notice of the Drawings, Tracings, and Models and

Miscellaneous Publications of the Arundel Society Exhibited November 1855, in the Crystal Palace, Sydenham, London, 1855

Di Bello, Patrizia, *Women's Albums and Photography in Victorian England*, Abingdon, 2007

Doran, Robert, *The Theory of the Sublime from Longinus to Kant*, Cambridge, 2015

Dorra, Henri, *Symbolist Art Theories: A Critical Anthology*, Berkeley, CA, 1994

Douce, Francis, *Illustrations of Shakespeare, and of Ancient Manners*, 2 vols, London, 1807

Duffy, Cian and Peter Howell (eds), *Cultures of the Sublime: Selected Readings, 1750–1830*, New York, 2011

Eliot, T.S., 'In Memoriam', in John Killham (ed.), *Critical Essays on the Poetry of Tennyson*, London, 1960

Eliot, T.S., 'In Memoriam', in Harold Bloom (ed.), *Alfred Lord Tennyson*, New York, 1985

Emerson, P.H., 'Mrs Julia Margaret Cameron', *Sun Artists*, no. 5, October 1890, pp. 33–42

Emerson, P.H., *Naturalistic Photography for Students of the Art*, London, 1899

Emerson, P.H., 'Photography, A Pictorial Art', *The Amateur Photographer*, vol. 3, 19 March 1886, pp. 138–9

Erskine, Mrs Stuart, 'Mr GF Watts' Portraits at Holland House', *The Studio*, vol. 29, no. 125, 15 August 1903, pp. 176–80

Facos, Michelle, *An Introduction to Nineteenth-Century Art*, New York, 2011

Facos, Michelle, *Symbolist Art in Context*, Berkeley, CA, 2009

Fenster, Thelma (ed.), *Arthurian Women: A Casebook*, New York, 1996

Ford, Colin, *The Cameron Collection: An Album of Photographs by Julia Margaret Cameron Presented to Sir John Herschel*, Wokingham, 1975

Ford, Colin, *Julia Margaret Cameron: A Critical Biography*, Los Angeles, CA, 2003

Ford, Colin, *Julia Margaret Cameron: 19th Century Photographer of Genius*, London, 2003

Fuller, Hester Thackeray, *Three Freshwater Friends: Tennyson, Watts and Mrs. Cameron*, ed. Elizabeth Hutchings, 3rd edn, Newport, Isle of Wight, 1992

Fuller, Hester Thackeray and Violet Hammerslay (eds), *Thackeray's Daughter: Some Recollections of Anne Thackeray Ritchie*, Dublin, 1952

Gaja, Katerine, G.F. Watts in Italy: Portrait of the Artist as a Young Man, Florence, 1995.

Gernsheim, Helmut, *Julia Margaret Cameron*, London, 1948

Gernsheim, Helmut, *Julia Margaret Cameron: Her Life and Photographic Work*, London, 1975

Glanville, Priscilla, *Tennyson's 'Maud' and its Critical, Cultural, and Literary Contexts*, New York, 2002

Gould, Veronica, *Compton, Surrey*, Farnham, 1990

Gould, Veronica, *G.F. Watts: The Last Great Victorian*, New Haven, CT, 2004

Gould, Veronica, *Mary Seton Watts (1849–1938)*, London, 1998

Gould, Veronica (ed.), *The Vision of G.F. Watts O.M. R.A.*, Salisbury, 2004

Gray, James Martin, *Thro' the Vision of the Night: A Study of Source, Evolution and Structure in Tennyson's Idylls of the King*, Edinburgh, 1980

Groth, Helen, *Victorian Photography and Literary Nostalgia*, Oxford, 2003

Gurney, Ellen Mary, *Letters of Emilia Russell Gurney*, London, 1902

Hallam, Arthur Henry, 'On Some of the Characteristics of Modern Poetry, and On the Lyrical Poems of Alfred Tennyson', *The Englishman's Magazine*, vol. 1, 1831, pp. 617–28

Hamilton, Violet, *Annals of my Glass House: Photographs by Julia Margaret Cameron*, Claremont, CA, 1996

Harker, Margaret, *Julia Margaret Cameron*, London, 1983

Haweis, Hugh, *Music and Morals*, London, 1871

Herschel, Sir John F.W., *Familiar Lectures on Scientific Subjects*, London, 1866

Herschel, Sir John, *A Preliminary Discourse on the Study of Natural Philosophy*, Cambridge, 1830

Hill, Marylu, "'Shadowing Sense at War with the Soul": Julia Margaret Cameron's Photographic Illustrations of Tennyson's *Idylls of the King*', *Victorian Poetry*, vol. 40, no. 4, 2002, pp. 445–62

Hinton, Brian, *Immortal Faces: Julia Margaret Cameron on the Isle of Wight*, Newport, Isle of Wight, 1992

Homer, *The Illiad*, trans. P.S. Worsley and J. Conington, 2 vols , Edinburgh, 1865 and 1868

Homer, *The Odyssey*, trans. P.S. Worsley, 2 vols, Edinburgh, 1861

Hood, James W., *Divining Desire: Tennyson and the Poetics of Transcendence*, Burlington, VT, 2000

Hopkinson, Amanda, *Julia Margaret Cameron*, London, 1986

Hunt, William Holman, *Pre-Raphaelitism and the Pre-Raphaelite Brotherhood*, 2 vols, London, 1905

Ilchester, Giles Stephen Holland Fox-Strangways, Earl of, *Chronicles of Holland House, 1820–1900*, London, 1937

Ilchester, Giles Stephen Holland Fox-Strangways, Earl of, *The Home of the Hollands, 1605–1820*, London, 1937

Jack, Belinda, *Beatrice's Spell*, New York, 2005

Jacobi, Carol and Hope Kingsley, *Painting with Light: Art and Photography from the Pre-Raphaelites to the Modern Age*, London, 2016

Jameson, Anna Brownell, *Characteristics of Women, Moral, Poetical, and Historical*, London, 1832

Jameson, Anna Brownell, *The History of our Lord as Exemplified in Works of Art*, 2 vols, completed by Lady Eastlake, London, 1864

Jameson, Anna Brownell, *Legends of the Madonna as Represented in the Fine Arts*, London, 1852

Jameson, Anna Brownell, *Legends of the Monastic Orders as Represented in the Fine Arts*, London, 1852

Jameson, Anna Brownell, *Memoirs and Essays Illustrative of Art, Literature, and Social Morals*, London, 1846

Jameson, Anna Brownell, *Sacred and Legendary Art*, 2 vols, London, 1848

Jameson, Anna Brownell, *Shakespeare's Heroines: Characteristics of Women, Moral, Poetical, and Historical*, London, 1897

Joseph, Gerhard, 'The Echo and the Mirror *en abîme* in Victorian Poetry', in Valentine Cunningham (ed.), *Victorian Poets: A Critical Reader*, Chichester, 2014, pp. 15–26

Joseph, Gerhard, 'Poetic and Photographic Frames: Tennyson and Julia Margaret Cameron', *The Tennyson Research Bulletin*, vol. 5, no. 2, 1988, pp. 43–8

Joseph, Gerhard, *Tennyson and the Text*, Cambridge, 1992

Joseph, Gerhard, *Tennysonian Love: The Strange Diagonal*, Minneapolis, MN, 1969

Joseph, Gerhard, 'Victorian Weaving: The Alienation of Work into Text in "The Lady of Shalott"', in Rebecca Stott (ed.), *Tennyson*, London, 1996, pp. 24–32

Jowett, Benjamin, *Letters of Benjamin Jowett, MA, Master of Balliol College, Oxford*, vol. II, ed. Evelyn Abbot and Lewis Campbell, London, 1897

Keens, H.L., 'Truth in Art Illustrated by Photography', *The Photographic Journal*, vol. 5, 15 November 1859, pp. 77–83

Kelsey, Robin, *Photography and the Art of Chance*, Cambridge, MA, 2015

Kermode, Frank (ed.), *Selected Prose of T.S. Eliot*, New York, 1975

Kermode, Frank, *The Sense of Ending: Studies in the Theory of Fiction with a New Epilogue*, Oxford, 2000

Killham, John (ed.), *Critical Essays on the Poetry of Tennyson*, New York, 1960

Kooistra, Lorraine Janzen, *Poetry, Pictures, and Popular Publishing*, Athens, OH, 2011

Lee, Vernon, *The Beautiful: An Introduction to Psychological Aesthetics*, Scotts Valley, CA, 2012

Leighton, Angela, 'Touching Forms: Tennyson and Aestheticism', *Essays in Criticism: A Quarterly Journal of Literary Criticism*, vol. 52, no. 1, 2002, pp. 56–75

Lincoln, Tennyson Research Center, Catalogue of Books in Alfred Tennyson's Library, n.d., TRC/N/24

Lincoln, Tennyson Research Centre, Letter from Alfred Tennyson to Julia Margaret Cameron, August 1852, TRC/LETTERS/5057A

Lincoln, Tennyson Research Centre, Letter from Alfred

Tennyson to Julia Margaret Cameron, March 1854, TRC/
LETTERS/5057B

Linkman, Audrey, *Photography and Death*, London, 2011

Linkman, Audrey, *The Victorians: Photographic Portraits*, London, 1993

London, Heinz Archive and Library, National Portrait Gallery,
Letters from G.F. Watts to Julia Margaret Cameron, n.d.,
GFW/1/12/31–43

London, Heinz Archive and Library, National Portrait Gallery,
Letter from Julia Margaret Cameron to G.F. Watts, 3 December
1860, GFW/1/4/87

London, National Portrait Gallery, Heinz Archive and Library
(Autograph Letter Series), Letter from Julia Margaret Cameron
to Sir John Herschel, 31 December 1864

London, Victoria and Albert Museum, Letter from Julia Margaret
Cameron to Sir Henry Cole, 7 April 1868, NAL 55.BB.Box 8

London, Victoria and Albert Museum, Letter from Julia Margaret
Cameron to Sir Henry Cole, 21 February 1866, NAL 55.BB.
Box 8

Lukitsh, Joanne, 'Julia Margaret Cameron's Photographic
Illustrations to Alfred Tennyson's *Idylls of the King*', *Arthurian
Literature*, vol. 7, 1987, pp. 145–57

Lupack, Barbara Tepa, with Alan Lupack, *Illustrating Camelot*,
Woodbridge, 2008

MacKay, Carol Hanbery, *Creative Negativity: Four Victorian Exemplars
of the Female Quest*, Stanford, CA, 2001

Macmillan, Hugh, *The Life-Work of George Frederic Watts*, London,
1903

Maitland, Frederic William, *The Life and Letters of Leslie Stephen*,
London, 1906

Mancoff, Debra N., 'Legend "From Life": Cameron's Illustrations
to Tennyson's "Idylls of the King"', in Sylvia Wolf, *Julia Margaret
Cameron's Women*, New Haven, CT, 1998, pp. 87–106

Mavor, Carol, *Pleasures Taken: The Performance of Sexuality and Loss in
Victorian Photographs*, Durham, NC, 1995

Maxwell, Catherine, *The Female Sublime from Milton to Swinburne*,
Manchester, 2001

Maynard, Frederic W., *Descriptive Notice of the Drawings and
Publications of the Arundel Society*, London, 1869

McLuhan, H.M., 'Tennyson and Picturesque Poetry', in John
Killham (ed.), *Critical Essays on the Poetry of Tennyson*, New
York, 1960, pp. 67–85

Millard, Charles W., 'Julia Margaret Cameron and Tennyson's
Idylls of the King', *Harvard Library Bulletin*, vol. XXI, no. 2,
1973, pp. 187–201

Mitchell, W.J.T., *Iconology: Image, Text, Ideology*, Chicago, IL,
1986

Monkhouse, Cosmo, 'The Watts Exhibition', *Magazine of Art*,
vol. 5, 1882, pp. 177–83, https://victorianweb.org/painting/
watts/paintings/monkhouse.html (accessed 12 January
2023)

Morton, John, *Tennyson among the Novelists*, London, 2010

Myers, F.W.H., 'Rossetti and the Religion of Beauty', in David
G. Riede (ed.), *Critical Essays on Dante Gabriel Rossetti*, New
York, 1992, pp. 50–65

Newhall, Beaumont, *The History of Photography from 1839 to the
Present Day*, New York, 1949

Newhall, Beaumont (ed.), *Photography: Essays & Images: Illustrated
Readings in the History of Photography*, New York, 1980

Newhall, Beaumont and Nancy Newhall (eds), *Masters of
Photography*, New York, 1958

Olsen, Victoria, *From Life: Julia Margaret Cameron and Victorian
Photography*, London, 2003

Oxford, Bodleian Library, Correspondence of G.F. Watts,
Bodleian Library MS. Eng. lett. c. 2.

Oxford, Bodleian Library, Julia Margaret Cameron to Blanche
Shore Smith Clough, 20 July 1862, Papers of A.H. Clough,
1829–1900, Bodleian Library MS. Eng. lett. d. 178, fol. 75

Oxford, Bodleian Library, Letters concerning her lecture on
Photography to the Oxford Camera Club, 1899, Bodleian
Library MS. Acland d. 166

Oxford, Bodleian Library, Letters to her, as Miss Cotton, from
various friends, 1834–1841, Bodleian Library MS. Acland
d. 193

Oxford, Bodleian Library, Letter from Henry Taylor on behalf of Charles Cameron, 11 June 1861, Bodleian Library MS. Eng. lett. d. 12, fols 17–18

Oxford, Bodleian Library, Letter from Julia Margaret Cameron to Henry Taylor, 1 July [1876?], Bodleian Library MS. Eng. lett. d. 13, fol. 79

Oxford, Bodleian Library, Letter from Henry Taylor to G.F. Watts, 5 September 1880, Bodleian Library MS Eng. lett. d. 14, fols 246–47

Oxford, Bodleian Library, Letters from various correspondents, 1841–1900, Bodleian Library MS. Acland d. 77

Oxford, Bodleian Library, Ruskin Papers, *c*.19th–early 20th century, Bodleian Library MS. Eng. lett. c. 50

Pater, Walter, *Studies in the History of the Renaissance*, London, 1873

Patmore, Coventry, 'Mrs. Cameron's Photographs', *Macmillan's Magazine*, vol. XII, 1866, pp. 230–31

Pergam, Elizabeth A., *The Manchester Art Treasures Exhibition of 1857*, Farnham, 2011

Pinion, F.B., *A Tennyson Chronology*, Boston, MA, 1990

Poulson, Christine, *The Quest for the Grail: Arthurian Legend in British Art*, Manchester, 1999

Prinsep, Val C., *Lectures Delivered to the Students of the Royal Academy of Arts of London, January 1902*, London, 1902

Prodger, Phillip, 'Ugly Disagreements: Darwin and Ruskin Discuss Sex and Beauty', in Barbara Larson and Fae Brauer (eds), *The Art of Evolution: Darwin, Darwinisms, and Visual Culture*, Hanover, NH, 2009, pp. 40–58

Prodger, Philip, *Victorian Giants: The Birth of Art Photography*, London, 2018

Ricks, Christopher (ed.), *The New Oxford Book of Victorian Verse*, Oxford, 1987

Ricks, Christopher (ed.), *The Oxford Book of English Verse*, Oxford, 1999

Riede, David G. (ed.), *Critical Essays on Dante Gabriel Rossetti*, New York, 1992

Riede, David G., 'Tennyson's "Little Hamlet"', in Valentine Cunningham (ed.), *Victorian Poets: A Critical Reader*, Chichester, 2014, pp. 268–85

Ritchie, Anne Thackeray, *Lord Tennyson and his Friends, with a series of 25 portraits and frontispiece in photogravure from the negatives of Mrs. Julia Margaret Cameron and H.H.H. Cameron*, London, 1893

Roberts, Pam, 'Julia Margaret Cameron: A Triumph over Criticism', in Graham Clarke (ed.), *The Portrait in Photography*, London, 1992, pp. 47–70

Robinson, Henry Peach, *Pictorial Effect in Photography Being Hints on Composition and Chiaro-oscuro for Photographers*, Philadelphia, PA, 1881

Rosen, Jeff, *Julia Margaret Cameron's 'Fancy Subjects'*, Manchester, 2016

Rosenberg, John D., 'Tennyson and the Passing of Arthur', in Christopher Baswell and William Sharpe (eds), *The Passing of Arthur: New Essays in the Arthurian Tradition*, New York, 1988.

Rosenblum, Naomi, *A History of Women Photographers*, New York, 2010

Rosenblum, Naomi, *A World History of Photography*, New York, 1989

Ross, Alison, *Walter Benjamin's Concept of the Image*, New York, 2015

Rossetti, William Michael, *Fine Art, Chiefly Contemporary: Notices Reprinted, with Revisions*, London, 1867

Rossetti, William Michael (ed.), *The Germ: Thoughts towards Nature in Poetry, Literature and Art*, London, 1901

Rossetti, William Michael, *Lives of Famous Poets*, London, 1878

Rossetti, William Michael, 'Mr. Palgrave and Unprofessional Criticisms in Art', *Fine Arts Quarterly Review*, 1866, pp. 325–34

Rossetti, William Michael, *Rossetti Papers, 1862–1870*, London, 1903

Ruskin, John, *Modern Painters*, 5 vols, London, 1907

Ruskin, John, *The Works of John Ruskin*, ed. E.T. Cook and Alexander Wedderburn, London, 1903

Schaaf, Larry, *Herschel, Talbot, and the Invention of Photography*, New Haven, CT, 1992

Schaaf, Larry, 'John Herschel, Photography and the Camera Lucida', *Transactions of the Royal Society of South Africa*, vol. 49, no. 1, 1994, pp. 87–102

Schmid, Susanne, *British Literary Salons of the Late Eighteenth and Early Nineteenth Centuries*, New York, 2013

Scholtz, Amelia, 'Photographs before Photography: Marking Time in Tennyson's and Cameron's *Idylls of the King*', *Literature Interpretation Theory*, vol. 24, no. 2, 2013, pp. 112–37

Shoberl, Frederic (ed.), *The Language of Flowers, with Illustrative Poetry*, Philadelphia, PA, 1839

Simpson, Roddy, 'Julia Margaret Cameron and the Photographic Society of Scotland', *History of Photography*, vol. 28, no. 1, 2004, pp. 86–7

Slocum, Sally (ed.), *Popular Arthurian Traditions*, Bowling Green, OH, 1992

Smith, Alison, 'The Symbolic Language of G.F. Watts', in Veronica Franklin Gould (ed.), *The Vision of G.F. Watts O.M. R.A.*, Salisbury, 2004, pp. 22–7

Smith, Lindsay, *Pre-Raphaelitism: Poetry and Painting*, Tavistock, 2013

Smith, Lindsay, *Victorian Photography, Painting and Poetry: The Enigma of Visibility in Ruskin, Morris, and the Pre-Raphaelites*, Cambridge, 1995

Sontag, Susan, *On Photography*, New York, 1973

Sotheby's, 'The "Signor 1857" Album', L12408, lot 65, 12 December 2012, https://www.sothebys.com/en/auctions/ecatalogue/2012/english-literature-history-l12408/lot.65.html (accessed 14 February 2023)

Spielmann, M.H., *G.F. Watts, R.A., O.M., as a Great Painter of Portraits: A Lecture with Additions and Emendations, delivered at the Memorial Hall, Manchester, 7 June*, Manchester, 1905

Spielmann, M.H., 'The Portraiture of George Frederic Watts,' *The Nineteenth Century*, vol. LXXIII (1913), pp. 1–32

Spielmann, M.H., 'The Works of Mr. George F. Watts, R.A., with a Complete Catalogue of his Pictures', *Pall Mall Gazette* ('Extra'), no. 22, 1886, pp. 118–32

Staines, David, *Tennyson's Camelot: The Idylls of the King and its Medieval Sources*, Waterloo, Ont., 1982

Staley, Allen (ed.), *The Victorian High Renaissance*, Minneapolis, MN, 1978

Starzyk, Lawrence, '"The Gardener's Daughter": The Exegesis of an Icon', *Mosaic: An Interdisciplinary Critical Journal*, vol. 32, no. 3, 1999, pp. 41–58

Stieglitz, Alfred, *Camera Work*, no. 41, January 1913

Symons, Arthur, 'The Art of Watts', *The Fortnightly Review*, vol. LXVIII (NS), July–1900, pp. 188–97

Symons, Arthur, *Plays, Acting, and Music*, New York, 1909

Taylor, Henry, *Autobiography of Henry Taylor, 1800–1875*, 2 vols, London, 1885

Taylor, Henry, *Correspondence of Henry Taylor*, ed. Edward Dowden, London, 1888

Taylor, Henry, *Notes from Life in Six Essays*, London, 1848

Taylor, Henry, *The Poetical Works of Henry Taylor, D.C.L.*, 3 vols, London, 1864

Taylor, Henry, *St. Clement's Eve*, London, 1862

Taylor, Henry, *Statesman*, London, 1836

Taylor, Una, *Guests and Memories: Annals of a Seaside Villa*, London, 1924

Tennyson, Alfred, *Idylls of the King*, ed. Hallam Tennyson, London, 1908

Tennyson, Alfred, *The Letters of Alfred Lord Tennyson*, vol. II, *1851–1870*, ed. Cecil Y. Lang and Edgar F. Shannon Jr, Oxford, 1987

Tennyson, Alfred, *The Poems* [Moxon edn], London, 1857

Tennyson, Alfred, *The Poems of Tennyson*, ed. Christopher Ricks, London, 1972

Tennyson, Alfred, *The Princess and Maud*, London, 1908

Tennyson, Alfred, *Tennyson: A Selected Edition*, ed. Christopher Ricks, Harlow, 2007

Tennyson, Alfred, *Tennyson's Maud: A Definitive Edition*, ed. Susan Shatto, London, 1986

Tennyson, Alfred, *The Works of Alfred Tennyson*, 10 vols, London, 1875–7

Tennyson, Alfred, *The Works of Alfred Tennyson*, ed. Karen Hodder, London, 1994

Tennyson, Charles, *Alfred Tennyson*, New York, 1949

Tennyson, Emily Sellwood, *The Letters of Emily Lady Tennyson*, ed. James O. Hoge, University Park, PA, 1974

Tennyson, Emily Sellwood, *Lady Tennyson's Journal*, ed. James O. Hoge, Charlottesville, VA, 1981

Tennyson, Hallam (ed.), *Tennyson and his Friends*, London, 1911

Tennyson, Hallam, *Alfred Lord Tennyson: A Memoir by his Son*, 2 vols, London, 1897

Terry, Ellen, *Four Lectures on Shakespeare*, London, 1932

Terry, Ellen, *The Story of My Life*, extra illustrated edn, London, 1908

Thorn, Michael, *Tennyson*, London, 1992

Troubridge, Laura, *Memories and Reflections*, London, 1925

Van Dyke, Henry, 'The Voice of Tennyson', *Century Magazine*, vol. XLV, 1893, pp. 539–44

Virgil, *The Aeneid*, trans. C. Day Lewis, Oxford, 1986

Waagen, Gustav Friedrich, *A Walk through the Art-Treasures Exhibition at Manchester, under the guidance of Dr. Waagen: A Companion of the Official Catalogue*, London, 1857

Ward, Chloe, *Drawings of G.F. Watts*, London, 2015

Warner, Marina, *Phantasmagoria: Spirit Visions, Metaphors, and Media into the Twenty-First Century*, Oxford, 2006

Watts, G.F., 'The Present Conditions of Art', *The Nineteenth Century*, vol. VII, no. 36, 1880, pp. 235–55

Watts, Mary Seton, *George Frederic Watts: Annals of the Artist's Life*, 3 vols, London, 1912

Weaver, Mike, *Julia Margaret Cameron, 1815–1879*, London, 1984

Weaver, Mike, 'Julia Margaret Cameron: The Stamp of Divinity', in Mike Weaver (ed.), *British Photography in the 19th Century: The Fine Art Tradition*, Cambridge, 1989

Weaver, Mike, *The Photographic Art: Pictorial Traditions in Britain and America*, London, 1986

Weaver, Mike, *Whisper of the Muse: The Overstone Album and Other Photographs by Julia Margaret Cameron*, Los Angeles, CA, 1986

Weiss, Marta, *Julia Margaret Cameron: Photographs to Electrify You with Delight and Startle the World*, London, 2015

Weld, Agnes, *Glimpses of Tennyson and of Some of his Relations and Friends*, New York, 1903

Wilton, Andrew, 'Symbolism in Britain', in Andrew Wilton and Robert Upstone (eds), *The Age of Rossetti, Burne-Jones and Watts: Symbolism in Britain, 1860–1910*, pp. 11–34

Wilton, Andrew and Robert Upstone, *The Age of Rossetti, Burne-Jones and Watts: Symbolism in Britain, 1860–1910*, London, 1997

Wind, Edgar, *Pagan Mysteries in the Renaissance*, New Haven, CT, 1958

Wolf, Sylvia, *Julia Margaret Cameron's Women*, New Haven, CT, 1998

Woolf, Virginia, *To the Lighthouse*, San Diego, CA, 1989

Woolf, Virginia and Roger Fry, *Victorian Photographs of Famous Men and Fair Women by Julia Margaret Cameron*, London, 1926

Yamashiro, Jennifer Pearson, 'Idylls in Conflict: Victorian Representations of Gender in Cameron's Illustrations of Tennyson's "Idylls of the King"', *Library Chronicle of the University of Texas at Austin*, vol. 26, no. 4, 1996, pp. 88–115

Yeats, William Butler, 'Symbolism in Painting', in *Ideas of Good and Evil* (1903), republished as *Essays*, London, 1924, pp. 180–87

Picture credits

Index

Entries in italics refer to illustrations

First published in 2023 by Bodleian Library Publishing
Broad Street, Oxford OX1 3BG
www.bodleianshop.co.uk

ISBN: 978 1 85124 584 0

Publisher: Samuel Fanous
Managing Editor: Susie Foster
Editor: Janet Phillips
Picture Editor: Leanda Shrimpton
Designed and typeset by Dot Little at the Bodleian Library
in 11/16 on Monotype Baskerville
Printed and bound by C&C Offset Printing Co., Ltd on 157 gsm Chinese Golden Sun matt art paper

MIX
Paper | Supporting
responsible forestry
FSC® C008047
www.fsc.org

British Library Catalogue in Publishing Data
A CIP record of this publication is available from the British Library